The Chrysler Museum

Handbook of the European and American Collections

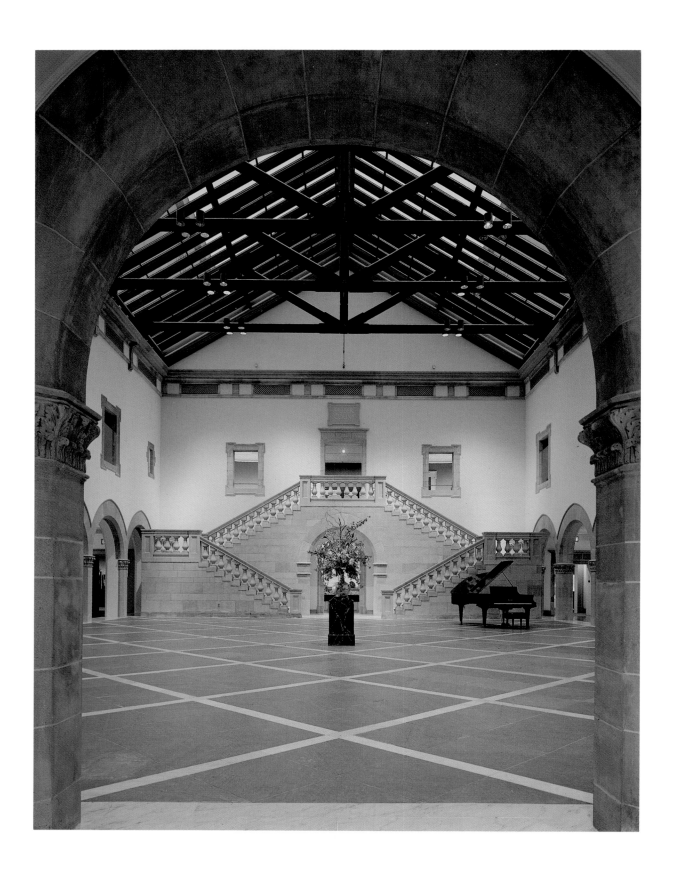

The Chrysler Museum

Handbook of the European and American Collections

Selected Paintings, Sculpture and Drawings

Jefferson C. Harrison

Norfolk, Virginia

This publication was supported in part by a grant from the National Endowment for the Arts, a federal agency. Further contributions in support of the book were generously made by Mr. Jack F. Chrysler, Jr., the estate of Mrs. Virginia Roper Whitney and the Edwin S. Webster Foundation.

Designed by Germaine Clair Designs
Object photographs by Scott Wolff
Edited by Joanne Jaffe
Typeset by B.F. Martin, Inc.
Printed by Teagle & Little, Inc.

Published by The Chrysler Museum

LCCN 90-086394
ISBN 0-940744-59-7 (softcover edition)
ISBN 0-940744-62-7 (hardcover edition)

Cover: Frederick Childe Hassam, *At the Florist,* entry no. 117, detail
Page 1: Jan Gossaert, *Madonna and Child,* no. 9, detail
Page 21: Nicolas de Largillierre, *The Artist in His Studio,* no. 39, detail
Page 57: Giovanni Battista Pittoni, *Memorial to James, First Earl Stanhope,* no. 50, detail
Page 85: Albert Bierstadt, *The Emerald Pool,* no. 101, detail
Page 165: Henry Matisse, *Bowl of Apples on a Table,* no. 132, detail

For Walter P. Chrysler, Jr.,
who made so much possible

Contents

Foreword

The origin of The Chrysler Museum can be traced to the activity of two talented teachers in the decades following the Civil War. Upon their move to Norfolk from Winchester, Virginia, Miss Irene Leache and Miss Anna Cogswell Wood founded the Leache-Wood Female Seminary in 1871. Irene Leache died in 1900. That year Miss Wood established the Irene Leache Library, to be managed by the alumnae of the Leache-Wood Seminary, and in 1905 she formed the Leache-Wood Alumnae Association, with the stated goal of establishing an art museum. The Norfolk Society of Arts, which evolved from the Association, was established in 1917 to encourage broader community interest, and a separate organization, the Irene Leache Memorial, was created. Both organizations still actively support the Museum.

In 1923, under the leadership of Mrs. William Sloane, fund raising began to construct a museum. Built on a site donated by the City, the first wing of the Italianate-style structure opened to the public on March 5, 1933, one day after the inauguration of President Franklin Delano Roosevelt, though the entire building was not completed until 1939. The Norfolk Museum of Arts and Sciences, as it was then called, housed not only a collection of painting and sculpture but also exhibits of natural and Tidewater history.

A rapidly growing collection, increased membership and the demand for lecture and changing exhibition space necessitated the construction in 1967 of a new wing which doubled the size of the building. The addition, which provided a theater and additional galleries, was made possible through a bequest from Wilmer Willis Houston and with funds provided by the City. The first exhibition in the new wing included material on loan from Walter P. Chrysler, Jr., of New York.

Walter Chrysler was already familiar with Norfolk. His wife, Jean Outland Chrysler, was from the city and had given a collection of contemporary paintings to the Museum in honor of her parents. In March of 1971 a substantial portion of the Chryslers' extraordinary art collection – literally thousands of paintings, sculptures, drawings, decorative art objects and an incomparable 8,000-piece collection of glass – was given to the newly renamed Chrysler Museum. From that point the collection expanded dramatically, and to accommodate this growth twenty galleries were added to the building in 1976. With a continuing program of active collecting in a broad range of areas, the need for additional exhibition and support areas was successfully met in 1989 with the completion of an ambitious building campaign that added new space to the Museum and renovated existing space. The new building not only met the needs of the collection but provided appropriate housing for the Jean Outland Chrysler Library.

As the present handbook reveals, The Chrysler Museum's collections of European and American paintings, sculpture and drawings contain remarkable examples from nearly every period and school, from the lapidary Renaissance works of Gerard David and Jan Gossaert (entry nos. 6, 9) to the ironic Pop Art productions of Tom Wesselmann and James Rosenquist (nos. 148, 149). The Museum's Italian Baroque and French holdings are particularly outstanding. As a collector of seventeenth- and eighteenth-century Italian art before the re-emergence of interest in these areas, Mr. Chrysler was able to acquire prime examples of Baroque painting from virtually every school. As a result, the Museum today contains an extraordinary succession of Italian Baroque pictures, including Guido Reni's imposing *The Meeting of David and Abigail* (no. 18), Guercino's *Samson Bringing Honey to His Parents* (no. 22), *The Baptism of the Eunuch* by Salvator Rosa (no. 34), Luca Giordano's playful *Bacchus and Ariadne* (no. 36) and Giuseppe Maria Crespi's majestic *The Continence of Scipio* (no. 47), to name only a few. Among the Museum's Italian sculptures is Gianlorenzo Bernini's incomparable *Bust of the Savior* from 1680 (no. 37).

Mr. Chrysler's interest in French art was even more far-reaching, ranging from cabinet pictures of the seventeenth century – among them gem-like paintings by Georges de La Tour (no. 21) and Laurent de La Hyre (no. 28) – to masterpieces of twentieth-century art, including Georges Rouault's 1905 *Head of Christ* (no. 126) and Henri Matisse's magical *Bowl of Apples on a Table* from 1916 (no. 132). The Museum's nineteenth-century French and American holdings are especially impressive and virtually encyclopedic, containing such highlights as Thomas Cole's monumental *Angel Appearing to the Shepherds* (no. 69), Jean-François Millet's *Baby's Slumber* (no. 80), Mary Cassatt's endearing vision of *The Family* (no. 118) and James Tissot's lively *The Artists' Wives* (no. 115). In the context of the current revival of interest in academic painting, the Museum's numerous canvases by France's leading nineteenth-century Salon painters are of particular note (see nos. 87, 97, 99, 100). Its *fin-de-siècle* French avant-garde paintings are even more impressive and include major productions such as Pierre Auguste Renoir's *The Daughters of Durand-Ruel* (no. 113) and Paul Gauguin's *The Loss of Virginity* (no. 119). The nineteenth-century American collection was further enriched during the 1970s – when Mr.

Chrysler's sister, Bernice Chrysler Garbisch, and her husband Edgar William Garbisch, donated a sizable portion of their renowned collection of American folk art (see nos. 65-68, 102) – and again in 1986, when the Museum acquired some seventy pieces of American Neoclassic sculpture from the incomparable New York collection of James H. Ricau (see nos. 73, 79, 84, 90).

The Chrysler Museum now houses an encyclopedic collection with material ranging from antiquity through contemporary art. This handbook is the first of a planned series of publications which will deal with all aspects of the holdings of the institution. It has been made possible through the dedication and generosity of the people of this community, who have encouraged the development of this museum from its modest beginnings to the present. Jefferson Harrison in his comments thanks those who have contributed to this project, and I will not repeat their names here. It is necessary, however, to especially thank those whose financial support allowed this volume to be published. I should like also to express my gratitude to Dr. Harrison, whose dedication to this project has been unwavering.

Robert H. Frankel
Director

Preface

This book represents a major step in The Chrysler Museum's ongoing effort to research and publish its remarkable collections of European and American art, much of which was donated by Walter P. Chrysler, Jr., between 1971 and his death in 1988. Many of the works included have already been discussed in scholarly monographs, periodical articles and exhibition catalogues. The present book, however, is the first publication to treat a significantly large number of these works – some 154 paintings, drawings and sculptures – in a single volume. It is the first book to offer a comprehensive survey of the Museum's European and American collections in all of their richness and variety. Although The Chrysler Museum is often praised for the breadth and quality of its collections, its holdings are still remarkably little-known. It is likely that both general readers and specialists will find much in this book that will surprise and delight them.

It is a pleasure to acknowledge the many people and organizations that have made this publication possible. I am indebted, above all, to those sponsors whose generous support has allowed the book to proceed smoothly from concept to completion. They are the National Endowment for the Arts, a federal agency; Mr. Jack F. Chrysler, Jr.; the estate of Mrs. Virginia Roper Whitney; and the Edwin S. Webster Foundation. I am also indebted to Robert H. Frankel, Director of The Chrysler Museum, whose vision and encouragement have helped to keep the project on track, and to David W. Steadman and Roger D. Clisby, who contributed so much during its early stages.

Rena Hudgins, Librarian of The Chrysler Museum, and Lynda Wright and Rosemary Dumais, catalogue librarians, deserve special praise for their kind assistance with countless reference requests, as does Library Assistant Charlotte Frazier. My work with the Museum's curatorial files was greatly facilitated by Registrar Catherine Jordan and Associate Registrar Irene Roughton, and I warmly acknowledge the crucial efforts and exemplary patience of Scott Wolff, Museum Photographer, who photographed the objects for the book; Patricia Sisk, Slide Librarian, who helped select the transparencies; Joanne Jaffe, who edited the text; and Germaine Clair, who designed the book and brought it, so expertly, to publication. I extend thanks as well to Trinkett Clark, Curator of Twentieth-Century Art, and H. Nichols B. Clark, Curator of American Art, for their kind responses to my many questions and their willingness to share information and offer advice.

Finally, I am deeply indebted to four former curators of The Chrysler Museum: Thomas Sokolowski, Thomas Styron, Joyce Szabo and Eric Zafran, who, during the late 1970s and early 1980s, began the formidable task of researching and publishing the extraordinary European and American collections that Walter Chrysler had only recently brought to the city of Norfolk. Their groundbreaking work has served repeatedly as a point of departure for my own research.

Jefferson C. Harrison
Curator of European Art

Notes to the Entries

All but two of the works discussed in this book have been selected from the permanent collection of The Chrysler Museum and were accessioned before September of 1991. The two exceptions – the works discussed in entry nos. 1 and 3 – are on extended loan to the Museum from the Irene Leache Memorial Collection.

Entries are arranged roughly chronologically by date of work and are grouped by century. In some cases, works that pre- or post-date a given century by a few years are nonetheless grouped within that century because of stylistic or art historical considerations.

The text of each entry is preceded by the following information:

The name of the artist, his nationality and birth and death dates, when known. If the work has been attributed to an artist, the notation "attributed to" follows the artist's name. In only one case – no. 3 – is an artist's identity unknown, and there the work is identified by regional school and approximate date of creation.

The title and date of the work. In most cases, if the date of the work is not documented, an approximate date is indicated by "c." (circa) or by decade.

Medium and dimensions. Dimensions are given both in inches and centimeters. For paintings and drawings, height precedes width. For sculpture, only height is given.

Acquisition information and accession number. The first two digits of the accession number denote the year of acquisition.

Bibliographical references. Where possible, one or more published discussions of the work have been cited for those interested in further reading. The reference section is intentionally skeletal; no more than four publications have been cited for any work. However, an attempt has been made to list the most recent and/or fullest discussions of the work.

The following abbreviations have been used in this section:

Atlanta, 1983:

> *French Salon Paintings from Southern Collections,* exhibition catalogue, High Museum of Art, Atlanta; Chrysler Museum, Norfolk; North Carolina Museum of Art, Raleigh; and John and Mable Ringling Museum of Art, Sarasota, 1983.

exhib. cat.:

> exhibition catalogue

Harrison, *CM,* 1986:

> Jefferson C. Harrison, Jr., *French Paintings from The Chrysler Museum,* exhibition catalogue, North Carolina Museum of Art, Raleigh, and Birmingham Museum of Art, 1986-87.

Manchester, 1991-92:

> *The Rise of Landscape Painting in France: Corot to Monet,* exhibition catalogue, Currier Gallery of Art, Manchester, New Hampshire; IBM Gallery of Science and Art, New York; Dallas Museum of Art; and High Museum of Art, Atlanta, 1991-92.

Paris, 1982:

> *France in the Golden Age: Seventeenth-Century French Paintings in American Collections,* exhibition catalogue, Grand Palais, Paris; Metropolitan Museum of Art, New York; and Art Institute of Chicago, 1982.

Sokolowski, *CM*, 1983:

> Thomas W. Sokolowski and Thomas W. Styron, *From Veneziano to Pollock,* exhibition catalogue, Chrysler Museum, Norfolk, 1983.

Szabo, *CM*, 1986:

> Joyce M. Szabo, *American Art – 1875-1913. The Chrysler Museum Gallery Guide,* Chrysler Museum, Norfolk, 1986.

Tokyo, 1985:

> *Millet and His Barbizon Contemporaries,* exhibition catalogue, Keio Department Store, Tokyo; Hanshin Department Store, Osaka; Miyazaki Prefectural Institution, Fukushima; and Yamanashi Prefectural Museum of Art, Kofu, 1985.

Yale, 1987-88:

> *A Taste for Angels: Neapolitan Painting in North America 1650-1750,* exhibition catalogue, Yale University Art Gallery, New Haven; John and Mable Ringling Museum of Art, Sarasota; and Nelson-Atkins Museum of Art, Kansas City, 1987-88.

Zafran, *CM*, 1977:

> Eric M. Zafran and Mario Amaya, *Treasures from The Chrysler Museum at Norfolk and Walter P. Chrysler, Jr.,* exhibition catalogue, Tennessee Fine Arts Center at Cheekwood, Nashville, 1977.

Zafran, *CM*, 1978:

> Eric M. Zafran and Mario Amaya, *Veronese to Franz Kline: Masterworks from The Chrysler Museum at Norfolk,* exhibition catalogue, Wildenstein and Co., New York, 1978.

Zafran, *CM*, 1979:

> Eric M. Zafran, *One Hundred Drawings in The Chrysler Museum at Norfolk,* exhibition catalogue, Chrysler Museum, Norfolk, 1979.

The text provides basic information about the artist's life, discusses the work's place and importance within the artist's career or its historic period, and notes the qualities distinctive to the work. Each work is illustrated in color in the text.

Fourteenth through Sixteenth Centuries

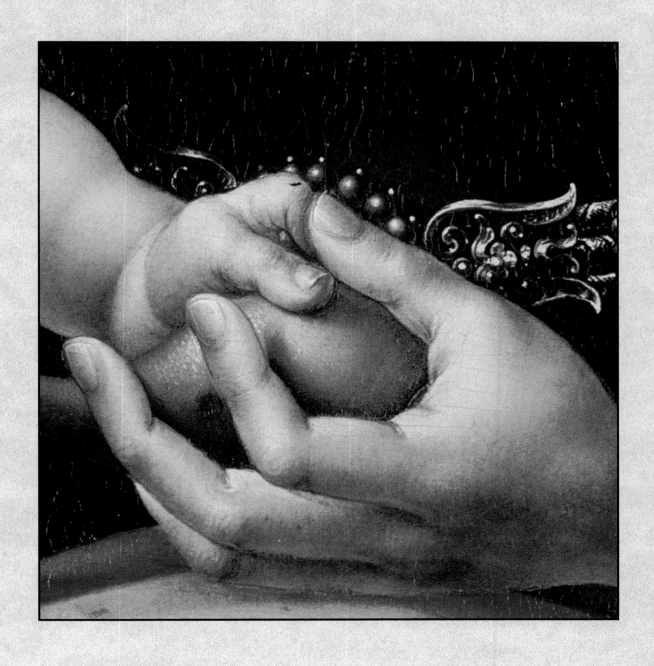

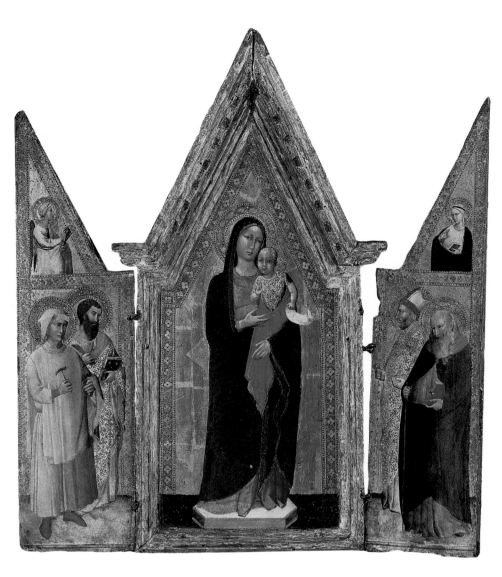

1 Naddo Ceccarelli *(attributed to)*

Italian, active c. 1339-1347

Madonna and Child Flanked by Four Saints

Tempera and gold leaf on panel, 22½" x 20½" overall (57.2 x 52 cm)

Irene Leache Memorial Collection, 72.3

References: Bernard Berenson, *Italian Pictures of the Renaissance: Central Italian and North Italian Schools,* London, 1968, I, p. 85; Cristina De Benedictis, "Naddo Ceccarelli," *Commentari,* 25 (1974), pp. 148, 153, note 14.

The authorship of this charming tabernacle – a three-part altarpiece, or triptych, topped with pointed, Gothic arches – remains an issue of scholarly discussion, though most writers have ascribed the work to Naddo Ceccarelli. Little-known today, Ceccarelli learned his craft in Siena from the painter Lippo Memmi. From 1339 he worked in Avignon with the great Sienese master Simone Martini, a principal founder of the Tuscan Trecento style. After Simone's death in 1344, he returned to Siena and probably practiced there until his death.

There exist only two signed paintings by Ceccarelli, an *Ecce Homo* in the Liechtenstein Collection, Vaduz, and a *Madonna and Child,* dated 1347, in the Cook Collection, Richmond, Surrey. In these, and in the few other paintings that can be ascribed to the artist with some degree of certainty, the influence of Simone's languid, decorative style is clear.

The intimate size of the Norfolk tabernacle – it measures less than two feet square – suggests that it was not a public, ecclesiastical commission, but a work intended for private devotion. So, too, do the saints who appear on the shutters. Three of them – Eligius, Bartholomew and Nicholas – are associated less with ecclesiastical or monastic institutions than with medieval craft guilds, those of blacksmiths, butchers and sailors, respectively. As Diane Scillia has speculated, the triptych may well have been ordered by a Sienese merchant for an altar in his home.

In the center panel the Virgin, with the Child in her arms, stands on a plinth, as though she were a polychromed statue come to life. This subtle imitation of sculptural form may reflect the influence of French Gothic ivories or the sculptural tradition of Nicola Pisano, who had worked in Siena in the 1260s.

Attending the Virgin at left are Saint Eligius, who holds his attributes – the tools of the blacksmith's forge – and Saint Bartholomew, who displays the knife with which he was martyred. At right are Saint Anthony Abbot, with his book and staff, and Saint Nicholas of Bari, who bears the three golden balls that, legend has it, he gave to enrich the dowries of an impoverished nobleman's daughters. Crowning the wings of the triptych is a two-part Annunciation to the Virgin; the angel of the Annunciation recalls the design of the angel in Giotto's *Annunciation* in the Arena Chapel, Padua (c. 1305). The clear, luminous colors and brocaded patterns of the figures' garments reveal the artist's taste for ornamental embellishment, as do the precisely punched haloes and delicate floral banding of the gold-leafed background.

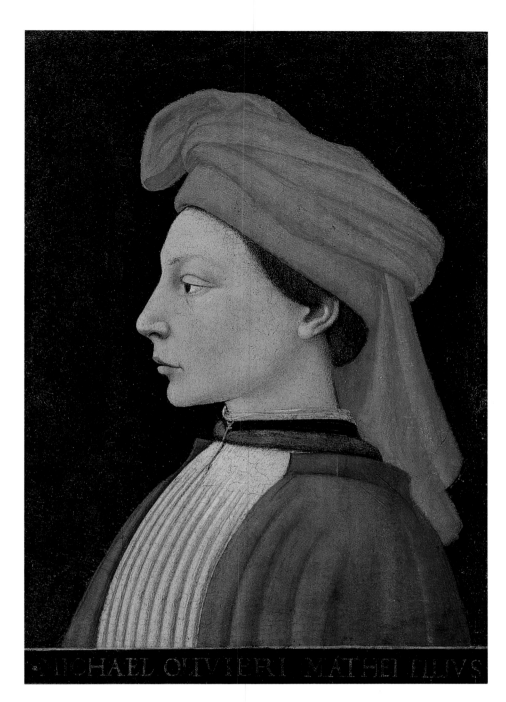

2 **Domenico Veneziano** *(attributed to)*

Italian, c. 1410-1461

Portrait of Michele Olivieri,
c. 1440-55

Tempera on panel, 17¾″ x 12¾″ (45 x 32.4 cm)

Inscribed lower edge:
 MICHAEL OLIVIERI MATHEI FILIVS

Gift of Walter P. Chrysler, Jr., 83.584

References: Hellmut Wohl, *The Paintings of Domenico Veneziano*, New York, 1980, pp. 138-140; Sokolowski, *CM*, 1983, pp. 6-7.

During the middle decades of the fifteenth century, the bust-length profile portrait enjoyed a remarkable popularity among the patrician classes of the Florentine republic. The Florentines used such stern and schematic self-images to project a sense of their social status and civic responsibility and to convey to posterity an eternal vision of republican and family virtues.

A rare, early example of this Florentine profile type is The Chrysler Museum portrait of 1440-55. The Latin inscription on the ledge at bottom identifies the sitter as "Michele Olivieri, Matteo's son," who was a member of a prominent Florentine merchant family. Though neither Michele Olivieri nor his father Matteo appears to have held high office in the Florentine government, Michele's grandfather, Ser Giovanni, served as prior in the city in 1349. The sitter's ceremonial attire – he wears a white, pleated doublet with fur collar, a rose-colored cape and a loosely tied, salmon-red turban – confirms his lofty social standing and helps to date the painting to the years after 1440. The pendant profile portrait of Matteo Olivieri is today in the National Gallery of Art, Washington, D.C.

Rediscovered by scholars in the early 1930s, the Olivieri pendants have been compared to three other, comparably designed Florentine male portraits (Musée des Beaux-Arts, Chambéry; Isabella Stewart Gardner Museum, Boston; and another in the National Gallery of Art). The pendants were attributed early to Paolo Uccello (1397-1475), but more recent writers have placed them within the sphere of Domenico Veneziano.

Some Florentine profile portraits were posthumous productions, idealized evocations of departed family members. The Olivieri pendants served a similarly commemorative function. At the time these portraits were made, Michele was roughly sixty-five years old and Matteo already dead, yet both are portrayed as young men. The paintings were intended, then, as timeless "memory images" of father and son, which may have taken their place in the Olivieri's own portrait gallery of illustrious family members.

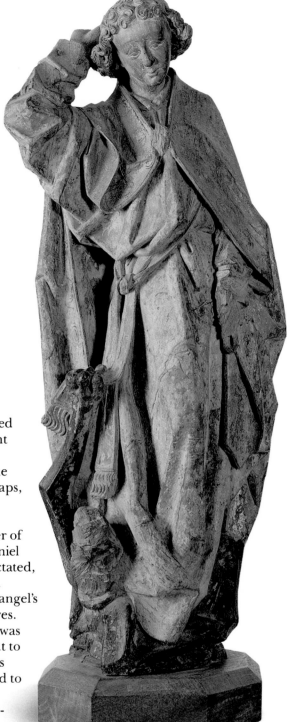

3 Anonymous

Franco-Flemish,
mid- to late fifteenth century
Saint Michael the Archangel
Painted wood, 59¾" (151.8 cm)
Irene Leache Memorial Collection, 51.10.1

The greatest of the seven archangels and the heroic captain of the hosts of heaven, Saint Michael is mentioned several times in the Bible and is frequently depicted in medieval and Renaissance art. Most often he is shown as a warrior doing battle with Lucifer, who appears in the form of a dragon or serpent. This dramatic image of struggle is taken from Revelation 12:7-9, in which Michael leads God's minions against Satan and drives him from heaven:

> And there was war in heaven:
> Michael and his angels fought against the dragon; and the dragon fought and his angels, and prevailed not; neither was their place found any more in heaven. And the great dragon was cast out, that old serpent, called the Devil, and Satan, which deceiveth the whole world: he was cast out into the earth, and his angels were cast out with him.

Such is the subject of the imposing, life-size wood sculpture of *Saint Michael the Archangel,* carved by an unknown Franco-Flemish artist during the second half of the fifteenth century. Here, following long-established pictorial custom, the full-length Michael subdues Satan by trampling him underfoot. The archangel was originally sculpted with wings. In his upraised right hand he probably held a spear or cross-staff. In his left hand he may have held a shield or, perhaps, a pair of scales, a traditional attribute of Saint Michael that alludes to his role as the weigher of souls at the Last Judgment (Daniel 5:27). As medieval tradition dictated, Satan is cast as a monster which clutches vainly here at the archangel's sash with one of its clawed hooves. Since the back of the sculpture was left rough and was hollowed out to prevent the wood's splitting, it is clear that the work was designed to be viewed frontally.

Medieval artists typically portrayed Michael as a youthful figure of great beauty, and the present work is no exception. With his delicate features and gently swaying, elongated form, *Saint Michael* is the essence of late Gothic beauty. He is an elegant figure whose grace and composure proclaim his righteousness and, thus, the certainty of his victory over evil.

Italian sculptors of the Middle Ages, following the classical tradition, customarily worked in marble. Their northern European colleagues, however, sculpted in both stone and wood. The lighter, more malleable medium of wood often lent itself to freer and more plastic sculptural effects, like the deeply undercut and densely folded drapery in *Saint Michael,* an impressive stretch of virtuoso late Gothic carving. Medieval wood sculpture was customarily polychromized – painted in an array of bold, bright colors – and often touched with gold. The traces of paint on *Saint Michael* indicate that the figure was originally cloaked in blue and vermilion, with the edges of his mantle gilded.

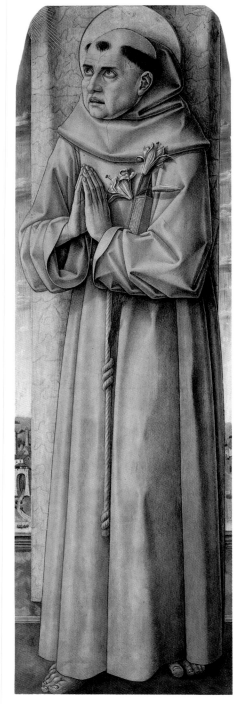

4 Carlo Crivelli

Italian, c. 1435-c. 1495

Saint Anthony of Padua, c. 1475-80

Oil on panel, 59¾″ x 19⅝″ (151.8 x 49.8 cm)

Gift of Walter P. Chrysler, Jr., 83.585

References: *Carlo Crivelli e i Crivelleschi,* exhib. cat., Palazzo Ducale, Venice, 1961, no. 22; Sokolowski, *CM,* 1983, pp. 8-9.

Born in Venice, Crivelli was imprisoned there briefly in 1457 for having engaged in an adulterous affair. Soon after his release he left the city and by 1468 had settled in the Marches, in central Italy. He remained in the Marches, in the provincial settings of Fermo and Ascoli Piceno, for the rest of his career. An inspired colorist in the Venetian tradition, Crivelli was, however, untouched by the atmospheric innovations of the burgeoning Venetian Renaissance. His insistently crafted, hard-edged art remained essentially late Gothic, revealing a unique blend of Paduan realism and the draftsmanly precision of central Italian painting.

The obsessive refinement and high-keyed emotionalism of much of Crivelli's painting have eased in the prayerfully restrained *Saint Anthony of Padua.* The undated panel is generally placed around 1475-80 on the basis of its strong stylistic affinity with the artist's 1476 altarpiece of *San Domenico* in the National Gallery, London. Indeed, the face of Saint Anthony brings to mind particularly Saint Thomas Aquinas in the London altarpiece. Crivelli painted numerous multi-panel retables like the *San Domenico* polyptych in which a central Madonna is flanked by attending saints. In all likelihood, *Saint Anthony of Padua* served originally as a flanking, wing panel in just such an altar ensemble.

In The Chrysler Museum painting the thirteenth-century Franciscan saint stands before a cloth of honor. Behind this a low balustrade gives way to a summary landscape that some writers believe was executed by the artist's younger and less gifted brother, Vittore. Gazing devoutly heavenward, Anthony may be contemplating the Christ Child, who, legend has it, appeared to him in a vision (see no. 35). His attributes, a stalk of lilies and a book, symbolize his purity and his fame as a preacher and theologian. With a characteristic passion for realistic portrayal, Crivelli delineated every detail in the narrow panel, from the veins in Anthony's temple to the precisely rendered turnings of his rope belt. Equally typical is the hardness of Crivelli's technique: the lilies seem almost metallic, and the saint's robe as dense and unyielding as stone.

5 Master of the *Virgo inter Virgines*

Netherlandish, active c. 1475-1500

Crucifixion, c. 1480

Oil on panel, 33¼″ x 20¼″ (84.4 x 51.4 cm)

Bequest of Walter P. Chrysler, Jr., 89.57

Reference: Albert Châtelet, *Early Dutch Painting: Painting in the northern Netherlands in the fifteenth century,* New York, 1981, pp. 233-234, no. 127A.

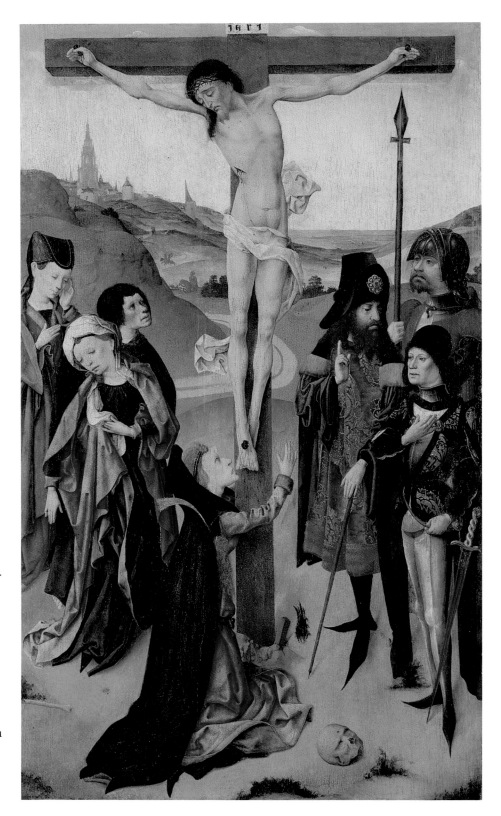

In the early decades of the twentieth century, the scholar Max J. Friedländer identified a stylistically similar group of paintings and woodcuts that he credited to an unknown late-fifteenth-century Netherlandish artist. He called the painter the Master of the *Virgo inter Virgines,* a pseudonym he derived from one of the artist's most famous pictures, the *Virgo inter Virgines,* or *Madonna and Child with Female Saints,* in the Rijksmuseum, Amsterdam. Since the Master's woodcuts appear in books published in Delft between 1483 and 1498, it is generally assumed that he practiced in that city during the final quarter of the fifteenth century. Scholars have sometimes attempted to identify him with either of two documented Delft painters of the period – Pieter die Maelre or Dirc Jansz. – but these identifications remain hypothetical.

In his later works the Master devised an eccentric, expressive late Gothic style that recalls the paintings of his contemporaries, Hugo van der Goes and Hieronymus Bosch. These highly emotional, angst-ridden works are often marked by violently animated figures and unsettling anecdotal details. Even in his somewhat quieter and more austere early works, like the *Crucifixion* of c. 1480, the Master's expressionism is already apparent in the pungent characterization of his doll-like figures – in the sharply linear rendering of their gaunt, bony forms and disquieting facial features, in the agitated calligraphy of their densely folded draperies. The style and dimensions of the *Crucifixion* correspond almost exactly to two other panels by the Master, a *Lamentation* in the Metropolitan Museum of Art, New York,

and a *Resurrection* in Amsterdam's Rijksmuseum. It is often suggested that all three panels originally belonged to the same altarpiece, a small Passion polyptych. In this, scholars speculate, the *Crucifixion* and *Lamentation* would have functioned together as the centerpiece and the *Resurrection* as the right shutter. The panel that is presumed to have served as the left shutter has yet to be discovered.

In the *Crucifixion* the weeping holy woman at the far left brings to mind particularly the female figures in the paintings of the Master's Flemish contemporary, Petrus Christus. The armor-clad man at the lower right, prayerfully attending the crucified Christ with a hand raised to his heart, seems to have been depicted in a more individualized manner than his neighbors and may portray the painting's donor.

6 Gerard David *(attributed to)*

Flemish, c. 1460-1523

Christ on the Cross between Saints John the Baptist and Francis of Assisi, c. 1484-92

Oil on panel, 26½" x 16¾" (67.3 x 42.4 cm)
Gift of Walter P. Chrysler, Jr., 83.586
Reference: Sokolowski, *CM*, 1983, pp. 12-13.

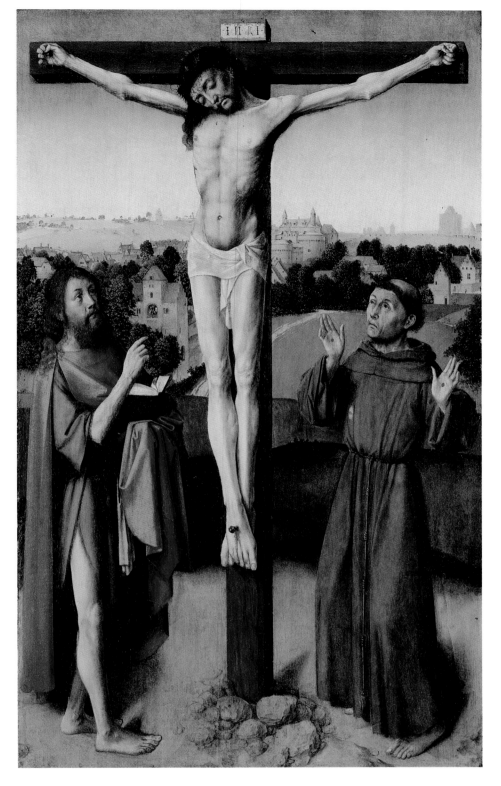

Auctioned in London in 1973 from the English parish of All-Hallows-Berkyngechirche-by-the-Tower, this panel is one of the most handsome early Netherlandish paintings to have come to light in recent years. The style of the painting – its meticulous realism and sense of calm, the noble stasis and solidity of its forms which are modeled softly in light – has prompted its attribution to Gerard David, the last of the great fifteenth-century Flemish artists. Trained quite probably in Haarlem in the northern Netherlands, David moved south to more cosmopolitan Bruges by 1484, the year he joined that city's painters' guild. His eclectic, revivalist style, which took much from Jan van Eyck and the other great founders of the Flemish *ars nova,* quickly found favor in Bruges, and after Hans Memling's death in 1494, David became the city's leading painter. In 1501 he was made dean of the Bruges painters' guild.

Christ on the Cross between Saints John the Baptist and Francis of Assisi has been dated around 1484-92, at the outset of David's career in Bruges. As Diane Scillia has noted, the figure of Christ – ultimately Eyckian in inspiration – follows the design of the crucified Savior in David's roughly contemporary *Calvary* painting in Lugano (Thyssen-Bornemisza Collection), while the characterization of Saint John the Baptist recalls the same figure in Memling's *Altarpiece of John Donne* of c. 1480 in the National Gallery, London.

The painting is not an illustration of the historic moment of the Crucifixion, but a meditative image of Christ on the Cross that transcends time and place. It is a symbol of Christ's sacrifice and the promise of salvation he offers. At left, John the Baptist preaches the advent of Christ: "one mightier than I cometh" (Luke 3:16). At right, Francis of Assisi (d. 1226), founder of the Franciscan order, displays the stigmata, which symbolize the transforming power of the Christian faith. The message of divine promise – and of promise fulfilled – receives triumphant, if delicately understated, expression in the tiny window of the building in the background at left. There the newly risen Christ, victorious over death, appears before the Virgin.

The presence of John the Baptist and Francis of Assisi suggests that the work was intended for a chapel dedicated to the veneration of those saints. The distant cityscape – similar to that in the background of David's *Nativity* in Budapest (Museum of Fine Arts) and quite possibly a depiction of an actual Flemish town – may well include the monastery or castle for which the picture was made.

7 Filippino Lippi

Italian, 1457-1504

Madonna and Child Enthroned, c. 1485

Oil on panel, 41½" x 24½" (105.4 x 62 cm)

Gift of Walter P. Chrysler, Jr., in Memory of Jean Outland Chrysler, 83.230

References: Bernard Berenson, *Italian Pictures of the Renaissance: Florentine School,* London, 1963, I, p. 110; Sokolowski, *CM,* 1983, pp. 10-11.

Filippino Lippi vied with Botticelli and Ghirlandaio for the leadership of the Florentine school of painting during the culminating decades of the fifteenth century. Along with them he played a key role in the transition from early to High Renaissance style in Italy.

The illegitimate offspring of the painter Fra Filippo Lippi, Filippino studied with his famous father and then, around 1472, joined the workshop of Botticelli. He was deeply impressed by Botticelli's restless, hypersensitive art, although he softened his master's insistent, calligraphic line with richer veils of light and shadow inspired, perhaps, by the *sfumato* of Leonardo da Vinci. In Filippino's *Madonna and Child Enthroned,* the refinement of the Virgin's face and long, tapering fingers reminds us of Botticelli, as does the wistful, melancholy mood pervading the scene.

Following venerable Gothic tradition, the Quattrocento image of the enthroned Madonna frequently served as the centerpiece in a triptych or polyptych whose wings carried pictures of adoring saints. The *Madonna and Child Enthroned* almost certainly functioned originally as the central panel in just such an altarpiece. The painting's composition is closely related to Filippino's *Madonna and Child with Four Saints and Angels* of 1485-86 in the Uffizi, Florence. This has led some scholars to conclude that Filippino made The Chrysler Museum picture shortly before the more ambitious Uffizi altarpiece. By the end of the fifteenth century the painting had been acquired by Giangiacomo Trivulzio of Milan, marshal of the Italian armies of Louis XII of France and a late patron of Leonardo.

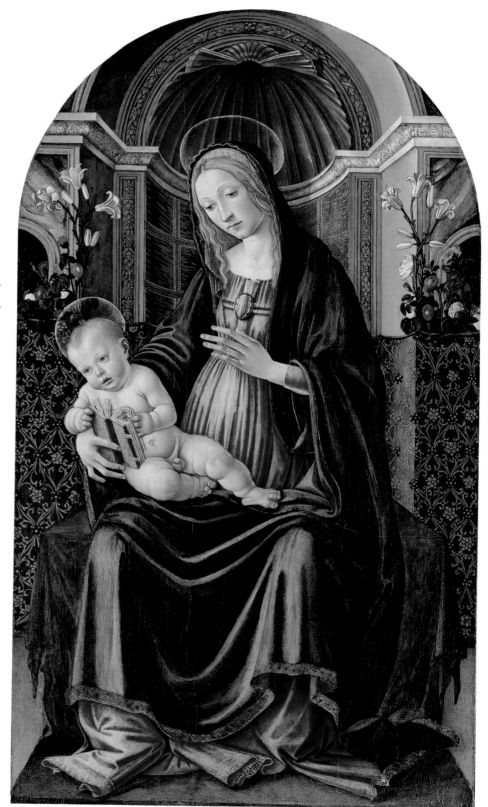

The picture's symbolic imagery is typical of fifteenth-century Florentine devotional art. The Madonna is seated in an elaborate shell niche – Filippino's carefully ruled perspective lines are clearly visible – on a simple cloth-covered bench, a humble perch signifying her humility. The cloth of honor behind her proclaims her holiness and may refer to the *hortus conclusus,* the "enclosed garden" of her chastity. Patterned with golden quatrefoils, this rich brocade may also be a proud allusion to Florence's lucrative cloth-weaving industry. The lilies at either side are symbols of the Virgin's purity. So, too, are the roses: the Madonna was traditionally described as a "rose without thorns" because she had been spared the corruption of Original Sin.

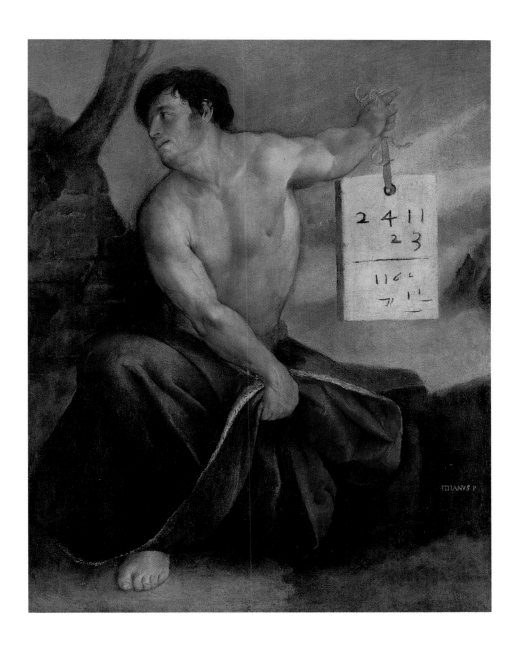

8 Giovanni de Lutero, called **Dosso Dossi**

Italian, c. 1490-1542

Learned Man of Antiquity, c. 1540

Oil on canvas, 57″ x 46¾″ (144.8 x 118.8 cm)

Gift of Walter P. Chrysler, Jr., 71.641

Reference: Felton Gibbons, *Dosso and Battista Dossi: Court Painters at Ferrara*, Princeton, 1968, pp. 192-193, no. 49.

During the fifteenth and sixteenth centuries, the north Italian principality of Ferrara enjoyed great fame as a center of humanistic culture. The art-loving Duke Alfonso d'Este (d. 1534) assembled at the Ferrarese court a brilliant group of painters, poets and musicians. Among them was the painter Dosso Dossi, the son of the court bursar, who apparently learned his craft in Mantua, with Lorenzo Costa, and in Venice. By 1514 Dosso was at work in Ferrara, where he quickly became the leading painter at court, producing a succession of mythological pictures, portraits, tapestry designs and festival decorations for Duke Alfonso and his successor, Ercole II. Dosso's friend, the poet Ariosto, cited him in *Orlando Furioso* as one of the greatest painters of the age.

Dosso was deeply affected by the poetic light and pastoral mood in the paintings of Giorgione and Titian. Indeed, his art remained tied to the Venetian Renaissance until the final decade of his life, when it began to exhibit the spatial and figurative distortions of Roman and Florentine Mannerism. These features are readily discerned in the *Learned Man of Antiquity* of roughly 1540. Here, a Herculean male with a dramatically foreshortened left arm strikes a complex, multi-directional pose, a stock Mannerist torsion. Both the *Prophet* sculptures by Loren-

zetti in Rome's Santa Maria del Popolo and Michelangelo's crucified Haman on the ceiling of the Sistine Chapel (Vatican, Rome) provided models for Dosso's figure.

The picture was originally one of a set of paintings in which Dosso depicted the *dotti d'antichità*, the learned men of antiquity. Scholars have located two other pictures from the same series (Alfred Bader collection, Milwaukee; private collection, Tel Aviv). Paintings of the famous wise men of the Bible and of ancient Greece and Rome – Saint Mark, Plato, Virgil, Euclid and many others – were popular in Renaissance Italy and were often produced in sets to decorate the studies or libraries of wealthy humanists like the Este of Ferrara. Noting the clay tablet that The Chrysler Museum figure holds, several writers have hypothesized that he represents a famous mathematician of old.

9 Jan Gossaert, called Mabuse
Flemish, 1478-1532

Madonna and Child, c. 1525-30
Oil on panel, 18¾" x 14½" (47.6 x 36.8 cm)
Gift of Walter P. Chrysler, Jr., 71.491

After spending his early career in Antwerp, Gossaert visited Rome in 1508 in the company of his first great patron, the art-lover Philip of Burgundy. But it was not until 1516, while working among the humanist writers and artists whom Philip had assembled at his castle near Middelburg in the northern Netherlands, that Gossaert began to temper his ornate late Gothic painting style with the more broadly idealizing manner of the Italian High Renaissance. By 1520 Gossaert had emerged as the first important interpreter of Southern style and themes among Netherlandish painters. He was recognized by his contemporaries, and is acknowledged today, as an aesthetic pioneer, a pathfinder who prepared the way for the rise of Italian influence in later sixteenth-century Netherlandish painting (see nos. 14, 15).

For Philip and other well-placed patrons in Utrecht, Mechelin and Middelburg, Gossaert painted not only Italianate allegories and mythological subjects, but more traditionally Northern images: portraits, altarpieces and modest devotional pictures of the Virgin and Child. Among the most lovely and least-known of his meditative Marian images is The Chrysler Museum's *Madonna and Child* of c. 1525-30, a tiny gem of a picture that exemplifies the synthesis of Italian

and Northern styles that Gossaert achieved in his final works.

The Virgin's broadly idealized face and form and the Child's heroic frame are resoundingly Southern in treatment, registering especially the influence of Leonardo da Vinci (and the Italianate Madonna paintings of Albrecht Dürer). Yet the Virgin's golden ringlets and pearly, polished flesh – the infant's fleecy curls, transparent gown and minutely pleated sash – reveal Gossaert's peculiarly Netherlandish taste for ornamental embellishment and exquisitely crafted detail. In their hands the Madonna and Child hold a golden yellow fruit – perhaps a pear, a traditional emblem of the Incarnate Christ that refers to his love for mankind. Particularly noteworthy is the Madonna's spectacular double topknot of hair, a complex sym-

bol of her perpetual virginity.

The *Madonna and Child* originally functioned as the center panel of a small Gossaert triptych. Its shutters, preserved today in Brussels in the Musées Royaux des Beaux-Arts de Belgique, contain portraits of the unknown male and female donors – presumably husband and wife – who commissioned the work. The triptych was dismantled before 1859, when the *Madonna and Child* was sold separately in London from the Cheltenham collection of John Rushout, second Baron Northwick (1769-1859). The dating of 1525-30 is based on the painting's strong stylistic kinship with several other late Madonna pictures by Gossaert (Art Institute of Chicago; Cleveland Museum of Art; Gemäldegalerie, Staatliche Museen Preussischer Kulturbesitz, Berlin).

10 Giovan Filippo Criscuolo

Italian, 1495-1584

Adoration of the Magi, c. 1545
Oil on panel, 60″ x 33½″ (152.4 x 85 cm)
Gift of Walter P. Chrysler, Jr., 78.294

Reference: Giovanni Previtali, *La pittura del Cinquecento a Napoli e nel vicereame,* Turin, 1978, p. 19.

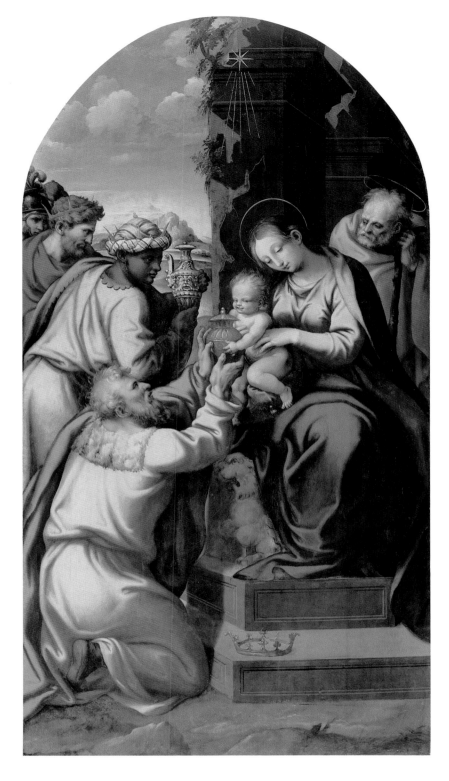

The Neapolitan school of painting began its rise to international prominence somewhat belatedly, in the first decades of the seventeenth century. Previously Naples had been a provincial art center, its painters influenced and overshadowed by the traditionally more progressive schools of Florence and Rome. As did many of his sixteenth-century colleagues, the Neapolitan Criscuolo no doubt visited Rome. There, his art was transformed by Raphael's High Renaissance paintings and by the Mannerist works of Raphael followers like Perino del Vaga. Returning to Naples, he devised a version of Roman Mannerism that made him one of the more sophisticated painters in that still parochial center. As his career progressed, Criscuolo – and the Neapolitan school with him – embraced more fully the tenets of the Roman and Florentine high *maniera* (later Mannerist style), prompted no doubt by visits from itinerant painters like Giorgio Vasari in 1544.

A work of Criscuolo's early post-Roman maturity, the undated *Adoration of the Magi* has been placed by scholars in the mid-1540s on the strength of its strong stylistic resemblance to the artist's 1545 *Adoration with the Trinity* in the Museo e Gallerie Nazionali di Capodimonte, Naples. In the *Adoration of the Magi,* Criscuolo reshapes the art of Perino del Vaga in more current *maniera* style, creating an elegant image of self-conscious grace, of characteristically compressive *maniera* forms and surface suavity. The artist's essentially two-dimensional design is particularly pronounced in the forms of the three kings, which have been flattened against the picture plane in a dense pattern of sinuous line and shifting color and texture.

As they present their gifts to the Child, the three kings – the young Moor Balthasar, the middle-aged

Melchior and the grey-bearded Caspar – proclaim the allegiance of all earthly rulers to the divine King of Kings. Symbolizing this act of fealty is the crown that the eldest magus has pulled from his head and placed on the steps beneath Christ's feet. Its piers crumbling and overgrown with vines, the architectural ruin behind the Holy Family serves as a venerable Christian symbol for the old Jewish law, which was "destroyed" by the coming of Christ.

Though based ultimately on High

Renaissance canons, the faces and forms of Virgin and Child have been keyed to a sharper *maniera* pitch and, thus, exhibit a more rarefied and eccentric kind of beauty. Remarkable, too, are Criscuolo's palette of acidic blues, greens and yellows and the snarling griffin carved from the leg of Christ's throne. Criscuolo's paintings are rare in American collections, and the *Adoration of the Magi* offers a unique and exceptionally fine example of the provincial Italian response to Roman high style in the mid-sixteenth century.

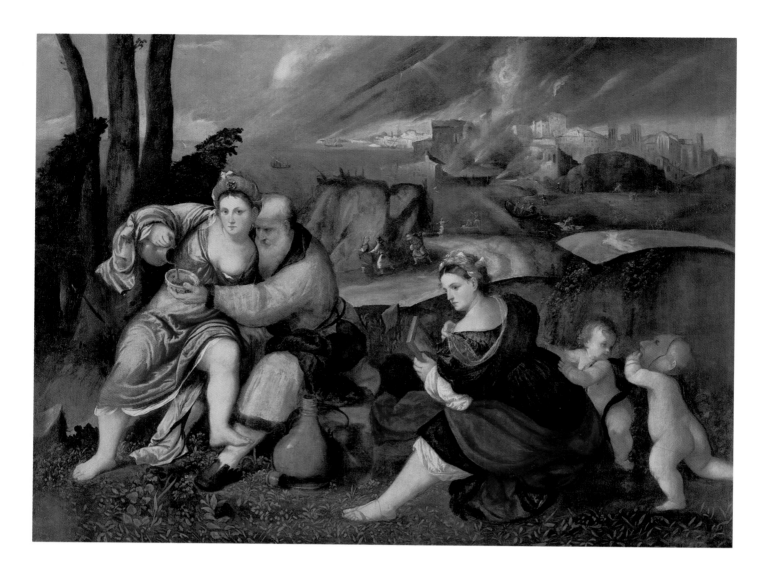

11 Bonifazio de' Pitati
Italian, 1487-1553

Lot and His Daughters, c. 1545
Oil on canvas, 47″ x 64½″ (119.4 x 163.8 cm)
Gift of Walter P. Chrysler, Jr., 71.622

Reference: Simonetta Simonetti, "Profilo di Bonifacio de' Pitati," *Saggi e memorie di storia dell'arte,* 15 (1986), pp. 116-117, no. 60.

Born in Verona, Bonifazio de' Pitati came to the fore in Venice in 1530, when he joined the city's guild of painters. About that time he also took over the workshop of the painter Palma Vecchio and, thus, became the leader of a productive and influential Venetian atelier. From his shop there issued a steady stream of biblical pictures, small mythological panels for marriage chests and other pieces of furniture, and larger decorative ensembles for the Palazzo dei Camerlenghi and other municipal buildings. His style of painting was poised between the old and the new, blending traditional, naturalistic elements from the art of earlier Venetian Renaissance painters like Palma

and Giorgione with certain more progressive aspects of central Italian Mannerism.

In The Chrysler Museum painting of c. 1545, Bonifazio recounts the Old Testament story of Lot (Genesis 19:1-38). After learning that God would destroy Sodom for its wickedness, Lot escaped from the city with his family and settled in the hills beyond Zoar. There his two daughters, eager to preserve the family line in the midst of their isolation, plotted to make their father drunk and "lie with him."

In the central background of the painting Lot and his daughters are shown fleeing Sodom, which is being consumed, along with Gomorrah, in a hail of fire and brimstone. Lagging behind is Lot's unfortunate wife, who because she turned back to look at Sodom was transformed into a pillar of salt. Bonifazio's fiery landscape recalls the infernos depicted by the Netherlander Hieronymus Bosch, who may have visited Venice around 1500, and whose pictures helped

develop a taste among local artists for conflagration imagery.

In the painting's foreground the seduction of Lot is shown. As did many of his artistic contemporaries both in Italy and the North, Bonifazio envisions this event as a moralizing allegory. The two daughters are made to illustrate the eternal struggle between truth and deception, between virtue *(virtus)* and the lowly desires of the flesh *(voluptas).* While one daughter brazenly tempts Lot with wine and her body, the other sits thoughtfully by herself, the mirror she holds functioning as a symbol of prudence and self-knowledge. The mask worn by the putto at right underscores the conflict between truth and deception. (By holding a mask that bears the features of a wizened old man, the putto also pokes fun at Lot and at the folly of his actions.) Bonifazio's conception of Lot as a grey-bearded elder owes much to the art of Giorgione, while the daughters bring to mind the fleshy female types found in the paintings of Palma and Lorenzo Lotto.

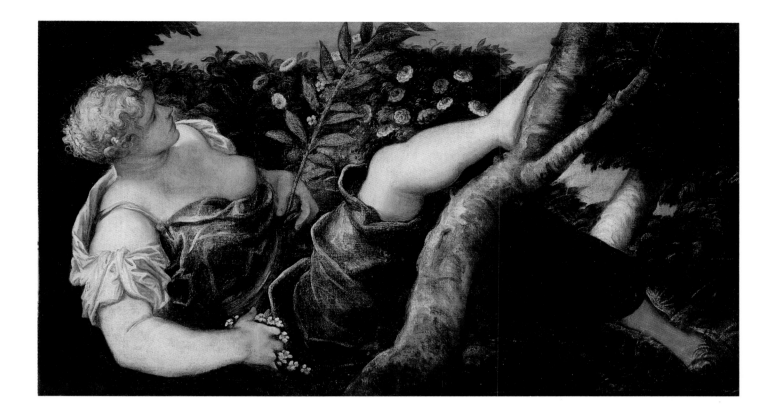

12 Jacopo Robusti, called Tintoretto
Italian, 1518-1594

Allegorical Figure of Spring, c. 1555
Oil on canvas, 41⅝″ x 76″ (105.7 x 193 cm)
Gift of Walter P. Chrysler, Jr., 71.1301

Reference: Rodolfo Pallucchini and Paola
Rossi, *Tintoretto: Le opere sacre e profane,* Milan,
1982, I, p. 176, no. 209, II, p. 426.

Together with Veronese (no. 13)
and the aging Titian, Tintoretto
presided over the Venetian school of
painting during the second half of
the sixteenth century. His style was
formed by Michelangelo, the Vene-
tian Mannerists and Titian, to whom
he may have been apprenticed. From
them he forged an art of violent
energy and monumental sweep, a
passionate late Mannerist style
marked by an astonishing technical
freedom. Tintoretto and his many
assistants worked almost continuously
on large-scale commissions for Vene-
tian churches, palaces, charitable
confraternities and government
buildings, covering acres of wall and
ceiling with a feverish velocity that
dumbfounded his rivals.

As had the classical writers and
artists who influenced them so pro-

foundly, sixteenth-century European
painters frequently used the cycle of
the seasons as a metaphor for the
eternal passage of time. Their paint-
ings of the seasons were often
produced in sets of four, with each
picture featuring a male or female
figure who personified the particular
season with the help of appropriate
seasonal attributes. Following tradi-
tional practice, Tintoretto produced
his *Allegorical Figure of Spring* around
1555 as part of a series of four paint-
ings of the Seasons. Here, a lively and
robust Flora, goddess of flowers and
spring, shakes off the torpor of winter.
The spray of flowers that seems to issue
from her womb shows that she is fertile
with the promise of new life. She is a
splendid, full-bodied symbol of the
generative power of the reawakening
earth. Tintoretto's companion pictures
of *Summer* and *Winter* survive: the for-
mer is found in the National Gallery of
Art in Washington, D.C., and the latter,
in a private collection in Bergamo. The
concluding painting of *Autumn* has yet
to be recovered. The Chrysler Museum
and National Gallery paintings were
originally fitted with octagonal frames

that covered their corners.

The seventeenth-century biog-
rapher of Venetian artists, Carlo
Ridolfi, noted in his *Le Maraviglie
dell'Arte* (1648) that Tintoretto pro-
duced a set of Seasons pictures as part
of his decoration of a room in the
Barbo Palace in Venice:

> In the Palazzo Barbo at San Pan-
> taleone one sees in the panelling of
> one room a "Capriccio of Dreams"
> with some gods in heaven and vari-
> ous symbols of things that come
> into the minds of men while they
> are dreaming; in the surrounding
> area the "Four Seasons" are
> personified.

Scholars have suggested that the
"Capriccio of Dreams" in the Barbo
Palace was a ceiling painting and that
it can be identified with a large, octag-
onal canvas by Tintoretto in the Detroit
Institute of Arts, the so-called *Dreams of
Man.* It has also been proposed that the
Allegorical Figure of Spring and its three
companion paintings are the "Four
Seasons" that originally flanked the
"Capriccio of Dreams" in the Barbo Pal-
ace, composing, perhaps, a frieze of
paintings along the tops of the walls.

13 Paolo Caliari, called Veronese
Italian, 1528-1588

The Virgin and Child with Angels Appearing to Saints Anthony Abbot and Paul, the Hermit, 1562

Oil on canvas, 112" x 66½" (284.5 x 169 cm)

Gift of Walter P. Chrysler, Jr., in Memory of Della Viola Forker Chrysler, 71.527

References: *The Genius of Venice 1500-1600,* exhib. cat., Royal Academy of Arts, London, 1983, no. 135; *The Art of Paolo Veronese 1528-1588,* exhib. cat., National Gallery of Art, Washington, D.C., 1988-89, no. 41.

Unlike his rival Tintoretto (no. 12), who evoked in his later paintings a spiritual realm of phantom shapes, Veronese celebrated the solidity and splendor of the material world. He exulted in the decorative allure of lavish costumes and clear, jewel-like colors uncompromised by the tonal concerns of other Venetian masters. Born the son of a Verona stonemason, Veronese established himself in Venice in 1553 and rapidly assumed a commanding position among the painters of the island republic.

The Virgin and Child with Angels Appearing to Saints Anthony Abbot and Paul, the Hermit was one of three large altarpieces commissioned of Veronese in December, 1561, for the monastery church of San Benedetto Po, near Mantua. The works were finished rapidly, by March of 1562, and The Chrysler Museum painting was placed in the church above the altar of Saint Anthony Abbot, in the second chapel on the right of the nave. The three paintings were already famous by 1568, when Giorgio Vasari praised them as the church's finest pictures. They were removed from San Benedetto Po shortly after the Napoleonic occupation of Mantua at the end of the eighteenth century. Of the two other altarpieces, one survives: *The Consecration of Saint Nicholas,* in the National Gallery, London. (The third altarpiece, *Saint Jerome in the Wilderness with the Madonna in Glory,* was destroyed by fire in London in 1836.)

The Museum's painting celebrates the lives of two early Christian hermit saints, Anthony Abbot (A.D. 251-356) and Paul, the Hermit (A.D. 229-342). As founders of the monastic life, both enjoyed a special reverence among the monks of San Benedetto Po. According to early Christian lore popularized in the thirteenth-century *Golden Legend,* Anthony Abbot renounced all of his earthly goods at the age of twenty and retired into the Egyptian desert, where he embraced a solitary life of penance and prayer. When he reached the age of ninety, he believed himself to be the oldest hermit. But he was surprised to learn, through a vision, that another saintly recluse – Paul, the Hermit – had lived in desert isolation for a longer time than he. Anthony then sought out Paul, and the two men lived together until Paul died at the age of 113.

In his altarpiece, Veronese illustrated none of the canonical legends associated with the aging Anthony and Paul. Instead he depicted an imaginary scene in which the saints are honored for their exemplary lives with a miraculous vision of the Virgin and Child. Distracted from their study of the Bible, which rests on Paul's lap, they gaze wonder-struck at the divine apparition. It may be that the Virgin has appeared in answer to Anthony's prayer of "Hail Mary," for the prayer is suggested by the rosary he holds. The rosary features a small death's head, a venerable Christian symbol indicating the brevity of life. Anthony is identified by two of his saintly attributes: the crutch, an allusion to his advanced age, and the bell on the ground at his feet, which may symbolize his power to repulse evil spirits. The sharply foreshortened figures suggest that the altarpiece was designed to be viewed from below.

Veronese's genius as a colorist is splendidly displayed in the handling of the Virgin's and angels' cloaks, which offer the eye a joyful bouquet of silvery blue, emerald green and lemon yellow hues. Long celebrated for its pictorial richness and compositional grandeur, the altarpiece was recently described by W. R. Rearick as "one of the most remarkable achievements of [Veronese's] middle years."

14 Maerten van Heemskerck

Netherlandish, 1498-1574

Concert of Apollo and the Muses on Mount Helicon, 1565

Oil on panel, 40¾" x 51¼" (103.5 x 130.2 cm)

Signed and dated lower center:
 Martinus Hemskirck
 [...] D. 1565

Inscribed lower left:
 [...]
 Parnassus [...]
 Vermulier varis [?]
 Calliopeia modis

Gift of Walter P. Chrysler, Jr., 71.479

References: Rainald Grosshans, *Maerten van Heemskerck: Die Gemälde*, Berlin, 1980, pp. 239-240, no. 96; *Kunst voor de beeldenstorm: Noordnederlandse kunst 1525-1580*, exhib. cat., Rijksmuseum, Amsterdam, 1986, no. 200.

Chief among the sixteenth-century Netherlandish proponents of Italian style (cf. nos. 9, 15) was the Haarlem painter Maerten van Heemskerck. Between 1532 and 1537 he visited Rome, where he made drawings of antique sculpture and architecture and was affected by the late Mannerist aesthetic of the painters Francesco Salviati and Jacopino del Conte. He returned to Haarlem a convert to Italian art and by mid-century had become the most prominent of Italianate painters working in the northern Netherlands.

Heemskerck produced mostly religious images – altarpieces and devotional panels for the Catholic churches of Haarlem, Amsterdam and Delft. But he also created a remarkable number of mythological and allegorical paintings that revealed his interest in humanistic themes. Painted by the artist toward the end of his career, the 1565 *Concert of Apollo and the Muses on Mount Helicon* confirms Heemskerck's enduring devotion to mythological subjects in the Italian mode.

Already in ancient Greek literature of the eighth century B.C. – and particularly in Hesiod's *Theogony* – Greece's Mount Helicon was identified as the sacred abode of the nine goddesses of poetry and song, the Muses. There, joined sometimes by Apollo – the god of music – the Muses danced, sang and inspired mortal singers and poets with their music and sprigs of laurel. Mentioned, too, as a source of poetic inspiration were the waters of Helicon's fountain of Hippocrene, which, according to Ovid, gushed forth from the hoofmarks of the winged horse Pegasus.

Heemskerck envisions Helicon as an idyllic, tree-shaded paradise, an antique pleasure garden set with statues and littered with books and musical instruments. He alludes to the creation of Hippocrene in an ingenious way, portraying Pegasus as a monumental bronze statue and the fountain as a spray of water issuing from its strut. The two male figures standing at right are poets who have received inspiration and been crowned with laurel. Other mortal pilgrims promenade, pick flowers or bathe in Hippocrene's inspiring waters, while above them putti hover, waiting to bestow more crowns of laurel.

With an informality typical of the age, Heemskerck chooses not to iden-tify the Muses by their traditional attributes. So casual is his approach that it is difficult even to locate all nine of the goddesses. Four of them have gathered to sing and make music at the positive organ at left, its bellows worked by a mischievous putto. A pair are seated at right, and two more join Apollo – kneeling, with his lyre in hand – in the central middleground. The remaining Muse has merged with the crowd of pilgrims beyond. A recent study of the painting's underdrawing using infrared reflectography has revealed an interesting detail: Heemskerck initially sketched two bearded, male heads at the extreme left of the composition, where he later chose to paint the standing nude Muse.

The High Renaissance image of Apollo and the Muses was perfected in early sixteenth-century Italy, where Raphael's Vatican *Parnassus* fresco of 1510-11 was profoundly influential. By the 1540s, French and Flemish artists had also begun to interpret the subject. Among contemporary north Netherlandish painters, Heemskerck seems to have been the principal champion of the theme. In 1549 he designed an etching of *Apollo and the Muses* and around 1555 returned to the subject in a painting today in the New Orleans Museum of Art. The Chrysler Museum painting is Heemskerck's final and most developed vision of Apollo and the Muses. It is also one of the richest representations of the theme in sixteenth-century art.

15 Hendrick de Clerck

Flemish, c. 1570-1629

Venus and Adonis, c. 1600
Oil on canvas, 63" x 57¾" (160 x 146.7 cm)
Museum Purchase, 67.34.3

Recounted in Ovid's *Metamorphoses* (10:519-559), the tragic love story of Venus and Adonis enjoyed widespread popularity among Renaissance and Mannerist artists who, like the Flemish painter Hendrick de Clerck, were interested in subjects drawn from classical mythology. Ovid relates how Venus, the goddess of love, became enamored of a handsome young mortal, the hunter Adonis. Fearing for his safety on the hunt, Venus repeatedly warned Adonis to avoid the fiercest wild animals. Adonis, however, ignored her counsels, and when the war god Mars – himself enamored of Venus – confronted the hunter with a wild boar, Adonis foolishly stalked the beast and was slain.

De Clerck, who painted in Brussels at the turn of the seventeenth century, based his *Venus and Adonis* of c. 1600 rather generally on Ovid's account. But he chose to depict a moment – Adonis' withdrawal from Venus and departure for his final, disastrous hunt – that is not mentioned in the *Metamorphoses*. That moment was first interpreted in Renaissance Venice, in the several paintings of Venus and Adonis produced after 1553 by Titian and his workshop (Prado, Madrid; National Gallery, London; etc.). In De Clerck's picture, an amorous Venus clutches eagerly at Adonis, trying to keep him seated safely at her side. Adonis' unstable standing posture, and the spear he holds, make it clear, however, that he is about to pull away from the goddess and lead his hounds off to the chase.

The moralizing writers of the seventeenth century viewed Adonis as a perennial example of rash and impetuous youth, whose failure to heed the warning of the gods precipitates his downfall. That Venus' love is powerless to restrain Adonis is symbolized in De Clerck's painting by the goddess's infant son Cupid, who is lost in sleep, his bow and arrows forgotten. Much of the imagery in De Clerck's picture – the sleeping Cupid, Adonis' prominently displayed spear, the curiously foreshortened dog at left – can be traced to Titian's groundbreaking paintings of Venus and Adonis, a fact that clearly suggests the Flemish master knew of Titian's compositions, probably through the engravings of Martino Rota or Giulio Sanuto.

A lifelong devotee of Italian themes and style, De Clerck studied in Brussels with the painter Martin de Vos. In mature works like *Venus and Adonis,* he evolved a highly refined late Mannerist aesthetic based squarely on the Italianate art of his teacher. After 1606, he served as painter to the Brussels court of the Archduke Albert and Archduchess Isabella, the governors of the Spanish Netherlands. He often collaborated with landscape specialists like Denis van Alsloot and Jan Brueghel the Elder, supplying the figurative designs for their landscape backgrounds. In his painting of *Venus and Adonis* De Clerck saw an opportunity to compose two monumental representations of male and female beauty in fashionable Italianate style. He presents the lovers as artfully proportioned and elegantly posed semi-nudes and places them directly before the viewer, their luminous bodies framed by the dark screen of foliage behind them. The elongation of their bodies and their complex, twisting postures are characteristic of later Flemish Mannerism. So, too, is the painting's decorative richness: Venus and Adonis are swathed in draperies of pink and gold, and their skin is as polished as porcelain.

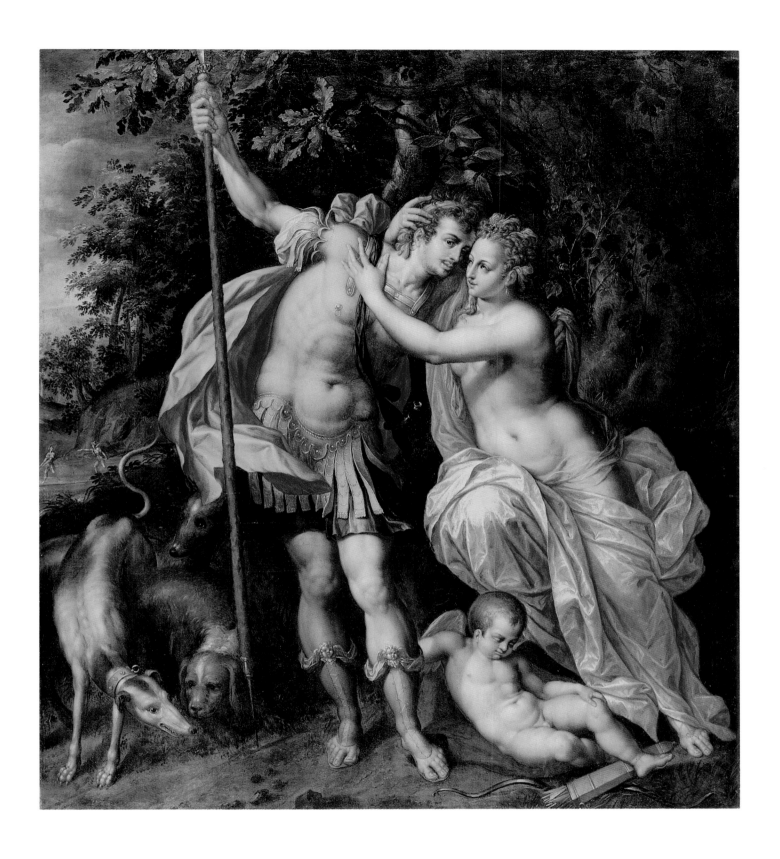

Seventeenth Century

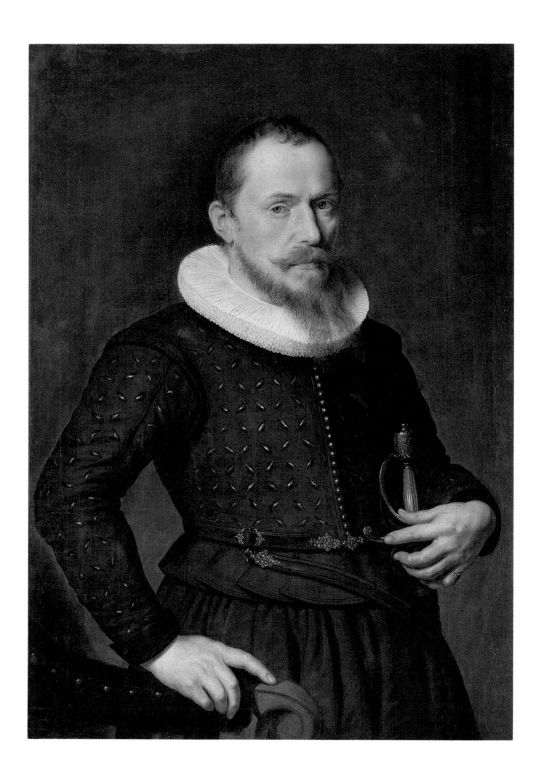

16 Peter Paul Rubens

Flemish, 1577-1640

Portrait of a Man with Sword, c. 1598-99

Oil on canvas, 38½" x 27" (97.8 x 68.6 cm)

Gift of Walter P. Chrysler, Jr., 71.463

References: *Peter Paul Rubens 1577-1640,* exhib. cat., Wallraf-Richartz-Museum, Cologne, 1977, no. 3; Michael Jaffé, *Rubens and Italy,* Ithaca, New York, 1977, p. 16.

The young Rubens began to work as an independent artist in 1598, when he was enrolled in the Antwerp painters' guild. In 1600 he left Antwerp for a lengthy stay in Italy. The intervening two years constitute what is, perhaps, the least documented period in Rubens' remarkably energetic and fruitful career. In fact, scholars have been able to place only a handful of paintings within the shadowy interval of Rubens' youthful, pre-Italian activity. Among these few works is the handsome *Portrait of a Man with Sword,* which has been attributed to the artist and dated c. 1598-99 on the strength of its close stylistic affinities with Rubens' signed *Portrait of a Young Man* of 1597 in the Metropolitan Museum of Art, New York (Linsky Collection).

The sitter's grave, aristocratic mien and three-quarter-length presentation recall the paintings of Anthonis Mor, the most influential Netherlandish portraitist of the preceding generation. Yet, the psychological remoteness of Mor's sitters and the elegant attenuations of his figures have been replaced here by a far more relaxed and accessible interpretation of personality and a weightier, more robustly three-dimensional form. Already in this early work Rubens has begun to liberate Flemish portraiture from the cold conventions of Mor's international Mannerist style, infusing it with a vigor and intensity that forecast the emergence of the fully Baroque manner of his mature portrait works.

17 Hendrick ter Brugghen

Dutch, 1588-1629

The Martyrdom of Saint Catherine,
c. 1618-20

Oil on panel, 39″ x 28⅞″ (99.1 x 73.3 cm)

Gift of Walter P. Chrysler, Jr., 71.2076

References: Benedict Nicolson, *Hendrick Terbrugghen*, London, 1958, pp. 76-77, no. A45; Christiaan Schuckman, "Did Hendrick ter Brugghen revisit Italy?" *Hoogsteder-Naumann Mercury*, 4 (1986), pp. 8-9, 19, note 2, p. 20, note 4.

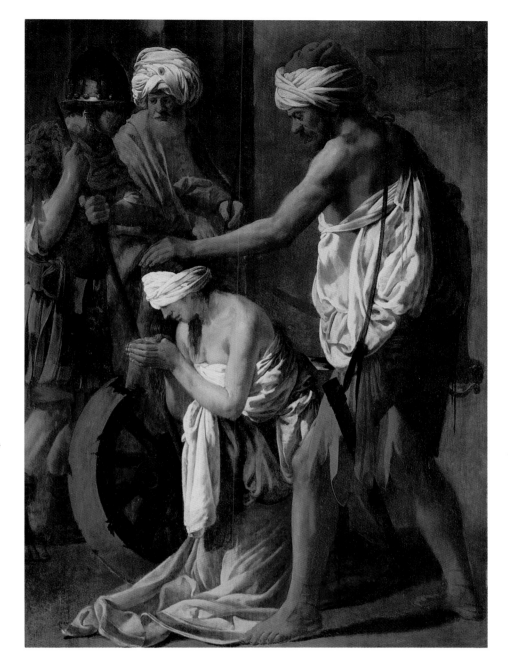

Ter Brugghen was the first and finest of Utrecht's Caravaggesque painters. He set the stage in that city for a school of artists who assumed the earthy naturalism and pronounced *chiaroscuro* (the sharp juxtaposition of lighted and shadowed forms) of Caravaggio's revolutionary Roman Baroque style (see also no. 27). Almost nothing is known of Ter Brugghen's brief life. Born near Deventer into an old Catholic family, he was raised in Utrecht and trained there as a painter by the Mannerist Abraham Bloemaert. From 1604 to 1614 he visited Italy, living mainly in Rome in close contact, no doubt, with Caravaggio and his circle. Returning to Utrecht, he married in 1616 and joined the city's painters' guild. Citing renewed Italian influence in his art around 1620, scholars have argued the possibility of a second journey to the South at that time.

Ter Brugghen's entire extant oeuvre – a mere eighty paintings – was produced in Utrecht in little more than a decade, between c. 1616 and 1629, when he died at the age of forty-one. The majority of these works are half-length Caravaggesque genre pictures of drinkers, gamblers and music makers, and half-length images of saints. The rest – more lofty mythological pictures and complex, multi-figured religious subjects as *The Martyrdom of Saint Catherine* – are exceedingly rare.

According to early medieval lore kept alive in Jacopo da Voragine's *Golden Legend,* the fourth-century princess, Catherine of Alexandria, defied the pagan Roman emperor Maxentius with her eloquent defense of the Christian faith and was sentenced to die. When she survived the tortures of a spiked wheel that was miraculously split asunder by God, Maxentius had her beheaded. Her attribute, a broken wheel, appears in Ter Brugghen's painting.

Echoing Caravaggio's bluntly realist aesthetic, Ter Brugghen portrayed the saint not as a beautiful heroine triumphant in her martyrdom, but as a plain woman cruelly depersonalized by her blindfold and bowed pathetically under the executioner's hand. Ter Brugghen did not, however, adopt Caravaggio's Baroque high drama. As always in his art, the mood here is hushed and contemplative. Equally restrained is the painting's color scheme of pinks and mauve, a typically lyric Ter Brugghen palette.

Though *Saint Catherine* has customarily been dated around 1622-25, recent writers have argued convincingly for an earlier dating of 1618-20 based on the work's clear stylistic relationship with Ter Brugghen's 1619 *Adoration of the Magi* in the Rijksmuseum, Amsterdam. The painting's numerous *pentimenti* – the executioner's sword was originally angled higher and a barred window on the wall behind was subsequently painted out – reveal that the artist reworked the composition considerably. Noteworthy, too, is the picture's oak panel support; Ter Brugghen almost invariably painted on canvas.

18 Guido Reni

Italian, 1575-1642

The Meeting of David and Abigail,
c. 1615-20

Oil on canvas, 61½″ x 64½″ (156.2 x 163.8 cm)

Gift of Walter P. Chrysler, Jr., 71.524

References: D. Stephen Pepper, *Guido Reni,* Oxford, 1984, p. 264, no. 131; *Guido Reni 1575-1642,* exhib. cat., Pinacoteca Nazionale, Bologna *et al.,* 1988-89, p. 232.

Guido Reni's father was the choirmaster of San Petronio, the cathedral of Bologna, and initially he hoped his son would follow in his footsteps as *maestro di cappella.* But the boy's artistic interests triumphed early over his father's wishes, and at the age of nine Reni was apprenticed in Bologna to the painter Denys Calvaert, with whom he remained for a decade. There followed a shorter, but more influential stay (1594-98) in the Accademia degli Incamminati, the Bolognese painting academy of Annibale, Agostino and Ludovico Carracci. There Reni tempered the elegant refinement of Calvaert's late Mannerist aesthetic with the earthy grandeur of the Carracci's new, naturalistic style.

By 1601 Reni was in Rome, which, despite frequent returns to Bologna, remained his base for the next thirteen years. Influenced briefly by Caravaggio, he soon evolved a more stately "Hellenic" classicism, evident in his famous *Aurora* fresco of 1613-14 (Palazzo Rospigliosi Pallavicini, Rome) and in other works for the principal patrons of his later Roman period, Cardinal Scipione Borghese and his uncle, Pope Paul V. An eccentric, temperamental genius who was addicted to gambling and disdainful of his patrons, Reni nonetheless became the city's most esteemed painter. When he resettled in Bologna in 1614, his fame had already preceded him, and by 1635 he was celebrated throughout Europe. Today he is recognized as one of the prime exemplars of the Baroque classical style.

Reni's early aesthetic – a warm, sensuous, chromatically vivid style featuring large, solidly modeled figures – shifted decisively around 1630, when he apparently suffered a brief nervous breakdown. There followed a lighter, more iridescent "second style" dominated by cooler colors and a more fluent brush technique. Throughout his career, however, Reni labored to restore to painting the ideal beauty and grace of earlier High Renaissance forms, a quest that led contemporaries to hail him as the inspired heir of Raphael.

The dating of Reni's splendid *Meeting of David and Abigail* has long divided scholars. Many have cited its restrained emotional tone and sentimental facial types as evidence for a date of c. 1630. Others, noting the compressive composition, firm figure style and vibrant palette of red, blue and gold, have persuasively argued for an earlier date, c. 1615-20. The painting illustrates the moment from the Old Testament (I Samuel 25:18-20) when Abigail, the wife of the chieftain Nabal, arrives with her servants in David's camp to intercede for her husband, who has foolishly insulted David and his men. (When Nabal dies soon after, Abigail returns to David, and the two marry.) Reni depicts Abigail riding sidesaddle into David's camp, her demure pose a marked contrast to the aggressive, hip-shot stance of the stalwart Israelite warrior. (Her crown of flowers may be a bridal wreath and, thus, may allude to the story's happy conclusion, when David and Abigail marry.) To Christian writers, the humble Abigail personified feminine prudence and diplomacy. She was viewed as a prime Old Testament precursor of the Virgin Mary.

At least three replicas of the painting are known to exist. Two of them (Musée National des Beaux-Arts, Algiers; Musée des Augustins, Toulouse) are later works ascribed to mediocre copyists. The third, in the Museum of Fine Arts, Budapest, is of higher quality than the Algiers and Toulouse replicas and is generally described as a collaborative production of Reni and his workshop.

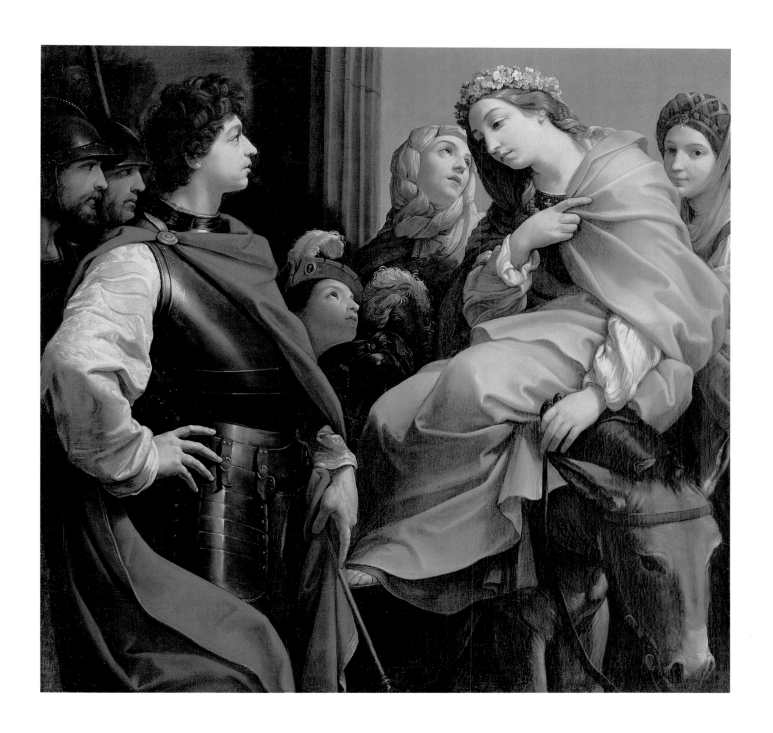

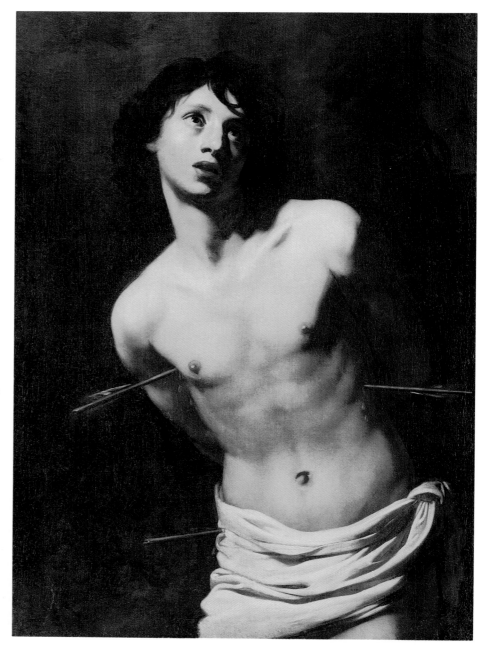

19 Nicolas Régnier

Flemish, 1591-1667

Saint Sebastian, c. 1620

Oil on canvas, 41″ x 31″ (104.1 x 78.7 cm)

Gift of Walter P. Chrysler, Jr., 71.558

References: Pier Luigi Fantelli, "Nicolò Renieri, 'Pittor Fiamengo'," *Saggi e memorie di storia dell'arte,* 9 (1974), pp. 82, 99, no. 63; Benedict Nicolson, *The International Caravaggesque Movement,* Oxford, 1980, p. 80.

Born in the Flemish village of Maubeuge, Nicolas Régnier first studied painting in Antwerp with Abraham Janssens, who had visited Italy around 1600 and whose art had been influenced by the Roman style of Caravaggio. After leaving Janssens' shop, Régnier himself journeyed to Rome around 1615 and there continued his studies with the painter Bartolomeo Manfredi, among the most important of Caravaggio's Italian followers. Remaining in Rome until 1625, Régnier became a prominent member of the city's colony of Flemish artists and was employed by several influential art patrons, including Caravaggio's former protector Vincenzo Giustiniani.

In his Roman paintings, Régnier endorsed Caravaggio's emphatic use of *chiaroscuro* (light-dark contrasts) to model form. This is evident in *Saint Sebastian* of c. 1620, in which the saint's boldly illuminated body is directly set against a murky backdrop. The figure's concentrated, three-quarter-length design and dramatic foreground placement were also inspired by Caravaggio and his Italian disciples, who produced similar "close-up" images of saints and other figures in half- and three-quarter-length. However, in *Saint Sebastian* and his other Roman works, Régnier tempered the realism of Caravaggio's and Manfredi's art with a more polished painting technique and a preference for pearly flesh tones.

By 1626 Régnier had settled in Venice, where he remained for the rest of his life. During his Venetian period he renounced his Caravaggesque aesthetic for a lighter, more elegant style influenced by Guido Reni (no. 18). All four of his daughters became painters; one married the prominent Venetian artist Pietro della Vecchia (no. 29).

The subject of The Chrysler Museum painting is the early Christian martyr Sebastian, who was an officer in the Roman Praetorian Guard during the reign of the pagan emperor Diocletian. A Christian sympathizer, he proclaimed his faith and was denounced by the emperor, who ordered that he be shot to death with arrows. (He survived the ordeal, only to be clubbed to death by Diocletian's henchmen.) In Régnier's day, Sebastian was typically shown bound to a tree or (as in the Museum's picture) a column, his almost nude body transfixed with arrows (cf. no. 20). Long venerated as a protector against the plague, he enjoyed widespread popularity among the Catholic faithful, who prayed to his image to deliver them from pestilence.

The Museum's painting is one of several devotional images of the wounded Sebastian that Régnier produced over the course of his career (Museo Civico, Bassano del Grappa; Museo d'Arte Antica, Milan; Hermitage, St. Petersburg; Gemäldegalerie, Dresden; etc.). Of these, the Dresden *Saint Sebastian* is particularly close in style and composition to the present work.

20 Anthony van Dyck

Flemish, 1599-1641

Saint Sebastian, c. 1623

Oil on canvas, 74½" x 56¾" (189.2 x 144.2 cm)

Gift of Walter P. Chrysler, Jr., 71.464

References: *Van Dyck as Religious Artist,* exhib. cat., Art Museum, Princeton University, 1979, no. 30; John Rupert Martin, "Van Dyck's Early Paintings of St. Sebastian," in *Art the Ape of Nature: Studies in Honor of H. W. Janson,* New York, 1981, pp. 393-400.

Van Dyck began his career in Antwerp as Rubens' most gifted assistant. In time, he would become the greatest of Rubens' Flemish rivals. He spent much of his brief life abroad. He was in Italy in 1621-27 and worked for most of the final decade of his career (1632-41) in England, where he was knighted by Charles I and made first painter to the Crown. Van Dyck achieved his greatest fame as a portraitist. Indeed, his depictions of the British nobility determined the style of English aristocratic portraiture for nearly two hundred years. But Van Dyck also worked as a painter of sacred subjects, especially in his early years, and one of his favorite religious themes was that of Saint Sebastian.

Van Dyck first turned to the story of Saint Sebastian around 1616 in a painting found today in the Louvre, Paris. Over the next decade he dealt almost obsessively with the theme, producing four additional canvases that reflect two distinct compositional schemes (National Gallery of Scotland, Edinburgh; Chrysler Museum; two in the Alte Pinakothek, Munich). The Chrysler Museum painting falls near the end of this series, around 1623, early in Van Dyck's Italian period. The painting's dynamic design and brush technique betray the still dominant influence of Rubens on the young mas-

ter's art. Soon after, Van Dyck created the slightly larger and more finished version in Munich. (Several preparatory studies for the Chrysler painting, including a sketch for the executioner kneeling at right, are found on the reverse of Van Dyck's *Man of Sorrows* painting in the Seilern collection, London.)

Van Dyck's protagonist, Sebastian, was a commander in the Roman Praetorian Guard and a Christian sympathizer. He professed his faith and was condemned by the pagan Roman emperor Diocletian, who ordered him shot to death with arrows. Northern European artists typically portrayed the story's grisly denouement. They would either show the wounded Sebastian bound to a tree or column, his body already pierced by

arrows (cf. no. 19), or portray him being rescued and ministered to by Saint Irene and her servants. In his paintings Van Dyck consistently chose to depict an earlier and less conventional moment, when Diocletian's henchmen, having removed the saint's armor, prepare him for execution. In the Chrysler picture two burly soldiers hold Sebastian and bind his arms and legs while a helmeted archer at right draws his arrows. The saint's composure and pale beauty isolate him from his tormentors. Instead, he confronts the viewer quietly, his gaze communicating both the pathos of his predicament and the steadfastness of his faith in the face of martyrdom. It is sometimes said that Van Dyck lent his own features to the face of the suffering Sebastian.

21 Georges de La Tour

French, 1593-1652

Saint Philip, c. 1625

Oil on canvas, 25″ x 21″ (63.5 x 53.3 cm)

Gift of Walter P. Chrysler, Jr., 77.431

References: Benedict Nicolson and Christopher Wright, *Georges de La Tour*, London, 1974, pp. 21-24, 181-182, no. 40; Harrison, *CM*, 1986, no. 5.

Though ranked today among the premier geniuses of seventeenth-century French painting, La Tour was forgotten soon after his death and was not rediscovered until the early twentieth century when scholars first began to research his life and work. His paintings are very rare: a mere forty – mostly religious images of saints or genre pictures of peasants, pickpockets and cardsharps – have been recovered to date. Eleven of them are in American collections.

Among the earliest of La Tour's surviving religious works, *Saint Philip* was painted around 1625 as part of a set of thirteen half-length images of Christ and the twelve apostles. Such "Apostle" series were common in Counter-Reformational Europe (similar sets in half- or full-length were produced by artists as diverse as El Greco and Jacques Callot), and they reflected the enduring power of the Catholic veneration of saints. By 1698 La Tour's series was included in the chapel of Saint John in the cathedral of Albi, far to the south of the artist's home in the village of Lunéville, in Lorraine. How the paintings got there is a mystery. In the early nineteenth century they were moved to the Albi museum, and, soon after, most of them were lost, though nine of the thirteen compositions were preserved in mediocre copies. Of the original thirteen canvases only three survive, *Saint Philip* and the paintings of *Saint Jude* and *Saint James the Less* in the Musée Toulouse-Lautrec, Albi.

La Tour portrays Saint Philip as a rugged man of the people. In fact, the set as a whole offers an invaluable repertoire of the coarse peasant types La Tour perfected during the first part of his career and used in such stylistically similar contemporary works as *The Old Man with Dog* (Musée Municipal, Bergues) and *The Musicians' Brawl* (J. Paul Getty Museum, Malibu). La Tour's abiding interest in peasant and low-life imagery reflects the influence of Caravaggio, as do the magical *chiaroscuro* of his candlelit nocturnals and the stark naturalism of "daylight" paintings like *Saint Philip*. This has led scholars to speculate that he studied in Rome before 1616 or among the Netherlandish *Caravaggisti* in Utrecht.

Saint Philip, his head bowed in prayer, holds as his attribute a plain wooden cross-staff tied with cord. The reference is to the miracles he allegedly performed late in life and to his martyrdom. While preaching the gospel in Hierapolis, Philip used his cross to banish a dragon from the temple of Mars. The dragon killed many people as it fled, an action that so infuriated the pagan Phrygian priests that they had Philip stoned and then tied to a cross and crucified upside down. The hushed stillness of mood in *Saint Philip*, the broad massing of forms, and the carefully crafted details – such as the saint's crystal buttons and their exquisite, light-filled shadows – offer a precious foretaste of the reverential realism of La Tour's mature religious art.

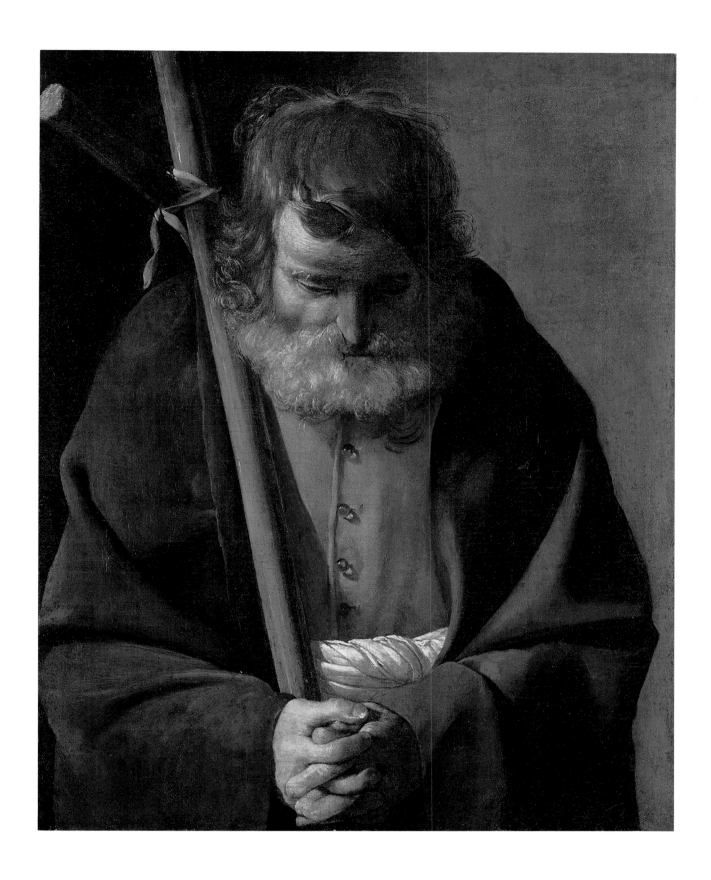

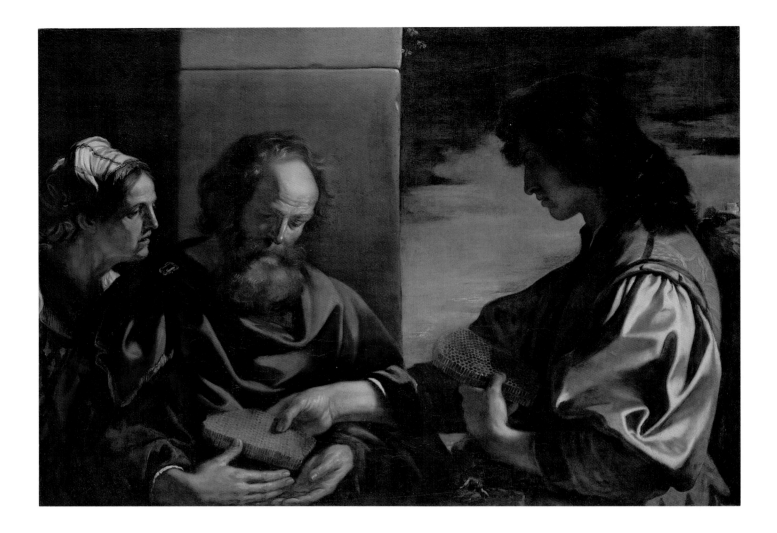

22 Giovanni Francesco Barbieri, called **Guercino**

Italian, 1591-1666

Samson Bringing Honey to His Parents, c. 1625-26

Oil on canvas, 39¾″ x 59″ (101 x 149.9 cm)

Gift of Walter P. Chrysler, Jr., in Honor of the Board of Trustees 1977-1985, 71.521

References: *Il Guercino*, exhib. cat., Palazzo dell'Archiginnasio, Bologna, 1968, no. 59; Zafran, *CM*, 1977, no. 8; *Il Guercino (1591-1666)*, exhib. cat., Pinacoteca Nazionale, Bologna; Schirn Kunsthalle, Frankfurt; and National Gallery of Art, Washington, D.C., 1991-92.

Nicknamed "il Guercino" because of his squint-eyed expression, Giovanni Francesco Barbieri developed a vital, dramatically lighted Baroque style during his early years in Bologna, where the art of Ludovico Carracci impressed him greatly (see also no. 23). In 1621 he went to Rome at the behest of Pope Gregory XV. There he painted his famous *Aurora* fresco on the ceiling of the Casino Ludovisi; the work was a precocious foretaste of virtuoso High Baroque illusionism and Guercino's fullest expression of Baroque painterly flash. Upon Gregory's death in 1623,

the artist returned to his native village of Cento. There, and after 1642 in Bologna, he gradually retreated from his exuberant Baroque manner and moved toward a restrained late style inspired by Guido Reni (no. 18).

A major decorator who completed his share of monumental altarpieces and mural programs, Guercino also throughout his career produced more modest-sized canvases of half-length design. A prime example of these dramatically compressive compositions is *Samson Bringing Honey to His Parents.* The style of the undated painting and its quiescent tone suggest that it was made in Cento around 1625-26. By then the artist had begun the transition to a more decorous and reserved manner, though he had not yet abandoned the smoldering colors and velvety, form-dissolving *chiaroscuro* of his early art.

As related in the book of Judges (14:5-9), the Old Testament hero Samson killed a lion with his bare hands, an event that takes place in the painting's background (below Samson's left hand). Discovering later that bees had

filled the lion's carcass with honey, Samson returned home with some of it as an offering to his parents. While appropriate to the story, the trio of bees at the upper edge of the canvas also cleverly alludes to the painting's commissioners, the Barberini family, whose coat of arms featured three bees.

With the election of Cardinal Maffeo Barberini as Pope Urban VIII in 1623, the Barberini became Rome's leading art patrons. Soon after, a member of this illustrious family – possibly Urban VIII himself – ordered The Chrysler Museum painting from Guercino. The picture must have been well-liked, for a copy (without the three bees) was produced by one of Guercino's assistants. That work was included in the Borghese collection by 1650 and hangs today in the Galleria Borghese, Rome.

The Chrysler painting remained in the Barberini's possession until 1764, when Francis, Marquess of Tavistock, purchased it for his Bloomsbury residence in London. From him it passed into the collection of the dukes of Bedford at Woburn Abbey.

23 Giovanni Francesco Barbieri, called Guercino

Italian, 1591-1666

Cephalus Discovers the Mortally Wounded Procris, c. 1644

Pen and brown ink with brown wash on laid paper, 8⅜″ x 12½″ (21.3 x 31.8 cm)

Museum Purchase, 50.48.90

References: Zafran, *CM*, 1979, no. 17; Denis Mahon and Nicholas Turner, *The Drawings of Guercino in the Collection of Her Majesty the Queen at Windsor Castle*, Cambridge, 1988, under no. 112; *Il Guercino (1591-1666)*, exhib. cat., Pinacoteca Nazionale, Bologna; Schirn Kunsthalle, Frankfurt; and National Gallery of Art, Washington, D.C., 1991-92.

This drawing was one of several preliminary sketches in which Guercino (see also no. 22) worked out the composition for his 1644 painting of *Cephalus and Procris.* The painting (formerly Gemäldegalerie, Dresden; destroyed World War II) was commissioned by the Marchese Cornelio Bentivoglio for the French queen, Anne of Austria, who gave it to her minister, Cardinal Mazarin.

Of the three other preliminary sketches that are known (Art Museum, Princeton University; formerly Crozat collection, Paris; and British Royal Collection, Windsor Castle), the one at Windsor Castle compares most closely to The Chrysler Museum drawing. In both works the artist illustrates the moment from Ovid's *Metamorphoses* (7:794-865) when the hunter Cephalus discovers to his horror that, with his spear, he has accidentally inflicted a mortal wound on his wife Procris. (In the drawings an arrow has been substituted for the spear.) In the two other drawings and finished painting, however, Guercino depicted a later moment when Cephalus mourns the dead Procris. This difference suggests that the Windsor and Chrysler sketches were made early in the design process. The abbreviated quality of the Museum's drawing also implies that it is an initial, conceptual study, one used primarily to block out the scene's compositional and emotional elements in broad terms. Forms are evoked in fluent outline, and only essential shadows – those on the figures themselves – have been determined in rapid strokes of brown wash. The landscape setting is even more broadly handled, and the hunting dog and weeping putto found in Guercino's subsequent drawings and painting have not yet made their appearance in this sketch.

Already among Renaissance painters, the tragic tale of Cephalus and Procris was one of the most popular of the many stories of ill-fated lovers found in classical mythology (cf. no. 15). Though summarily drawn, Guercino's sketch captures the story's dramatic denouement with great feeling and originality. Here Cephalus, his arms flung wide in grief and shock, collapses before his dying wife. Procris' head is almost lost in a pool of wash, a poignant visual correlative for the shadow of death stealing slowly over her.

24 Bernardo Strozzi

Italian, 1581-1644

The Martyrdom of Saint Justina, c. 1635

Oil on canvas, 92½″ x 51½″ (235 x 130.8 cm)

Gift of Walter P. Chrysler, Jr., 71.526

Reference: Zafran, *CM,* 1977, no. 6.

Though Strozzi spent the first three decades of his career in his native Genoa, he is celebrated more today for his subsequent work in Venice. Together with the Roman Domenico Feti and the German Johann Liss – two other gifted foreigners who painted in Venice shortly before him – Strozzi was a principal founder of the Venetian Baroque style, a leader and reviver of the school of painting there following the fallow decades after Tintoretto's death (1594).

Escaping a legal dispute over his status as a lay brother of Genoa's Capuchin monastery of Saint Barbara, Strozzi settled in Venice in 1630. He brought with him a taste for the exuberant art of Rubens (no. 16), who had worked in Genoa during his visit to Italy in 1600-08. Onto this Strozzi grafted the Venetian colorist traditions of Titian and Veronese (no. 13). What he fashioned from these influences was a lush-colored Baroque style of great emotional power – a vigorous, expansive manner readily evident in *The Martyrdom of Saint Justina.* This undated altarpiece has been placed around 1635, toward the outset of Strozzi's Venetian period. It was about this time that he created another similarly styled work of full maturity, his *Saint Sebastian* altarpiece (San Benedetto, Venice).

Since early Christian times, the third-century Saint Justina (d. A.D. 303), patron saint of Padua and Venice, had enjoyed a special devotion in the Veneto region of northern Italy. A number of Paduan and Venetian painters before Strozzi had illustrated her martyrdom, as did Veronese in his famous altarpiece of 1575 in the church of Santa Giustina, Padua. According to legend, Justina was the daughter of King Vitalicino of Padua, an early Christian convert who also had his daughter baptized in the faith. Later condemned by the Emperor Maximian for her Christianity, Justina was arrested by his soldiers on a bridge traversing the River Po. She

fell to her knees, beseeching God for courage, and was taken to Maximian, who had her stabbed to death.

Strozzi's altarpiece condenses the story into a single scene. Here the saint, kneeling on the bridge and gazing heavenward, has already been set upon by her executioner, who prepares to plunge a dagger into her breast. Hovering above her is an angel who, at the very moment of her death, offers her the martyr's palm and crown.

25 Giovanni Benedetto Castiglione, called Grechetto

Italian, c. 1610-c. 1665

Moses Striking the Rock, after 1650

Oil on canvas, 39" x 47¼" (99 x 120 cm)

Signed lower left: *IO. BENEDITVS
CASTILIONV.
IANVE*

Gift of Walter P. Chrysler, Jr., 71.629

The protean master Castiglione left his mark on a host of contemporary and later European artists, including the Neapolitan Andrea di Lione, the Dutchman Tempesta (no. 40) and the French painter François Boucher (no. 51). In his biblical and mythological works Castiglione displayed a rare genius as a painter of animals, still life and landscape. While training in his native Genoa, he probably worked with Sinibaldo Scorza, who introduced him to etching and prompted his passion for landscape. From the paintings of the Bassano family – plentiful in Genoese collections – he may have derived his taste for biblical and pastoral themes, while Genoa's thriving colony of Flemish animal and still-life painters honed his interest in those particular genres.

During his middle years in Rome, from 1632 to c. 1640 and again from 1647 to 1651, Castiglione joined the circle of artists clustered around Nicolas Poussin. He produced at this time a series of pastoral and biblical pictures – chief among them his "patriarchal journeys" drawn from the Old Testament – that tempered the influence of Poussin's taut classicism with a tender, bucolic mood. The years after 1651 found him mostly in Mantua, where he served as court painter to the Gonzaga family.

The story of Moses, who delivered the Israelites from captivity in Egypt and led them to the Promised Land, was among Castiglione's favorite Old Testament narratives. Several of his drawings in the British Royal Collection at Windsor Castle illustrate episodes from that narrative, including a brush drawing that depicts the same subject as The Chrysler Museum painting: Moses striking the rock (Exodus 17:1-6 and Numbers 20:1-11).

After their escape from Pharoah, Moses and the Israelites wandered in the wilderness, where "there was no water for the people to drink." Thirsty and dispirited, the Israelites chided Moses and angrily demanded that he provide them with water. Moses in turn beseeched the Lord, who instructed him to "smite the rock" with his rod, "and there shall come water out of it, that the people may drink." In Castiglione's picture, Moses, at left, follows God's command and miraculously draws from the barren rock a shimmering spray of water. The water has attracted the Israelites' thirsty livestock, who crowd the foreground of the painting in a virtuoso display of meticulously rendered feathers and fur. Castiglione's fame as a caricaturist is amply revealed in his depiction of the faithless Israelites, whose astonished reactions to the miracle provide a veritable gallery of intense and varied emotions, ranging from expressions of outright terror and indignant disbelief, to wonder and pious thanksgiving. Though the painting has traditionally been ascribed to Castiglione alone, recent writers have suggested that one of his two principal workshop assistants, his son Francesco (c. 1641-1716) or brother Salvatore, may also have helped.

26 Bernardo Cavallino
Italian, 1616-1656

Procession to Calvary, c. 1645

Oil on canvas, 40″ x 52″ (101.6 x 132.1 cm)

Gift of Walter P. Chrysler, Jr., 71.522

Reference: *Bernardo Cavallino of Naples
1616-1656,* exhib. cat., Cleveland Museum of
Art; Kimbell Art Museum, Fort Worth; and
Museo Pignatelli Cortes, Naples, 1984-85,
no. 41.

Cavallino may have been the most complex and refined of the mid-seventeenth-century Neapolitan painters. In his mature paintings – mostly small-scale cabinet pictures of biblical, mythological or historical themes – he devised a delicate and courtly style, an elegant "neo-Mannerism" marked by iridescent color, elongated figure designs and a taste for pungent genre detail.

Virtually nothing is known of Cavallino's brief life. Possibly he traveled outside of Naples, though there are no documents that confirm this. Early in his career he allegedly worked on the ceiling decorations of San Giuseppe Maggiore dell' Ospedaletto in Naples. But he soon renounced such monumental projects for a series of more intimate easel pictures in the manner of the *Procession to Calvary.* The disastrous plague of 1656 killed nearly half of Naples' five-hundred thousand inhabitants. Cavallino may have been among those stricken by the plague, for he died prematurely in 1656, at the age of forty. His paintings are rare today; roughly eighty are known to exist.

In Cavallino's anguished vision of Christ's journey to Calvary, the condemned Savior has all but collapsed under the weight of the cross. Overwhelmed by his burden and the brutality of his tormentors, he looks back at Saint John, the Virgin and other holy women, who follow helplessly behind him. The grisly procession turns, at right, and proceeds into the background, where intervening veils of air reduce it to a ghostly shimmer of grey-white monochrome. The painting, which Cavallino produced around 1645, contains one of his eight known self-portraits. The artist – an elegant, still youthful figure of roughly thirty years – stands in the background just left of center, turning his head to gaze at the viewer. Christ's tormentors recall the coarse peasant types found in the contemporary Neapolitan paintings of Jusepe de Ribera. The pointing onlooker, seated at right, brings to mind the genre figures of the Dutch painter Hendrick ter Brugghen (no. 17), who may have visited Naples during his trip to Italy in 1604-14. It is sometimes suggested that the *Procession to Calvary* was painted by Cavallino as a pendant to his *Christ Driving the Merchants from the Temple,* today in the National Gallery, London.

27 Jan van Bijlert

Dutch, 1598-1671

Mars Bound by Amoretti, after 1630

Oil on canvas, 50¼″ x 55⅞″ (128 x 141.9 cm)

Signed lower right on the drum:
J. bijlert. fec.

Gift of Walter P. Chrysler, Jr., 71.457

References: G. J. Hoogewerff, "Jan van Bijlert, Schilder van Utrecht (1598-1671)," *Oud Holland,* 80 (1965), p. 26, no. 31; Peter C. Sutton, "A Pair by Van Bijlert," *Hoogsteder-Naumann Mercury,* 8 (1989), pp. 4-16.

Caravaggio's influence was felt widely among northern European artists (see nos. 19, 21). The painters in the Dutch city of Utrecht were particularly receptive to his art, and in the decades after 1600 the town's finest artists adopted Caravaggio's revolutionary realism and dramatic *chiaroscuro* with great originality and sensitivity. Heading the list of the Utrecht *Caravaggisti* were Hendrick ter Brugghen (no. 17), Gerrit van Honthorst and Jan van Bijlert, who followed Ter Brugghen's and Honthorst's Roman sojourns with his own visit to Italy in 1621-24. Deeply affected by Caravaggio's works and those of his Roman followers, Van

Bijlert returned to Utrecht and assumed Caravaggio's heavy light-shadow contrasts. He developed, too, a preference for Caravaggesque subjects and compositional types, painting life-size half-lengths of music makers, shepherds and mythological figures like The Chrysler Museum Mars. Around 1630 Van Bijlert renounced the murky tenebrism of his earlier art and, as is evident from the clear lighting and airy blues and mauves in *Mars Bound by Amoretti,* moved toward a brighter, more polished style.

A suggestive and humorous allegory of desire, *Mars Bound by Amoretti* draws upon a humanistic theme – the prisoner of love – that had been part of profane Italian art since the early sixteenth century. The prisoner depicted here is an unlikely one: the powerful Roman war god Mars, whose passion for Venus, the goddess of love, has led to his capture. (As Homer recounts in the *Odyssey* [8:266-366], Mars had an affair with Venus, who was married to Vulcan. Warned of their adultery, Vulcan surprised Venus and Mars in bed

and then summoned the other gods to condemn them. Instead, the gods laughed at the embarrassed lovers.) Appropriately dressed in classical military attire and crouching submissively over his battle drum, Mars has been taken prisoner by two of Venus' mischievous offspring. While one of these amoretti binds Mars at the wrists, the other stands guard over him, threatening to plunge an arrow into the god's posterior. Similar subjects involving Cupid, Venus and Mars had been illustrated by Caravaggio and his Italian followers, whose paintings Van Bijlert surely studied in Rome.

As a pendant to his *Mars,* Van Bijlert produced an equally ribald painting of *Venus Chastising Amoretti* (Museum of Fine Arts, Houston). In this picture the goddess whips her two offspring for the misdeed depicted in the Norfolk canvas. (Thus did Van Bijlert reassure his high-minded Dutch audience that physical desire must be countered by self-control.) A related set of pendant engravings of Venus and Mars as lovers was published in 1643 by Crispijn de Passe II after Van Bijlert's designs.

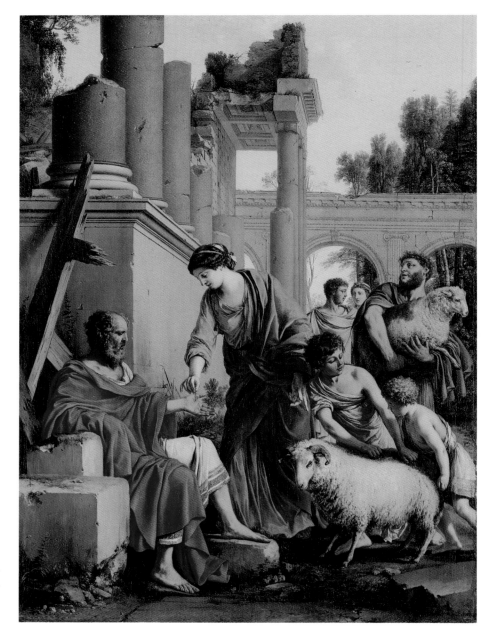

28 Laurent de La Hyre

French, 1606-1656

Job Restored to Prosperity, 1648

Oil on canvas, 51¾" x 39¾" (131.5 x 101 cm)

Signed and dated lower left:
L. De La Hire, in. & F. 1648

Gift of Walter P. Chrysler, Jr., 71.512

References: Paris, 1982, no. 32; Harrison, *CM*, 1986, no. 4; Pierre Rosenberg and Jacques Thuillier, *Laurent de La Hyre 1606-1656: L'homme et l'oeuvre*, Geneva, 1988, pp. 280-281.

Together with his younger colleague Eustache Le Sueur (no. 30), Laurent de La Hyre led a small group of seventeenth-century French painters who developed an Italianate aesthetic without the customary visit to Italy. The group, whose classicizing style dominated much of the Parisian art world in the years before 1650, has come to be known as the First School of Paris.

La Hyre's early painting style of the 1620s was influenced by the Mannerist art of Fontainebleau, while during the 1630s his work reflected more decorative, Baroque concerns. By the mid-1640s he had embraced the coolly classical Roman manner of Nicolas Poussin, who abandoned Rome briefly for Paris in 1640-42 and profoundly influenced the French capital's resident painters. La Hyre's mature, classical style is fully revealed in *Job Restored to Prosperity*, which he painted in 1648, the year he was named one of the twelve *anciens*, or founding members, of the Académie Royale de Peinture et de Sculpture.

An amateur musician, passionate huntsman and capable mathematician, La Hyre also knew the Bible well. His surviving oeuvre of religious paintings includes a remarkable number of Old Testament themes that had seldom or never been illustrated in earlier French art and whose novelty must have delighted his private patrons. Among the loveliest of these Old Testament pictures is *Job Restored to Prosperity*. Here La Hyre presents the rarely depicted moment from the Book of Job (42:1-12) when the Lord finally ends the suffering and restores the wealth of that "perfect and upright" man:

> Then Job answered the Lord, and said, I know that thou canst do every thing, and that no thought can be withholden from thee....
> the Lord said to Eliphaz the Temanite....take unto you now seven bullocks and seven rams, and go to my servant Job....also the Lord gave Job twice as much as he had before. Then came there unto him all his brethren, and all his sisters ...[and] every man also gave him a piece of money, and every one an earring of gold. So the Lord blessed the latter end of Job more than his beginning.

His trials over, a weary Job receives the tribute of his family and friends. In true Poussinesque fashion, La Hyre envisions this Old Testament account of divine restitution as a grave, high-minded drama, a moment of decorous and noble action. The colors of the landscape and skillfully executed temple ruin – a delicate medley of lilac, green, blue and light brown – are characteristic, too, of La Hyre's gently understated art.

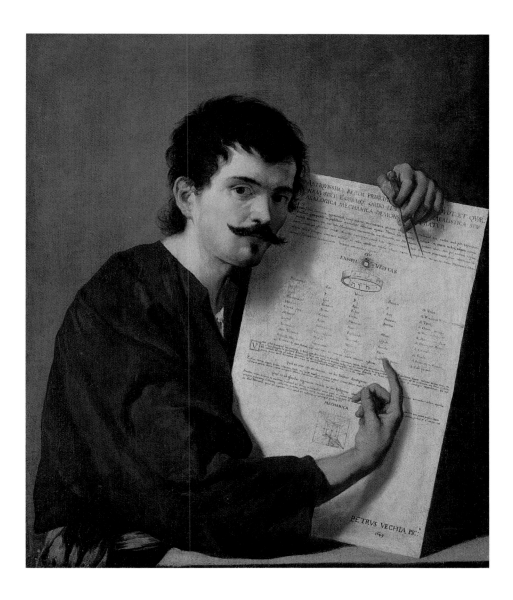

29 Pietro della Vecchia

Italian, 1603-1678

Portrait of Erhard Weigel, 1649

Oil on canvas, 36⅜″ x 31⅝″ (92.4 x 80.3 cm)

Signed and dated lower right:

PETRUS VECHIA PIC:^R
1649

Gift of Walter P. Chrysler, Jr., 71.614

References: Bernard Aikema, "Pietro della Vecchia, a Profile," *Saggi e memorie di storia dell'arte,* 14 (1984), p. 92; *Baroque Portraiture in Italy: Works from North American Collections,* exhib. cat., John and Mable Ringling Museum of Art, Sarasota, and Wadsworth Atheneum, Hartford, 1984-85, no. 47.

Still little-known today, Pietro della Vecchia was one of the principal painters of Seicento Venice. He headed a large and productive atelier in that city and was especially popular for his many genre paintings of lovers and gallants in imitation of Giorgione, and for his pictures of gypsies and warriors in the manner of Caravaggio. He also produced altarpieces in the expansive, High Baroque style, as well as a handful of portraits. Among the most

powerful examples of Vecchia's portraiture is his 1649 likeness of the German philosopher and mathematician Erhard Weigel (1625-1699). It is the only dated portrait by Vecchia.

Erhard Weigel lived for most of his adult life in Jena, near Weimar, where he taught mathematics and served as an advisor to Duke William of Saxony-Weimar. Shown in Vecchia's portrait at the age of twenty-five, Weigel stands at his worktable and displays a large chart on which he has presumably been working. In his left hand he holds a compass, which alludes to his facility as a geometrician. The chart contains a complex philosophical treatise in Latin, a cabalistic invention of his own design. Blending contemporary scientific and religious thought with more occult concepts drawn from alchemy and magic, the treatise purports to present in schematic form the various branches of human knowledge and the properties that compose them. Its title translates:

"The most ancient principles of things, how many and what they are, and what their order of importance is. They are shown here by means of this cabalistic or analogic chart." Below the title is the motto, "In wisdom is truth," and just beneath that is a drawing of a ringlike object inscribed with Hebrew letters. This may represent King Solomon's ring, a mythic magical font of wisdom in late medieval lore. Toward the middle of the chart are five columns that list the major branches of knowledge and the properties that Weigel and his colleagues believed constituted them.

Like many of his contemporaries, Vecchia may well have shared Weigel's fascination with the mystical, cabalistic properties of contemporary philosophical and number theories. Indeed, Vecchia produced several genre pictures of philosophers, astronomers and mathematicians at work, and it is known that his son was both a painter and mathematician.

30 **Eustache Le Sueur**
French, 1616-1655

Virgin and Child with Saint Joseph, 1651

Oil on canvas, 36″ diameter (91.4 cm)

Gift of Walter P. Chrysler, Jr., 71.675

References: Paris, 1982, no. 54; Harrison, *CM,* 1986, no. 1; Alain Mérot, *Eustache Le Sueur (1616-1655),* Paris, 1987, pp. 287-288, no. 156.

Le Sueur was a painter of immense promise and increasing influence in mid-seventeenth-century Paris. When barely thirty years old, he achieved fame in 1647 for his celebrated suite of mythological pictures – the Cabinet de l'Amour – for the Paris town house of Jean-Baptiste Lambert, who had served as Louis XIII's secretary. Within a decade Le Sueur had helped found the Académie Royale (1648), had worked for the royal family at the Louvre, and been named *peintre du Roi.* He might well have become Charles Le Brun's chief artistic rival at court had his life not been cut short at the age of thirty-eight by a slow "wasting fever."

Attracted first to the decorative manner of his teacher, Simon Vouet, Le Sueur had by the early 1640s embraced a more personal, classical style. This transformation was prompted by his study of Raphael and his encounter with the art of Nicolas Poussin, who visited Paris in 1640-42. In his final years, Le Sueur evolved a kind of lyric classicism, a style in which the rigors of structural order and emotional restraint were softened by a sweetly human feeling and a palette of precious, powdery tints. This blend of classical control and poetic *tendresse* is fully revealed in the *Virgin and Child with Saint Joseph* of 1651, an endearing vision of domestic harmony within the Holy Family.

The instability inherent in the painting's circular, tondo shape – a format that had been in regular use for devotional pictures in Italy and France from the fifteenth century and that Vouet himself had utilized in a *Holy Family* picture of c. 1626 (Fine Arts Museums of San Francisco) – is effectively counteracted by the anchoring verticals of the columns, palm tree and distant buildings. Drawing its inspiration particularly from Raphael's meditative images of the Madonna and Child, Le Sueur's painting "renews, without imitating, the Renaissance ideal of perfection" (Pierre Rosenberg).

The earliest recorded reference to the *Virgin and Child with Saint Joseph* is found in the brief biography of Le Sueur included in Florent Le Comte's *Cabinet des singularités* of 1702. There, in a paragraph listing the artist's productions from the year 1651, Le Comte records that the work – "a round painting of a Virgin, the infant Jesus, and Saint Joseph" – was commissioned by a "Monsieur Foucaut." The identity of Foucaut is not known, though scholars have suggested he might have been Louis de Foucault, maréchal de France in the 1650s, or possibly Claude Foucault, who served as counselor to the Paris Parliament after 1627. Whoever commissioned the piece, its modest size and meditative content suggest that it was meant for private devotion. A closely related pen and ink drawing of *The Holy Family,* once attributed to Poussin but now generally ascribed to Le Sueur, is in the Art Institute of Chicago.

31 Diego Velázquez

Spanish, 1599-1660

Portrait of a Man, c. 1651-52

Oil on canvas, 25¼″ x 17½″ (64 x 44.4 cm)

Gift of Walter P. Chrysler, Jr., 83.587

Reference: José Gudiol, *The Complete Paintings of Velázquez 1599-1660*, New York, 1983, pp. 212, 336, no. 124.

Velázquez has long been celebrated as the presiding genius of Spain's seventeenth-century Golden Age of painting. After working initially in his native Seville, in 1623 he was called to the royal court at Madrid and was named official painter to Philip IV. He served the court for the rest of his life, acting as the king's confidant and premier artist and performing a host of other official duties. Twice he visited Italy, in 1629-31 and again in 1649-51. Though the trips enriched his art – he was deeply affected by Titian's work – they did not fundamentally alter his sober, realist style. Perhaps as crucial to his artistic development were the Italian, and especially the Venetian, paintings in Philip IV's collection in Madrid. As he approached maturity, Velázquez renounced the sharp *chiaroscuro* effects he had employed in his early Sevillian paintings for a more diffuse, daylight clarity. He devised, too, a fluid, sketchy brush technique through which his thinly applied veils of color were bound in a shimmering yoke of silver-grey.

The inquisitional stance of Spain's all-powerful Catholic Church encouraged Velázquez's colleagues to devote themselves largely to religious images in keeping with Counter-Reformational doctrine (cf. no. 35). Velázquez's privileged position at court, however, gave him access to a richer variety of pictorial themes: mythological and historical subjects, genre images, and, above all, portraiture, which he approached with rare sensitivity. As Philip's principal painter, he was called upon repeatedly to record the king's visage and those of his courtiers. His likenesses ranged from grandiose, formal equestrian portraits of the royal family and full-length images of Spanish grandees to smaller, but nonetheless powerful, bust-length images like the *Portrait of a Man* in The Chrysler Museum.

This portrait is one of only a handful of works by Velázquez in American collections. As contemporary aristocratic fashion dictated, the sitter is dressed austerely, in a black doublet and flaring white linen collar. Though the gentleman's identity is not known, the intimacy and directness of the portrait has led more than one writer to speculate that he was a close friend of the artist and almost certainly someone of high rank connected to the Madrid court.

On the basis of style, the undated painting has generally been placed at the threshold of Velázquez's final period, c. 1651-52, immediately following his second visit to Italy. It was then that Velázquez brought to perfection the thinly layered, atmospheric painting method so readily evident in the portrait. Though intimate in scale, the *Portrait of a Man* displays many characteristics of Velázquez's best work: his austere realism, fluent painting method and extraordinary talent for psychological penetration.

32 Pierre Patel the Elder

French, c. 1605-1676

Landscape with the Journey to Emmaus,
1652

Oil on canvas, 27⅜" x 36½" (69.5 x 92.7 cm)

Signed and dated lower right:
 P. PATEL. INVE.
 1652

Gift of Walter P. Chrysler, Jr., 71.686

References: Paris, 1982, no. 78; Harrison, *CM*,
1986, no. 3.

Pierre Patel was one of the most
prominent mid-seventeenth-century
French landscape painters. Originally
from Picardy, he was already estab-
lished in Paris by 1635, when he was
made a master painter in the city's
guild of St. Luke. His reputation in
Paris derived in large measure from his
collaborative work with other artists on
large decorative projects. In 1645-47,

for example, he worked under
Eustache Le Sueur in the Hôtel Lam-
bert (no. 30), supplying landscapes for
the opulent mural program conceived
and directed by Le Sueur in that fash-
ionable Paris town house. In an era
when so many of France's finest land-
scape painters – Gaspard Dughet,
Sébastien Bourdon, Claude Lorrain –
studied or lived in Italy, Patel chose to
remain in Paris. His classically con-
structed landscapes, set with nostalgic
temple ruins, owe an obvious debt,
nonetheless, to the Roman works of
Claude and to the Italianate landscapes
of Laurent de La Hyre (no. 28).

Claude's influence is easily discerned
in *Landscape with the Journey to Emmaus,*
which Patel created in 1652, following
his period of activity in the Hôtel Lam-

bert. As recounted in Luke 24:13-16,
the newly risen Christ joined two of his
disciples on the road from Jerusalem to
the village of Emmaus, and he traveled
with them unrecognized. In Patel's
painting the gospel episode is illus-
trated in the lower right foreground,
where Christ and his disciples appear
as tiny, "staffage" figures. As is often
the case in Patel's work, the biblical nar-
rative in this instance is little more than
a footnote to the landscape itself. It is
largely a pretext for a sweeping vista of
idyllic, open countryside and crum-
bling, vine-draped ruins, all minutely
crafted and suffused with the pearly
pink light of dusk. Patel determined
the shape of the splendid ruin at left in
a preparatory drawing that is also in
The Chrysler Museum (no. 33).

33 Pierre Patel the Elder

French, c. 1605-1676

Classical Ruins in a Landscape, c. 1652

Black and white chalk on brown paper, 9″ x 9″
(22.8 x 22.8 cm)

Museum Purchase, 84.180

Reference: *From Fontainebleau to the Louvre:
French Drawing from the Seventeenth Century,*
exhib. cat., Cleveland Museum of Art; Fogg
Art Museum, Cambridge; and National Gal-
lery of Canada, Ottawa, 1989-90, no. 81.

In this delicate, light-filled sketch the
seventeenth-century Parisian land-
scapist Pierre Patel established the
design for the left half of his *Landscape
with the Journey to Emmaus,* a painting
that is also in The Chrysler Museum
(no. 32). The painting bears Patel's
signature and the date 1652. In all like-
lihood, the undated preliminary

drawing was produced slightly earlier
that same year.

Drawings by Patel are rare, and
fewer still can be dated with precision.
Classical Ruins in a Landscape is doubly
rare, therefore, because it not only
offers a precious glimpse of Patel the
draftsman, but does so at a specific
moment in his career.

Patel's landscape paintings are cele-
brated for their atmospheric and
luminary subtleties. As the present
drawing attests, the artist developed
these effects first in his preliminary
sketches. In the drawing we can
observe the scumbled, atmospheric
touch of a mature and confident
draftsman, a landscape master at the
height of his career.

34 Salvator Rosa

Italian, 1615-1673

The Baptism of the Eunuch, c. 1660

Oil on canvas, 79″ x 48″ (200.7 x 122 cm)

Signed in monogram lower right:
SR (in ligature)

Gift of Walter P. Chrysler, Jr., 71.525

References: Michael Mahoney, *The Drawings of Salvator Rosa,* New York and London, 1977, I, pp. 103-104, 122, 521-522; *Salvator Rosa in America,* exhib. cat., Wellesley College Museum, Wellesley, Massachusetts, 1979, p. 17.

Though Rosa was born in Naples, his controversial artistic career unfolded in Florence and Rome. He left Naples for Rome in 1635 and achieved his first fame there as a painter of landscapes and coastal views. These dark and threatening vistas beset with storms and battles, with macabre scenes of witchcraft and rural ambush, were rediscovered with great enthusiasm by English artists and collectors during the Romantic era.

The contentious Rosa also put himself forward in Rome as a poet and satiric dramatist. His scornful lampoon of the powerful Bernini (no. 37) in a 1639 play earned him the ire of Rome's artistic elite. Rosa quickly retreated to Florence, where he worked for the next decade. He returned to Rome permanently in 1649 and, hoping to transcend his earlier reputation as a landscapist, painted a series of larger and more ambitious figurative subjects drawn from the Bible and classical antiquity.

Among the most famous of these mature Roman figurative works is *The Baptism of the Eunuch* in The Chrysler Museum. Rosa painted it and a pendant *Saint John the Baptist Preaching in the Wilderness* around 1660 for Monsignor Giovanni Battista Costaguti (d. 1704), a member of the papal court who in 1690 was elevated to cardinal. Rosa's *Saint John the Baptist Preaching in the Wilderness* belongs to the St. Louis Art Museum. Both the St. Louis and Chrysler paintings make clever allusions to their commissioner. The St. Louis picture features Costaguti's namesake, John the Baptist ("Giovanni Battista" in Italian), while the Chrysler painting depicts an act of baptism, a reference again to Costaguti's Christian name. By 1786 the two paintings were in England, where they were purchased by the Earl of Ashburnham for his London art collection. They remained in that renowned collection until 1953.

The Bible story of Saint Philip's baptism of the Ethiopian eunuch was seldom illustrated in seventeenth-century Italian art. Its choice reveals Rosa's penchant for rare and novel themes. As recounted in Acts 8:26-39, the evangelist Philip was instructed by an angel of the Lord to travel southward into the desert along the road from Jerusalem to Gaza. At a desolate spot he encountered an Ethiopian, a eunuch who was treasurer to Queen Candace of Ethiopia. Philip converted the heathen eunuch with his preaching and baptized him into the Christian faith with water. The newly converted eunuch then "went on his way rejoicing."

In the painting Philip, clothed in white and pointing dramatically heavenward, baptizes the kneeling eunuch, whose heathen companions respond with confusion and surprise. The scene unfolds in a barren, rock-bound landscape, a gloomy and forbidding setting typical of Rosa. Characteristic, too, of Rosa's restive, proto-Romantic art is the galvanic mood of "storm and stress" that courses through the scene and manifests itself particularly in the Ethiopians' theatrical gestures, wide-eyed expressions and exotic costumes.

Three preliminary drawings for the painting survive, all of them executed in pen and brown ink: a sketch for the soldier seated in the painting at left (Teylers Museum, Haarlem) and two studies for Saint Philip (Pierpont Morgan Library, New York, and Museum der bildenden Künste, Leipzig).

35 Claudio Coello

Spanish, 1642-1693

The Vision of Saint Anthony of Padua,
1663

Oil on canvas, 67" x 50½" (170.2 x 128.3 cm)

Signed and dated lower left: *CLAVDIO.*
FA. 63

Gift of Walter P. Chrysler, Jr., 71.542

Reference: Edward J. Sullivan, *Baroque Paint-*
ing in Madrid: The Contribution of Claudio Coello,
Columbia, Missouri, 1986, p. 103, no. P4.

Coello was one of the most promi-
nent artists to work in Madrid during
the second half of the seventeenth cen-
tury. A prolific painter of altarpieces,
fresco cycles and portraits, he even-
tually won the patronage of the
Spanish Crown. He served as *pintor del*
rey – painter to King Charles II – from
1683, and in 1686 he assumed the more
prestigious post of *pintor de cámara,*
painter to the king's chamber. Coello
is often called the last major painter
of the seventeenth-century school
of Madrid.

With the exception of Saint Francis
of Assisi, Anthony of Padua (1195-1231)
was, by the seventeenth century, the
most revered of the Franciscan saints.
In Catholic Spain his following was
especially strong, and contemporary
Spanish artists were often called upon
to illustrate the miracles associated
with his life. Chief among these was
Anthony's vision of the infant Christ,

a subject that Coello first depicted in
The Chrysler Museum painting of
1663 and returned to in two other pic-
tures – one a nearly identical replica
found today in a private Madrid collec-
tion and the other an altogether
different composition from c. 1690
(private collection, Barcelona).

According to legend, Anthony's
vision occurred while he was explaining
the mystery of the Incarnation to lis-
teners in his chamber. His discourse
was interrupted by a miraculous visit
from the Christ Child, who alighted on
the saint's book. In the Chrysler paint-
ing, Anthony, dressed appropriately
in the habit of a Franciscan monk, is
shown kneeling in wonder before the
infant Savior, who descends upon a
cloud of cherubs. The saint's book is
brought forward by a pair of helpful

angels in the background. The trans-
parent globe the Christ Child straddles
is an age-old symbol of his worldly
dominion. The lilies in the ewer at left
are one of Anthony's saintly attributes,
signifying his purity.

Coello's vibrant late Baroque style
owed much to the art of Rubens and
Renaissance Venice. These debts are
evident in *The Vision of Saint Anthony*
of Padua, particularly in its dynamic,
even unstable composition and its high
emotional pitch. The warm, sonorous
palette and the Christ Child's robustly
sculptural form clearly bring Rubens
to mind.

Acquired in Spain in 1836 for King
Louis-Philippe of France, the picture
was displayed between 1838 and 1848
in Paris, in the Galerie Espagnole in
the Louvre.

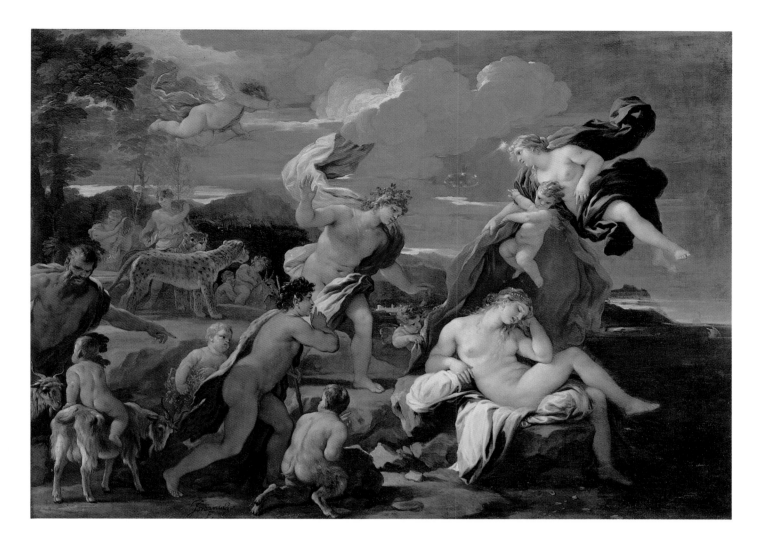

36 Luca Giordano
Italian, 1634-1705
Bacchus and Ariadne, c. 1685-86
Oil on canvas, 48″ x 69″ (121.9 x 175.3 cm)
Signed lower left: *Jordanus F.*
Gift of Walter P. Chrysler, Jr., 71.650
Reference: Yale, 1987-88, no. 11.

The iridescent color schemes and illusionistic designs of late Baroque decoration were first championed in Naples by Luca Giordano. He was the unrivaled leader of the Neapolitan school of painting during the second half of the seventeenth century and one of the most influential of contemporary European artists. His extraordinary speed and productivity as a painter were legendary. Colleagues called him "the Thunderbolt" and *Luca fa presto.* Equally dazzling was his capacity to imitate the works of other artists. His boundless talent for creative mimicry was first honed by his father Antonio, a Neapolitan painter and copyist, and in time it earned him the nickname "Proteus."

For Giordano, the decades after 1650 were marked by almost constant travel – to Florence, Venice, Rome and eventually to Spain. Already by 1660 he had abandoned the dark, Caravaggesque style of Jusepe de Ribera, quite possibly one of his teachers, for a lighter, more colorful late Baroque manner derived from Pietro da Cortona's Roman works and those of the great sixteenth-century Venetians.

The Chrysler Museum painting is one of at least three pictures by Giordano (Museo di Castelvecchio, Verona; Gemäldegalerie, Dresden) that illustrate the mythology of Bacchus and Ariadne. A fluent work of full maturity, it has been dated to Giordano's Florentine sojourn of 1685-86. The dating is based on its strong stylistic kinship to the artist's contemporary frescos in the Palazzo Medici-Riccardi, and particularly to the Medici-Riccardi *Triumph of Bacchus.*

As recounted in Ovid's *Metamorphoses* (8:170-182) and other classical sources, Ariadne, the daughter of King Minos of Crete, helped her beloved Theseus escape the Labyrinth and then sailed with him to the island of Naxos, where he deserted her. Heartbroken at her abandonment, she was discovered on the shore by Bacchus, god of wine, who fell in love with her and, after his voyage to India, returned to marry her. He then placed her marriage crown in the heavens, where it was transformed into a constellation, the "corona borealis."

In Giordano's painting a love-smitten Bacchus and his celebrants – maenads, satyrs, putti – encounter Ariadne for the first time, stealing up on her as she slumbers sadly at water's edge. Ariadne's future betrothal is forecast in the crown of stars that hovers above her. The painting's stately tone and cool palette of silvery pinks and blues evoke Poussin and Titian, while the striding figure of Bacchus pays homage specifically to Titian's *Bacchus and Ariadne* in the National Gallery, London. In Ariadne's pose the "inspired mimic" Giordano presents a witty reprise of Michelangelo's sculpture of *Night* from the Tomb of Giuliano de' Medici (San Lorenzo, Florence).

37 Gianlorenzo Bernini

Italian, 1598-1680

Bust of the Savior, 1679-80

Marble, 36½″ (92.7 cm)

Gift of Walter P. Chrysler, Jr., 71.2043

References: Irving Lavin, "Bernini's Death," *Art Bulletin*, 54 (1972), pp. 159-186; *idem*, "Afterthoughts on 'Bernini's Death'," *Art Bulletin*, 55 (1973), pp. 429-433; *idem*, "On the Pedestal of Bernini's Bust of the Savior," *Art Bulletin*, 60 (1978), pp. 548-549; *Le Immagini del Santissimo Salvatore*, exhib. cat., Museo Nazionale di Castel Sant'Angelo, Rome, 1988-89, pp. 229-283.

Bernini was the greatest sculptor and architect of the seventeenth century and the major founder of the Italian High Baroque style. An artistic demigod who dominated the Roman art world for more than fifty years, he was courted by kings and popes throughout his career. At the time of his death – he succumbed to a stroke in Rome in 1680 – he was revered throughout Europe.

Bernini began the marble *Bust of the Savior* in 1679, only a year before his death. Both of his early biographers, Filippo Baldinucci (1682) and Bernini's son Domenico (1713), discuss the work at length. They record that the artist intended to present the bust – his final work – as a gift to his dear friend and ardent supporter, Queen Christina of Sweden, who was then living in Rome. Baldinucci writes:

> Bernini was already in the eightieth year of his life. For some time past he had been turning his most intense thoughts to attaining eternal repose rather than to increasing his earthly glory. Also, deep within his heart was the desire to offer, before closing his eyes to this life, some sign of gratitude to Her Majesty the Queen of Sweden, his most special patron. In order, therefore, to penetrate more deeply into the first concept and to prepare himself better for the second, he set to work with the greatest intensity to create in marble a half-length figure, larger than life-size, of Our Savior Jesus Christ. This is the work that he said was his favorite and it was the last given to the world by his hand.

According to Baldinucci, Christina refused the gift in a moment of royal self-deprecation: "The Queen's opinion of, and esteem for, the statue was so great that, not finding herself in circumstances in which it was possible to give a comparable gift in exchange, she chose to reject it rather than fail in the slightest degree to equal the royal magnificence of her intention." Bernini then bequeathed the bust to her, and, at Christina's death in 1689, it passed to Pope Innocent XI Odescalchi, in whose family it remained at least until 1713, when it was mentioned in an inventory of the Palazzo Odescalchi. By then the sculpture had achieved considerable fame, having been chosen as the official emblem of the Apostolic Hospital in Rome.

An early description of the bust states that it originally stood atop an elaborate and richly ornamented pedestal that rose more than seven feet from the floor. Constructed from Bernini's own design, the pedestal was composed of a gilded wooden socle, stepped at the top, that supported a pair of kneeling angels, also in gilded wood. The angels, in turn, upheld the bust on a base of Sicilian jasper. As Irving Lavin noted in 1972,

> Bernini's *Savior* is the first monumental marble bust since antiquity that…[was designed to]…stand free on a pedestal and include both arms. [The figure's left hand is tucked beneath the right, its wrist just visible.] It combines, in an unprecedented way for a Christian image, the living and dramatic quality of a narrative figure with the commemorative and idolous quality of a classical bust monument.

Turning his head heavenward and raising his right hand in blessing, Bernini's Christ proclaims his role as intercessor between God and man, his divine mission as *Salvator Mundi*. Though universal in its spiritual message, the bust remains an intensely personal creation, Bernini's very private tribute to the deity on the eve of his own demise. It is Bernini's last will and testament as an artist, an embodiment of his faith and hope for salvation.

Among the artist's preliminary drawings for the *Bust of the Savior* are a black chalk study of the angels that once supported the bust (Museum der bildenden Künste, Leipzig) and a sheet of black chalk studies of the Savior's head and chest (Gabinetto Nazionale delle Stampe, Rome). A marble copy of the bust, made by an unknown artist at the time of Bernini's death, is preserved in the Cathedral at Sées in France.

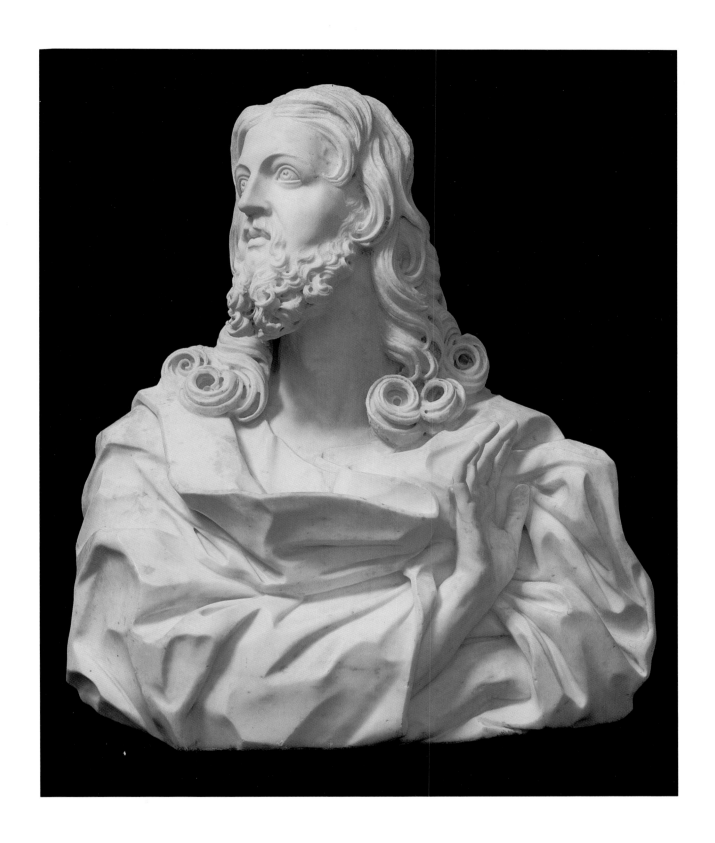

38 David Teniers the Younger

Flemish, 1610-1690

The Surgeon, 1670s

Oil on canvas, 22½″ x 29″ (57.2 x 73.7 cm)

Signed lower left: *D. TENIERS. FEC.*

Gift of Walter P. Chrysler, Jr., 71.480

The Antwerp-born Teniers followed his father's lead as a painter and in 1633 joined the Antwerp painters' guild. His 1637 marriage to the daughter of Jan Brueghel the Elder allied him to another illustrious family of Flemish artists. In 1651 Teniers moved from Antwerp to Brussels, where he had been made court painter to the Archduke Leopold Wilhelm, the governor of the southern Netherlands. He also became curator of the archduke's famous paintings collection, retaining both posts until 1659.

Teniers was popular among his contemporaries and is highly prized today for his landscape paintings and satiric genre scenes. These works were renowned for their technical excellence, their brilliant surface values and carefully crafted details. Teniers' corpus of genre pictures includes innumerable images of carousing peasants, off-duty soldiers smoking in guard rooms, and alchemists at work. As seen in The Chrysler Museum painting, it also includes images of the country barber-surgeon.

Already in the late Middle Ages, a good many members of the professional classes – lawyers, dentists, doctors – were satirized by Netherlandish writers and painters, who frequently portrayed doctors as charlatans and quacks. This was especially true of the lowly traveling barber-surgeon, whose medical skills were often nonexistent and whose hapless patients usually belonged to the rural lower class. The barber-surgeon typically tended wounds, removed skin growths, let blood, administered purges and even amputated limbs. He also served as the village barber. Teniers responded to the widespread prejudice against these pseudo-scientists by producing numerous pictures of quack doctors who study flasks of urine or operate on a gullible victim's head, foot or back.

In the Museum's painting, a barber-surgeon tends to a patient's back, possibly preparing to lance a boil. At right the surgeon's young apprentice bends over a dish of glowing coals, warming a mustard plaster that will be applied to the wound. In the background an older assistant readies another patient for the doctor. The patient's rolled-up sleeve suggests that he will be bled. On the stool nearby is the barber-surgeon's shaving basin, which possibly doubled as a bleeding bowl. Arrayed in the foreground in jugs and bottles, the doctor's various potions and medications compose a flawlessly executed still life.

The primitive hocus-pocus of the barber-surgeon depended heavily on the pseudo-science of alchemy. In the painting both the fish skeleton and the globe suspended from the ceiling are alchemical images, and they point to the doctor's ignorant reliance on the debased, false science of alchemy. The chained monkey at the lower right carries the sharpest satiric bite of all. In contemporary northern European art, monkeys often appeared as symbols of foolishness, and Teniers' animal makes the association clear. He holds an apple, an emblem of the biblical Fall of Man and, thus, of humankind's sin and folly. The monkey bears witness generally to the foolishness of men who constantly run to the doctor, seeking cures for every minor ailment, when they should be tending to the health of their eternal souls. Indeed, the animal's posture "apes" the pose of the patient seated behind him. This visual pun suggests that the gullible man is, like the bound animal, a suffering victim, a captive of the doctor's stupidity and his own foolish acquiescence to it. In short, the patient is chained to his ignorance as the monkey is tied to his iron ball.

39 Nicolas de Largillierre

French, 1656-1746

The Artist in His Studio, c. 1686

Oil on canvas, 58½" x 45½" (148.6 x 115.6 cm)

Signed lower right:
Peint Par N. De Largillierre

Gift of Walter P. Chrysler, Jr., 71.513

References: *Largillierre and the Eighteenth-Century Portrait,* exhib. cat., Montreal Museum of Fine Arts, 1981, no. 45; Harrison, *CM,* 1986, no. 8.

Like his friend and artistic rival Hyacinthe Rigaud (no. 41), Largillierre was one of France's premier portrait painters during the late-seventeenth and early eighteenth centuries. In fact, as portraitists, Rigaud and Largillierre virtually divided the moneyed classes of Paris between them. Rigaud drew his subjects mainly from the aristocracy. Largillierre drew his from the city's upper middle class – from the ranks of its lawyers, government bureaucrats, financiers and, as seen in the splendid portrait group in The Chrysler Museum, from its artistic community as well. For these well-placed sitters Largillierre devised a highly flattering portrait type, one that blended the grandeur and refinements of contemporary court portraiture with the penetrating naturalism of the middle-class portrait.

The Artist in His Studio is among the most famous and most complex of Largillierre's early masterpieces. It was painted around 1686, the year he joined the Académie Royale, and it contains what may well be Largillierre's earliest self-portrait. The artist, roughly thirty years old, sits at right in a gilded chair, his palette and brushes in hand. Seated beside him in his studio is the Flemish engraver Gerard Edelinck (1640-1707), who moved from Antwerp to Paris in 1666 and soon became a leading printmaker in the French capital. Edelinck regularly made engravings from Largillierre's portraits, and in the Chrysler painting he and Largillierre display one of these portrait prints, a 1685 engraving of the royal magistrate Thomas-Alexandre Morant (1616-1692). The source for Edelinck's engraving – Largillierre's painted portrait of Morant – is displayed on the easel at left. (A related portrait of Morant by Largillierre is today in the Musée National du Château de Versailles.) The man who stands behind Edelinck gesturing toward the easel has yet to be identified, but he may be Pierre Bernard, who commissioned Edelinck's engraving of Morant.

Eager to own images of famous contemporaries, many Frenchmen in Largillierre's day collected prints like the one illustrated here. The commercial collaboration of portrait painter and engraver, therefore, could be immensely profitable to both parties. It also brought art images to a mass audience at affordable prices. In *The Artist in His Studio* Largillierre documents the production of Edelinck's print from his own portrait of Morant. In the process, he celebrates the collaborative enterprise of painter, engraver and patron, the kind of joint professional effort that enriched his own career and was so vital to the artistic life of seventeenth-century Paris.

In Largillierre's day the instructional curriculum of the Académie Royale stressed drawing and the study of classical sculpture as key components of an artist's education. Largillierre endorses these principles in the still life at the lower left of the painting. There we see a portfolio of drawings, a roll of paper and casts of three antique sculptures: the Belvedere Torso, the Vatican *Antinoüs* and a bust of Athena. With these objects the artist pays tribute to the academic practices that, in his time, underlay the art of both painter and engraver and led ultimately to the creation of works like the portrait and print of Morant.

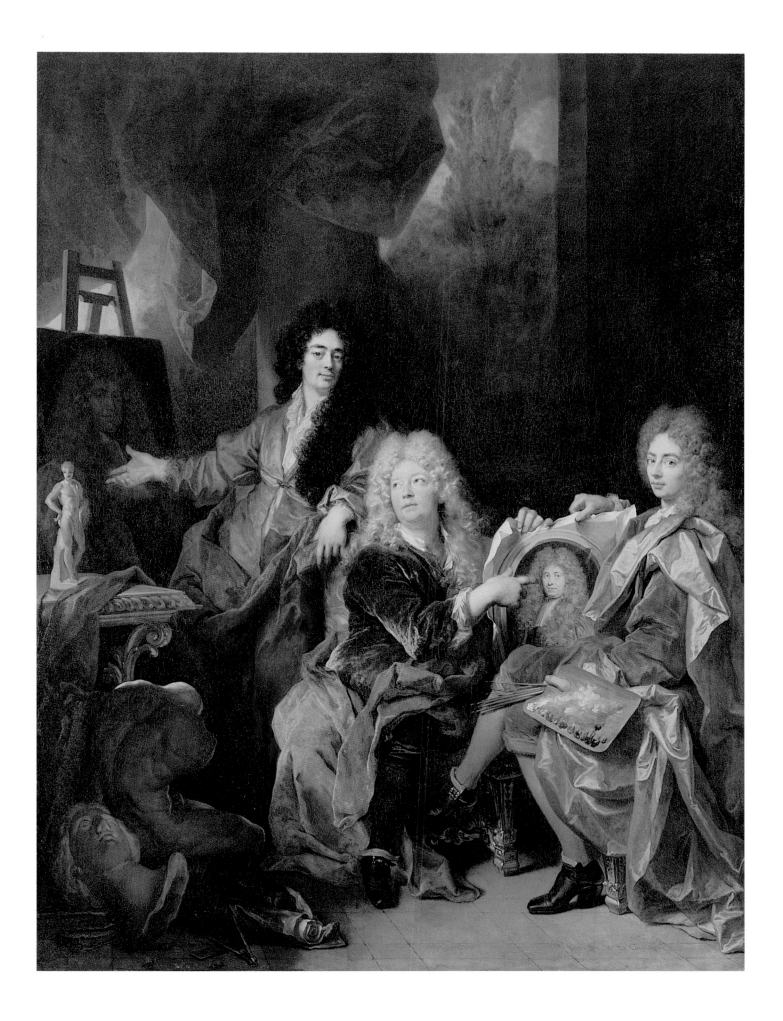

40 Pieter Mulier the Younger, called Tempesta

Dutch, 1637-1701

Landscape with the Journey of Rebekah,
c. 1687-90

Oil on canvas, 47″ x 61″ (119.4 x 155 cm)

Gift of Walter P. Chrysler, Jr., 71.539

Reference: Marcel Roethlisberger-Bianco, *Cavalier Pietro Tempesta and His Time,* Haarlem, 1970, pp. 48, 111, no. 265.

The Cavalier Tempesta was perhaps the most important landscapist working in northern Italy in the decades after 1670 and one of the principal marine painters of his age. He was also the epitome of the cosmopolitan and eclectic Baroque artist. Born in Haarlem as Pieter Mulier, the son of a Dutch marine painter, he spent the first part of his career (c. 1655-68) in Rome. There he achieved fame early for his landscapes, animal subjects and storm-swept seascapes. These last earned him his Italian nickname, "Tempesta." Thereafter he worked and traveled widely in northern Italy – in Genoa, Milan, Parma, Venice. His personal life was colorful and often

troubled. In 1675, for example, he conspired in the murder of his first wife, Lucia Rossi. Convicted of the crime in 1679, he spent eight years in a Genoa prison. He continued to paint throughout his imprisonment.

In his paintings Tempesta creatively blended the styles of several of Italy's dominant mid-seventeenth-century landscapists – Gaspard Dughet, Salvator Rosa (no. 34), Castiglione (no. 25). In his mature, north Italian productions like the *Landscape with the Journey of Rebekah,* he forged the principal link between the earlier works of the Roman landscape school and the future landscape efforts of Venetians like Marco Ricci.

The early history of the *Landscape with the Journey of Rebekah* – it was formerly part of the famous Venice art collection of Consul Smith (d. 1770) – has led scholars to conclude that Tempesta painted it during his productive Venetian period of 1687-90. Its popular Old Testament story is drawn from Genesis 24:1-61, in which the aging

Abraham sends his servant Eliezer from Canaan to Mesopotamia to find a wife for his son Isaac. With the Lord's guidance the servant meets Rebekah, who returns with him to Canaan to marry Isaac. In Tempesta's painting Rebekah – riding camel-back across the bridge in the middle distance, a parasol shielding her from the sun – journeys to Canaan with her dowry and servants. The caravan threads its way through an arcadian landscape of rolling hills and rippling stream, all overhung by a sunny, powder-blue sky.

A large, stately composition from the artist's full maturity, the painting has been called "one of Tempesta's finest works altogether" (Marcel Roethlisberger) and his most masterful interpretation of Castiglione's style. Both the exotic procession and its idyllic country setting bear the stamp of Castiglione, whose pastoral paintings and prints impressed Tempesta during his Genoese years and who also presented his Old Testament scenes as grand "patriarchal journeys."

41 Hyacinthe Rigaud

French, 1659-1743

Portrait of a Man, 1696

Oil on canvas, 53¼″ x 41¼″ (135.2 x 104.8 cm)

Signed and dated lower left:
 fait par hyacinthe Rigaud. 1696

Gift of Walter P. Chrysler, Jr., 77.409

Reference: Harrison, *CM,* 1986, no. 6.

Born in Perpignan, Rigaud was descended from a family of craftsmen – painters and tailors – who had lived for generations in that French village at the foot of the Pyrenees. The penchant for precise realism evident in his later Paris portraits may well have been formed during his early years of study in southern France. The young Rigaud displayed a precocious talent for painting, and in 1671, at the age of twelve, he was sent by his widowed mother to Montpellier to begin his artistic training. He remained until 1677, working under the painter Antoine Ranc, who seems to have introduced him to the portrait styles of Peter Paul Rubens (no. 16) and Anthony van Dyck (no. 20). From these Flemish masters Rigaud distilled much of the grandeur of his own mature portraiture.

After further study in Lyon, Rigaud arrived in Paris in 1681 to perfect his art at the Académie Royale. At first he worked to make himself known pri-

marily as a painter of historical subjects. But by the mid-1680s his genius as a portraitist had already attracted a large and increasingly influential clientele, and at the urging of Charles Le Brun, First Painter to Louis XIV, he decided to concentrate on building his portrait practice.

By the turn of the century Rigaud had consolidated his reputation as the principal portraitist of the Parisian upper classes and the French Crown (cf. no. 39). Louis XIV sat for him in 1694, 1701 and 1715, and Louis XV, in 1716 and 1729. The artist was also besieged with portrait requests from provincial nobles and clergy and from the titled heads of other European nations. Rigaud was himself ennobled in 1727, when he was named *chevalier* of the *Ordre de Saint-Michel.* He rose steadily within the hierarchy of the

Académie and became its director in 1733.

Rigaud painted the imposing *Portrait of a Man* in 1696. (The date and the artist's signature are inscribed on the leg of the elaborately carved, marble-topped table at left.) The three-quarter-length presentation of the sitter and his commanding, seated pose owe much to the art of Van Dyck and were compositional elements favored by Rigaud throughout his career. A nearly identical version of the composition is found in Rigaud's undated *Portrait of Denis François Secousse* in the Musée des Beaux-Arts, Lyon. Though the identity of the Chrysler sitter is unknown, his official black robes and the weighty tome he balances on his lap suggest that he was a man of considerable position and learning – a lawyer, perhaps, or a member of Parliament.

Fame

Mercury

42 **Antoine Coysevox** (*or follower*)
French, 1640-1720

Fame and *Mercury,* after 1702

Bronze, 24″ each (61 cm)

Gifts of Walter P. Chrysler, Jr., 71.2041A and
71.2041B, respectively

Antoine Coysevox was a leading
sculptor of Louis XIV's reign and a
major interpreter of the Sun King's
Baroque court style. After studying at
the Académie Royale, he was named
royal *sculpteur* in 1666. With the as-
sistance of Louis' all-powerful first
painter, Charles Le Brun, he was made
a professor at the Académie in 1678.
Soon after he joined in the sculptural
decoration of Versailles. His subse-
quent career was one of unbroken
ascent. Royal commissions and court
requests for portrait busts and statues,
for funerary monuments and château
decorations followed one another in

rapid succession, and in 1702 Coysevox
was named director of the Académie.

Perhaps the most renowned sculp-
tures of Coysevox's career were the
monumental equestrian marble groups
of *Fame* and *Mercury* that he produced
in 1701-02 for the terrace of the
Abreuvoir (horses' watering pond) at
Louis' château at Marly. The pendants,
which were moved in 1719 to the
Tuileries gardens in Paris, were wide-
ly acclaimed. The king rewarded
Coysevox with an annual pension of
4000 *livres,* the largest yearly stipend he
ever granted to an artist in his employ.
In the years after 1702 Coysevox and
his followers were called upon to issue
numerous small replicas in bronze,
among them the pair in The Chrysler
Museum.

Soaring aloft on the winged Pegasus,
the female figure of Fame blows upon
her horn, while her companion Mer-
cury rides heavenward on his own
winged mount. The political import
of these allegorical pendants is made
clear in the imagery decorating their
struts. Each bears a breastplate on
which Minerva, the Roman goddess of
wisdom, entrusts the female person-
ification of France to Louis XIV. The
image underscores Louis' absolute
power as guardian and ruler of France
and his divine right as king. As Pegasus
leaps skyward with the trumpeting fig-
ure of Fame, it is the king's own ascent
to greatness and immortality that is
celebrated. As emissary of the gods,
Mercury carries the same divinely-
sanctioned message heavenward.

Eighteenth Century

43 Sebastiano Ricci

Italian, 1659-1734

*The Contest Between Apollo and Pan
Judged by King Midas,* c. 1685-87

Oil on canvas, 53½" x 68¼" (135.9 x 173.3 cm)

Gift of Walter P. Chrysler, Jr., 71.696

Reference: Jeffery Daniels, *Sebastiano Ricci,*
Hove, 1976, pp. 79-80, no. 261.

Sebastiano Ricci was significant in
the emergence of the rococo style of
painting in early eighteenth-century
Venice. Much of his middle career
was spent in travel. During the 1680s
and 1690s he worked and studied in
Bologna, Pavia, Parma, Rome and
Milan, resettling in Venice around
1700. He acquired an array of princely
Italian patrons – Pope Innocent XII
among them – and a reputation as a
high-living libertine with an uncanny
knack for escaping the legal repercus-
sions of illicit love affairs. Subsequent

visits to Vienna (where in 1701-02 he
decorated the Schönbrunn Palace for
Joseph, King of the Romans) and to
England, 1711-16, and France, 1716,
earned him an international reputa-
tion as an inspired decorator, and he
returned to Venice as one of Europe's
most famous living artists. By 1720 he
had evolved an airy, radiant rococo
style that exerted a formative influence
on an entire generation of younger
Venetian painters, including Giovanni
Battista Pittoni (no. 50).

*The Contest Between Apollo and Pan
Judged by King Midas* is one of the first
of Ricci's mythological paintings, a
youthful work probably created in
Parma around 1685-87. Though its
robust figure style is still tied to the
waning late Baroque, its delicate pal-
ette and dappling brushwork offer
a glimmer of Ricci's subsequent
rococo manner.

The painting's classical subject
illustrates an episode from Ovid's
Metamorphoses (11:145ff.). Pan, the lowly
Greek god of the fields, brazenly chal-
lenged Apollo to a musical contest,
daring to pit his rustic pipes against the
inspired strings of the god of music.
After both contestants had performed,
the audience proclaimed Apollo the
victor. Only King Midas, a devoted fol-
lower of Pan, dissented. Offended by
the slight, Apollo gave Midas ass's ears,
a derisive symbol of the king's failure
as a music critic. In the painting, the
wooly Pan blows ingenuously on his
pipes, while Apollo – a youthful figure
whose perfect beauty suggests a station
far higher than that of his coarse,
cloven-hoofed competitor – confidently
awaits his turn at the lyre. Behind them
King Midas, identifiable by his crown,
listens intently, preparing to deliver the
dissenting vote.

44 Paolo de Matteis

Italian, 1662-1728

Olindo and Sophronia Rescued by Clorinda, c. 1690-95

Oil on canvas, 71⅜" x 92⅜" (181.3 x 234.6 cm)

Signed and dated lower right:
Paolus de Matheis F 169[]

Gift of Walter P. Chrysler, Jr., 71.540

Reference: Yale, 1987-88, no. 28.

The painter Paolo de Matteis was one of the chief Neapolitan rivals of Francesco Solimena. He first formed his style in Naples from Luca Giordano (no. 36), to whom he was apprenticed. After further study in Rome around 1680 in the Accademia di San Luca, De Matteis returned to Naples and reentered Giordano's shop. There, in the later 1680s and early 1690s, he produced the first of his mature paintings, among them *Olindo and Sophronia Rescued by Clorinda* (whose date is only partially legible today: 169[]). Inspired particularly by Giordano, De Matteis in these works crafted a spirited rococo style marked by hyper-refined figure designs and a palette of shimmering pinks and blues.

The subject of The Chrysler Museum painting is taken from Italian Renaissance literature, from an episode in Torquato Tasso's popular epic poem of 1581, *Gerusalemme Liberata (Jerusalem Delivered,* 2:26-35). Set in the Holy Land during the early Middle Ages, the story features the virtuous Christian girl Sophronia and her devoted suitor Olindo. The tale begins when the pagan king of Jerusalem, the Saracen Aladine, seizes an image of the Virgin from a church and places it in a mosque, only to have the image vanish. To save the Christian community from Aladine's wrath, Sophronia claims to have committed the theft and is condemned to be burned at the stake. In an attempt to save her, Olindo professes to have taken the image. But his self-sacrificing plan goes awry, and he is forced to join Sophronia on the pyre. Just as Aladine's men are about to light the pyre, the Persian warrior maiden Clorinda appears on the scene and negotiates the lovers' freedom by offering Aladine military assistance in exchange.

The painting presents the story's dramatic climax, as Clorinda arrives on horseback just in the nick of time and halts the execution with her offer to Aladine – who stands at right – and his startled men. Placed at the center of the composition, the delivered lovers serve as historic exempla of unswerving faith and love in the face of great adversity. De Matteis based the design of the painting on Giordano's picture of the same subject in the Palazzo Reale, Genoa. As a pendant to *Olindo and Sophronia,* he painted another pair of lovers from Tasso's poem, *Tancred and Erminia* (private collection, Switzerland).

Like Giordano, De Matteis was a technical virtuoso, famous for his speed with pen and brush. His genius for creating brilliant effects at high velocity is revealed in *Olindo and Sophronia,* whose galloping design and streaming brushwork give shape to an image of sheer visual poetry.

45 Alessandro Magnasco
Italian, 1667-1749

Landscape with Monks and Other Figures,
c. 1690

Oil on canvas, 97¼″ x 61½″ (247 x 156.2 cm)

Initialed (?) on the *cartello* at center: *AM*

Gift of Walter P. Chrysler, Jr., 71.541

References: Benno Geiger, *Magnasco,*
Bergamo, 1949, p. 73; Zafran, *CM*, 1978, no. 8.

The moody, "romantic" vistas of
Salvator Rosa (no. 34) exerted a for-
mative influence on the landscapes of
Magnasco, the eccentric Genoese
genius whose paintings, like Rosa's, are
full of dark foreboding and spectral
gleams. Magnasco's hectic, brushy style
had a bracing effect, in turn, on young-
er north Italian masters and particular-
ly on Venetian landscapists like Marco
Ricci and Francesco Guardi.

Trained first in Genoa by his
painter-father Stefano, Magnasco
moved to Milan after Stefano's death in
1677, remaining there for much of his
career. He visited Florence in 1703-11 at
the invitation of Grand Duke Gian Gas-
tone de' Medici and returned in 1735 to
Genoa, where he lived until his death.
After distinguishing himself early as a
portraitist, Magnasco devoted himself
primarily to macabre genre pictures of
monastic life and to small-figure land-

scapes like The Chrysler Museum
painting. These landscapes – arcadian
vistas, mysterious, haunted forest
scenes and storm-tossed seascapes – he
inhabited with sorcerers, monks and
brigands and filled with a flickering,
hallucinatory light. His lively "staffage"
figures and vital, unbridled brushwork
possess a nervous energy that became
more and more pronounced as his
career progressed.

Dated stylistically around 1690 – to
Magnasco's early years in Milan – the

unusually large and imposing *Land-
scape with Monks and Other Figures* was
one of the artist's first major landscape
efforts and, as such, does not yet show
the violently expressive, slashing brush
technique of his mature art. In this
melancholic vista of splintered trees
and moldering buildings a shepherdess
rests as another woman draws water
from a fountain. In the left foreground
a group of traveling friars has stopped
to eat, while sinister figures – bandits,
perhaps – peer at them from the trees.

46 **Donato Creti** (*attributed to*)
Italian, 1671-1749
Musical Group, c. 1695
Oil on canvas, 77½″ x 57½″ (196.8 x 146 cm)
Gift of Walter P. Chrysler, Jr., 71.544
Reference: Zafran, *CM,* 1978, no. 10.

This impressive *Musical Group* was almost certainly produced in Bologna in the late seventeenth century by a painter working in the circle of Lorenzo Pasinelli (1629-1700). Some writers have ascribed it to Domenico Maria Muratori (1661-1744), a student of Pasinelli whose later career unfolded in Rome. But more often it has been attributed to another gifted Pasinelli disciple, Donato Creti. Together with Giuseppe Maria Crespi (no. 47), Creti headed the Bolognese school in the decades around 1700. He countered Crespi's smoldering late Baroque style with a restrained classicism that owed much to the earlier manner of Guido Reni (no. 18). Creti painted gentle religious images and poetic pastoral and mythological scenes with linear precision and a self-conscious archaism. He has been called the last important interpreter of the Bolognese academic style.

Typically Bolognese in its emotional and formal restraint, the undated *Musical Group* has been placed early in Creti's career, around 1695. Its genre subject brings to mind the elegant images of aristocratic music makers painted around 1550 by Nicolò dell'Abate in the Palazzo Poggi in Bologna. In the painting an ensemble of four handsome young people in courtly dress perform on a violin, lute, double bass and harpsichord. They are accompanied, as it were, and inspired by the Greek god Pan, who appears as a statue blowing on his syrinx. A rustic, rural deity of shepherds and huntsmen whose rough music was judged inferior to Apollo's (see no. 43), Pan symbolizes the earthy, sensuous power of music. Though first and foremost a sensuous pleasure, music was believed, at its best, to elevate the spirit to a higher moral plane. In the sheer beauty of Creti's painting – in the grace and composure of the performers and the harmony of their concert – one senses a metaphor for the transcendent power of music itself, its capacity to lift both player and listener to a loftier realm of intellectual and moral concord.

47 Giuseppe Maria Crespi
Italian, 1665-1747

The Continence of Scipio, c. 1700

Oil on canvas, 86⅞" x 66" (220.6 x 167.6 cm)

Gift of Walter P. Chrysler, Jr., 71.543

Reference: *Giuseppe Maria Crespi and the Emergence of Genre Painting in Italy,* exhib. cat., Kimbell Art Museum, Fort Worth, 1986, no. 6.

Crespi was a principal leader of the eighteenth-century Bolognese school of painters (see also no. 46). He divided his career between lofty religious and historical pictures – *The Continence of Scipio* is a premier instance of the latter – and far more earthy genre paintings of laundresses, butchers and other proletarian laborers. He achieved great success with both and helped to redefine genre painting in Italy – traditionally disparaged as "minor" by earlier theorists and collectors – as an art worthy of the greatest masters.

Crespi emerged from his years of study in Bologna with a deep reverence for the venerable classical tradition of the Carracci. This he blended with a taste for the pictorial opulence of earlier Venetian painting, and specifically for the loose, sensuous brush technique and flashing color of Titian and Veronese (no. 13). His sumptuous late Baroque style is revealed to full advantage in *The Continence of Scipio,* one of the richest works by Crespi to be found in an American collection. In the past scholars viewed the undated painting as a mature effort of the 1720s. More

recently, however, it has been reconsidered as a major early production datable to the end of the 1690s, the only decade when Crespi produced large-scale classical subjects with life-size figures. It may have been painted for Count Ercole Giusti of Verona, among the most discerning Italian collectors of his day and a champion of contemporary Bolognese art. In any event, a *Continence of Scipio* by Crespi was recorded as belonging to Giusti as early as 1718 by the Veronese writer Bartolomeo Dal Pozzo. Yet another version of the subject, described as "very beautiful" in Giampietro Zanotti's 1739 biography of Crespi, belonged to Count Antonio di Colato in Bologna.

Taken from Livy's *History of Rome* (26:50), the painting's ancient theme refers to the generosity of Scipio Africanus the Elder (c. 236-184 B.C.), the Roman general whose capture of New Carthage in Spain led to Hannibal's defeat in the Second Punic War. Among the captives taken by Scipio's forces in the fall of New Carthage was a beautiful Celtiberian princess. Demonstrating the celebrated Roman virtue of magnanimity in victory, Scipio released the princess unharmed. When her grateful parents offered him gifts in return, Scipio refused the treasure and decreed that it serve instead as her dowry. In Crespi's painting the general, seated at center, proclaims his decision, relinquishing his right to the treasure offered by the kneeling princess as her grateful suitor rushes forward to claim her. As in much of Crespi's finest work, the fluently painted figures emerge poetically from darkness, and colors gleam fitfully like jewels shrouded in shadow.

48 Willem van Mieris

Dutch, 1662-1747

Magdalene in a Landscape, 1718

Oil on panel, 15″ x 13½″ (38.1 x 34.3 cm)

Signed and dated lower right:
W. van Mieris. Fc. Anno 1718

Gift of Walter P. Chrysler, Jr., 71.476

Willem van Mieris was the younger son of the more famous Frans van Mieris (1635-1681). As a leader of the *fijnschilders* (fine painters) of Leiden, Frans van Mieris devoted his career to small-scale genre and portrait pictures of miniaturistic precision and refinement. Inheriting from his father a polished technique and a passion for meticulously rendered detail, Willem produced a series of modest, gem-like paintings that carried his father's suave manner well into the eighteenth century. A typical example of Willem's mature style is his *Magdalene in a Landscape* of 1718. In it the textures of the Magdalene's blue robe and alabaster

ointment jar have been flawlessly recreated, the surfaces worked to a high porcelain gloss.

According to a ninth-century, Provençal legend kept alive in *The Golden Legend* of Jacopo da Voragine (d. 1298), Mary Magdalene left the Holy Land after Christ's resurrection and traveled in a rudderless boat to Marseilles. After converting many people in that city to the new Christian faith, she retired into the wilderness of Provence and devoted the next thirty years to penance and prayer. In Van Mieris' painting the penitent Magdalene kneels devoutly before a crucifix at the mouth of her wilderness cave. The skull she holds is a traditional *memento mori,* an emblem of the transience and vanity of earthly life. It serves as an aid to her meditations on death and on the promise of eternal life through Christ. Among the plants growing in the left foreground is a this-

tle. A venerable Christian symbol of sin and sorrow, the thistle alludes both to Christ's crown of thorns and, thus, to his Passion, and to God's cursing of the fallen Adam in Genesis 3:17-18: "cursed is the ground for thy sake.... thorns also and thistles shall it bring forth to thee." Countering the thistle's dolorous meaning is the more hopeful message contained in the Hebrew text on the Magdalene's scroll. Drawn in part from Psalm 96:11-13, the text proclaims God's righteous judgment of man:

> ...let the heavens rejoice, and let the earth be glad; let the sea roar, and the fullness thereof. Let the field be joyful, and all that is therein: then shall all the trees of the wood rejoice. Before the Lord: for he cometh, for he cometh to judge the earth: he shall judge the world with righteousness, and the people with his truth.

49 Francesco Bertos

Italian, 1678-1735

Sculpture and *The Drama,* c. 1710

Bronze, 42½" each (107.9 cm)

Gifts of Walter P. Chrysler, Jr., 71.2609 and
71.2608, respectively

Little is known about the early eigh-
teenth-century Italian sculptor Bertos.
A native Venetian, he is documented
in Rome in the early 1690s but had re-
turned to Venice by 1710, about the
time he made the pendant images of
Sculpture and *The Drama* in The
Chrysler Museum. He often worked
in marble yet was more highly prized,
particularly among foreign collectors
in Italy, for his small-scale compositions
in bronze. In these complex virtuoso
pieces – beautifully exemplified by
the bronze allegories of *Sculpture* and
The Drama – Bertos created dynamic,
multi-figured arrangements.

These sculptures were often
designed to serve as table centerpieces
and, thus, were meant to be viewed
from all sides. Bertos typically stacked
his animated, acrobatic figures one
atop another in towering pyramidal or
conical displays that draw the eye up
and around in broad spirals. Though
Bertos' spiraling compositions have
clear precedents in sixteenth-century
Mannerist art, his graceful, expan-
sive figures are fully Baroque in
conception.

Couching his commentary in the
witty and arcane allegorical language
so beloved by Baroque artists, Bertos
celebrates in the Museum's pendants
both the sculptural and dramaturgical
arts. *Sculpture* features a rearing cen-
taur poised atop a pedestal, *The Drama*
a matching centauress. At the base of
The Drama are figures with painter's
brushes and palettes, musical instru-
ments and scores, quills and manu-
scripts. These figures personify the arts
of painting, music and poetry, all of
which contribute to a dramatic produc-
tion. Also at the base is the winged
figure of Time, portrayed as a
defeated, kneeling figure. Surely he
alludes to the eternal power of the
drama and to the triumph of art over
time. At the apex of the sculpture the
female personification of Drama holds
aloft a theatrical mask.

In *Sculpture* there is a playful ambi-
guity of "animate" and "inanimate"

Sculpture

forms that blurs the distinction
between the "living" sculptors depicted
and the art they create. This sophisti-
cated interplay of creator and creation
celebrates the poetic unison of the artist
and his work. One of the sculptors,
with chisel and mallet in hand, labors
on a portrait bust. Two others work on

the larger equestrian sculpture group,
while another works on a sculpture
lying at the base of the pedestal. The
centaur upholds a female figure, prob-
ably the personification of Sculpture
itself. Hovering above her is a putto
bearing a chisel and rule, the attributes
of her art.

The Drama

50 Giovanni Battista Pittoni

Italian, 1687-1767

Memorial to James, First Earl Stanhope, 1726

Oil on canvas, 87″ x 56″ (221 x 142.2 cm)

Signed right of center:

GĪO. BĀTA. PITTONI. FIGVRAVIT.

Gift of Walter P. Chrysler, Jr., 71.546

References: Zafran, *CM*, 1978, no. 11; Franca Zava Boccazzi, *Pittoni*, Venice, 1979, p. 147, no. 131.

Inspired by his study of Sebastiano Ricci (no. 43) and Giambattista Tiepolo, the Venetian painter Pittoni evolved during the 1720s a delicate, fluid style of painting that marked him as an early leader of the Venetian rococo. His art was especially close to the French rococo, prompting some scholars to suggest that he was familiar with contemporary aesthetic trends in France and may even have visited Paris.

Painted in Venice in 1726, the *Memorial to James, First Earl Stanhope* belonged originally to a large and highly imaginative series of paintings commissioned from leading north Italian artists by Owen McSwiny. A bankrupt opera impresario who had fled London in 1711 to evade his creditors, McSwiny tried to recoup his losses in Italy by working as an intermediary in the production of artworks for British aristocrats. Acting on behalf of Lord March, the future Duke of Richmond, he brought together a group of prominent Bolognese and Venetian painters in the mid-1720s and had them collaborate on a set of twenty-four "Allegorical Paintings of Imaginary Tombs or Monuments, Commemorating Recently Deceased Englishmen of Note." The paintings, McSwiny wrote, were designed to celebrate "the

British monarchs, the valiant commanders and other illustrious personages who flourished in England about the end of the 17th and the beginning of the 18th centuries." Included among these British luminaries was James Stanhope (1674-1721), whose distinguished career as a soldier and statesman is lionized in The Chrysler Museum painting.

McSwiny determined the complex allegorical program of the series and divided the labor. Each painting became the collaborative production of several "specialists," with one artist supplying the figures, another architectural details, and still another the landscape background. The figures in the *Memorial to James, First Earl Stanhope* were painted by Pittoni, the grandiose architectural monument by Domenico Valeriani (d. 1771) and his brother Giuseppe (d. 1761), and the landscape by Giovanni Battista Cimaroli (d. 1753). The different hands harmonized perfectly, creating a seamless rococo fantasy of extraordinary fluency and verve. Only ten of the twenty-four paintings in the series, including the Museum's picture, were ultimately purchased by the Duke of Richmond, who hung them in the dining room at Goodwood, his Sussex estate. The remaining fourteen were acquired in 1730 by Sir William Morice.

During the War of the Spanish Succession (1701-14), James Stanhope served as commander-in-chief of the British forces in Spain, and in 1714 he was appointed secretary of state. In 1717 he was made first lord of the treasury, and in 1718 – three years before his death – he negotiated the Quadru-

ple Alliance of England, France, Austria and Holland. In the painting the allegorical embodiment of the deceased hero appears in classical military dress at the lower right. Accompanied by his standard bearers, he is received at his own funerary monument, a brilliant architectural *capriccio* in the shape of a Roman triumphal arch. The arch is crowned with Stanhope's heraldic device: a tower surmounted by a demi-lion holding a fired grenade. Stanhope has set aside his arms and the spoils of war at the pedestal in the foreground and accepts in their place the laurel wreath of peace. As Eric Zafran has shown, the female figure seated before Stanhope is probably the personification of Victory, who on the Earl's behalf accepts the book of History, the trumpet of Fame and the gold chains of Honor. The sculptures adorning the monument further celebrate Stanhope's virtues and accomplishments. The statue of the seated man above Victory represents Reward and is flanked by the lion of Courage and brazier of Patriotism. The sculpture groups on the plinths above symbolize, at left, Virtuous Action bestowing a laurel wreath and, at right, Honor kneeling under the scales of Statecraft.

Panini's slightly later grisaille *bozzetto* of the Chrysler painting – one of several small oil sketches made for a projected set of engravings of the McSwiny series – is in Sarasota, in the John and Mable Ringling Museum of Art. Preliminary drawings by Pittoni for the figures in the painting are found today in the Accademia and Museo Correr, Venice.

51 François Boucher

French, 1703-1770

Pastorale: The Vegetable Vendor, c. 1735

Oil on canvas, 95″ x 67″ (241.3 x 170.2 cm)

Signed lower right: *f. Boucher.*

Gift of Walter P. Chrysler, Jr., 71.504

Reference: *François Boucher 1703-1770,* exhib. cat., Metropolitan Museum of Art, New York *et al.,* 1986-87, pp. 163-168, under no. 27.

Love was the presiding theme of French rococo painting, and François Boucher, Louis XV's premier artist and the quintessential exponent of mid-eighteenth-century French style, paid lavish homage to rococo romance in his *pastorales.* In these bucolic genre scenes Boucher fashioned a rural paradise of perfect, unfettered love. It is an idyllic dreamworld in which comely young shepherdesses and peasant girls — improbably well-scrubbed and attired — are courted by their handsome swains under an eternally blue sky. Inspired in part by the idealized vision of rustic life found in pastoral poetry and contemporary theatrical productions, Boucher's *pastorales* were a response to the escapist fantasies of the French aris-

tocracy, who found in his peasant idylls a mental refuge from the pressures and formalities of life at court.

A masterful instance of Boucher's ravishing palette and buttery brushwork, the undated *Pastorale: The Vegetable Vendor* has been placed on the basis of style around 1735. This was shortly after the artist returned to Paris from his study trip to Italy (1728-31) and joined the Académie Royale (1734). It is an early work and among the first of Boucher's major *pastorales.* In it a farm boy displays his produce to a young female buyer — a kitchen maid, perhaps — while her bashful companion looks on. As in all of the artist's *pastorales,* the encounter here of peasant boy and girl brims with amorous intent; their ostensibly mercantile dealings surely symbolize the romantic exchange of hearts. Much of the painting's landscape imagery and the splendid array of vegetables, animals, buckets and jugs in the foreground recall the earlier pastoral paintings and

prints of the Genoese Castiglione (no. 25), whose art exerted a formative influence on Boucher while he was in Italy.

As a companion to *The Vegetable Vendor,* Boucher painted *Pastorale: A Peasant Boy Fishing,* which is in the Frick Art Museum, Pittsburgh. Scholars have recently argued that two other paintings by the artist, *Le bonheur au village* and *Le halte à la fontaine* (both Bayerische Landesbank, on loan to the Alte Pinakothek, Munich), were originally part of the same decorative ensemble and that together the four works constituted one of Boucher's first major painting commissions. That Boucher put special care into the design of *The Vegetable Vendor* is attested to by the existence of two preparatory drawings, both executed in red chalk: a sketch of the girl who stands behind the donkey (Nationalmuseum, Stockholm), and a sheet of studies for the farm boy proffering parsnips (formerly Michel-Lévy collection, Paris).

52 Jean-François de Troy
French, 1679-1752

Christ in the House of Simon, 1743

Oil on canvas, 76¾" x 57½" (195 x 146.1 cm)

Signed and dated lower edge, left of center:
1743 DE TROY A ROME

Gift of Walter P. Chrysler, Jr., 71.639

Christ and the Canaanite Woman, 1743

Oil on canvas, 76½" x 57½" (194.3 x 146.1 cm)

Signed and dated upper right:
De Troy à Rome 1743

Museum Membership Purchase, 69.34.6

Reference: Harrison, *CM*, 1986, nos. 9-10.

Born into a distinguished family of painters, Jean-François de Troy was trained initially by his father François, a fashionable Parisian portraitist and director of the Académie Royale. After further study in Rome (1699-1706), he returned to Paris and was admitted to the Académie as a history painter. A prolific artist who embraced a wide range of themes, De Troy excelled at portraiture and grandiose decorative cycles of mythological and religious content. He was also famous for his tapestry designs and his small-scale genre pictures of aristocratic dalliance, his elegant *tableaux de modes.* In all of these works De Troy employed a charming, yet vigorous style that blended the delicacy of the emerging rococo with the more vibrant Baroque language of Rubens and Jacob Jordaens.

By the mid-1730s De Troy had won the patronage of Louis XV and had collaborated with François Boucher (no. 51) and Charles Natoire at Versailles. However, his fondest wish – to become *premier peintre du Roi* (first painter to the king) – was denied him in 1736, when his old rival François Le Moyne was chosen for the post. In 1738 De Troy returned to Rome, where he served as director of the French Academy until 1751.

Painted in Rome in 1743, the ambitious biblical pendants in The Chrysler Museum typify the dramatic, grand manner of De Troy's second Ital-ian period, the weighty, classic figure style that he distilled from Jordaens, Jean Jouvenet and the Neapolitan Baroque. In both pictures – *Christ and the Canaanite Woman* (Matthew 15:22-28) and *Christ in the House of Simon* (Luke 7:36-50; John 12:1-8) – Jesus blesses an outcast woman, demonstrating his compassion for the downtrodden victim who has, despite everything, remained faithful. The broad handling and stark monumentality of *The Canaanite Woman* contrast with the more finely worked and opulent *House of Simon,* where the figures all but vanish beneath billowing waves of brilliant-hued fabric. The pendants remained with the artist until his death and were sold from his estate in Paris in 1764.

Christ and the Canaanite Woman

53 Louis Tocqué

French, 1696-1772

***Portrait of Charles-François-Paul Le
Normant de Tournehem,*** c. 1750-52

Oil on canvas, 54¼" x 41¾" (137.8 x 106 cm)

Inscribed on the verso lower right:
 L. Toquet. pinxit.

Gift of Mr. and Mrs. Jacob John Gurdus and
Walter P. Chrysler, Jr., 71.2097

References: Arnauld Doria, *Louis Tocqué*, Paris,
1929, pp. 14, 140, under no. 325; Harrison,
CM, 1986, no. 11.

The Parisian portraitist Tocqué
joined the Académie Royale in 1734.
He received his first royal commission
three years later, when he was sum-
moned to Versailles to paint the
portrait of the young Dauphin, Louis
de France. Like Rigaud earlier in the
century (see no. 41), Tocqué found
himself favored with a steady stream of
commissions from the French aristoc-
racy, who responded warmly to his
staid and solid portrait style. By mid-
century he had become one of Paris'
most famous painters.

Among the most influential of
Tocqué's high-placed patrons was the
subject of The Chrysler Museum
portrait, Charles-François-Paul Le
Normant, Seigneur de Tournehem
(1684-1751). Tournehem was a wealthy
financier and a trusted advisor to the
Crown. During the 1720s and 1730s he
served as protector and guardian to the
young Mme de Pompadour, who in
time became Louis XV's mistress. In
1746 Tournehem was named *directeur
général des bâtiments du Roi* (director-

general of the king's buildings), the
chief administrator of all architectural
and artistic projects connected with the
Crown. As such, he supervised the
business of the Académie Royale, dis-
pensing official, state commissions to
its members and making recommen-
dations to the king regarding such
matters as the appointment of the
premier peintre du Roi. Tournehem re-
tained his position as director-general
until his death.

In 1750, the year before he died,
Tournehem commissioned Tocqué to
paint his portrait. The piece, which was
shown at the 1750 Salon, was immense-
ly popular among both Tocqué's and
Tournehem's colleagues, and the artist
produced at least four replicas of the
portrait by 1752. One of these, today
at Versailles, was painted for the
Académie.

It is not known for certain if the

Chrysler painting is Tocqué's prototype
– the portrait he displayed at the 1750
Salon – or if it is, like the Versailles ver-
sion, one of the autograph replicas
produced in 1751-52. As Arnauld
Doria noted in 1920, however, the con-
dition of the Chrysler portrait is better
than the Versailles version, "its tonality
clearer and fresher."

The painting shows Tournehem in
his official role as director-general.
Lavishly attired in a gold-embroidered
suit coat of apricot velvet and holding
a black *tricorne* – three-cornered hat –
under his arm, he stands before his
worktable. With his left hand he points
to the architectural design resting on
the table, as though busy with one of
his projects. Also on the table is a
bronze statuette of Minerva, who, as
goddess of wisdom and patroness of
the arts, is understood to inspire and
guide his work.

54 Giovanni Paolo Panini

Italian, 1691-1765

The Piazza Farnese Decorated for a Celebration in Honor of the Marriage of the Dauphin, 1745

Oil on canvas, 65½" x 93½" (166.4 x 237.5 cm)

Gift of Walter P. Chrysler, Jr., 71.523

References: Zafran, *CM,* 1977, no. 20; Martine Boiteux, "Il carnevale e le feste francesi a Roma nel Settecento," in *Il teatro a Roma nel Settecento,* Rome, 1989, I, pp. 336-341.

Widely esteemed in his lifetime as the greatest of Rome's *vedutisti* ("view painters" who specialized in landscape and urban vistas), Panini also achieved early fame in that city as a designer of festival decorations and fireworks displays. In 1745 he and his son Giuseppe were commanded by the French ambassador to the Vatican, the Abbé de Canillac, to create the decorations for the Roman celebration of the wedding of Louis, Dauphin of France, to the Infanta María Teresa Rafaela of Spain. The wedding took place in Paris on February 23, 1745, and was commemorated in Rome on June 25 of that year with festivities in the Piazza Farnese. Among the many dignitaries who witnessed the event was Pope Benedict XIV, who watched from the balcony of the Palazzo Farnese, the imposing

palace that is shown spanning the middleground of The Chrysler Museum painting.

Panini probably created this large, but broadly handled canvas as a grand *bozzetto,* or sketch, of his plans for the decoration of the piazza, which he submitted in all likelihood for the Abbé de Canillac's approval. As the painting reveals, Panini and his son erected an immense festival apparatus in the center of the piazza. This took the form of a fanciful Temple of Minerva, Roman goddess of wisdom, that was seventy feet high. Sculptures within the temple represented the wedding of Love and Hymen (the god of marriage) overseen by Minerva herself – a highly flattering allegorical allusion to the alliance of the Dauphin and María Teresa. As evening fell on the festivities the temple became a launch for fireworks. These, viewers reported, burst over the piazza for nearly three hours after sunset.

As the first Italian artist to elevate the "lowly" genre of view painting to the realm of high art, Panini inspired many of the eighteenth century's finest *vedutisti* – the Venetian Canaletto, Piranesi in Rome, and the French painter Hubert Robert (no. 60). Dur-

ing the final three decades of his career, he specialized in two kinds of view paintings. One type were *vedute esatte,* or "exact views" – precise, topographical vistas of Rome that recorded with unerring accuracy the city's contemporary monuments and classical ruins. The second were *vedute ideate,* or "ideal views" – imaginary depictions of ancient ruins that evoked the vanished grandeur of the city's imperial past (cf. no. 60). His "ideal views" were popular among wealthy foreign tourists – particularly the English and the French – who made the Grand Tour of Italy and purchased these paintings as poetic souvenirs of their visits to the South.

The Museum's painting is one of the rare *vedute esatte* by Panini that records a specific historical event. As part of an important French commission, it also bears witness to Panini's long and profitable association with Rome's community of French artists and connoisseurs, an association already underway in 1729, when he oversaw Rome's celebration of the Dauphin's birth. Twelve of Panini's preliminary drawings for the lively figures which fill the painting's foreground are today in the British Museum, London.

55 Joseph Badger

American, 1708-1765

Jemima Flucker, c. 1760

Oil on canvas, 45⅛″ x 33¹⁵⁄₁₆″ (114.6 x 86.2 cm)

Gift of Edgar William and Bernice Chrysler Garbisch, 80.181.18

The Colonial American painter Joseph Badger was born in Charlestown, Massachusetts, the son of a tailor. In 1733 he moved to Boston, where he established himself as an artisan, working as a glazier and a painter of houses and signs. Around 1740 he began to paint portraits as well. Like many Boston portrait limners of the day, Badger based his simple, forthright style upon the portraiture of John Smibert and Robert Feke and derived many of his compositions from European portrait prints. During the 1750s he was Boston's principal face painter and New England's best-known artist. After 1760, however, his influence waned rapidly with the emergence of John Singleton Copley and his more sophisticated portrait art (no. 59).

During his career Badger painted more than a hundred portraits, many of them likenesses of small children. A mature production of c. 1760, *Jemima Flucker* possesses that quality of naive charm – the sweetness and fragility – which Badger typically bestowed upon his youngest sitters. The girl is dressed in a blue satin frock trimmed in white and tied loosely at the waist with a pink satin sash. The floral spray in her hair is probably a piece of jewelry, a delicate enamel and silver ornament called a *tremblant* (a French term that alludes to the fact that the ornament trembled, and shimmered, when the wearer moved). In her right hand she holds a sprig of cherries and on her left, a pet bird.

As was often the case when Badger painted children, Jemima Flucker is shown out-of-doors, her full-length form placed directly before the viewer in the foreground of a hilly landscape. The tree that frames the composition at left is almost a Badger signature, a landscape device that occurs throughout his portraiture. A resident of Boston and Cambridge, Jemima Flucker reportedly lived to the age of ninety-five and bequeathed the portrait to her only daughter Elizabeth Child, who was born in 1779. The painting remained in the possession of Jemima Flucker's descendants until 1947. The Chrysler Museum also possesses a letter written by Jemima Flucker to Elizabeth on June 15, 1795.

56 Jean-Baptiste-Siméon Chardin

French, 1699-1779

Basket of Plums, c. 1765

Oil on canvas, 12¾" x 16½" (32.4 x 41.9 cm)

Signed lower left: *chardin*

Gift of Walter P. Chrysler, Jr., 71.506

References: *Chardin 1699-1779*, exhib. cat.,
Grand Palais, Paris *et al.*, 1979, pp. 333-334;
Harrison, *CM*, 1986, no. 13.

In the art academies of eighteenth-century Europe, painters of historical and religious themes (see nos. 47, 52) were valued far more highly than those who devoted themselves to the "minor subjects" of genre, landscape and still life. Yet, the most inspired interpreters of the minor subjects could achieve considerable fame in their lifetimes and genuine immortality in the annals of art history. One such genius was Chardin, who was among the most revered painters of still life and genre in mid-eighteenth-century Paris. Championed particularly by the influential philosopher and art critic Denis Diderot (d. 1784), Chardin enjoyed both official and popular success. He was an honored member of the Académie Royale and a regular exhibitor at the Paris Salon, and his paintings were avidly collected by a newly affluent French middle class.

In his later still lifes, Chardin abandoned his earlier interest in the meticulous delineation of texture and detail and concentrated on more profound visual elements. Color and volume, half-light and highlight, the broad compositional interplay of solid and void – these became the underlying concerns of his mature still lifes such as the *Basket of Plums*. When the painting – or its replica, which is located today in a private French collection – was shown by Chardin at the 1765 Salon, Diderot described it briefly in his commentaries on the exhibition:

> …placed on a stone bench, a wicker basket full of plums, for which a paltry string serves as a handle, and scattered around it some walnuts, two or three cherries and a few small bunches of grapes [in truth, white currants].

Though the arrangement is typically spare, the effect on the eye is magical. The luscious mound of purple and rosy red plums smolders in the shadowy light. The currants gleam like pearls. What emerges from this humble assembly of fruit and nuts, and from the velvety brushwork that informs it, is a vision of the poetic essence of objects that dazzled Chardin's contemporaries and captivates us perhaps even more today.

57 Giovanni Domenico Tiepolo

Italian, 1727-1804

*Man Comforting a Rearing Horse
Watched by Several Oriental Figures,*
after 1770

Pen and brown ink, brown wash over black
chalk on laid paper, 7¼" x 9¾" (18.4 x 24.8 cm)

Signed lower left: *Dom Tiepolo f*

Museum Purchase, 50.48.99

Reference: Zafran, *CM*, 1979, no. 33.

Like his younger brother Lorenzo,
Domenico Tiepolo spent much of his
career in the shadow of his famous
father Giambattista Tiepolo, the pre-
siding genius of eighteenth-century
Venetian art. He studied under him
and, as his principal assistant, traveled
with him to Würzburg and Madrid,

where the elder Tiepolo died in 1770.
Inheriting the heavy mantle of family
tradition, Domenico returned to Venice
and continued to paint grandiloquent
fresco suites in the heated, rhetorical
language of his father. In private, how-
ever – in the murals for his villa at
Zianigo and in innumerable later draw-
ings – he nurtured a far less heroic,
more measured personal style and
indulged his predilection for fantasy
images and bitingly satirical genre
subjects.

Most of Domenico's later drawings
belonged to large, thematically related
series. Such is the case of The Chrysler
Museum sheet. It is one of a set of
drawings by Domenico (Janos Scholz

collection, New York; Art Museum,
Princeton University; Metropolitan
Museum of Art, New York; etc.) that
features horses with figures in Eastern
dress, usually described as Turks or
Saracens. These enigmatic, quasi-imag-
inary scenes were part of a fashion for
Oriental subjects that appeared in
European art during the second half
of the eighteenth century.

Like his father, Domenico often
preferred to make his sketches in pen
and wash. However, as is evident in the
present drawing, his stroke is more
careful and uniform than Giambat-
tista's. His contours are slender, delicate
and wavering, and his washes fastidi-
ously applied.

58 Thomas Gainsborough

English, 1727-1788

Miss Montagu, c. 1774

Oil on canvas, 30″ x 25″ (76.2 x 63.5 cm)

Gift of Walter P. Chrysler, Jr., 71.528

References: Ellis Waterhouse, *Gainsborough,* London, 1958, p. 82, no. 494; Zafran, *CM,* 1977, no. 24.

Together with Sir Joshua Reynolds, Thomas Gainsborough presided over Britain's late-eighteenth-century Golden Age of portrait painting. The son of a Sudbury cloth merchant, he studied in London c. 1740-45 with the French engraver Hubert Gravelot. In 1748 he returned to Sudbury, where he worked as a country portrait painter. His subsequent stays in Ipswich (1752-59) and the royal resort of Bath (1759-74) brought him an increasingly influential portrait clientele and greater professional prominence. In 1768 he was asked to become a founding member of the Royal Academy of Arts, and upon his return to London in 1774, he was among the most admired of British artists.

Though Gainsborough made his reputation from grand, full-length portraits of the British nobility and landed gentry, he earned his living primarily by producing smaller, half- or bust-length images for the stylish society trade of London and Bath. A fine example of the latter is the intimate, bust-length portrait of *Miss Montagu.* Painted toward the end of Gainsborough's stay in Bath, the portrait depicts Sophia Montagu (1759-1854), the youngest child and only daughter of Admiral John Montagu of Avisford.

Presented in three-quarter profile, she turns her head to gaze at the viewer, her delicate features evoked in a glimmer of pale, neutral tints. Her powdered hair is combed high and crowned with a loose-fitting turban of grey brocade decorated with small jeweled stars. Her dress of grey satin – masterfully portrayed in Gainsborough's summary style – is trimmed with gold braid and fringe and tied at the waist with a rose-colored sash.

Inspired especially by Van Dyck (no. 20), Gainsborough devised an elegant, yet casual portrait manner for his fashionable patrons. His style was admired for its blithe optimism, spirited brushwork and shimmering surface lightness. These qualities are amply revealed in *Miss Montagu,* a sprightly image that captures all the freshness and charm of young womanhood.

59 John Singleton Copley

American, 1738-1815

Portrait of Miles Sherbrook, 1771

Oil on canvas, 49½" x 39" (125.7 x 99 cm)

Dated on the letter the sitter holds: *1771*

Gift of Walter P. Chrysler, Jr., in Memory of his Grandparents, Anna-Maria Breymann and Henry Chrysler, 80.219

References: Jules David Prown, *John Singleton Copley,* Cambridge, 1966, I, p. 229; *idem,* "John Singleton Copley in New York," *The Walpole Society Note Book,* 1987, p. 31.

During the two decades preceding the American Revolution, the portraitist Copley emerged in Boston as the most distinguished of Colonial artists. His many portraits of influential New Englanders – merchants, clergymen, lawyers – were remarkable for their craftsmanly polish and clarity of design. Their excellence captured the attention of Benjamin West (no. 61) and other artists in London, where Copley began to exhibit in 1766. The lure of London and the Continent eventually proved irresistible for Copley. In 1774 he embarked on a European tour and the next year settled in London. He remained there for the rest of his life, building a dazzlingly successful European career on the strength of his portraits of the British aristocracy and his ambitious figurative paintings of historical and religious content.

Copley spent most of his early, American period working in Boston. In 1771, however, he briefly interrupted his Boston practice with a seven-month visit to New York. The trip was prompted in part by an invitation from a New York resident, Stephen Kemble. In April of 1771 Kemble wrote to Copley that he had secured the names of several influential New Yorkers who would sit for the artist if he came to that city. Among the subscribers Kemble listed was the merchant Miles Sherbrook, who agreed to have his likeness painted in the artist's standard half-length format of 50" x 40" at a price of twenty guineas. The result was the imposing *Portrait of Miles Sherbrook* in The Chrysler Museum.

Many of Copley's New York patrons were British loyalists, Tories who sided with England during the American War of Independence. One such loyalist was Sherbrook. Born in Britain, he immigrated to the Colonies and during the late 1760s achieved prominence in New York business circles as a partner in the import firm of Perry, Hayes and Sherbrook. He was condemned for his royalist sympathies during the Revolutionary War; the New York legislature voted in 1779 to seize his property and banish him from the state. In 1787 he was allowed to return.

Copley's portrait of Sherbrook appeared in England at some point after the Revolution – possibly after Sherbrook's death. Scholars lost sight of the painting during the nineteenth century, and it was presumed to have vanished for good. It was rediscovered in England only in 1977 and acquired by the Museum three years later.

The portrait shows Sherbrook seated at his worktable, dealing with his affairs. A handsome man in the fullness of middle age, he is portrayed without a wig and is dressed simply in business clothes: russet breeches, waistcoat (a kind of vest) and coat, which glow warmly in the light that penetrates the picture from the left. His cheek is scarred with pockmarks, possibly from a childhood bout of smallpox. They give a weathered quality to Sherbrook's face that seems to underscore our impression of him as an unpretentious, forthright businessman.

Copley typically provided his male sitters with attributes that signified their vocations. Sherbrook holds a letter and quill pen, objects the artist also used in several other portraits to indicate the mercantile profession. The eloquent simplicity of the painting and its extraordinarily incisive presentation of character are the marks of Copley's best portraits of the late 1760s and early 1770s. At that time the artist began to place his subjects in darker, more neutral settings and made dramatic use of *chiaroscuro* to spotlight their faces and hands. In portraits like *Miles Sherbrook,* Copley advanced beyond the rococo extravagances of earlier European portraiture to create images that captured the simple strength and moral idealism of the emerging American Republic.

60 Hubert Robert
French, 1733-1808

Landscape with a Temple

Oil on canvas, 64″ x 46″ (162.5 x 116.8 cm)
Gift of Walter P. Chrysler, Jr., 81.1
Reference: Harrison, *CM*, 1986, no. 14.

"The ideas which the ruins awake in me are grand. Everything vanishes, everything dies, everything passes, only time endures." Thus did the famous encyclopedist and art critic Denis Diderot (d. 1784) pay tribute to the elegiac power of Hubert Robert's Roman *vedute,* his views of ancient Rome. Robert was quite likely the most widely known painter of antique ruins in later eighteenth-century France, a distinction that earned him the nickname "Robert of the ruins."

A native Parisian, he was in Italy from 1754 to 1765. He studied at the French Academy in Rome and, accompanied by the young Fragonard – who remained in Italy from 1756 to 1761 – he traveled widely in the countryside, making landscape drawings out-of-doors. Among his teachers at the French Academy was Giovanni Paolo Panini (no. 54), whose *vedute ideate* – imaginary views of the sculptural and architectural remains of classical Rome – exerted considerable influence on Robert and confirmed his calling as a painter of ancient ruins.

The free and feathery technique of Robert's early *vedute* and his equally vibrant drawing style are tied to the rococo. The archeological tone of his paintings, however, reflects the rising Neoclassical interest in Roman antiq-

uity, an interest fueled no doubt by the excavations at Herculaneum and Pompeii in the years after 1738. Robert's work projects, too, a wistful and sometimes sublime mood that was, as Diderot's comment suggests, very much in keeping with the later eighteenth-century *sensibilité.* His paintings function not only as nostalgic evocations of Rome's vanished grandeur, but as melancholy reminders of the transitoriness of all human achievement.

As do many of Robert's mature *vedute ideate, Landscape with a Temple* depicts an imaginary assembly of antique monuments that were actually miles apart in Rome. This conflated evocation of the Eternal City was quite probably intended for a foreign buyer

who had made the Grand Tour of Italy. Here the Colosseum, the Pantheon, a sculpture of a captive barbarian and one of the marble Horse Tamers of Monte Cavallo are all made to occupy the same acre of land.

The portico of the Pantheon inspired many of Robert's architectural *capricci,* including a closely related black chalk drawing in the Kupferstichkabinett, Staatliche Museen Preussischer Kulturbesitz, Berlin. The statue of the captive barbarian recurs in a red chalk drawing by Robert in the Musée des Beaux-Arts, Valence. The Chrysler Museum painting originally served as a pendant to Robert's *Landscape with View under a Bridge* (present location unknown).

61 Benjamin West

American, 1738-1820

Mary, Wife of Henry Thompson of Kirby Hall, as Rachel at the Well, 1775

Oil on canvas, 50¼" x 40½" (127.6 x 102.9 cm)

Signed and dated lower right: *B. West.*
1775.

Gift of Walter P. Chrysler, Jr., 71.720

Reference: Helmut von Erffa and Allen Staley, *The Paintings of Benjamin West,* New Haven and London, 1986, p. 293, no. 247.

The subject of this portrait by the London-based American painter Benjamin West is Mary Thompson. Born Mary Spence, she wed Henry Thompson of Kirby Hall, near York, in 1769. To the wealthy, titled Thompson family she brought her own considerable inheritance as the only child of Thomas Spence of Harts Hall, Suffolk. By 1775, the date of West's portrait, she had given birth to at least two children. She died in 1843.

West portrayed Mrs. Thompson as the Old Testament worthy Rachel. The beautiful daughter of Laban, Rachel met her cousin Jacob at the well in Haran, where she had come to water her father's sheep (Genesis 29:1-12). Jacob fell in love with Rachel and eventually married her. The presentation of well-placed portrait sitters in the guise of virtuous biblical or mythological figures reflected a taste for allegorical portraiture that had been current in European art since the sixteenth century. This practice enjoyed a special vogue in eighteenth-century France and England. West's colleague Sir Joshua Reynolds had shown four allegorical portraits at the inaugural exhibition of the Royal Academy of Arts in London in 1769. West quickly followed suit and during the 1770s produced several portraits of aristocratic ladies as Rebekah, Armida, Una and, as in The Chrysler Museum painting, as Rachel at the well.

Representing Rachel, Mrs. Thompson turns to encounter Jacob, who introduces himself and offers to help her water her flock. It is possible that the figure of Jacob is an idealized portrait of Henry Thompson. However, scholars have doubted that West would have shown Thompson as so youthful a figure, for in 1775 he would have been thirty-two years old. The two figures at right may also be portraits, though their identities are unknown.

The distinguished career of Benjamin West was marked by a succession of firsts. Born the son of an innkeeper near Springfield, Pennsylvania, he was the first native American painter to study abroad – he was in Rome from 1760 to 1763 – and the first to achieve international fame. He accomplished this after 1763, when he settled permanently in London and began to paint portraits and historical subjects. He helped found the Royal Academy in 1768, and in 1792 he became its president. His atelier in London became a mecca for American artists working abroad, and he labored tirelessly to promote the careers of his countrymen in England (see no. 59).

While in Rome, West had been influenced markedly by the Neo-classical styles of Anton Raphael Mengs and Gavin Hamilton. In subsequent London portrait efforts, like *Mary, Wife of Henry Thompson,* the influence of Mengs' suave and decorous Neo-classicism is clearly evident. By the time he painted the Chrysler portrait, West had begun his long and profitable tenure as history painter to King George III.

62 George Morland

English, 1763-1804

A View of Westmorland, 1792

Oil on canvas, 40½″ x 56½″ (102.9 x 143.5 cm)

Signed and dated on the sacks at center:
 G. Morland
 1792

Gift of Morrie A. Moss, 74.5.2

An artistic prodigy, George Morland was already exhibiting drawings at London's Royal Academy by the age of ten. The elder Morland – a painter and an art dealer who restored Old Master pictures – was cynically aware of the commercial value of his son's precocious talent, and he pushed him to perfect his craft. While apprenticed to his father in 1777-84, the boy was kept perpetually busy. He made drawings for sale and copied the popular seascapes of Joseph Vernet and the Dutch and Flemish paintings that his father restored in his studio. Once free of his father, Morland rejected the strict discipline of his early years and embraced a life of reckless self-indulgence. Despite his increasingly dissolute ways, he produced a remarkable number of pictures. Many of them were consigned to unscrupulous art dealers who systematically underpaid him and kept him in debt. He died, alcoholic and debt-ridden, at the age of forty-one.

During the later 1780s Morland specialized in moralizing genre paintings of upper middle-class life and in fashionable, sentimental pictures of children at play. After 1790 he turned almost exclusively to picturesque scenes of English country life – interiors of stables and landscapes with gypsies, smugglers and peasants. These subjects were determined partly by the Dutch paintings he had first encountered in his father's shop and partly by the coastal scenes of Vernet and Philipp de Loutherbourg. Influential, too, were the contemporary landscape styles of Thomas Gainsborough (no. 58) and the French rococo masters.

With his landscapes Morland forged a vision of rustic English life that affected native artists for generations.

The finest works of Morland's uneven career were his country scenes of the early 1790s. Among them is *A View of Westmorland* of 1792, which reveals the artist at the height of his powers. Here an apparently innocent genre interlude is made the pretext for a stunning evocation of the English coast. The painting depicts a peasant family proceeding toward the shore where two men await them in a boat. The rather anxious, covert glance of the woman suggests that she and her family are actually involved in the not so innocent act of smuggling contraband, an activity often depicted in Morland's landscapes. Though the figures possess the solidity and mass of the seventeenth-century Dutch masters, the landscape itself, evoked in fluid strokes, is a lush tribute to the rococo.

63 Jean-Baptiste Greuze
French, 1725-1805

Saint Mary of Egypt, 1800

Oil on canvas, 71½" x 57¼" (181.6 x 145.4 cm)

Gift of Walter P. Chrysler, Jr., 71.652

References: *Jean-Baptiste Greuze 1725-1805,*
exhib. cat., Wadsworth Atheneum, Hartford;
California Palace of the Legion of Honor, San
Francisco; and Musée des Beaux-Arts, Dijon,
1976-77, no. 113; Harrison, *CM,* 1986, no. 15.

At the height of his influence, between 1760 and 1780, Greuze enjoyed great popularity in Paris as a portraitist and genre painter. He was known particularly for his sentimental genre scenes of domestic trials and tragedy. He invested these poignant images of family life with the emotional force and moral weight of history painting, creating a novel form of genre picture that defied the Académie Royale's venerable hierarchy of subjects (see no. 56). He was lauded for his efforts by the critic Denis Diderot, who saw in his intense, high-minded genre scenes a welcome departure from the frivolities of the rococo.

In later years, however, Greuze's career began to falter. He was hampered increasingly by his own flawed character: he was an arrogant and argumentative man who made a good many enemies within the Académie and suffered from the mounting stresses of a disastrous marriage. When Greuze finally divorced his wife in 1793, the settlement ruined him financially. He spent his final decade impoverished and dispirited.

Nowhere is the melancholy of his late period more strikingly revealed than in *Saint Mary of Egypt,* one of the artist's rare religious pieces and, perhaps, the most ambitious of his final commissions. Greuze produced this large canvas in 1800 for Napoleon's brother, Lucien Bonaparte, who was France's Minister of the Interior. It was exhibited the next year at the Paris Salon. So precarious was Greuze's financial position at the time it was done that he wrote twice to Bonaparte pleading for advances on the painting. "I have lost everything," he lamented, "except talent and courage....all my life I have never had so painful a moment to live through."

According to medieval legend, the fourth-century Alexandrian harlot, Mary of Egypt, embraced the Christian faith on a visit to the Church of the Holy Sepulchre in Jerusalem. She then retired into the wilderness to devote the remainder of her life to penance and prayer. A lion – her saintly attribute – allegedly appeared after her death to help a passing priest dig her grave. As scholars have suggested, the sorrowful Saint Mary in Greuze's picture – naked and repentant in her desert cave and attended by a lion of even more doleful aspect – almost certainly mirrors the anguish of the artist's own life. His final figure painting, *Saint Mary of Egypt* has been aptly described by Robert Rosenblum as Greuze's "last will and testament [as an artist], translating a world of private sorrows and misgivings into a [final] public statement."

Nineteenth Century

64 Sir David Wilkie

English, 1785-1841

Diana and Callisto, 1803-04

Oil on canvas, 22¼" x 28½" (56.5 x 72.4 cm)

Gift of Walter P. Chrysler, Jr., 71.2081

Reference: *Sir David Wilkie of Scotland (1785-1841)*, exhib. cat., Yale Center for British Art, New Haven, and North Carolina Museum of Art, Raleigh, 1987, no. 1.

According to Ovid's *Metamorphoses* (2:401-465), Diana, the Roman goddess of the chase and protectress of women, required that the nymphs who attended her on her hunts in Arcadia be chaste. One of them, the beautiful Callisto, had the misfortune to catch Jupiter's eye while she was hunting alone in the forest. Disguised as Diana, Jupiter came to her and seduced her. Upon her return to Diana's camp, Callisto reluctantly disrobed to bathe along with the other nymphs and was discovered to be pregnant. Enraged at Callisto's transgression, Diana drove her away. This dramatic moment of banishment is the subject David Wilkie depicted in his painting of *Diana and Callisto*.

A lofty historical subject drawn from classical mythology, the theme of Diana and Callisto was an unusual one for the Scottish-born Wilkie. Moving to London in 1805, he achieved fame there primarily as a portraitist and painter of earthy, humorous genre images like his well-known *Blind Fiddler* (Tate Gallery, London). But *Diana and Callisto* was produced at the beginning of Wilkie's career, in 1803-04, when the nineteen-year-old artist was still a student at the Trustees' Academy in Edinburgh and had not yet freed himself from the academic interests of his teacher, John Graham. Under Graham's direction, the Academy held a yearly competition among its students for the best history painting. In 1803 the contest subject was Diana and Callisto; Wilkie submitted the present painting and with it won the first prize of nine pounds in early 1804.

Wilkie clearly intended to depict the elevated theme of Diana and Callisto in a suitably serious, idealizing style. Nevertheless, there is much in the painting – for example, the powerful and highly individualized facial expressions of Diana and her nymphs – that forecasts the pithy naturalism of the artist's mature genre pictures. Writing about *Diana and Callisto* in 1848, John Burnet remarked that the

> close observation of nature [in the painting] was apparent, however inappropriate to the higher walks of art....[Callisto] was made to blush with so deep a colour in the ear and the upper part of the neck as gave Graham an opportunity...for descanting on the difficulty of introducing the peculiarities of familiar life into the higher branches of art.

Wilkie's preliminary compositional study for *Diana and Callisto*, rendered in black and red chalk, is in the National Gallery of Scotland, Edinburgh.

65 Joshua Johnson
American, active c. 1796-1824

Mrs. Abraham White and Daughter Rose,
c. 1808-09

Oil on canvas, 30″ x 25½″ (76.2 x 64.8 cm)

Gift of Edgar William and Bernice Chrysler
Garbisch, 74.6.12

Reference: *Joshua Johnson: Freeman and Early
American Portrait Painter,* exhib. cat., Maryland
Historical Society, Baltimore *et al.,* 1987-88,
no. 50.

The recent revival of interest in
early American folk art has led to the
rediscovery of a host of humble artisan-
painters. The disarmingly direct styles
of these "naive" painters stand in
marked contrast to the more sophisti-
cated art of their academically-trained
colleagues (see nos. 55, 66, 67, 68, 102).
Among the most fascinating of Amer-
ica's nineteenth-century folk limners
is the Baltimore painter, Joshua John-
son. Johnson was one of the very few
African-American artists working in
the United States in the post-Revolu-
tionary War period and the first free
African-American portraitist in this
country to earn a professional reputa-
tion. Although his origins are uncer-
tain, it is likely he was brought to Phila-
delphia from the West Indies as a slave
boy before 1777. He may have been a
servant in the Philadelphia household
of painter Charles Willson Peale and
possibly learned his craft from a mem-
ber of the Peale family – from Charles
Willson himself or his nephew Charles
Peale Polk. In any event, Johnson's later
portraits take their imagery and com-
positional designs from the Peales'
more polished portrait art.

Johnson had established himself in
Baltimore both as a freedman and
portraitist by 1796, when he was first
listed in the city's street directory and
described there as a portrait painter.
He remained active at least until 1824,
the last year his name appears in the
Baltimore directory.

Of the roughly eighty portraits that
have been attributed to Johnson, only
two depict African-American subjects.
The rest of his sitters were prosperous
whites, mostly members of Baltimore's
middle class of merchants, military
officers and government officials. Sev-
eral were abolitionist sympathizers.
Johnson may have gained his influen-
tial clientele with the help of the Peales,
for Charles Peale Polk and Rembrandt
and Raphaelle Peale all practiced in
Baltimore in the 1790s and painted
many of the same sitters.

The Chrysler Museum portrait de-
picts Martha Bussey White (1778-1809)

and one of her seven children, Rose
Elizabeth (1807-1875). Martha was the
daughter of Captain Bennett Bussey of
Hartford County, Maryland. In 1797
she married Abraham White, a Bal-
timore merchant who ran a grocery
establishment on High Street, not far
from Johnson's home. Johnson painted
Martha and her daughter around 1808-
09, about the time of Rose's second
birthday and shortly before Martha's
untimely death at the age of thirty.

Their attributes – Martha holds a
book and Rose a sprig of strawberries –
were used repeatedly by the artist in his
many portraits of women and children.
Though Johnson's approach to his sub-
jects is characteristically stylized, he
nonetheless conveys the warmth of
their relationship, the tenderness unit-
ing the seated Mrs. White with the
young daughter standing sweetly at
her side.

66 Jacob Marling

American, 1774-1833

The Crowning of Flora, 1816

Oil on canvas, 30⅛" x 39⅛" (76.5 x 99.4 cm)

Gift of Edgar William and Bernice Chrysler Garbisch, 80.181.20

References: Davida Deutsch, *"The Crowning of Flora:* Mr. Marling and Ladies identified," *The Luminary,* 9 (summer, 1988), pp. 3-4; *idem,* "The polite lady: portraits of American school-girls and their accomplishments, 1725-1830," *The Magazine Antiques,* 135 (1989), p. 744.

America's nineteenth-century folk artists often traveled widely in their search for employment (cf. no. 67), and Jacob Marling was no exception. After learning his craft from James Cox, who practiced mostly in Philadelphia, Marling worked initially as an itinerant painter and art teacher; he instructed young students in Philadelphia and New York City and conducted drawing classes at girls' schools in Fredericksburg, Richmond and Petersburg, Virginia. By 1815 he and his wife Louisa had settled in Raleigh, North Carolina, where they remained for the rest of their lives. In Raleigh Marling produced mostly portraits and miniature paintings, which he showed in his "exhibition gallery." His wife, who was also an artist, taught drawing and painting to the female students of the Raleigh Academy, which had been established in 1804 to instruct both boys and girls (in separate quarters) from Raleigh and surrounding Wake County. The school prospered through the 1820s, drawing pupils from throughout North Carolina and from other Southern states as well.

As Davida Deutsch has shown, Marling's delightful genre painting, *The Crowning of Flora,* commemorates the May Day pageant performed in 1816 by the female pupils of the Raleigh Academy. The festivities were described later that year in *The Echo,* a Lynchburg, Virginia, newspaper:

> On the first day of May, the young ladies belonging to the Raleigh... academy assembled under the wide spreading trees which embosom their building, and proceeded to the election of a queen. Miss Mary Du Bose of Georgia was the successful candidate. She was conducted to the rural throne...[and] crowned with a chaplet of flowers....[An] address to the queen was read by Miss Anne W. Clark of Georgia....The echoes of the grove were awakened by the melody of music, and the mirthful scene impressed all so happily, that the students will long believe this day was not lost. Mr. Marling, so well known for his skill and taste in painting, was present, and sketched a likeness of the May queen, as she appeared in her ensigns of royalty.

As Deutsch suggests, the man holding a clarinet in the painting's right foreground is almost certainly the Academy's music teacher, while the gentleman standing next to him is probably its headmaster William McPheeters. The man and woman portrayed in profile at the extreme right may well be Marling and his wife. Just visible above the trees in the right background, the cupola of North Carolina's first statehouse helps place the scene geographically. The imposing brick building in the left background is probably the first State Bank of North Carolina, another of Raleigh's early architectural landmarks.

Before the advent of public education in the South, young ladies from well-to-do families were taught at home by tutors or sent to private schools like the Raleigh Academy. There they were expected to learn how to read, write and do needlework, and to achieve proficiency in painting and drawing, elocution and music making. In ceremonies like that shown in *The Crowning of Flora,* school girls demonstrated progress in these pursuits as their teachers and parents looked on. As one of the earliest paintings to deal with the subject of women's education in America, Marling's work provides a fascinating glimpse of the life of young women in the early United States.

67 Erastus Salisbury Field

American, 1805-1900

Harriet Sophia Jones, c. 1833

Oil on canvas, 44″ x 28¼″ (111.7 x 71.7 cm)

Gift of Edgar William and Bernice Chrysler Garbisch, 78.633.3

Reference: *Erastus Salisbury Field: 1805-1900,* exhib. cat., Museum of Fine Arts, Springfield, Massachusetts *et al.,* 1984-85, no. 27.

Despite a period of study in Samuel Morse's New York studio, the Massachusetts folk artist Erastus Salisbury Field was largely self-taught. During the first phase of his career he worked as an itinerant portrait painter in and around his hometown of Leverett, Massachusetts, and in the villages stretching south along the Connecticut River (see also no. 102). Between 1825 and 1860 he produced more than 150 portraits for his rural New England clientele – stern, sober images of Yankee farmers and shopkeepers, their strait-laced wives and well-scrubbed children. He rendered these frank, frontal likenesses in a decidedly linear style and enlivened his broadly massed, planar forms with finely-worked details of dress and setting: embroidered lace collars, pleated bonnets and brightly patterned carpets.

Field's most productive time as a country face painter came in the 1830s. It was at the beginning of that decade that he painted his portrait of *Harriet Sophia Jones* (1829-1915). Shown here at the age of four, Harriet wears a fashionable, Empire-style frock and carries a basket of pink and white roses. Her parents were Sophia Fuller (d. 1894) and Charles Backus Jones (d. 1878), who married in 1828 and settled in Monson, Massachusetts, some twenty miles south of Leverett. At the time that Field painted Harriet, he also made portraits of her parents, which are in the Mead Art Museum at Amherst College (Amherst, Massachusetts).

68 Edward Hicks

American, 1780-1849

Washington at the Delaware, 1849

Oil on canvas, 28″ x 35½″ (71.1 x 90.2 cm)

Dated on the reverse: *1849*

Gift of Edgar William and Bernice Chrysler Garbisch, 77.1271

Reference: Eleanore Price Mather and Dorothy Canning Miller, *Edward Hicks: His Peaceable Kingdoms and Other Paintings,* Newark, Delaware, 1983, p. 162, no. 69.

Edward Hicks is probably the best known American folk painter from the first half of the nineteenth century. He was a native of Bucks County, Pennsylvania, where he worked primarily as an itinerant Quaker preacher and a painter of coaches and signs. Self-taught as an artist, Hicks also painted farm scenes, stirring patriotic images taken from Colonial American history, and religious allegories that mirrored his Quaker pacifism. He commonly would duplicate or vary a composition – for example, his famous *Peaceable Kingdom* – in scores of paintings.

Like many folk painters, Hicks often took inspiration from the prints or paintings of other artists. The Chrysler Museum's *Washington at the Delaware,* for instance, was based on George S. Lang's engraving after Thomas Sully's well-known painting of 1819, *Washington at the Passage of the Delaware* (Museum of Fine Arts, Boston). Dated 1849 – the year of Hicks' death – the Chrysler picture is almost certainly the last of at least eight versions Hicks produced of this subject over a twenty-five year period (John A. Harney collection, Trenton; Abby Aldrich Rockefeller Folk Art Center, Williamsburg; etc.). Two of these works (private collection; Mercer Museum, Doylestown, Pennsylvania) appear on commemorative wooden signboards, which the artist painted in 1834. Interestingly, they were hung at either side of the bridge spanning the Delaware River at the very spot crossed by Washington and some twenty-five hundred of his troops on Christmas night, 1776, enroute to their victory over the British forces at Trenton. Washington's daring crossing of the Delaware helped boost American morale at the start of the Revolutionary War, and as Hicks' many versions of the subject indicate, the theme became a particularly popular one for nineteenth-century American painters (see also no. 83).

As a devout member of the Society of Friends, Hicks was well aware of the Quaker proscription against the "vanity" and "temptation" of "ornamental painting," and throughout his career he struggled to reconcile his artistic and religious convictions. The military subject of *Washington at the Delaware* might be deemed especially curious in view of Hicks' pacifism, but the artist managed to justify his choice by describing Washington as an instrument of God:

> ...that distinguished instrument in the hand of the infinitely wise Jehovah...[who established] the American Republic, a system of government the most healthy and happy, the most successful and generous, now under heaven....and while virtue, liberty and independence continue to be esteemed among the children of men, the name of Washington will be pronounced with veneration and respect by millions of intelligent beings.

69 Thomas Cole

American, 1801-1848

The Angel Appearing to the Shepherds,
1833-34

Oil on canvas, 101½″ x 185½″ (257.8 x 471 cm)

Gift of Walter P. Chrysler, Jr., in Memory of
Edgar William and Bernice Chrysler Garbisch,
80.30

References: Ellwood C. Parry III, "Thomas
Cole and the Problem of Figure Painting,"
American Art Journal, 4 (spring, 1972), pp.
79-86; *idem,* "Recent discoveries in the art of
Thomas Cole," *Antiques,* 120 (November, 1981),
pp. 1157-1160; *idem, The Art of Thomas Cole:
Ambition and Imagination,* Newark, Delaware,
1988, pp. 119-120, 149-151, 153-154.

Thomas Cole is celebrated today as
America's first great landscape painter
and the progenitor of the influential
group of mid-nineteenth-century New
York landscapists known as the Hud-
son River School (nos. 78, 101, 107).
Born in Lancashire, England, he immi-
grated with his family to Philadelphia
in 1818. Over the next several years he
labored to teach himself the art of
painting as his family moved from
Philadelphia to Ohio and western
Pennsylvania. After additional study in
Philadelphia at the Pennsylvania Acad-
emy of the Fine Arts, Cole settled in
New York City in 1825. There his early
landscape pictures were hailed by fel-
low-artists John Trumbull and Asher
B. Durand (no. 78). The young artist
was suddenly famous.

Cole journeyed to Europe twice, in
1829-32 and again in 1841-42. While

in New York between these visits, he
painted the two ambitious allegorical
series for which he is most remem-
bered: *The Course of Empire* (1836) and
The Voyage of Life (1840). By the time
of his premature death in 1848 (he
died unexpectedly of a lung inflamma-
tion), he had become New York's lead-
ing artist and America's first fully
Romantic painter.

The Angel Appearing to the Shepherds
is Cole's largest canvas – it measures
more than eight by fifteen feet – and
one of his earliest and most ambitious
attempts at historical landscape paint-
ing. It was produced in New York City
during the winter of 1833-34, and as
Cole later noted in a letter to his friend
Francis Alexander, it was completed in
the astonishingly brief span of "about
two months; I could not afford more
[time]." Though Cole executed the can-
vas rapidly, his initial ideas and designs
for it evolved over several years, during
his first European trip. He first con-
ceived of the subject in 1829, while
visiting the British Museum in London,
where he saw Rembrandt's 1634 etch-
ing of *The Angel Appearing to the
Shepherds.* Impressed by its composi-
tional grandeur and dramatic
chiaroscuro effects, he began making
preliminary drawings for his own com-
position while in England. During his
stay in Florence in 1831-32, he expand-
ed upon these initial sketches with

more drawings and painted figure
studies (several of which are in the
Detroit Institute of Arts), and he also
produced at least three small pre-
paratory compositional sketches in oil
in 1831-33. Two of these are in The
Chrysler Museum (nos. 70, 71).

The painting's shepherds were
almost certainly intended as allegorical
representations of the three ages of
man. They were also meant to signify
three successively higher states of spir-
itual response to the miraculous
apparition of the angel, beginning with
the stunned incomprehension of the
kneeling, nearly prostrate youth and
culminating in the quiet understanding
and acceptance of the standing elder.
Cole derived the semi-reclining pose of
the middle shepherd from the antique
sculptures of the *Ilissus* and the *Dying
Gaul,* both of which he had sketched
while in Europe. Some scholars have
noted that the middle shepherd bears a
resemblance to Cole and may be an
idealized self-portrait.

The artist exhibited *The Angel
Appearing to the Shepherds* in the spring
of 1834 at the American Academy of
the Fine Arts in New York City. It was
shown later that year in Albany, New
York, and in Boston. Though the
painting was coolly received by Cole's
contemporaries, it is acknowledged
today as one of his most ambitious
works before *The Course of Empire.*

70 Thomas Cole

American, 1801-1848

Study for *The Angel Appearing to the Shepherds,* c. 1831

Oil on board, 4½" x 6⅛" (11.4 x 15.5 cm)

Museum Purchase with Funds from the Armour Foundation, 84.32

Reference: Ellwood C. Parry III, "Thomas Cole and the Problem of Figure Painting," *American Art Journal,* 4 (spring, 1972), p. 81.

In addition to Thomas Cole's monumental canvas *The Angel Appearing to the Shepherds* (no. 69), which the artist painted in New York during the winter months of 1833-34, The Chrysler Museum possesses two of the three small compositional sketches in oil that Cole made in preparation for this painting (the present entry and no. 71). The third oil study is currently on loan to the Los Angeles County Museum of Art from the collection of Arthur and Nancy Manella.

Of the three sketches, the present one is generally believed to be the earliest. It was produced in the winter of 1831, soon after Cole arrived in Florence toward the end of his European visit of 1829-32. The Museum's other sketch (no. 71) was probably painted shortly after.

In a letter Cole sent from Florence on January 31, 1832, to a friend in New York, he noted that he was working on several projects, among them "a scripture subject, the Angel appearing to the Shepherds." Subsequently distracted by other paintings, he seems to have delayed work on this subject until the winter of 1833, nearly a year after he had returned to New York from Europe. It was probably then that he completed the third oil sketch and began work on the final canvas (no. 69).

The Museum's two oil studies provide a rare record of Cole's first thoughts on the design of his subject and offer a fascinating insight into his working method. Cole was only thirty years old when he made these studies, and it is proof of his precocious talent that he was able to secure the design of the colossal *Angel Appearing to the Shepherds* in rapid sketches only slightly larger than postcards.

70

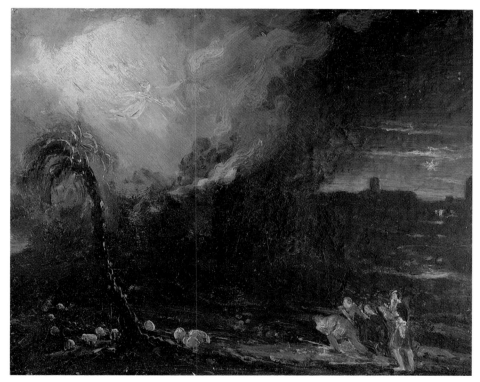

71

71

Thomas Cole

American, 1801-1848

Study for *The Angel Appearing to the Shepherds,* 1831

Oil on board, 7" x 8¾" (17.8 x 22.2 cm)

Signed and dated on the reverse: *Thomas Cole Florence 1831*

Museum Purchase, 86.193

Reference: Ellwood C. Parry III, "Thomas Cole and the Problem of Figure Painting," *American Art Journal,* 4 (spring, 1972), p. 81.

This study is the later of two small compositional sketches in oil that Thomas Cole produced in Florence in 1831 in preparation for his monumental canvas of 1833-34, *The Angel Appearing to the Shepherds.* For a full discussion of this study, the earlier sketch in oil and the finished painting, all of which are in The Chrysler Museum, see nos. 69, 70.

72 Jean-Baptiste-Camille Corot

French, 1796-1875

Landscape in a Thunderstorm, c. 1835-56

Oil on canvas, 38½" x 53¼" (97.8 x 135.2 cm)

Signed and dated lower left: *Corot 1856*

Gift of Walter P. Chrysler, Jr., 71.632

References: Alfred Robaut, *L'Oeuvre de Corot,* Paris, 1905, II, pp. 92-93, no. 259; Harrison, *CM,* 1986, no. 23.

Corot was the first great landscapist of nineteenth-century France and a progenitor of the Barbizon school of landscape painters (nos. 86, 93, 103). He exerted a formative influence on both his Barbizon colleagues and on the Impressionists who succeeded them. After training in Paris with Achille-Etna Michallon and the classical landscapist Jean-Victor Bertin, Corot visited Italy in 1825-28. While in Rome he received valuable instruction from the landscapist Caruelle d'Aligny and perfected his first landscape style, a markedly classical manner featuring broadly faceted landscape forms that are clearly defined in crystalline light and bathed in southern sun. He re-turned twice to Italy in later years, in 1834 and again in 1843.

Back in France Corot's work reg-imen shifted with the seasons. The warm months found him in the provinces, where he made landscape studies *en plein air* (out-of-doors). In winter he retreated to his Paris studio and there used his warm weather sketches to compose larger, finished landscapes for the Salon. Around 1850 he embarked on a new style in which his earlier classical landscapes gave way to a series of Romantic *souvenirs* — gauzy, poetic landscape visions suf-fused with silvery light.

Though *Landscape in a Thun-derstorm* is dated 1856, the relative clarity of its forms and atmosphere suggests an earlier moment in Corot's career, well before he embraced the gauzy manner of his *souvenirs.* Quite possibly it was painted around 1835 and then kept by the artist, who retouched it in 1856 and only then signed and dated it. A date of c. 1835 would place the painting just after Corot's second visit to Italy, and possi-bly the landscape depicts an Italian vista. On at least one occasion the pic-ture has been described as a portrayal of a rocky valley in the Roman *Campagna.*

In the early 1830s Corot was in-fluenced briefly by the works of the seventeenth-century Dutch land-scapists, particularly Jacob van Ruisdael. The rushing stream and twisted vegetation in the present paint-ing, as well as the approaching storm, bring Ruisdael to mind, supporting a date of c. 1835.

A lonely sentinel in this desolate landscape, the tree at left is struck by the chilly lowering light that often pre-cedes a storm. It is a ghostly illumina-tion that lends a spectral clarity and depth to both the tree and surround-ing landscape. In the middleground, beyond the stream, a shepherd with his dog and flock awaits the approach-ing rain.

73 Thomas Crawford

American, c. 1813-1857

Paris Presenting the Golden Apple to Venus, 1837

Marble, 58″ (147.3 cm)

Signed and dated on the strut:
*T. Crawford Fect
Rome, 1837*

Gift of James H. Ricau and Museum Purchase, 86.463

References: Lauretta Dimmick, "Thomas Crawford's *Orpheus:* The American *Apollo Belvedere*," *The American Art Journal*, 19 (1987), p. 48; *idem*, "Veiled Memories, or, Thomas Crawford in Rome," in *The Italian Presence in American Art 1760-1860*, New York, 1989, pp. 178-179, 182.

This splendid, three-quarter life-size marble is one of seventy American Neoclassic sculptures The Chrysler Museum acquired in 1986 from the renowned New York collection of James H. Ricau (see also nos. 79, 84, 90). It was produced by Thomas Crawford, who by 1843 had joined Horatio Greenough and Hiram Powers as a leader of the first generation of American Neoclassic sculptors.

Born in New York City, Crawford was apprenticed there to the stone-cutters John Frazee and Robert E. Launitz. In 1835 he went to Rome, where he completed his studies with the famous Danish sculptor Bertel Thorwaldsen. Except for brief visits to the United States and northern Europe, Crawford remained in Rome for the rest of his short life (see no. 79). He was the first American sculptor to live there permanently.

The basic tenets of Neoclassical theory were expressed most eloquently by Johann Joachim Winckelmann (d. 1768) in his authoritative treatise of 1755, *Thoughts on the Imitation of Greek Works in Painting and Sculpture*. Reacting against the excesses of Baroque and rococo art, Winckelmann exhorted sculptors to create works that revived the "noble simplicity and calm grandeur" of classical Greek statuary. The perfect medium for this was pure white marble. According to Winckelmann, the artist's mission was essentially moral: to educate the viewer and

elevate his thoughts. To achieve this goal, the artist must emulate the ideal beauty and edifying subjects of ancient sculpture.

Crawford spent his first months in Rome making portrait busts and copies of antique marbles. But he soon resolved to produce idealized subjects of his own design that, he hoped, would make his reputation back home in America. The earliest of these pieces that survives is *Paris Presenting the Golden Apple to Venus* of 1837, which Crawford based loosely on Antonio Canova's 1812 statue of the same subject (Hermitage, St. Petersburg). As Lauretta Dimmick notes, both Crawford's and Canova's figures "wear the Phrygian cap, with curling tresses beneath. Both are shown nude, except for a fig leaf. Crawford's *Paris* wears elaborately carved sandals, a strap across his chest and drapery over his arm, all in a manner of the famed Apollo Belvedere."

Crawford's sculpture refers to the Greek myth in which the Trojan prince Paris judges a beauty contest on Mount Ida among the goddesses Athena, Hera and Venus. Proclaiming Venus the winner, he awards her the golden apple, in return for which she allows Paris to abduct the Spartan queen Helen, an act that leads directly to the Trojan War. In the sculpture, Paris, his left hand raised pensively to his chin, seems about to decide the contest in favor of Venus and to offer her the apple he holds.

Soon after he completed *Paris*, Crawford decided not to replicate the statue and went so far as to destroy his plaster model. The piece is, therefore, unique. It is also one of the rare nineteenth-century American sculptures that depicts the nude male form (cf. no. 90).

74　Sir William Beechey

English, 1753-1839

Portrait of Sir Thomas Livingstone Mitchell, c. 1838

Oil on canvas, 84″ x 64½″ (213.4 x 163.8 cm)

Gift of Walter P. Chrysler, Jr., 71.529

Reference: Zafran, *CM*, 1977, no. 26.

At the turn of the nineteenth century William Beechey emerged as one of the most popular and productive English portraitists, the chief rival of John Hoppner and Sir Thomas Lawrence. He began his London practice in 1787 and in 1793 was named painter to Queen Charlotte, wife of George III. Thereafter, he was regularly favored with portrait commissions from the royal family and from "the rank and fashion" of British society, who often preferred his staid and traditional por-

trait images to the more suave and eccentric works of younger Romantic painters like Lawrence. In 1798 Beechey was knighted by George III and made a member of the Royal Academy.

Beechey's stolid, forthright style is richly embellished in his portrait of the renowned Scotch surveyor and explorer Sir Thomas Livingstone Mitchell (1792-1855). Named surveyor-general of the British colony of New South Wales in 1828, Mitchell led four expeditions into the then uncharted Australian interior, where he discovered the Gwydir River and in 1835-36 mapped the courses of the Darling and Glenelg rivers.

Beechey's portrait of Mitchell has been dated to 1838, when the explorer

returned from Australia to England to be knighted and to publish his treatise, *Three Expeditions into the Interior of Eastern Australia.* The portrait shows Mitchell at work in a luxurious study, seated in an armchair draped with his scarlet-lined fur cloak. In his right hand he holds a letter, and displayed on the writing table is the title page of his book, *Survey of Glenelg,* which bears his map of New South Wales. The mountainous landscape behind the sitter is Beechey's own fanciful evocation of the Australian wilds. The portrait effectively captures the grand manner of earlier Continental portraiture, recalling, for example, Hyacinthe Rigaud's famous 1726 likeness of Samuel Bernard, today found at Versailles (cf. no. 41).

75 Antoine-Jean Gros

French, 1771-1835

Acis and Galatea, 1833

Oil on canvas, 51½" x 64" (130.8 x 162.6 cm)

Signed and dated lower right: *Gros. 1833*

Gift of Walter P. Chrysler, Jr., 71.2080

Reference: Harrison, *CM,* 1986, no. 16.

Gros originally achieved fame in Paris as one of Napoleon's principal painters, glorifying the emperor and his military exploits in a series of vast, heroic canvases. In these works he employed a style inspired less by the Neoclassicism of his revered teacher Jacques-Louis David than by the paintings of Rubens (no. 16), which he had studied during his years in Italy (1793-1800). Gros' style, with its passionate emotion and vibrant colors, was hailed by the rising generation of French Romantic painters. The most famous of his Napoleonic history paintings, *The Pesthouse at Jaffa* (Louvre, Paris), was the highlight of the 1804 Salon; with it, Gros' reputation was secured.

Despite his success, Gros became increasingly worried that he had abandoned the lofty principles of David's art for what he called the "impertinence and vagabondage" of Romantic style, and with David's death in 1825, he sensed the need to return to an art more strictly aligned to the Neoclassicism of his former mentor. This reversion to an older, and no longer fashionable, manner isolated Gros from many of his earlier supporters, and his art became the object of mounting criticism. The crisis came at the 1835 Salon. There Gros exhibited two works of decidedly classical style and subject matter – *Hercules and Diomedes* (Musée des Augustins, Toulouse) and *Acis and Galatea,* which the artist had painted in David's memory two years before. The devastating critical response caused Gros to fall into a deep depression, and, soon thereafter, he drowned himself in the Seine. Today Gros is rightly recognized as the crucial link "between the austere and learned classicism of his teacher David and the more colorful Romanticism of …Delacroix" (Francis Broun).

Gros took the mythological subject of *Acis and Galatea* from a passage in Ovid's *Metamorphoses* (13:738-897). In it the nymph Galatea is courted by the hideous Cyclops, Polyphemus, whose love she spurns for that of the shepherd Acis. To proclaim his love, the Cyclops makes music upon his pipes, while Acis and Galatea hide nearby listening. The giant soon spies the pair and, raging with jealousy, crushes Acis beneath a boulder. In Gros' painting the terror-stricken lovers, concealed in a cave at water's edge, cower at the approach of Polyphemus, who stalks the countryside blowing his horn.

Gros' critics balked at the painting's melodramatic tone. They complained, too, that its figures lacked grace, but conceded that they were effectively drawn. In truth, both figures were modeled upon antique sculptural prototypes: Galatea's pose recalls that of the so-called "Crouching Aphrodite," while Acis' suggests the stance of a combative Hercules.

The painting and two preliminary drawings (locations unknown) were dispersed during the posthumous sale of Gros' studio in November of 1835. In 1863 the picture was acquired by Jean-Baptiste Delèstre, a former student of Gros who authored the first biography of the artist.

76 Eugène Delacroix

French, 1798-1863

Arab Horseman Giving a Signal, 1851

Oil on canvas, 22″ x 18¼″ (55.9 x 46.4 cm)

Signed and dated lower left: *Eug Delacroix 1851.*

Gift of Walter P. Chrysler, Jr., 83.588

References: *Eastern Encounters: Orientalist Painters of the Nineteenth Century,* exhib. cat., Fine Arts Society, London, 1978, no. 83; Harrison, *CM,* 1986, no. 20.

In the decades following Napoleon's Egyptian campaign of 1798-99, the mysteries of the Islamic East were gradually revealed to a fascinated public in France. Questing for novel and exotic experiences, many Romantic artists began to journey to Morocco, Egypt and the Holy Land. There they discovered new subjects for genre paint-ing in the "Oriental" cultures of North Africa and the Near East (see also nos. 88, 99). Among the first, and by far the most important, of these French artist-travelers was Delacroix. In 1832 he joined the Comte de Mornay on a dip-lomatic mission sent by the French government to the sultan of Morocco. Though his visit lasted only six months, it transformed his art. Delacroix was so impressed by the brilliant sunlight and vivid colors of the North African desert and so intrigued by the dignity of Arab life that he devoted much of his later career to Orientalist pictures like the 1851 *Arab Horseman Giving a Signal.*

For Romantic artists the horse became a symbol of their restless and passionate souls. Delacroix was fasci-nated by these creatures, by their nervous beauty and untamed energy. By the end of his life he had devot-ed more than 150 works – paintings, drawings and watercolors – to equine subjects, and in many of them he captured the splendid wildness of a galloping or rearing steed.

In The Chrysler Museum painting an Arab scout, his red cloak whipped by the dry desert wind, halts in mid-gallop to signal his comrades, who descend a narrow mountain path in the distance. The painting's exotic Eastern theme and spirited brush technique, its gleaming colors and vig-orously animated forms combine to create a nearly flawless example of Delacroix's mature Romantic style.

77 Narcisse Virgile Diaz de la Peña

French, 1807-1876

Young Girl with Her Dog, c. 1850

Oil on paper, mounted on canvas, 80½" x 47¼"
(204.5 x 120 cm)

Signed lower left: *N. Diaz.*

Gift of Walter P. Chrysler, Jr., 71.640

Reference: Harrison, *CM,* 1986, no. 25.

The Romantic painter Diaz was an early member of the Barbizon group (nos. 72, 80, 86, 89, 112). He committed himself seriously to painting after 1830, inspired in particular by the vibrant brushwork and Romantic themes of Delacroix (no. 76) and by the works of the Barbizon landscapist Rousseau (no. 86), with whom he was closely associated after 1837.

Between 1831 and 1859 Diaz exhibited regularly at the Salon in Paris. Included among the many landscapes, Orientalist subjects and mythological pictures he showed were a number of fantasy images – dreamlike visions of Bohemians, gypsies and nymphs in deeply shadowed forest and garden settings. An unusually large and opulent example of this genre is *Young Girl with Her Dog* of c. 1850, though, apparently, it was not shown at the Salon and may well have been a lucrative private commission.

Diaz's fantasy pictures, which he seems to have turned to in the mid-1840s, derived much from the earlier garden scenes and *fêtes galantes* of Antoine Watteau and other rococo painters. Reflecting the nostalgic taste for eighteenth-century art and culture that prevailed in Paris in the decades around 1850, they helped make the artist a leader of the fashionable "rococo-revival" style. As Eric Zafran has noted, Diaz's brightly colored images of beautiful girls in fancy dress may have been prompted in part by the rococo patterns he encountered at the beginning of his career, when he worked briefly as a painter of porcelain at Sèvres.

Following in the tradition of Delacroix, Diaz became "the principal colorist of his generation" (William Johnston) and a master of painterly brio. These qualities are readily apparent in The Chrysler Museum picture in which a young girl dressed in shimmering satin, her hair woven with pearls, poses in a broadly brushed landscape beneath a profusion of roses, dahlias and woodbine. It is a richly decorative image and a virtuoso demonstration of Diaz's mastery of three genres: landscape, figure and flower painting. The extreme refinement of the girl and her little dog – a King Charles spaniel – is characteristic of Diaz's mature Romantic style, as are the dappling brushwork and the softness it imparts to figure and foliage.

Like the artist's other fantasy pictures composed in the spirit of *l'art pour l'art* (art for art's sake), the painting is virtually free of narrative content. All is designed to dazzle the eye and set the mind to dreaming. Indeed, when the painting was displayed in Paris at the Galerie Durand-Ruel in 1873 (see no. 113), it was called *La Rêverie,* and the girl's eyes, lost in pools of shadow, proclaim that herself is deep in dreams.

78 Asher B. Durand

American, 1796-1886

God's Judgment Upon Gog, c. 1851-52

Oil on canvas, 60¾" x 50½" (154.3 x 128.3 cm)

Gift of Walter P. Chrysler, Jr., 71.499

References: Zafran, *CM,* 1977, no. 29; J. Gray Sweeney, "'Endued with Rare Genius' Frederic Edwin Church's *To the Memory of Cole,*" *Smithsonian Studies in American Art,* 2 (winter, 1988), pp. 63, 71, note 47.

After winning acclaim early in New York City as an engraver and as a painter of portraits and genre scenes, Asher B. Durand turned to landscape painting in the later 1830s. With the financial backing of his patron Jonathan Sturges, he toured the Continent in 1840-41 and upon his return joined his close friend Thomas Cole at the head of New York's famed Hudson River School of landscape painters (see nos. 69, 101, 107).

Durand was closely associated with Cole throughout his middle period. It was on an 1837 sketching campaign with Cole in the Adirondacks that Durand decided to specialize in landscape painting, and after 1850 he was influenced considerably by Cole's Romantic landscape style. In 1826 Durand joined Cole and thirteen other artists in founding New York's National Academy of Design, where he served as president for a full sixteen years, from 1845 to 1861. After Cole's sudden death in 1848, Durand painted, in his memory, the landscape that would become his most famous work, *Kindred Spirits* of 1849 (New York Public Library, New York City).

Durand devoted himself overwhelmingly to "pure" landscape images: straightforward, naturalistically conceived forest scenes and contemplative mountain views. Only occasionally did he produce more imaginative historical or allegorical landscapes in the manner of Cole. By far the most notable of these rare narrative works is *God's Judgment Upon Gog* of c. 1851-52. The painting's grandiose biblical subject – so unusual in Durand's otherwise placid oeuvre – was chosen by Jonathan Sturges, who commissioned the picture and had it shown in 1852 at the National Academy of Design, where it was generally well received.

The painting was inspired by a passage from the book of Ezekiel (39:17) in which that Old Testament prophet foretells God's destruction of Gog, the infidel prince of Rosh, Meshech and Tubal and the enemy of Israel. Standing on the promontory at the lower left of the picture, Ezekiel calls forth, at God's command, predatory birds and wild beasts which devour Gog's troops in the valley of Hamon-gog:

And, thou son of man, thus saith the Lord God; Speak unto every feathered fowl, and to every beast of the field, Assemble yourselves, and come; gather yourselves on every side to my sacrifice...that ye may eat flesh, and drink blood.

The basic structure of the landscape in *God's Judgment Upon Gog* recalls that of *Kindred Spirits.* Yet its setting – the rocky crags, boiling black clouds and jagged lightning – is considerably more desolate and wild and is even more closely allied with the pictorial conventions of the eighteenth-century "sublime" landscape.

79 Thomas Crawford

American, c. 1813-1857

Boy with Broken Tambourine and
Dancing Girl (Dancing Jenny), 1855

Marble, 42½″ and 43″, respectively (108 and
109.2 cm)

Each signed and dated on the base:
> T. CRAWFORD. FECIT.
> ROMAE. 1855.

Gifts of James H. Ricau and Museum Purchase, 86.465 and 86.464, respectively

References: William H. Gerdts, *American Neo-Classic Sculpture*, New York, 1973, pp. 82-83; Lauretta Dimmick, *A Catalogue of the Portrait Busts and Ideal Works of Thomas Crawford*, PhD diss. (UMI), University of Pittsburgh, 1986, pp. 312-314, 381-382.

Shortly after he completed his 1837 sculpture of *Paris Presenting the Golden Apple to Venus* (no. 73), Thomas Crawford began working in Rome on another, more ambitious marble that he hoped would establish him as a leading Neoclassicist back home in America. This work, *Orpheus and Cerberus*, 1843, was purchased by the Boston Athenaeum and proved a great success. By the early 1850s Crawford had received an extraordinary number of prestigious public commissions in the United States, more than any other American Neoclassic sculptor. Before his untimely death from eye cancer in 1857, he had begun work on an equestrian bronze statue of *George Washington* for the State House grounds in Richmond, the pedimental sculptures for the Senate wing of the United States Capitol and the bronze statue of *Armed Freedom* for the top of the Capitol dome.

While he pursued these monumental projects, Crawford also produced in his final years a number of smaller pieces, among them the portrait busts, genre images and sentimental figures of children that comprised the customary repertoire of America's Neoclassic sculptors. The deliberate sweetness of Crawford's sculptures of children appealed to American Victorian taste. Such works were usually modest in size and often intended as parlor ornaments. Among the most unusual of Crawford's childhood themes are the 1855 pendant marbles of the *Boy with Broken Tambourine* and *Dancing Girl* in The Chrysler Museum. (The artist reportedly modeled the *Dancing Girl* after his second child Jenny, who was born in 1847.) Together the sculptures al-

legorize the power of music and its capacity to produce joy and vitality. Responding happily to a melody, the sprightly little girl lifts her skirt to dance. In contrast, the boy has been "deprived of music," for his tambourine is broken. While the girl moves gaily to the sound, he stands dejected and still (William Gerdts). As Melissa Hoffman has observed, "The boy's tambourine is a flawless demonstration of virtuoso stone carving, its delicate, broken membrane portrayed skillfully in hard, unyielding marble."

Crawford's sentimental pendant studies of joy and sadness were a standard part of the Victorian sculptors' repertoire of childhood themes. The Belgian artist Eugène Simonis, for example, displayed similar companion sculptures of the *Happy Child* and *Unhappy Child* at London's Crystal Palace Exhibition in 1851. Though Crawford made replicas of the *Boy with Broken Tambourine* and *Dancing Girl*, the Museum currently possesses the only known pendant grouping of these two works.

80 Jean-François Millet

French, 1814-1875

Baby's Slumber, c. 1855

Oil on canvas, 18¼" x 14¾" (46.3 x 37.5 cm)

Signed lower right: *J. F. Millet*

Gift of Walter P. Chrysler, Jr., 71.517

References: Tokyo, 1985, no. 21; Harrison, *CM*, 1986, no. 28.

In 1849 the painter Millet moved from Paris to Barbizon. Within a decade he had become a leader of the small, but influential group of landscape and genre painters that had assembled in that tiny village near the Fontainebleau Forest (nos. 72, 77, 86, 103, 112). There, inspired by seventeenth-century Dutch painting and warm recollections of his peasant upbringing in Normandy, Millet produced a revolutionary series of rural genre scenes – among them *Baby's Slumber* of c. 1855 – that celebrated the lives and labors of the French peasants (see also nos. 81, 89). The humble naturalism of these pictures – their "naive directness of vision" (Robert Herbert) – helped shape the new Realist aesthetic that surfaced in French painting in the mid-nineteenth century.

While at Barbizon, Millet instructed a number of younger American painters, who helped to popularize his work in the United States, particularly in Boston. Among them was the Boston artist Edward Wheelwright, who came to Barbizon to study with Millet in

October, 1855. Wheelwright stayed on until the following spring and published his recollections in 1876 in the *Atlantic Monthly;* one of the noteworthy events he recounted was his viewing of *Baby's Slumber.* Not long after Millet had finished the picture, Wheelwright and several other painters visited his studio while he was away in Paris on business. Inspecting his canvases one by one, they happened upon the painting:

> At last was brought out from its hiding place a picture representing the interior of a peasant's cottage. A young mother was seated, knitting or sewing, while with one foot she rocked the cradle in which lay a child asleep....Anything more exquisitely beautiful than this sleeping child has rarely, I believe, been painted. Through the open window the eye looked out into a garden where a man with his back turned appeared

to be at work. The whole scene gave the impression of a hot summer's day; you could almost see the trembling motion of the heated air outside, you could almost smell the languid scent of flowers, you could almost hear the droning of the bees, and you could positively feel the absolute quiet and repose, the solemn silence, that pervaded the picture. All those at least felt it who saw the picture upon that...morning. A sudden hush fell upon all the noisy and merry party....The silence that was in some way painted into the canvas seemed to distill from it into the surrounding air.

To give depth and resonance to his genre images, Millet frequently alluded to biblical or classical themes. *Baby's Slumber* suggests the domestic harmony of the Holy Family, a parallel that lends an air of sacredness to this modest peasant scene.

81 Jean-François Millet

French, 1814-1875

Peasant Woman Guarding Her Cow,
c. 1857

Black chalk with white heightening on
paper, mounted on board, 12⅜″ x 17⅛″
(31.4 x 43.5 cm)

Signed lower right: *J. F. Millet*

Gift of Walter P. Chrysler, Jr., 71.2128

References: Zafran, *CM*, 1979, no. 63; Tokyo,
1985, no. 26; Manchester, 1991-92, no. 88.

In 1852 Millet's agent Alfred Sensier
secured a state commission for the
artist to paint a subject of his own
choosing. Millet selected an image
new to his art – and to French genre
painting in general – that of a solitary
peasant woman tending the family cow.
Over the next six years he worked
intermittently on the composition,
perfecting its design in a series of pre-
liminary drawings (Museum Boymans-
van Beuningen, Rotterdam; Museum
of Fine Arts, Boston; Art Institute of
Chicago; Louvre, Paris). Millet com-
pleted the painting, *Woman Tending
Her Cow,* in 1858 and showed it at
the Salon in Paris the following year.
After the exhibition it was given by the
government to the Musée de l'Ain in
Bourg-en-Bresse.

Though scholarship is vague on the
point, it seems likely that Millet's highly
finished drawing in The Chrysler
Museum was also a preparatory study
for the Bourg-en-Bresse painting, per-
haps one of the last in the artist's series
of preliminary designs. Indeed, the
drawing's composition – with the cow,
at left, viewed laterally and the young
woman standing at right – was modi-
fied only slightly in the 1858 painting.

As Alexandra Murphy has noted,
French peasants not prosperous
enough to own land had little choice
but to stand guard over their cows as
they grazed to make sure they did not
wander into fields belonging to others.

The numbing, day-long task of pastur-
ing the cow – often a poor family's
most valued possession – was typically
assigned to an older daughter.

In Millet's drawing the young
woman has secured a safe grazing spot
for her family's animal along a public
road, while the herd of a more pros-
perous farmer grazes in his fields
beyond. The thick line of trees bor-
dering the road isolates the figure
compositionally and may also allude
to the social exclusion she suffers be-
cause of her poverty. To pass the time
she engages in knitting, an activity
common to many of Millet's peasant
women (see no. 80) and one long asso-
ciated in European art with the
feminine virtue of domestic diligence.
Like all of Millet's peasant figures, this
country lass is portrayed as a noble fig-
ure of quiet strength, who patiently
perseveres despite the hardships of a
life on the land.

82 Thomas Couture

French, 1815-1879

Pierrot the Politician, 1857

Oil on canvas, 44½″ x 58″ (113 x 147.3 cm)

Initialed and dated left edge: *T.C.*
1857

Gift of Walter P. Chrysler, Jr., 71.2064

References: Albert Boime, *Thomas Couture and the Eclectic Vision*, New Haven and London, 1980, pp. 309-312; Harrison, *CM*, 1986, no. 29.

In his mature paintings like the spectacular *Romans of the Decadence* of 1847 (Louvre, Paris), Thomas Couture combined an interest in academic subjects and compositions with a more innovative commitment to open, scumbled brushwork, resonant color and sharp tonal contrast. His style has been described as the very essence of the *juste milieu* – that moderating blend of conservative and avant-garde aesthetic impulses that occupied so many later-nineteenth-century French painters. A gifted portrait painter, Couture was also an inspired satirist. His biting wit, which was brought to bear on ambitious history pieces like the *Romans*, found particularly sharp expression in his later genre paintings.

Chief among these later, small-scale easel pictures are Couture's *arlequinades*, or harlequin paintings, in which he used the popular stage personae of the Commedia dell'Arte – Harlequin, Pierrot, Columbine, the Doctor – to satirize respectable middle-class life. The series, which spanned the years from 1854 to 1870 and includes *Pierrot the Politician* and six other works, was allegedly prompted in part by Harlequin "visions" that the artist experienced while working on a mural cycle in the church of Saint-Eustache in Paris. The *arlequinades* he distilled from his visions served as allegories of modern folly, thinly-veiled indictments of the foolishness of mid-nineteenth-century Parisian lawyers, doctors, businessmen – "all the situations," Couture proclaimed, "of our contemporary world."

In *Pierrot the Politician* of 1857, two men have doffed their street clothes – an overcoat and top hat rest at right –

and have donned the costumes of Pierrot (in white) and Harlequin for a masked ball. But they have abandoned the festivities for a bit of political shoptalk and gossip over the latest issue of *Le Moniteur Universel*, the official newspaper of the French government. Couture despised the bourgeois preoccupation with "business, always business," and in the painting he takes a jab at those who, even at a costume gala, cannot forgo their dull, mundane concerns.

Couture's satiric intent is underscored by his name for the gala, the *Bal Molière*, emblazoned on the poster on the wall behind the men. The reference is to the great seventeenth-century French dramatist Molière, whose satiric comedies Couture deeply admired and used as a source of inspiration for his moralizing paintings. The surviving studies for *Pierrot the Politician* include a black chalk drawing in the Cummings collection, Detroit, and a preparatory oil sketch in the Wallace Collection, London.

83 George Caleb Bingham

American, 1811-1879

Washington Crossing the Delaware,
1856-71

Oil on canvas, 36¼" x 57¼" (92 x 145.4 cm)

Gift of Walter P. Chrysler, Jr., in Honor of Walter P. Chrysler, Sr., 83.589

References: Sokolowski, *CM*, 1983, pp. 20-22; E. Maurice Bloch, *The Paintings of George Caleb Bingham: A Catalogue Raisonné*, Columbia, Missouri, 1986, pp. 101, 210-211, no. 299.

In groundbreaking genre paintings like his 1845 *Fur Traders Descending the Missouri* (Metropolitan Museum of Art, New York), George Caleb Bingham created an enduring image of frontier life among the trappers and boatmen of the Missouri and Mississippi rivers. He achieved success, too, with his political genre scenes – he himself was elected to the Missouri state legislature in 1848 – and with his portraits. It was as a portrait painter that he first gained artistic fame in the mid-1830s in Missouri, where he had moved with his family from his native Virginia in 1819.

Throughout his career Bingham also worked to establish himself as a painter of elevated historical subjects, longing for the lucrative government commissions and wider reputation that such pictures often brought. His efforts in this area were largely frustrated, however, and he produced only a handful of history paintings. One of the most important of these rare works is his stirring tribute to American Revolutionary War heroism, *Washington Crossing the Delaware*.

Inspired by Emanuel Leutze's famous picture of the same subject (1851; Metropolitan Museum of Art, New York), Bingham began preliminary work on *Washington Crossing the Delaware* in Columbia, Missouri, in early 1856. He had probably seen Leutze's painting in 1853, when it was exhibited in New York, and in January of 1855 he wrote to his friend James Sidney Rollins that he hoped to produce a picture of Washington "connected with some historical incident, in a manner that would rival the far famed picture by Leutze." Bingham's resolve was no doubt strengthened during his study sojourn in Düsseldorf in 1856-58, when he met Leutze himself.

Bingham initially hoped that the project would develop into a commission from the Missouri state legislature. When this did not happen, his work on the painting slowed considerably. It was only in 1871, possibly while he was working with the engraver John Sartain in Philadelphia, that he completed the picture. It remained with the artist until his death and was sold to Thomas Hoyle Mastin of Kansas City in the 1893 auction of the Bingham estate.

Like Leutze, Bingham placed Washington at the apex of a pyramid of figures and made dramatic use of light to emphasize the stalwart, firm-jawed general. But while Leutze showed Washington in profile, standing in a narrow rowboat that moves laterally across the ice-choked river, Bingham portrayed him frontally and on horseback, riding upon a broad, flat-bottomed raftboat that proceeds directly toward the viewer. Bingham's more commanding, iconic equestrian image and his use of a raft may have been inspired by another mid-nineteenth-century historical river scene, William T. Ranney's *Marion Crossing the Pedee* (c. 1850; Amon Carter Museum, Fort Worth).

84 Chauncey Bradley Ives

American, 1810-1894

Undine Receiving Her Soul, after 1859

Marble, 50½" (128.3 cm)

Signed on the base: *C.B. IVES.*
FECIT. ROMAE

Gift of James H. Ricau and Museum Purchase,
86.481

Born in Hamden, Connecticut, the Neoclassic sculptor Ives learned the rudiments of his craft from the New Haven woodcarver Rodolphus Northrop. After additional study in New Haven with the more accomplished marble sculptor Hezekiah Augur, Ives built an early reputation in Boston and New York for his portrait busts. Over the course of his career he produced more than 120 such images, and among the many famous Americans whose portraits he carved were Thomas Sully, Noah Webster and Winfield Scott.

In 1844 Ives went to Italy, in part to improve his failing health. (His family was prone to tuberculosis.) At first he worked in Florence, where most of his American colleagues originally congregated to study. But in 1851 he settled permanently in Rome, which by that time had supplanted Florence as the center of the American Neoclassic movement.

In Italy Ives' portrait busts and winsome images of childhood were perennially popular, especially among wealthy Americans making the Grand Tour. But like so many of his artist countrymen, he felt that only high-minded, idealized works would bring him enduring fame. Thus, after 1844 he began work on a series of subjects drawn primarily from the Bible and classical myth. These, too, were warmly received by his American clientele, and Ives spent much of his later career overseeing the replication of his most popular idealized marbles. They included his 1851 *Pandora* and *Undine Receiving Her Soul,* which Ives first conceived in 1859 and reworked in 1880.

The subject of Ives' *Undine* can be traced ultimately to medieval legends. According to these, undines were Mediterranean sea sprites, mortal, but without souls. To gain a soul and, with it, immortality, an undine had to take on human form and trick a man into marrying her. She then could leave the sea, but only as long as her mate remained true. If he discovered her real identity and rejected her, she would destroy him. The dark tale of the undine's treacherous, ill-fated love was especially popular among Romantic and Victorian artists and writers, and Ives probably encountered it in Friedrich de la Motte-Fouqué's *Undine,* a well-known German romance of 1811. In Ives' sculpture, the sea sprite is shown assuming human form as she emerges from the water – tiny waves on the pedestal lap at her feet. As she reaches heavenward to receive her soul, her wet, clinging gown – a virtuoso example of mid-nineteenth-century "see-through illusionism" (William Gerdts) – runs like water down her body. As Roger Clisby has noted, "The delicate carving and tactile rendering of the drapery folds and the thinness of the marble cloak held high above her head make *Undine* one of the most skillfully crafted pieces in The Chrysler Museum's large collection of American Neoclassic sculptures" (see also nos. 73, 79, 90). The inspired melodrama of Ives' *Undine* is indicative of American Victorian taste. So, too, are the ample proportions of his sea sprite and the voyeuristic intent of her drapery, which does little to conceal her form.

85 Edouard Manet

French, 1832-1883

The Little Cavaliers, c. 1859-60

Oil on canvas, 18″ x 29¾″ (45.7 x 75.6 cm)

Signed lower right: *Manet d'après Vélasquez*

Gift of Walter P. Chrysler, Jr., 71.679

References: *Manet 1832-1883*, exhib. cat., Grand Palais, Paris, and Metropolitan Museum of Art, New York, 1983, pp. 120-121, 506; Harrison, *CM*, 1986, no. 31.

The son of a well-to-do Paris bureaucrat, Manet entered the atelier of Thomas Couture (no. 82) in 1850 and that same year registered as a student copyist in the Louvre. Though he stayed with Couture for six years, he often disagreed with his master's style and working method. He was especially critical of Couture's academic approach to light and shadow – his use of *chiaroscuro* and subtly graded halftones to model form. "It is preferable," Manet contended, "to pass brusquely from light to dark than to accumulate [on the canvas] things the eye cannot see."

Manet soon found an antidote to Couture's art in earlier Spanish painting, and particularly in the works of Velázquez (no. 31), which he began to copy at the Louvre in the late 1850s. He was delighted by the clarity of Veláz-

quez's paintings, their abrupt tonal contrasts and informal figurative compositions. These elements figured prominently in the genesis of his revolutionary Realist style.

More than a third of the paintings Manet produced between 1859 and 1868 were of Spanish themes or bore the compositional or iconographic imprint of Spanish art – a clear reflection of the widespread contemporary French interest in *les choses espagnoles* (things Spanish). Manet made his debut at the Salon in 1861 with a Spanish subject, the *Guitarrero* (Metropolitan Museum of Art, New York), and in 1865 made his long-anticipated trip to Spain "to seek the counsel of Velázquez."

Among the most important of Manet's early studies after Velázquez is *The Little Cavaliers.* In it Manet copied the *Réunion de treize personnages* (or *Gathering of Thirteen Persons of Rank),* a painting acquired by the Louvre in 1851 and in Manet's day attributed to Velázquez (though in recent years it has been ascribed to an artist in Velázquez's circle). Manet also assumed the painting to be by Velázquez, and he paid homage to him in the inscrip-

tion – *Manet d'après Vélasquez* ("Manet after Velázquez") – at the lower right of the canvas.

Having discovered the *Réunion* soon after the Louvre acquired it, Manet was immediately impressed by its bright, daylight clarity. "Ah, that's clean," he reportedly remarked at the time. "How disgusted one gets with all the stews and gravies [of contemporary academic painting]."

Though *The Little Cavaliers* has been dated variously from 1852 to 1860, recent writers tend to agree that it was produced soon after July 1, 1859, the date when Manet, having completed his student years, registered as a professional artist for copying privileges at the Louvre. Probably painted in 1859-60, the picture is one of the earliest surviving documents of Manet's *espagnolisme* and one of the first paintings of his early maturity – a crucial transitional work that ushered in his style of the 1860s.

In 1861 Manet produced the first of five states of an etching after *The Little Cavaliers.* In 1867 he showed both the etching and the painting in his one-man exhibition on the Avenue de l'Alma in Paris.

86 Théodore Rousseau

French, 1812-1867

A Clearing in the Forest of Fontainebleau, c. 1860-62

Oil on canvas, 32½" x 57¼" (82.5 x 145.4 cm)

Signed lower left: *Rousseau.*

Gift of Walter P. Chrysler, Jr., 71.2054

References: Tokyo, 1985, no. 89; Harrison, *CM*, 1986, no. 24; Manchester, 1991-92, no. 107.

Théodore Rousseau was a founding member of the Barbizon group of artists (nos. 72, 77, 80, 89, 103, 112) and one of the most esteemed landscape painters in mid-nineteenth-century France. In the late 1820s he was already at work at Chailly, near the Fontainebleau Forest. There, and on subsequent visits to the Auvergne (1830) and Normandy (1831), he produced a revolutionary series of vibrant and spontaneous *plein-air* landscapes, "pure" landscapes that dispensed with traditional narrative subject matter and classical compositional schemes.

Rousseau's subsequent career in Paris was a constant struggle against the conservative forces of the Salon and Académie Royale. Between 1836 and 1841 his paintings were consistently rejected by the Salon juries, a cruel example of official persecution that earned him the sardonic soubriquet, *le grand refusé.* In 1841 the frustrated Rousseau turned his back on the Salon, where he did not exhibit again until 1849.

The years of rejection had their effect on the artist, who took care after 1850 to produce landscapes more in line with official taste. These composed and carefully worked pictures borrowed much from the landscape art of the seventeenth-century Dutch masters. *A Clearing in the Forest of Fontainebleau,* one of several canvases that Rousseau undertook at Barbizon in 1860-62, is an impressive example of his mature, more finished and traditional style. Its composition and the handling of foliage recall particularly the works of the Dutch landscapist Meindert Hobbema. The site depicted may be the *Carrefour de la Reine Blanche* ("The Crossroads of the White Queen"), a glade in the forest near Barbizon. The site was a favorite of Rousseau's. Three of his other paintings show the same spot; the best known of these is in the Louvre, Paris. The Chrysler Museum picture conveys the clarity and dewy calm of a spring morning near Barbizon, when the first rays of the rising sun bathe the ancient oaks of Fontainebleau in a golden glow.

87 Adolphe William Bouguereau

French, 1825-1905

Orestes Pursued by the Furies, 1862

Oil on canvas, 91″ x 109⅝″ (231 x 278.5 cm)

Signed and dated lower right:
W-BOVGVEREAV-1862

Gift of Walter P. Chrysler, Jr., 71.623

References: *William Bouguereau 1825-1905,*
exhib. cat., Petit Palais, Paris; Montreal
Museum of Fine Arts; and Wadsworth Athe-
neum, Hartford, 1984-85, no. 29; Harrison,
CM, 1986, no. 22.

Bouguereau was among the most
powerful members of France's late-
nineteenth-century art establishment, a
conservative *grand maître* whose paint-
ings helped set the style of official
French art in the decades between 1850
and 1900. His career in Paris was
marked by a succession of professional
triumphs and increasingly prestigious
awards. In 1888 he was made a pro-
fessor at the government-run Ecole des
Beaux-Arts, and from 1876 he served
as a leading member of the all-power-
ful Institut de France. During the late
1870s and the 1880s he also served as
an instructor at the Académie Julian,
one of the most important private art
schools in Paris. After 1860 he began a
series of immensely popular genre pic-
tures – sentimental images of peasant
children and devoted mothers that he

rendered in a flawlessly realistic, aca-
demic style. By 1870 his paintings
fetched consistently high prices from
wealthy collectors in France, England
and America.

A pure product of the Ecole
and its rigorous academic regimen,
Bouguereau throughout his life
stressed the superiority of the classical
ideal. As a teacher he preached the
importance of precise draftsmanship
and a tight, enameled painting tech-
nique. Those avant-garde artists who
ignored such traditional concerns –
chief among them the Impressionists –
he dismissed with scorn.

Orestes Pursued by the Furies of 1862 is
one of the grandest of Bouguereau's
mythological pictures. Its classical
Greek subject is taken from the *Oresteia*
by Aeschylus, in which Orestes, the son
of King Agamemnon, kills his mother
Clytemnestra to avenge the death of his
father, whom she murdered. Orestes is
then set upon by the Furies, the three
spirits of retributive justice, who
relentlessly pursue him as he seeks
to purge his guilt at Delphi and in
Athens. In Bouguereau's painting, the
Furies – Tisiphone, Alecto and Mega-
era – their hair swarming with snakes,
confront Orestes with his crime, point-
ing angrily at the corpse of his mother.

The horrified Orestes lurches away,
vainly trying to escape the Furies and
their hideous cries of accusation. The
grisly scene is given a dramatic noctur-
nal setting – especially appropriate as
the Furies were the daughters of Nyx,
the goddess of night. The painting's
classical composition and imagery
were inspired in part by Pierre Paul
Prud'hon's famous canvas of 1808,
*Justice and Divine Vengeance Pursuing
Crime* (Louvre, Paris), and by John
Flaxman's *Orestes and the Furies,*
engraved in 1793.

When it was shown at the 1863
Salon, Bouguereau's painting was
judged harshly by the critics, who
balked at its heavy, histrionic tone.
Bouguereau had seldom before
attempted so pure an expression of
Romantic high melodrama, and when
Orestes was criticized, he abandoned
the genre for good. Thereafter he
returned to a quieter, Raphaelesque
style and favored far less dramatic pic-
tures of beggar children and classical
nudes. "I soon found that the horrible,
the frenzied, the heroic does not pay,"
he lamented, "and as the public of
today prefers Venuses and Cupids
and I paint to please the public, it is
to Venus and Cupid that I chiefly
devote myself."

88 Eugène Fromentin

French, 1820-1876

Arab Falconer, 1863

Oil on canvas, 42" x 27¾" (106.7 x 70.5 cm)

Signed lower left: *Eug. Fromentin.*

Gift of Walter P. Chrysler, Jr., 71.648

References: *The Orientalists: Delacroix to Matisse,* exhib. cat., National Gallery of Art, Washington, D.C., 1984, no. 24; James Thompson and Barbara Wright, *La vie et l'oeuvre d'Eugène Fromentin,* Paris, 1987, pp. 194-197.

Fromentin possessed remarkably varied artistic talents. He achieved fame not only as a painter, but as a travel writer, novelist and art critic. After devoting his youth to the study of law, he resolved to become an artist and in 1844 began his training in Paris with the landscape painter Louis Cabat. A fleeting visit to Algeria in 1846 confirmed his growing interest in romantic, Orientalist themes (see nos. 76, 99). When two of his North African pictures were applauded at the 1847 Salon in Paris – his public debut – he returned to Algeria for a longer stay. By 1850 Fromentin was well-known in France as a leading Orientalist painter, and his final Algerian sojourn of 1852-53 provided enough material to sustain him in this genre for the rest of his life.

Fromentin's passionate interest in North Africa inspired him to write two travel accounts, *A Summer in the Sahara* and *A Year in the Sahel,* in the later 1850s. In 1862 his famous novel *Dominique* appeared in print, and just before his untimely death at age fifty-five, he issued his treatise on Dutch and Flemish painting, *Les Maîtres d'autrefois,* which is viewed today as one of the most significant pieces of art criticism produced in the nineteenth century.

Displayed at the 1863 Salon, The Chrysler Museum painting captures one of Fromentin's favorite and most picturesque subjects – the nomadic Arab plainsman astride his coursing steed. Here a falconer on the hunt races before his comrades, clutching in his upraised hand a perch and the leather leashes holding his birds of prey. Fromentin's Salon offerings elicited almost unanimously positive reactions from conservative critics and the public, and the *Arab Falconer* was especially well received. The critic Paul Mantz, for example, marveled at the spirited conception of the horseman, who seemed "bewitched by the seductions of the chase. The figure...is full of movement and wild energy." Others praised the artist's fluid handling of the brush, which bathes the painting's surface in veils of liquid color.

Many European artists of the day viewed the Arab plainsman as an uncorrupted "child of Nature," a heroic Noble Savage whose life was still intimately tied to the rhythms and pulse of nature. Fromentin endorses this romanticized view in the *Arab Falconer,* in which the hunter seems as fierce and wild as his mount and birds of prey.

The great popularity of the painting encouraged Fromentin to repeat its composition, in mirror image, one year later in a picture now in the Metropolitan Museum of Art, New York. A closely related watercolor, possibly a study for the *Arab Falconer,* is in the Cleveland Museum of Art.

89 Charles-Emile Jacque

French, 1813-1894

Shepherd Watching Over His Flock, 1864

Pencil with white and red heightening on grey paper, mounted on board, 12¾″ x 9½″ (32.4 x 24.1 cm)

Signed and dated lower left:
ch. Jacque. 1864.

Gift of Walter P. Chrysler, Jr., 71.2641

Reference: Zafran, *CM,* 1979, no. 66.

The lives and labors of the peasants became popular subjects with French painters particularly in the decades after 1850. The sudden fashion for rustic themes at mid-century was due to changes in political and aesthetic tastes. France's Revolution of 1848 toppled King Louis-Philippe and unleashed a fiercely democratic wave of anti-royalist feeling among French intellectuals, who found a new cultural hero in the country's hard-working rural laborer. The 1848 Revolution also marked the advent of a new style of painting, Realism. Led by Gustave Courbet and the Barbizon painters gathered around Jean-François Millet (nos. 80, 81) and Charles-Emile Jacque, the Realists discovered in peasant themes an ideal outlet for their earthy, naturalistic styles and often radical political sentiments. They viewed the peasants as "natural men" who, unlike their urban counterparts, still lived in harmony with the land and the endless cycle of the seasons. They saw them as possessors of simple, timeless virtues — honesty, industriousness, piety — that seemed to have vanished from the streets of Paris.

In this highly finished drawing of 1864, and in a painting by him also in The Chrysler Museum (no. 112), Jacque paid tribute to France's peasant worker with what was, no doubt, his favorite image of rural labor: the sheepherder tending his flock. Containing within them a pious allusion to Christ as Good Shepherd, Jacque's many depictions of the diligent French herdsman appealed especially to conservative Parisian audiences. Though Jacque's brand of Realism occasionally matched the starkness of Millet's, it was generally more sentimental in tone, as in the present drawing. Here the shepherd is an innocent, a barefooted boy who performs his task with stoic resolve. The rural world he inhabits seems as mild and untroubled as Arcadia and recalls the bucolic paradises depicted during the previous century by François Boucher (no. 51) and other rococo artists.

90 William Henry Rinehart

American, 1825-1874

Hero, 1874

Marble, 33½" (85 cm)

Signed and dated on the base:
 *WM. H. RINEHART. SCULPT.
 ROME. 1874*

Leander, after 1859

Marble, 40" (101.6 cm)

Gifts of James H. Ricau and Museum Purchase, 86.512 and 86.513, respectively

Reference: William H. Gerdts, *American Neo-Classic Sculpture,* New York, 1973, pp. 56-57.

The American Neoclassic movement lasted roughly fifty years, from 1825 to 1875, and among the finest sculptors who worked during its creative apogee was William Henry Rinehart. Like so many of his American colleagues (nos. 73, 79, 84), Rinehart was an expatriate who centered his career in Rome, where he eventually settled in 1858. He was an inveterate traveler who left Italy often during his short career for trips to Paris and London and visits home to the United States. A native of Maryland, he made many of these trips at the behest of American patrons like the Baltimore art collector William T. Walters. Rinehart had already attracted the attention of Walters and other businessmen while a student in Baltimore at the Maryland Institute of the Mechanic Arts. It was they who encouraged his first trips to Italy, in 1855 and 1858, and helped to build his moneyed clientele of American industrialists, bankers and railroad tycoons.

American Neoclassic sculptors produced a remarkable number of pendant works (see no. 79), though few of these pairs remain together today. Rinehart created his marble, half-life-size pendants of *Hero* and *Leander* over several years. He began work on *Leander* in 1859, soon after he settled in Rome, and he perfected its design using the traditional preliminary steps of clay sketch and plaster model. *Hero,* however, was first executed in marble only in 1866. Rinehart's idealized images of male and female beauty proved popular; at least seven replicas of *Hero* were produced. The sculptor sometimes sold the two pieces separately – each functions well as a self-contained composition – and today pendant groupings of *Hero* and *Leander* are exceedingly rare. The only other known set besides the Chrysler's is in the Newark Museum.

Hero

Rinehart's pendants were inspired by the tragic love story of Hero and Leander recounted in Ovid's *Heroides* and other classical literary sources. Hero, a beautiful priestess of Aphrodite, resided on the west side of the Hellespont, her lover Leander, on the east. Each evening Leander would swim across the Hellespont to be with his beloved. One stormy night the light that guided him failed, and Leander lost his way and drowned. Overcome with grief, Hero threw herself into the sea and drowned. Their story was illustrated often by contemporary artists, particularly after Lord Byron's celebrated 1810 swim of the Hellespont in imitation of the mythic Greek Leander. Rinehart's works show Leander disrobing in preparation for his evening swim, while Hero, her beacon lamp beside her, ardently awaits her lover on the other shore. Waves "lap" at the bases of both sculptures.

Nineteenth-century American audiences were generally conservative regarding nudity in sculpture. They tended to favor the unclothed male

Leander

body far less than the female form,
which they felt more successfully
reflected the classical notion of beauty.
Sculptors, therefore, produced rela-
tively few male nudes, and Rinehart's
Leander is one of the finest examples of
this rare genre. Inspired particularly
by Michelangelo's marble *David*
(Accademia, Florence), *Leander* has
been described by William Gerdts as
"probably the most beautiful male
nude in all of American Neoclassicism."

91 Paul Cézanne

French, 1839-1906

Bather and Rocks, c. 1860-66

Oil on canvas, transferred from plaster, 66″ x 41½″ (167.6 x 105.4 cm)

Gift of Walter P. Chrysler, Jr., 71.505

References: Harrison, *CM,* 1986, no. 32; *Cézanne: The Early Years 1859-1872,* exhib. cat., Royal Academy of Arts, London *et al.,* 1988-89, pp. 5-6.

A major influence on early twentieth-century modernism, Cézanne labored to restore structure and intellectual control to painting following the era of Impressionism. "I want to make of Impressionism something solid," he once proclaimed, "like the art of the Museums." In his mature paintings of the 1880s and 1890s, and particularly in his later landscapes and still lifes, Cézanne portrayed the visible world as an architectonic interlocking of colors and simple, reductive forms, a tight and "permanent" semiabstraction that would in time inspire the Cubism of Picasso and Braque (no. 139).

Cézanne's mature, Post-Impressionist style began to emerge after 1872, when his encounters with Camille Pissarro (no. 96) rapidly transformed his art. Before that time, the young painter had worked in an altogether different style, a blunt and brooding Romantic mode full of dark energy and often violent emotion. This early style, which scholars have only recently begun to research in depth, is revealed to spectacular effect in *Bather and Rocks* of c. 1860-66.

Cézanne initially divided his time between his native Provence and Paris, where his paintings were consistently refused by the Salon and ridiculed by the critics at the Impressionist exhibits of 1874, 1876 and 1877. After 1877 he secluded himself more and more in Provence – at L'Estaque and in his hometown of Aix-en-Provence – and there lived the life of a misanthropic recluse. He often worked in these years at the Jas de Bouffan, his family's country estate on the outskirts of Aix.

Cézanne's father, a hard-nosed banker who had little patience for his son's artistic aspirations, purchased the seventeenth-century mansion of the Jas de Bouffan in 1859. Soon after, he reluctantly agreed to let Cézanne have a studio there. During the following decade he also allowed his son to decorate the grand salon of the Jas de Bouffan with murals of his own design. These large-scale paintings, which Cézanne executed in oil directly on the plaster walls of the room, are among the most ambitious of his early works. They included two large landscape murals, painted in 1860-62. Probably after his visit to Paris in 1862-64, Cézanne added the figure of a massively-muscled male nude seen from behind to one of these landscapes – a rocky vista with pine trees and a rushing stream. This *Landscape with Bather* remained *in situ* and intact until 1907, the year after Cézanne's death. At that time Louis Granel, who had purchased the house from the artist in 1899, had most of the murals detached from the walls, transferred to canvas and readied for sale. The only portion of the *Landscape with Bather* that was removed from the wall (and saved from destruction) was the nude male figure – i.e., the *Bather and Rocks* that is today in The Chrysler Museum.

The design and dorsal presentation of Cézanne's nude were clearly influenced by Gustave Courbet, as can be seen, for example, from Courbet's 1853 painting of *The Bathers* in the Musée Fabre in Montpellier. However, the style of Cézanne's figure – its turbulent brush technique and heavy, black contours – more closely recalls the passionate Romantic art of Delacroix (no. 76).

92 Jean-Baptiste Carpeaux

French, 1827-1875

Ugolino and His Sons, c. 1870

Bronze, 19″ (48.3 cm)

Signed and dated on the base:
JBte Carpeaux Roma 1860

Gift of Walter P. Chrysler, Jr., 71.2066

Reference: *The Romantics to Rodin: French Nineteenth-Century Sculpture from North American Collections,* exhib. cat., Los Angeles County Museum of Art *et al.,* 1980-81, no. 32.

The son of a stonemason from Valenciennes, Jean-Baptiste Carpeaux became one of the most celebrated and controversial of the French Romantic sculptors. After training with sculptors François Rude and Francisque Duret at the Ecole des Beaux-Arts in Paris, Carpeaux won the Ecole's coveted fellowship, the *Prix de Rome,* in 1854. Soon after he departed for Italy, where he worked and studied for six years (1856-62) at the French Academy in Rome. Independent and strong-willed, he ignored the antique sculptures the French Academy prescribed for study and immersed himself instead in the sculptural art of Michelangelo.

Carpeaux's most ambitious Roman work and his first undisputed masterpiece – the famous *Ugolino and His Sons* – was conceived in 1857-58 as his fourth-year-student project at the French Academy. Hampered by the Academy's director, Victor Schnetz, who at first opposed the project, he did not finish the sculpture until 1861, more than a year after his fellowship had lapsed.

Carpeaux completed the preliminary clay model of *Ugolino* in late 1858, when an initial plaster sketch, or maquette, was cast from it. By November of 1861 he had finished a life-size plaster cast, which was shipped to Paris and shown at the Ecole des Beaux-Arts in 1862. The triumphant display of the life-size bronze cast at the 1863 Salon earned Carpeaux a first-class medal and marked his emergence as "the sculptural star of the Second Empire" (Jeremy Cooper).

Recounted in canto 33 of Dante's *Inferno,* the story of Ugolino is a grim tale of death and cannibalism that had long been popular with Romantic artists. The thirteenth-century Italian nobleman Ugolino de' Gherardeschi was condemned for his treachery against the town of Pisa and was imprisoned in a tower with two of his sons and two grandsons. There all five were slowly starved to death. When in desperation Ugolino gnawed upon his hands, his children, Dante writes, "thought [he] did it through desire of feeding" and begged him to consume their bodies once they were dead. Ugolino eventually succumbed and devoured his dead sons and grandsons.

Carpeaux compresses all the horror and suffering of Dante's narrative into an imposing pyramid of five tightly interlocking figures. At the apex sits Ugolino, overwhelmed by despair as his children and grandchildren expire at his feet. Michelangelo's influence is particularly evident in Ugolino's brooding pose and in the "agonized realism of [the figures'] straining muscles and clawing fingers" (Anne Wagner).

Around 1870 Carpeaux issued several reductions of the popular sculpture, among them the present bronze cast.

93 Henri Joseph Harpignies

French, 1819-1916

Moonrise on the Loire at Briare, 1866

Oil on canvas, 54" x 87¼" (137.2 x 221.6 cm)

Signed and dated lower left:
 h. harpignies 1866.

Gift of Walter P. Chrysler, Jr., 71.658

The landscapist Harpignies was a late-comer to painting. His father, a Valenciennes sugar merchant, had little tolerance for his son's artistic interests and initially demanded that he pursue a career in business, as an itinerant iron salesman. Only in 1846, when Harpignies was twenty-seven years old, did his father relent and allow him to begin studying art in Paris with the landscape painter and engraver Jean Achard.

Though he was never a member of its inner circle, Harpignies was fundamentally influenced by the Barbizon group (nos. 72, 80, 86) and especially by the landscapes of Camille Corot (no. 72). He visited Italy twice – in 1850-52 and again in 1863-65 – and it was just after the first Italian trip that he made his debut at the Paris Salon, in 1853. He also worked at Barbizon and nearby Marlotte and became known for his paintings and watercolors of the French and Italian countryside. His favorite landscape motifs included trees and undergrowth, which he often painted with the broad brush and silvery, atmospheric hues of Corot's Romantic *souvenirs* (see no. 72). His approach was deliberate and undramatic, his tone understated and serene. After 1878 Harpignies worked primarily at Saint-Privé, near Paris. Though nearly blind in later years, he continued to paint until his death at the age of ninety-seven. He is celebrated

today as one of the last great exponents of the Barbizon style.

During his middle years Harpignies frequently worked in the Nivernais region south of Paris, painting the countryside along the river Loire. This is the setting of The Chrysler Museum landscape, which the artist produced in 1866 and showed at the 1885 Salon. This poetic twilight scene captures the fleeting atmosphere of early evening, when the sun has set but still lights the sky. A majestic oak, already shrouded in shadow, is silhouetted against the sky's fading light. Just beneath it, barely visible in the gathering darkness, a figure hurries homeward. The work recalls Corot in its loose, approximate brush technique and monochrome palette. A smaller version of the painting was formerly in the London collection of Denys Hague.

94 Eastman Johnson

American, 1824-1906

Fiddling His Way, 1866

Oil on canvas, 24¼″ x 36¼″ (61.6 x 92 cm)

Signed and dated lower left:
 E. Johnson 1866

Bequest of Walter P. Chrysler, Jr., 89.60

References: *Eastman Johnson,* exhib. cat., Whitney Museum of American Art, New York; Detroit Institute of Arts; and Milwaukee Art Center, 1972, no. 49; Patricia Hills, *The Genre Painting of Eastman Johnson,* New York and London, 1977, pp. 63-64.

Genre painting – the straightforward depiction of scenes drawn from ordinary, daily life – did not become widely popular in the United States until the decades after 1830. It was then that the pioneering genre artists William Sidney Mount and George Caleb Bingham (no. 83) first began to capture on canvas the essence of the indigenous American experience. Chief among their younger colleagues was the Maine-born Eastman Johnson, one of the most commercially successful and academically sophisticated genre painters who worked in post-Civil War America. Johnson studied in Europe – at the Düsseldorf Academy, at The Hague and in Paris with Thomas Couture (no. 82) – in 1849-55. Thereafter he practiced in New York, where his rustic images of rural American life and scenes of fashionable Victorian interiors attracted a wealthy clientele of bankers and merchants.

As Mount had done in the 1830s, Johnson devoted several of his early genre paintings to African-American subjects – a topical choice in the years around 1860, when the heated national debate over slavery escalated into the Civil War. In fact, Johnson made his reputation in New York with one of these paintings, the 1859 *Life in the South* (New-York Historical Society, New York City). This sentimental portrayal of contented slaves in the antebellum South was widely acclaimed and prompted his election to the National Academy of Design. During the 1860s, Johnson followed it with other African-American subjects, some of which also depicted music making.

A particularly ambitious example is *Fiddling His Way* of 1866, which offers a sanguine appraisal of life in America for the newly emancipated black man.

In the painting an itinerant black fiddler – a freedman now able to earn his livelihood from his music – performs in the kitchen of a rural white family. The musician is portrayed as noble, sensitive and self-composed, and his rustic white audience welcomes him as an equal as they listen respectfully to his music. The "episodic" quality of the scene – the panoramic presentation of several, independent genre vignettes – is typical of Johnson's work and of the Düsseldorf school in general. As Patricia Hills has observed, the painting also recalls the genre works of the seventeenth-century Dutch masters and the country genre scenes of the earlier nineteenth-century Englishman, David Wilkie (no. 64). *Fiddling His Way* was shown in New York in 1866 at the National Academy of Design and was displayed the following year at the Universal Exposition in Paris.

95 Johan Barthold Jongkind

Dutch, 1819-1891

Along the Ourcq, 1866

Oil on canvas, 13⅜″ x 22¼″ (34 x 56.5 cm)
Signed and dated lower right: *Jongkind 1866*
Gift of Walter P. Chrysler, Jr., 71.545
Reference: Harrison, *CM*, 1986, no. 41.

The marine and landscape specialist Jongkind was, perhaps, the most important precursor of the French Impressionist school. He served as mentor to Eugène Boudin (no. 109) and to the young Claude Monet, whom he encountered in Normandy in the summer of 1862 and impressed greatly with his sparkling *plein-air* pen sketches and watercolors. "From that time on," Monet wrote, "he was my real master, and it was to him that I owed the final education of my eye."

Born and trained initially in Holland, Jongkind arrived in Paris in 1846 and joined the atelier of the famous marine painter Eugène Isabey. Within a year he was painting along the Nor-

mandy and Brittany coasts. He made his debut at the 1848 Salon, and though his works sold well, he was plagued by debts and was often deeply depressed. At his mother's death in 1855, Jongkind suffered a nervous collapse and withdrew to Holland, where he lived for five years as an impoverished semi-recluse.

After his return to Paris in 1860, however, his fortunes brightened, largely through the efforts of his enthusiastic patron Théophile Bascle and his new-found companion Josephine Fesser-Borrhée. By the mid-1860s Jongkind had reached his creative pinnacle, producing some of the most vibrant and spontaneous of his Pre-Impressionist landscapes. Among these mature works is the 1866 *Along the Ourcq*, which was apparently purchased from the artist by Bascle.

The painting depicts the Ourcq canal, which lies just northeast of Paris. Since Mme Fesser-Borrhée's brother-in-law lived near the canal, in the vil-

lage of Pantin, Jongkind had ample opportunity to study and paint the waterway and its well-trodden towpaths. The Ourcq was, in fact, one of Jongkind's preferred sites in the mid-1860s, when he sketched and painted it repeatedly under varying atmospheric conditions – in sunlight, in moonlight, in the rain. An 1864 painting of the canal by Jongkind, today in the collection of Paul Mellon (Upperville, Virginia), and a watercolor view from the same year (private collection, Paris) directly anticipate the design of The Chrysler Museum canvas.

Jongkind customarily composed his paintings in the studio, consulting sketches he had made *sur le motif* (on the spot). Though not painted out-of-doors, *Along the Ourcq* nonetheless conveys the freshness and freedom of a rapidly executed *plein-air* impression. These were the very qualities that attracted Monet and, as Boudin said, "opened the door through which all the Impressionists passed."

96 Camille Pissarro

French, 1830-1903

The Maidservant, 1867

Oil on canvas, 36½" x 28¾" (92.7 x 73 cm)

Initialed lower right: *C.P.*

Gift of Walter P. Chrysler, Jr., 71.530

References: Ludovic Rodo Pissarro and Lionello Venturi, *Camille Pissarro: Son Art – Son Oeuvre*, Paris, 1939, I, p. 85, no. 53; Harrison, *CM*, 1986, no. 33.

Pissarro was one of the most politically radical members of the French Impressionist school (cf. nos. 111, 113, 120). Profoundly affected by the anarchist ideology of Pierre Joseph Proudhon, he became an anarchist republican, espousing a workers' utopia of social egalitarianism. He was philosophically indifferent to the picturesque landscapes, sunny portraits and sophisticated urban views of his fellow Impressionists (nos. 111, 113). He chose instead for his paintings rather stark, utilitarian settings – mill scenes and anonymous village thoroughfares – and the common men who inhabited them – rural peasants and ordinary laborers like *The Maidservant*.

Emile Zola, one of Pissarro's earliest and most ardent champions among the critics, sensed the proletarian honesty and directness of his art at the 1866 Salon. (Pissarro had made his Salon debut some seven years earlier.) Zola wrote:

> I know that you were admitted [to the Salon] with great difficulty, and I congratulate you on that....You chose [to exhibit] a wintry scene with nothing but an avenue, a hill at the far end, and empty fields stretching to the horizon. Nothing whatever to delight the eye. An austere and serious kind of painting, an extreme concern for truth and accuracy, an iron will. You are a great blunderer, sir – you are an artist that I like.

Zola might well have made a similar comment about *The Maidservant*, in which the humble figure of a domestic carrying a tray into a garden is depicted without artifice, yet with quiet compassion. Dated stylistically to 1867, the painting is an early work, produced shortly after Pissarro moved from Paris to Pontoise, some thirty miles northwest of the French capital. The work predates Pissarro's conversion to Impressionism, which took place shortly after he settled in Louveciennes in 1869.

The Maidservant is one of fewer than seventy paintings that survive from Pissarro's first phase of artistic activity preceding the Franco-Prussian War (1870-71). The overwhelming majority of his early works were lost during the war, when invading Prussian troops occupied his house at Louveciennes and destroyed most of the fifteen hundred pictures he had stored there. The few remaining paintings from this period are mostly landscape views that reflect the influence of Corot (no. 72), Pissarro's first great teacher, and Daubigny (no. 103). *The Maidservant* offers a rare glimpse of the artist's early figure style. The woman's heavy, broadly modeled form and the paint thickly applied with a palette knife recall the art of Gustave Courbet, whose influence on Pissarro was also strong at the time.

97　Gustave Doré

French, 1832-1883

The Neophyte (First Experience of the Monastery), c. 1866-68

Oil on canvas, 57⅜″ x 107½″ (145.7 x 273 cm)

Signed lower left: *Gve Doré*

Gift of Walter P. Chrysler, Jr., 71.2061

References: Annie Renonciat, *La vie et l'oeuvre de Gustave Doré,* Paris, 1983, p. 171; *Gustave Doré 1832-1883,* exhib. cat., Musée d'Art Moderne, Strasbourg, 1983, no. 64.

Gustave Doré was born in Strasbourg but spent part of his childhood in Bourg-en-Bresse, near Lyon, where his father worked as a railroad engineer. An artistic prodigy, he had already produced his first lithographs by the age of fifteen, when he and his parents left Bourg-en-Bresse to visit Paris. Resolving to stay in the French capital, he made his debut at the Salon in 1848 with a pair of ink drawings and by 1854 had achieved considerable fame with his illustrations for the collected works of Rabelais. Extraordinarily prolific, he went on to illustrate over 220 books, among them Balzac's *Droll Stories* (1855), Dante's *Inferno* (1861) and the *Bible* (1866). His graphic style – a darkly Romantic *Grand Guignol* – was immensely popular, and by 1875 he had become France's most celebrated illustrator.

Though unrivaled in his success as a graphic artist, Doré aspired to the more "serious" profession of painting, and after 1850 he began submitting pictures – landscapes, genre paintings, historical and biblical scenes – to the Salon. He produced more than two hundred, the bulk of them after 1868. These works were received less enthusiastically in Paris than in London, where the artist helped establish the Doré Gallery in 1869 and sold his paintings briskly to an appreciative British and American clientele.

The Neophyte, Doré's superb genre painting in The Chrysler Museum, features a young Carthusian novice (a newly admitted monk) who has apparently taken his vows somewhat hastily and is beset by misgivings. Seated in chapel among his fossilized elders, he stares out at the viewer, his eyes full of loneliness and alienation. The painting's unusual subject was inspired by George Sand's 1838 novel of monastic life, *Spiridion,* in which the troubled young novice Brother Angel recalls the aridity and isolation of his life behind the monastery wall: "The weeks and months slipped away [and] each day the solitude widened its circle....All my friends had left me....I had too much faith in my vocation to conceive any idea of rebellion or flight....I would live and die misunderstood."

This melodramatic and very Romantic image of spiritual alienation was one of Doré's favorites. He first turned to the subject of the neophyte in 1855, when he produced a lithograph, *Brother Angel,* to illustrate an edition of *Spiridion.* During the next two decades, he varied and expanded upon this composition in more than a dozen etchings and drawings. One of these drawings is in the Museum's collection (no. 98).

Doré also produced another painting of *The Neophyte* (City Art Collection, Los Angeles), a somewhat larger and more ambitious composition that features two rows of twenty-four praying monks. Dated 1866, this painting was shown at the Salon of 1868, the same year that Doré displayed the undated Chrysler picture at the German Gallery in London. Though scholars are uncertain as to which of these two works was created first, it seems probable that the Chrysler picture preceded and inspired the more complex Los Angeles painting.

The Neophyte exhibits Doré's genius for caricature, which serves to heighten the extreme contrast in the painting between youth and old age. As a British reviewer of the time noted, the neophyte's "pure, spiritual and intellectual head stands out in contrast with a row of doting, drivelling, brutally sensual...or smoothly hypocritical companions." Doré himself sensed the grim comedy of the young man's predicament and quipped, "He will be over the wall tonight."

98 Gustave Doré

French, 1832-1883

The Neophyte, c. 1869

Pen and brown ink over traces of pencil on laid
paper, 7¼″ x 4½″ (18.4 x 11.4 cm)

Signed lower left: *G Doré*

Museum Purchase, 83.358

Reference: *One Century: Wellesley Families Collect,*
exhib. cat., Wellesley College Museum, Well-
esley, Massachusetts, 1978, no. 20.

Acquired by The Chrysler Museum
in 1983, this drawing of *The Neophyte*
illustrates the monastic theme that
Gustave Doré reworked repeatedly
from 1855 to 1876 in more than a
dozen compositionally related paint-
ings, drawings and prints. Doré's two
paintings of *The Neophyte* include one in
the Museum's collection, c. 1866-68 (see
no. 97 for a discussion of the theme
and related works), and another, dated
1866, in Los Angeles (City Art
Collection).

Because Doré often repeated com-
positional and figurative motifs in his
many illustrations of *The Neophyte,* it is
difficult to chronologically locate the
undated Chrysler drawing in the series.
Though the three principal figures in
the drawing clearly resemble the cen-
tral figures in the Museum's painting
(no. 97), the drawing contains two rows
of praying monks, the painting only
one. In this respect the drawing brings

to mind the central portion of Doré's
other painting of 1866, a more ambi-
tious composition featuring two tiers of
twenty-four monks.

Of Doré's three other known draw-
ings of *The Neophyte* (private collection;
Musée Municipal, Nemours; Musée de
Peinture et de Sculpture, Grenoble),
the Chrysler sketch most closely re-
sembles the works in Nemours and
Grenoble. It might well have been a
preliminary study for the central fig-
ures in either of these two more highly
finished drawings, both of which, in
turn, probably served as models for
etchings. The undated Nemours and
Grenoble drawings are often dated c.
1869, and the Chrysler sketch may date
from the same period.

As Ann Gabhart has observed, the
drawing displays Doré's characteristic

> fluidity of line, skill in depiction,
> and exuberance of surface design.
> Doré alternates with great assur-
> ance between a fully descriptive
> mode for the sensitively rendered
> head of the young monk and the
> briefly suggested depiction of the
> old men in the second stall. Occa-
> sionally his pen seems animated by
> a simple joy in flow and movement
> of line, especially in the endless
> folds of the expanse of Carthusian
> robes.

99 Jean-Léon Gérôme

French, 1824-1904

Excursion of the Harem, 1869

Oil on canvas, 31″ x 53″ (78.7 x 134.6 cm)

Signed at left on the stern of the boat:
J.L. GEROME.

Gift of Walter P. Chrysler, Jr., 71.511

References: Harrison, *CM,* 1986, no. 26;
Gerald M. Ackerman, *The Life and Work of Jean-Léon Gérôme,* London and New York, 1986,
p. 226, no. 188.

Like his colleague Bouguereau (no. 87), Gérôme was a standard-bearer of the French academic style, a conservative grand master who carried the hallowed traditions of Davidian classicism into the second half of the nineteenth century. Like Bouguereau, too, he was one of the most influential artists of his day. For a full forty years (1863-1904) he served as a professor at the Ecole des Beaux-Arts in Paris, where his impeccable professional credentials drew generations of students, many of them Americans, to his atelier.

Gérôme achieved his greatest fame as an interpreter of Orientalist sub-jects (see nos. 76, 88). In the years after 1853 he traveled repeatedly to North Africa and the Near East – he visited Egypt alone seven times – and he devoted more and more of his art to genre images of Arab life. These works offered a more balanced and realistic portrayal of contemporary Egypt and Arabia than had earlier Romantics like Delacroix (no. 76). However, in the clarity and polish of their brushwork – in their careful crafting of detail and draftsmanly precision – Gérôme's Orientalist pictures remained thoroughly academic.

Gérôme made his earliest tour of Egypt in 1856. He spent half of his eight-month visit in Cairo and the other half navigating the Nile, sketching the fabled waterway and its exotic river traffic. Thereafter the Nile became a favored setting for his Egyptian genre pieces, as can be seen in the well-known *Excursion of the Harem* of 1869, in which a delicate private pleasure craft ferries a sultan's seraglio along the river. Gérôme exhibited the painting at the Salon of 1869, where it was warmly received. The Empress Eugénie, wife of Napoleon III, hoped to buy it but demurred when told its price – 30,000 francs. After viewing the *Excursion,* the critic Théophile Gautier marveled at its atmospheric and luminary subtleties:

> The boat slips over the clear transparent water, along the misty shore in a sort of luminous fog which produces a magical effect. The bark seems to float at the same time in the water and in the air....the delicate tones of the "land of light" are rendered by Monsieur Gérôme with absolute fidelity.

A recent cleaning of the painting has once again revealed its luminous palette of mauve and violet hues.

The work must also have appealed to the young American Thomas Eakins, who studied with Gérôme from 1866 to 1869 and whose Philadelphia sculling pictures of the early 1870s owe an obvious debt to Gérôme's *Excursion* and other Egyptian river scenes.

100 Charles Gleyre

Swiss, 1806-1874

The Bath, 1868

Oil on canvas, 35½″ x 25″ (90.2 x 63.5 cm)

Signed and dated lower right: *C. GLEYRE 1868.*

Gift of Walter P. Chrysler, Jr., 71.2069

References: Harrison, *CM,* 1986, no. 21; *Paris 1889: American Artists at the Universal Exposition,* exhib. cat., Chrysler Museum, Norfolk; Pennsylvania Academy of the Fine Arts, Philadelphia; and Memphis Brooks Museum of Art, 1989-90, pp. 246-248.

Though Charles Gleyre centered his distinguished career in Paris, he maintained close professional and personal connections with his native Switzerland. Indeed, the major works of his middle years were a pair of nationalistic Swiss history paintings for the Musée Arlaud in Lausanne: *Major Davel* (1846-50) and *The Romans Passing under the Yoke* (1850-58).

Gleyre arrived in the French capital in 1825 and from there traveled to Italy and the Near East in 1828-37. Returning to Paris, he made his reputation in 1843, when his most famous painting, *Evening* (Louvre, Paris), was unanimously applauded at the Salon.

Gleyre was a meticulous craftsman who sometimes labored for years on a single canvas. His precise draftsmanship and crystal clarity of form marked him as an academic, as did his penchant for historically accurate genre detail. Yet, he was by no means an "establishment" artist. A brooding, solitary figure, he spurned wealth and official honors to devote much of his energy to teaching. His liberal aesthetic views attracted hundreds of pupils, including several fledgling Impressionists and a good many Americans, and his atelier became one of the most popular in mid-nineteenth-century Paris.

Having initially devoted himself to Orientalist themes (cf. nos. 76, 88, 99) and grandiose historical works, Gleyre turned late in life to more intimate, poetic visions of the unclothed female form. Imbued with a "sense of grace and quiet introspection" (William Hauptman), these pellucid genre and mythological paintings are said to reflect the serenity of Gleyre's final years. *The Bath,* 1868, is a case in point. A captivating bit of antique Roman genre, it is one of only a handful of Gleyre's paintings found in the United States.

The setting is the atrium of a patrician Roman household, where a mother prepares to bathe her infant son. The nude girl who attends at right, her supple form radiating light, may be the woman's sister. The artist apparently derived the subject from an antique terra-cotta relief in the Campana collection, housed at that time in the Musée Napoléon III in Paris. Following traditional academic practice, Gleyre perfected his figure designs for *The Bath* in a series of exquisite preliminary drawings and painted sketches. Four of these – pencil drawings of the mother, infant and girl, and an oil study of the girl's head – are in the Musée Cantonal des Beaux-Arts, Lausanne.

The Bath was painted for John Tay-lor Johnston, a well-known New York art collector and the first president of the Metropolitan Museum of Art. While in Paris in the autumn of 1868, Johnston visited Gleyre's studio and recorded in his journal his first impressions of the painting. "I was delighted to find that it was really a remarkable picture of great power and sweetness," he wrote, "and such as I am perfectly satisfied to take." Later writers have responded with equal ardor, as is seen, for example, in Edward Strahan's glowing tribute:

> The picture, in its blond perfection and ivory translucence, gives rather the idea of statuary than of painting....It is such an achieved bit of perfection as a teacher leaves but once or twice in his career.

101 Albert Bierstadt

American, 1830-1902

The Emerald Pool, 1870

Oil on canvas, 78" x 119¾" (198 x 304.2 cm)

Signed and dated lower right center:
ABierstadt
1870 (initials conjoined)

Bequest of Walter P. Chrysler, Jr., 89.59

References: Gordon Hendricks, *Albert Bierstadt Painter of the American West,* New York, 1974, p. 196; Catherine H. Campbell, "Albert Bierstadt and the White Mountains," *Archives of American Art Journal,* 21 (1981), pp. 14-15, 17.

The scene of *The Emerald Pool* is laid in the White Mountains of New Hampshire....The dark pool in the foreground, from which it is named, is a favorite resort of tourists....On either side are rocky walls clad with trees and moss, while in the distance rises Mount Washington, veiled, but not hid, by light, curling vapors, through which breaks the sunlight with softened splendor....the atmosphere is that of Indian summer in the New England hills. We have seen no painting that came nearer our ideal of the best landscape art, combining perfect truth with freedom, largeness and sentiment.

Thus did an enthusiastic reviewer, writing in the July 23, 1871, edition of the *San Francisco Daily Evening Bulletin,* record his impressions of Albert Bierstadt's *The Emerald Pool.* Having exhibited the mammoth canvas in New York, Boston and Philadelphia, Bierstadt brought it with him to San Francisco in the summer of 1871, his third visit to the West. He displayed the painting at the gallery of Snow and Roos, where San Franciscans flocked to see it.

A principal member of the Hudson River School of landscape painters (nos. 69, 78, 107), Bierstadt was at that time at the height of his popularity. He had gained fame and wealth for his landscapes of the Rocky Mountains and Yosemite Valley and is still valued today primarily as a painter of panoramic Western scenes. Yet his earliest important landscapes were of Eastern subjects, many of them inspired by his frequent trips to New Hampshire's White Mountains between 1852 and 1871. *The Emerald Pool* was among the most spectacular of these Eastern scenes, and it resulted from Bierstadt's calculated decision to create an ambitious, virtuoso landscape painting for public exhibition. "I never had so difficult a picture to paint," the artist later confided in a letter, "[but] my artist friends think it is my best picture and so do I."

Bierstadt began work on the composition in the autumn of 1869, when he went to the White Mountains and made the first of many preliminary studies for the painting. (He later said that he produced more than two hundred sketches for the picture. Curiously, only one of these – a sketch of the ferns at the lower right – has been recovered to date.) The site he chose, the Emerald Pool, was situated on the Peabody River a few miles east of Mount Washington. Its proximity to the Glen House, a well-known tourist lodge where Bierstadt himself often stayed, insured its popularity among visitors.

Between 1853 and 1856 Bierstadt returned to his native Germany and studied at the Düsseldorf Academy. The sharp, dry, tonal style of *The Emerald Pool* and its additive compilation of many distinct landscape motifs share much with the mid-nineteenth-century Düsseldorf aesthetic.

In his 1835 "Essay on American Scenery," Thomas Cole (nos. 69-71) praised the "overflowing richness" of America's nineteenth-century wilderness, the grandeur of those "undefiled" landscapes where one could still trace the hand of God the creator. "In civilized Europe," Cole wrote, "the primitive features of scenery have long since been destroyed or modified [by man]....[but in America] nature is still predominant....We are still in Eden." In *The Emerald Pool,* Bierstadt conveys the same sentiment as he depicts the wilds of New Hampshire as a new Eden, an unspoiled paradise of fierce beauty and absolute tranquility.

102　Erastus Salisbury Field

American, 1805-1900

The Last Supper, c. 1875-80

Oil on canvas, 35″ x 46″ (88.9 x 116.8 cm)

Gift of Edgar William and Bernice Chrysler
Garbisch, 80.181.16

Reference: *Erastus Salisbury Field: 1805-1900*,
exhib. cat., Museum of Fine Arts, Springfield,
Massachusetts *et al.*, 1984-85, p. 51, no. 94.

With the invention of the daguer-
reotype in 1839 and the subsequent
rise in popularity of photographic por-
traiture, the careers of many mid-
nineteenth-century American face
painters gradually ended. The Mas-
sachusetts folk portraitist Erastus Field
(see also no. 67) was no exception.
Though Field learned the new art
of photography in New York in the
mid-1840s and began to paint more
"realistic" portraits from photographs
he took of his sitters, the demand for

his portraiture declined significantly
in the 1850s. By 1860 he had virtually
abandoned the genre and turned
instead to paintings of historical and
biblical subjects. These works – vision-
ary allegories, historical landscapes and
religious images like *The Last Supper* of
c. 1875-80 – occupied him throughout
the second half of his career, which he
spent mainly at his relatives' Connecti-
cut Valley farm in Plumtrees, near
Leverett, Massachusetts.

Field based *The Last Supper* on a pop-
ular chromolithograph of Leonardo da
Vinci's renowned fresco in Santa Maria
delle Grazie, Milan. He maintained
the basic design of Leonardo's mural,
dividing the twelve apostles into groups
of three. Yet the painting's palette of
brilliant polychrome hues, the knife-

edge clarity of its figures and insistent
patterning of the walls and ceiling were
Field's own additions. With them he
invested his lofty High Renaissance
model with the naive charm of Con-
necticut Valley folk style. As Mary Black
wryly observes, "The table [in the
painting] is clearly set with Plumtrees
glass and pottery. The mountains, as
viewed from the windows, are reminis-
cent of those rising from the valley
floor on the west side of the Connecti-
cut River, and the faces, bearded and
astonished, might be portraits of
[Field's] Connecticut Valley cousins."
The painting retains its original
wooden frame, which Field covered
with a delicate, gold snowflake design
that complements the decorative pat-
terning in the picture itself.

103 Charles-François Daubigny

French, 1817-1878

The Beach at Villerville at Sunset, 1873

Oil on canvas, 30¼" x 56½" (76.8 x 143.5 cm)

Signed and dated lower left: *Daubigny 1873*

Gift of Walter P. Chrysler, Jr., 71.635

References: Robert Hellebranth, *Charles-François Daubigny 1817-1878*, Morges, 1976, p. 208, no. 618; Harrison, *CM*, 1986, no. 30.

The landscape painter Daubigny visited Barbizon occasionally following 1843, but he spent most of his life away from his fellow artists there (nos. 72, 77, 86, 112). Nonetheless, because he shared their deep commitment to nature and their passion for working out-of-doors – he was, perhaps, the most confirmed *plein-air* painter of his generation – he is viewed as an important, if somewhat peripheral, member of the Barbizon group.

Daubigny had a studio in his native Paris, but his favorite spots were decidedly rural: Villerville on the coast of Normandy; Auvers, where he had a house; and the rivers Seine, Oise and Marne, which he painted from his studio-boat, *Le Botin* ("The Little Box").

His restless quest for new landscape sites, which anticipated the peripatetic spirit of the Impressionists, led him also to Brittany and the Channel coast, to Holland in 1871 and to England in 1866 and 1870. Daubigny was fascinated by the shifting qualities of nature's color and light, above all by the reflective properties of water and the fleeting atmospheric effects of dusk and dawn. These he recorded with an ever freer and more rapid brush technique and an increasingly brighter and more vivid palette. By the early 1870s his art verged on Impressionism, though it never embraced the most revolutionary tenets of the new style.

A small fishing village and seaside resort in Daubigny's day, Villerville is located just south of the Seine estuary on the Atlantic coast. To the north, across the harbor, is Le Havre and further south, Trouville, which at the time was a fashionable tourist spot. Its sandy beaches were immortalized after 1860 in the paintings of Eugène Boudin (no. 109). Daubigny first discovered Villerville on a visit to Normandy in 1854 and returned regularly to paint its beach and coastal hamlet. He often encountered Boudin there and under his influence began to work in a lighter and more spirited Pre-Impressionist style. This more spontaneous manner is evident in The Chrysler Museum canvas, which Daubigny probably conceived at Villerville in 1872 and exhibited successfully one year later at the Salon in Paris. The artist painted at least two other, nearly identical views of the beach at Villerville, one dated 1870 (formerly Matzukata collection, Japan) and the other 1874 (Museum Mesdag, The Hague).

In the present painting a dramatic expanse of bluff and beach is evoked in broken, summary brushstrokes and cast in the rosy, fading light of dusk, one of Daubigny's favorite atmospheric settings. In the foreground a group of Norman peasants abandons the beach as night falls, ending a day of fishing. The quiet naturalism and gentle contemplative mood of this seashore scene are typical of Daubigny's final landscape style.

104 Daniel Ridgway Knight

American, 1839-1924

Harvest Repast, 1876

Oil on canvas, 40″ x 59½″ (101.6 x 151.1 cm)

Signed and dated lower right: *D. R. Knight Paris 1876*

Gift of Walter P. Chrysler, Jr., 71.2118

Reference: *A Pastoral Legacy: Paintings and Drawings by the American Artists Ridgway Knight and Aston Knight,* exhib. cat., Herbert F. Johnson Museum of Art, Cornell University, Ithaca et al., 1989-90, no. 1.

In the decades following the Civil War, American artists were increasingly influenced by aesthetic developments in Paris, which was then becoming the center of the Western art world. Encouraged in part by the growing interest among American collectors in French artistic styles and themes, painters after 1865 traveled to Paris in ever greater numbers to train at the government-run Ecole des Beaux-Arts, in independent art schools like the Académie Julian or in the private studios of academic *grands maîtres* such as Charles Gleyre (no. 100). Once they had mastered their craft, many of these Americans chose to remain abroad and pursue their artistic careers as expatriates (see also no. 118).

One such painter was the Philadelphia-born Ridgway Knight, who studied in Paris with Gleyre and at the Ecole in 1861-63. After returning to the United States to serve in the Union army during the Civil War – he was present at the capture of Richmond and made sketches of the city as it burned – Knight resettled in France in 1871 and completed his studies with the great academic realist Ernest Meissonier. He remained in France for the rest of his life, working mainly in the villages of Poissy and Rolleboise west of Paris. He exhibited at the Salon until 1921 and sustained his large American audience with regular submissions to the National Academy of Design in New York.

In 1874 Knight visited Barbizon, where he met Jean-François Millet (nos. 80, 81) and painted out-of-doors. (His obsession with the depiction of nature's light and atmosphere ultimately led him to build a studio entirely of glass where he could paint his models accurately in outdoor light.) Thereafter he specialized in rural genre images of French peasants, a kind of subject that was especially popular among American buyers during the 1880s and 1890s. Like fellow-Americans Walter Gay and Theodore Robinson, Knight became known as a sensitive interpreter of Gallic peasant themes, closely following the manner of such native French specialists as Jules Breton, Léon Lhermitte and Jules Bastien-Lepage.

Painted in 1876 and exhibited the same year at the Salon, *Harvest Repast* is among the most ambitious of Knight's early peasant pictures. Its precise, pellucid realism and golden tonality reveal the influence of Meissonier. While painters like Millet often stressed the harshness of rural life, Knight's works were unabashedly optimistic and sentimental in tone. "Mr. Knight selects what is beautiful and pretty in the peasant and avoids all that is hideous and unsightly," wrote the critic Theodore Child. Child's observation is borne out by the present picture, where French peasant life is portrayed as ordered, ennobling and virtuous – a pastoral ideal (cf. no. 51).

In the painting a group of peasants in the midst of harvest have temporarily laid down their scythes and rakes and have gathered in a cleared area to take their midday meal. The older members of the group radiate a rugged, weathered handsomeness and a strength of character that proceed naturally, we conclude, from decades of hard physical labor. The younger peasants display an idealized beauty reflecting their innate virtue. Devotion to family is tenderly conveyed in a touching detail: a child sleeps in the shade of an umbrella provided, no doubt, by her solicitous mother. Nature, too, seems sanguine and tender. Though the peasants' work is difficult, the harvest has been a good one. The sun shines warmly, and the field is ablaze with poppies.

105 Auguste Rodin

French, 1840-1917
The Age of Bronze, 1876
Bronze, 71¼″ (181 cm)
Signed on the base: *Rodin*
Inscribed on the side of the base:
 Alexis Rudier
 Fondeur Paris
Gift of Walter P. Chrysler, Jr., 71.2045

Repeatedly rejected by the Ecole des Beaux-Arts in Paris and ignored by the Salon until 1875, the young Rodin developed his craft as a sculptor largely without the encouragement of the Academy. His isolation spared him the intellectual restrictions of a conventional education and gave him the freedom to forge a revolutionary sculptural art. In time he would rock France's art establishment with a succession of controversial masterpieces, among them his *Gates of Hell* (begun in 1880) and *Monument to Balzac* (1891-98). His sculptures – passionate and heroic, full of primal suffering and dark dreams – reshaped the Romantic styles of Carpeaux (no. 92) and François Rude into the raw material of modern art. By 1900 he had become the most famous artist alive.

Rodin first worked as an assistant in the Paris workshop of Carrier-Belleuse, who produced statuettes and decorative sculptures for buildings. Discouraged by the lack of commissions in

Paris in the wake of the Franco-Prussian War (1870-71), Rodin followed Carrier-Belleuse to Brussels in 1871 and there, over the next six years, really launched his career. (He returned to France in 1877.) Created toward the end of his Brussels period, *The Age of Bronze* is Rodin's first masterpiece and the earliest full-size figure that he exhibited. It was also the work that he hoped would at last make his reputation in Paris.

Rodin began the sculpture in the summer of 1875 and labored over it for the next eighteen months. "I was in the deepest despair with that figure," he later said, "and I worked so intensively on it, trying to get what I wanted, that there are at least four figures in it." Using as his model a Belgian soldier named Auguste Neyt, Rodin created the image of a vanquished warrior that many scholars believe was meant to evoke the tragedy of France's defeat in the Franco-Prussian War. (One of the artist's drawings of the sculpture suggests that the figure initially held a spear in its left hand. Apparently Rodin realized that the spear was unnecessary and removed it.) Rodin had long admired the sculpture of Michelangelo, and the figure's pose brings to mind particularly Michelangelo's *Dying Slave* (Louvre, Paris), as

well as other works by that Renaissance master which the artist surely studied on a brief visit to Italy in early 1875.

The plaster cast of Rodin's sculpture was first exhibited in early 1877 under the title *The Vanquished* at the Cercle Artistique in Brussels. When he showed it later that year at the Paris Salon, Rodin changed its title to *The Age of Bronze*, a reference to one of the epochs of earth's mythological history when men were consumed by violence and warfare.

The critics of the day, both in Brussels and Paris, were shocked by the sculpture's unflinching, earthy realism. Many of them, including members of the Salon jury, unjustly accused Rodin of *surmoulage* – of having made the statue from casts taken directly from his model (a disreputable, but not uncommon practice at the time). The artist angrily denied the charge and, to disprove it, supplied the jury with his casts and with photographs of Neyt taken in the nude. Thus began the first of many artistic *succès scandaleux* that would lead Rodin on to international fame. Since the first bronze cast of *The Age of Bronze* was triumphantly displayed at the 1880 Salon, numerous bronzes have been made in several sizes, among them the life-size Chrysler Museum sculpture.

106 Winslow Homer

American, 1836-1910

Song of the Lark, 1876

Oil on canvas, 38⅝″ x 24¼″ (98.1 x 61.6 cm)

Signed and dated lower left:
*WINSLOW HOMER NA
1876.*

Gift of Walter P. Chrysler, Jr., in Honor of
Dr. T. Lane Stokes, 83.590

References: Sokolowski, *CM*, 1983, pp. 23-25;
Patricia Hills, "Images of Rural America in the
Works of Eastman Johnson, Winslow Homer,
and Their Contemporaries," in *The Rural
Vision: France and America in the Late Nineteenth
Century,* Omaha, 1987, pp. 74, 76.

During the decades following the
Civil War, Winslow Homer won increasing acclaim as America's foremost
genre painter (see also nos. 83, 94). His
foursquare, realist depictions of robust,
barefoot children and laboring farmers, rugged wilderness guides and
storm-tossed New England fishermen,
stressed the powerful and often perilous relationship between man and
nature, and they have assured him
enduring fame as the premier chronicler of rural life in late-nineteenth-
century America.

Born in Boston, Homer was apprenticed in that city to the lithographer
John H. Bufford and then launched
his career as a free-lance illustrator. He
moved to New York in 1859 and by
1861 was providing *Harper's Weekly* with
his famous sketches of Union troop life
during the Civil War. Though he continued to supply illustrations to *Harper's*

Weekly and other magazines until 1875,
he focused on oil painting after the
war and in 1873 produced the first of
his incomparable watercolors. He
traveled twice to Europe, visiting Paris
in 1866-67 and England in 1881-82.
Between these visits he lived primarily
in New York and, after 1883, in the
secluded coastal hamlet of Prout's
Neck, Maine. A solitary figure in later
life, Homer spurned all would-be biographers and seldom sought the company of other artists. He is viewed today
as a reclusive and heroic "original," an
essentially self-taught artist who created
a fresh and indigenously American
style in the manner of Thomas Eakins
and Albert Pinkham Ryder.

Dated 1876, The Chrysler Museum
painting may have been inspired by
Homer's trip to Virginia in the summer
of 1875. He showed the picture twice:
in 1877 at the Century Association in
New York and one year later at the
National Academy of Design. On both
occasions it was exhibited under the
title, *Song of the Lark.* (An engraving of
it in the 1878 *Art Journal* was supplied
with the less poetic title, "In the
Fields.")

In the painting, a young farmer
leaving his fields at sunset is transfixed
momentarily by the call of an unseen
bird. What results is a transcendent
communion of man and nature.
Though scholars have often contended

that European art had little direct
influence on Homer's painting, the
rustic theme and naturalist style of *Song
of the Lark* bring to mind the peasant
paintings of such mid-nineteenth-century Frenchmen as Jean-François Millet
(nos. 80, 81) and Jules Breton. Little is
known of Homer's activities during his
ten-month stay in France in 1866-67.
But it is important to note that a large
exhibit of Millet's paintings was on display at that time in Paris, at the 1867
Universal Exposition, where Homer
exhibited two of his own works.

While the French peasants of Millet
are often portrayed as the long-suffering victims of an unjust economic
system, the hardy farmer in *Song of the
Lark* has clearly been empowered by
America's participatory democracy. As
Patricia Hills observes, "Homer's stalwart figure has his booted legs planted
firmly on the ground, his hat and
scythe held firmly....He is no peasant,
but a heroic individual who works for
himself." By the mid-1870s America's
farmers had virtually abandoned the
scythe as their principal harvest tool,
preferring instead the more efficient
mechanical reaper of Cyrus McCormick. By depicting the farmer in
Song of the Lark with a scythe, Homer
nostalgically alludes to an earlier and
simpler era in American farm life,
when rugged individuals worked their
land manually and alone.

107 Jasper Francis Cropsey
American, 1823-1900

The Old Mill, 1876

Oil on canvas, 48½" x 84¼" (123.2 x 214 cm)

Signed and dated lower right:
 J. F. Cropsey 1876.

Museum Membership Purchase, 63.34.1

References: Gertrude Dahlberg, "Jasper Francis Cropsey: Painter of Autumn," *American Art and Antiques,* 2 (1979), pp. 106-107; William S. Talbot, *Jasper F. Cropsey 1823-1900,* New York and London, 1977, pp. 210-211, 457-458, no. 195.

The landscapist Cropsey was a prominent member of the second generation of New York's Hudson River School (nos. 69, 78, 101). During the 1850s and 1860s he built his reputation as a painter of fall landscapes, producing scores of paintings that captured the blazing colors and hazy, sunlit atmosphere of autumn in New England. The high point of Cropsey's career came in 1876, when he was awarded a gold medal at the Philadelphia Centennial Exhibition. There he displayed three landscapes, including The Chrysler Museum's large and impressive canvas *The Old Mill,* which has been called the most significant of Cropsey's works from the 1870s. The painting was immensely popular among visitors to the exhibition, and an engraving of it by R. Hinshelwood

appeared in the official souvenir booklet, *Masterpieces of the Centennial International Exhibition.* Since then *The Old Mill* has been illustrated in literally thousands of prints and photographic reproductions, making it one of the most familiar images in American art. Cropsey painted a smaller replica of the picture in 1879, which is in the Mead Art Museum, Amherst College (Amherst, Massachusetts).

Though the site depicted in the Chrysler's painting can no longer be located with certainty, some scholars have identified the mill as the Sanford gristmill, which stood on the banks of the Wawayanda Creek near Warwick, New York, not far from the spot where Cropsey had built his palatial estate "Aladdin" in 1869. The Sanford mill was constructed in 1800 and stood until 1902, when a flood washed away its flume and foundation.

Rural water mills had long been at the heart of America's pre-industrial economy. By the 1870s, however, they were fast being replaced by more efficient steam-powered mills and factories, and many had already been abandoned or demolished. As a beloved and endangered symbol of a

simpler past, the water mill had considerable sentimental appeal in Cropsey's day. *The Old Mill's* great popularity at the Philadelphia Centennial can surely be credited in part to its nostalgic, picturesque tone. The early leader of the Hudson River School, Thomas Cole (nos. 69-71), had painted a number of similarly nostalgic mill scenes during the 1840s, among them his *Old Mill at Sunset* of 1844 (private collection, New York).

The idyllic country setting in Cropsey's picture, and particularly the detail of the young couple conversing on the footbridge at left, is subtly reminiscent of the arcadian landscapes found in earlier European art (cf. nos. 51, 60). So, too, is the painting's palette, which a recent cleaning has revealed to be far richer and more delicate than previously thought. The bright red mill and brilliant fall foliage are bathed in a luminous pastel haze of pink, mauve and yellow. The painting's poetic light may owe a debt to the seventeenth-century French master Claude Lorrain, whose landscapes impressed Cropsey greatly during his first European sojourn in 1847-49 and inspired him for the rest of his career.

108 William Michael Harnett

American, 1848-1892

Still Life, 1877

Oil on canvas, 9″ x 12″ (22.8 x 30.5 cm)

Signed and dated lower right:
W M HARNETT. 1877
(initials arranged in monogram)

Gift of Walter P. Chrysler, Jr., 71.657

Reference: Alfred Frankenstein, *After the Hunt:
William Harnett and Other American Still Life
Painters 1870-1900,* Berkeley, Los Angeles and
London, 1969, p. 166, no. 21B.

Born in County Cork, Ireland, William Harnett grew up in Philadelphia, where his youthful work as a silver engraver helped determine the precise, draftsmanlike style so evident in his subsequent still-life paintings. After training at the Pennsylvania Academy of the Fine Arts and at the National Academy of Design and the Cooper Union in New York, Harnett established himself in the mid-1870s as a still-life specialist. Among his first works in this vein were small, realistically painted table scenes that made use of a limited array of familiar objects often with distinctly masculine overtones: beer mugs, pipes, tobacco cans, books and newspapers. These works pleased his growing clientele — composed largely of modest, middle-class collectors in New York and Philadelphia — and helped finance his European trip of 1880-86, during which he studied and worked primarily in Munich.

Painted in Philadelphia in 1877, The Chrysler Museum canvas is a handsome example of Harnett's early still-life manner. In it the top of a plain wooden table displays a typically spare arrangement of smoking implements. The open can of tobacco, burnt matches and the glowing ash in the meerschaum pipe suggest the presence of an unseen smoker who has laid down his pipe for a moment. The folded newspaper projecting beyond the table edge seems to invade the viewer's space, a modest foreshadowing of the dramatic illusionism that would come to dominate Harnett's later New York work and make him the leading exponent of *trompe l'oeil* still-life painting in late-nineteenth-century America. Among the considerable number of East Coast *trompe l'oeil* artists who followed in his wake were John F. Peto and John Haberle.

The arrangement of objects in the 1877 Chrysler picture was varied by Harnett in two other still-life paintings of the same year. One is in the New York collection of Gifford Cochran, the other on loan from Edwin Hewitt to the Fine Arts Museums of San Francisco, California Palace of the Legion of Honor.

109 Eugène Boudin

French, 1824-1898

Beached Boats at Berck, 1879

Oil on canvas, 32¼" x 59" (81.9 x 149.9 cm)

Signed and dated lower right: *E. Boudin. 1879*

Gift of Walter P. Chrysler, Jr., 77.343

References: Robert Schmit, *Eugène Boudin 1824-1898*, Paris, 1973, II, no. 1271; Harrison, *CM*, 1986, no. 35.

Born in Honfleur, the landscape and marine painter Boudin was the son of a Norman ship's captain. In his mature pictures he repeatedly portrayed the grand sweep of sea and sky along the French Atlantic coast. Though his first years as a painter were not easy, Boudin remained true to his brisk *plein-air* technique, and in 1858, at Rouelles in Normandy, he began to teach the young Claude Monet how to paint out-of-doors. The budding Impressionist was soon entranced by the directness of Boudin's approach and by his ability to capture the ever-changing qualities of nature's light and atmosphere. "If I have become a painter," Monet later said, "I owe it to Eugène Boudin." Boudin's role as mentor to Monet – a role later assumed by Johan Jongkind (no. 95) – confirmed his position as one of France's most important Pre-Impressionist painters.

Boudin received his first recognition in the mid-1860s with his now-famous Trouville and Deauville beach scenes. Executed *en plein air* with a revolutionary fluidity and dash, these small paintings of fashionable Second-Empire vacationers at seaside were applauded at the Salon in Paris and laid the groundwork for his subsequent success. In later productions like *Beached Boats at Berck* – an unusually large landscape for Boudin – the artist somewhat tempered his early style with a more deliberate, descriptive realism.

The site depicted in the painting is the shore at Berck-sur-Mer, a small village along the English Channel between Dieppe and Calais. Boudin had already visited Berck in 1874, five years before he produced the picture. In the painting, Norman fishermen rest in the humid haze of a summer afternoon, their boats temporarily beached by the receding tide. Some of the fishermen repair their craft, while others take their midday meal. The vast canopy of cloud-filled sky is masterfully portrayed, confirming Corot's salute to Boudin as "the king of skies." The Impressionists were fascinated by Boudin's ability to evoke specific kinds of weather and times of day. So, too, were the critics. One can guess "the very season, the time of day, and the wind" in Boudin's work, marveled Charles Baudelaire in his account of the 1859 Salon.

110 Jean-Paul Laurens
French, 1838-1921

The Late Empire: Honorius, 1880

Oil on canvas, 60½″ x 42½″ (153.7 x 107.9 cm)

Signed and dated lower right:
Jn. Paul Laurens. 1880

Gift of Walter P. Chrysler, Jr., 71.671

References: Atlanta, 1983, no. 47; Robert
Rosenblum and H. W. Janson, *19th-Century Art,*
New York, 1984, pp. 376-377; Lois Marie Fink,
*American Art at the Nineteenth-Century Paris
Salons,* Cambridge, 1990, p. 163.

Laurens was one of the last great
practitioners of the nineteenth-century
French academic style (see also nos. 87,
99, 100). Born in Fourquevaux near
Toulouse, he arrived in Paris around
1860 and completed his artistic studies
there with Léon Cogniet and Alex-
andre Bida. Though he exhibited
regularly at the Salon from the mid-
1860s, his career languished until 1872,
when two of his Salon entries were
widely acclaimed and earned him a
first-class medal. The two paintings –
The Death of the Duke of Enghien (Musée,
Alençon) and the *Exhumation of Pope
Formosus* (Musée des Beaux-Arts,
Nantes) – revealed his growing interest
in obscure and often macabre themes
drawn from ancient Roman, Byzantine
and medieval history. In the decades
that followed, Laurens made a specialty
of such subjects, producing darkly
satiric visions of the Inquisition and
imperial Rome. A particularly striking
example is The Chrysler Museum's *The
Late Empire: Honorius* of 1880.

Reflecting the enduring Romantic
fascination with the shadowy underside
of history, Laurens' paintings were
quite popular in his day and brought
him considerable success. His meticu-
lously finished works sold briskly to
conservative collectors in Europe,
America and even Japan. He received
a number of prestigious public com-
missions in France, completing mural
cycles for the Panthéon (1882) and
Hôtel de Ville (1890s) in Paris, and he
taught for years at the Académie Julian
and Ecole des Beaux-Arts.

The subject of the Chrysler paint-
ing, Flavius Honorius (A.D. 384-423),
was the son of the Roman emperor
Theodosius I. At his father's death,
Honorius – barely eleven years old –
inherited the imperial throne together
with his brother Arcadius. The two
divided the crumbling empire between
them, and Honorius became Emperor
of the West. During Honorius' inept

and chaotic reign, the western empire
inexorably declined; it was repeatedly
besieged by barbarian invaders, culmi-
nating in the sack of Rome by the
Visigoths in 410.

In Laurens' vivid portrayal of Hon-
orius at the time of his coronation, the
young emperor is characterized as a
helpless, dimwitted child overwhelmed
by the forces of history. When the
painting was exhibited at the 1880
Salon, it was unanimously praised for
its brilliant colorism and sharply moral-
izing tone. Among the painting's many
admirers was the American artist
Edwin Blashfield, who applauded Lau-
rens' satiric depiction of "the vacant-
faced boy-emperor of the west, the
very symbol of decadence and of a

shrunken empire, a child muffled and
lost in the imperial mantle, sitting stu-
pid with inert dangling legs upon his
throne, and unable to hold up the
heavy globe and scepter." Laurens' dra-
matic frontal presentation of Honorius
– an "iconic" compositional scheme he
probably derived from a Byzantine
ivory portrait of the emperor – also
appealed to the painter Albert Maig-
nan, who based the frontal design of
his 1883 *Homage to Clovis II* (Musée des
Beaux-Arts, Rouen) on the Chrysler
painting.

Purchased shortly after the 1880
Salon by Darius O. Mills of New York,
The Late Empire: Honorius was one of the
first paintings by Laurens to enter an
American collection.

111 Alfred Sisley

French, 1839-1899

Apple Trees in Flower, 1880

Oil on canvas, 25¼″ x 31¾″ (64.1 x 80.6 cm)

Signed lower left: *Sisley*.

Gift of Walter P. Chrysler, Jr., 77.412

References: François Daulte, *Alfred Sisley*, Lausanne, 1959, no. 355; Harrison, *CM*, 1986, no. 37.

Though celebrated today as one of the earliest and most creative of the Impressionists, the landscapist Sisley enjoyed no such recognition during his lifetime. From the early 1870s, when he began to paint professionally, until his death in 1899, he practiced his art in poverty and obscurity, struggling in vain against a hostile public and indifferent press.

A Parisian by birth, Sisley entered the atelier of Charles Gleyre (no. 100) in 1862 and there befriended fellow students Claude Monet, Frédéric Bazille and Renoir (no. 113). Within months the four young artists had departed from Gleyre's studio for Chailly-en-Bière and the nearby Fontainebleau Forest. There, through their communal experiments with *plein-air* painting, they sowed the first seeds of Impressionism, and by 1870 Sisley's landscapes had begun to exhibit the clear, high-keyed tones and sketchy, broken color touches of the new style. Though his later landscapes displayed the formal disintegrations inherent in the Impressionist technique, Sisley remained committed to an art of compositional and spatial clarity, to architectonically structured landscapes and carefully calibrated perspectives.

Sisley spent most of his life working in the villages and countryside around Paris. Initially he lived in or near Louveciennes (1871-74), Marly-le-Roi (1875-77) and Sèvres (1877-79) and showed a special interest in river and snow scenes. In later years (1880-99) he resided near Fontainebleau in the hamlets of Veneux-Nadon and neighboring Moret, at the juncture of the Seine and Loing rivers, where he repeatedly painted the banks of these waterways and the adjacent fields.

Produced at the onset of his final Moret period, *Apple Trees in Flower* of 1880 portrays the crisp, breezy weather of early spring, when the chill of winter still lingers on the land. Its forms merely summarized by Sisley's dappling, Impressionist brush, the landscape is brought into structural focus through the anchoring verticals of the blossoming fruit trees. The receding lines of the trees also create a sense of deep space, a characteristic feature of Sisley's art.

Sisley relished the challenge of capturing the transitory effects of light and weather and the fleeting magic of seasonal change. In an enthusiastic letter written from Moret in the spring of 1883, he reported:

> The weather has been wonderful. I have started work again, but unfortunately, because it has been such a dry spring, the fruit trees are not flowering all at once, and the blossoms are dropping very quickly. And I am trying to paint them!

112 Charles-Emile Jacque
French, 1813-1894
Shepherd and His Flock, 1880

Oil on canvas, 104″ x 82½″ (264.2 x 209.5 cm)
Signed and dated lower right: *ch. Jacque. 80.*
Gift of Walter P. Chrysler, Jr., 71.2055
Reference: Harrison, *CM,* 1986, no. 27.

Jacque was a distinguished member of the artist colony that flourished in the French village of Barbizon in the decades around 1850. He arrived there from Paris in 1849 with fellow-painter Jean-François Millet (nos. 80, 81) and soon after began to perfect his specialties, producing rural genre scenes and pictures of farm and field animals, especially chickens and sheep (see also no. 89). His depictions of laboring peasants and their livestock are hailed today as superior examples of mid-nineteenth-century French Realist art, and Jacque clearly intended that these populist images reflect the egalitarian sentiments that revived in France with the Revolution of 1848. In 1854 Jacque left Barbizon and settled in a studio just outside of Paris. By the end of the 1860s he had been elected to the Legion of Honor (1867) and become France's pre-

mier master of farmyard subjects.

A regular contributor to the Salon in his early years, Jacque withdrew from the annual Paris exhibit in 1871 and did not return until 1888. His major submission that year was The Chrysler Museum's 1880 *Shepherd and His Flock.* The painting's monumental size – it measures nearly nine by seven feet – effectively conveys the grandeur of a genuine "Salon" work. Though the Barbizon masters often painted out-of-doors, directly from nature, Jacque almost certainly made the colossal *Shepherd and His Flock* in his studio from life studies. Indeed, the Smithsonian Archives of American Art (Washington, D.C.) possesses a photograph of Jacque at work in his studio near Paris, and in it he is shown seated before the Chrysler canvas. Possibly Jacque's small, bust-length portrait of a

shepherd, *Le Vieux Berger* (Petit Palais, Paris), served as a life study for the herdsman in the present work.

Fleeing an approaching storm, the shepherd in the painting strides with crook in hand over the crest of a hill as he leads his flock to safety. His dog halts momentarily to survey the herd's progress. The broad, flat pastureland behind them sweeps to the horizon, conveying a sense of infinite space. The distant landscape recalls the panoramic vistas found in seventeenth-century Dutch landscape painting, which the artist knew well. Jacque's genius as a painter of animals is splendidly revealed in the sheep that crowd the foreground. Dramatically spotlighted by an errant ray of sunlight, they are more fully characterized than their keeper, whose impassive, masklike face lies in shadow beneath his hat.

113 Pierre Auguste Renoir

French, 1841-1919

The Daughters of Durand-Ruel, 1882

Oil on canvas, 32" x 25¾" (81.3 x 65.4 cm)

Signed and dated lower right: *Renoir. 82*

Gift of Walter P. Chrysler, Jr., in Memory of Thelma Chrysler Foy, 71.518

References: François Daulte, *Renoir*, New York, 1973, p. 78; Harrison, *CM*, 1986, no. 38.

In 1833 Jean-Marie-Fortuné Durand and his wife Marie (née Ruel) expanded their Paris stationer's shop to include a commercial art gallery. This establishment, the Galerie Durand-Ruel, became one of Europe's most prestigious art houses, playing a major role in the promotion and eventual public acceptance of avant-garde painting in late-nineteenth-century France.

The gallery's spectacular rise can be credited largely to Fortuné and Marie's son Paul Durand-Ruel (1831-1921), who joined the family firm in 1851 and became its guiding force after 1865. Paul Durand-Ruel initially used the gallery to promote the work of such mid-century painters as Delacroix, Corot and the Barbizon masters. But encounters in London in 1871 with Claude Monet and Camille Pissarro redirected his interests toward a more radical group of younger French painters, the Impressionists. Returning to Paris, the dealer rapidly established himself as the city's most enthusiastic promoter of the Impressionist group – Monet, Pissarro, Alfred Sisley, Pierre Auguste Renoir – and he remained the group's most faithful commercial supporter during its early decades of struggle. In 1888 he opened a gallery in New York, attracting a new clientele of wealthy American collectors (see no. 118). "Without him," Renoir reportedly said, "we would not have survived."

Durand-Ruel met Renoir in Paris at the end of the Franco-Prussian War and purchased his first pictures from him in 1872. Within a decade the dealer was buying Renoir's paintings regularly and in quantity, and the two had become close colleagues. Thus, in 1882, when Durand-Ruel asked the artist to paint his children, Renoir readily obliged. He did a portrait of Durand-Ruel's eldest son Joseph and a double portrait of younger sons Charles and Georges, both of which are in the Durand-Ruel collection in Paris. Renoir also produced The Chrysler Museum painting, an enchanting double portrait of Durand-Ruel's two daughters, Marie-Thérèse, then fourteen, and the twelve-year-old Jeanne.

Dressed in light summer frocks and Milan straw hats (Jeanne's rests beside her), the sisters pose on a garden bench, smiling amid the coolness and dappled light of their tree-shaded perch. Executed entirely out-of-doors, the picture retains the vibrant "rainbow palette" and vigorous open brushwork – the broad scatter of gay color touches – of Renoir's "pure" Impressionist paintings of the later 1870s.

114 Henri Fantin-Latour

French, 1836-1904

Portrait of Léon Maître, 1886

Oil on canvas, 51¾″ x 38¾″ (131.4 x 98.4 cm)

Signed and dated lower left: *Fantin. 86*

Gift of Walter P. Chrysler, Jr., 71.509

References: *Fantin-Latour,* exhib. cat., Grand Palais, Paris; National Gallery of Canada, Ottawa; and California Palace of the Legion of Honor, San Francisco, 1982-83, no. 143; Harrison, *CM,* 1986, no. 34.

During the final decades of the nineteenth century, Henri Fantin-Latour achieved considerable prominence in France and England as a portrait and still-life painter. He kept company with the leading writers and artists of the Parisian avant-garde, among them Charles Baudelaire, Emile Zola, Manet (no. 85) and Renoir (no. 113). Nonetheless, he himself was an aesthetic conservative, a traditionalist who championed the cause of the Académie and dismissed the Impressionists – many of them close friends – as mere "dilettantes who produce more noise than art."

In 1854 the young Fantin enrolled in the Ecole des Beaux-Arts in Paris but was dismissed within months. Thereafter he followed an independent course in the Louvre, studying and copying for more than a decade its endless array of Old Master pictures. He emerged from this period of study as a painter of remarkably eclectic tastes, and in mature portraits like the imposing *Léon Maître* of 1886, he blended an austere, "bourgeois" realism with the venerable portrait types of Frans Hals and the sixteenth-century Italians.

Exhibited at the Paris Salon in 1886 and at the Royal Academy in London one year later, *Léon Maître* has been deemed among the finest of Fantin's male portraits. The sitter, dressed in a black frock coat, is placed starkly against a luminous brown backdrop. He holds his top hat, a pair of yellow gloves and his gold-tipped walking stick – the fashionable accessories of the late-nineteenth-century Parisian gentleman. The purity and aloofness of Maître's profile stance are mitigated only slightly as he turns his head to gaze imperiously at the viewer. The painting's composition recalls Fantin's 1867 likeness of Edouard Manet (Art Institute of Chicago), the other principal masterpiece among his male portraits.

The subject of the painting, Léon Maître (1847-1929), was the elder brother of Edmond Maître, a cultivated Parisian dilettante who befriended Fantin in 1865 and shared his love of music and literature. For a time Léon and his wife lived in South America – in Peru and Chile. Fantin also painted two portraits of Léon Maître's wife; one, dated 1882, is in the Brooklyn Museum, and the other, from 1884, hangs in the City Art Gallery, Leeds.

Fantin's *Léon Maître* elicited almost universal praise at the Salon. The critic Amédée Pigeon advised other portraitists to "meditate upon this grave and powerful work…[and] recognize there all those masterful qualities that make you admire the most beautiful portraits of the old museums." Among the Old Master portraits that inspired so much of Fantin's work, the profile images of the sixteenth-century north Italian portraitist Giovanni-Battista Moroni compare most closely to *Léon Maître.*

115 James Jacques Joseph Tissot
French, 1836-1902

The Artists' Wives, 1885

Oil on canvas, 57½" x 40" (146 x 101.6 cm)

Signed lower left: *J. J. Tissot*

Gift of Walter P. Chrysler, Jr., and The Grandy Fund, Landmark Communications Fund, and "An Affair to Remember" 1982, 81.153

References: Atlanta, 1983, no. 63; Michael Wentworth, *James Tissot,* Oxford, 1984, pp. 162-167; Harrison, *CM,* 1986, no. 36.

A fashionable artist-dandy who enjoyed great wealth and renown in his lifetime, James Tissot devoted much of his mature career to contemporary genre images of modishly dressed Parisians and Londoners. Though he shared his subject matter with many of his Impressionist friends, his precise, anecdotal realism and conservative, polished painting method placed him more firmly in the camp of the academics.

Born in Nantes to a rich cloth merchant, Tissot arrived in Paris around 1856 to begin his art studies. He made his Salon debut three years later. After launching his career with a series of highly finished, medieval costume pictures, by 1865 he turned to society portraiture and scenes of modern urban life that featured an array of beautiful women. These elegant images of chic Second-Empire *parisiennes* were immensely popular at the Salon, where Tissot exhibited regularly until 1870. To escape the disastrous end of the Franco-Prussian War, Tissot fled Paris for London in 1871 and remained there for the next eleven years. In London he continued to specialize in stylish society paintings, producing portraits of the British upper class and "conversation pieces" of affluent Victorians taking tea by the Thames.

With the death of his beloved Irish mistress Kathleen Newton in 1882, Tissot resettled in Paris. To reawaken interest in his work there, he displayed at the Galerie Sedelmeyer in 1885 a set of genre paintings entitled *La Femme à Paris (The Parisian Woman),* his first major production since his return from England. This ambitious series of fifteen large canvases, to which The Chrysler Museum painting originally belonged, celebrated the fabled beauty and style of the women of the French capital – its debutantes and shop girls, its performers and, as seen in the Chrysler painting, the wives of its artists. The series, which was also exhibited in London, at the Tooth Gallery, in 1886, is an extraordinarily rich chronicle of Parisian life during the *Belle Epoque.*

The gathering depicted in *The Artists' Wives* celebrates *le vernissage,* or Varnishing Day. On this, the eve of the official opening of the Salon, the participating artists traditionally gathered to view the exhibition privately and to put a final, protective coat of varnish on their paintings. In the Chrysler picture the artists, together with their wives and friends, toast the year's effort with a luncheon on the terrace of the restaurant Ledoyen, their smiling faces glowing from the salutary effects of gay company and good wine. Behind them is the entrance to the Palais de l'Industrie (with its famous caryatid portico), which at that time hosted the Salon.

A reviewer writing in the May 10, 1885, edition of *The New York Times* noted that "nearly all the faces [in *The Artists' Wives*] are celebrities." Among the luminaries who have been identified are the sculptor Rodin (no. 105), the brown-bearded, spectacled gentleman standing in the center of the picture, and the painter John Lewis Brown, the bearded man with top hat who sits with two female companions at the lower left. Beckoned by one of these women, who turns in her chair to greet us, we are invited to take a seat at the empty tables in the foreground and join the happy throng.

116 Jules-Joseph Lefebvre

French, 1836-1911

Une Japonaise (The Language of the Fan),
1882

Oil on canvas, 51½″ x 35½″ (130.8 x 90.2 cm)

Signed lower left: *Jules Lefebvre*

Gift of Walter P. Chrysler, Jr., 71.2058

References: Atlanta, 1983, no. 49; *Paris 1889: American Artists at the Universal Exposition,* exhib. cat., Chrysler Museum, Norfolk; Pennsylvania Academy of the Fine Arts, Philadelphia; and Memphis Brooks Museum of Art, 1989-90, pp. 248-249.

The American naval officer Matthew Perry opened Japan to the West in 1854. The French were insatiably curious about the art and culture of this mysterious and long-inaccessible land, and France was soon swept by *le Japonisme,* the craze for all things Japanese. Several French artists of the day – Manet (no. 85) and Degas (no. 120) among them – engaged in a serious study of Japanese prints and worked to incorporate their compositional and spatial principles into their own paintings.

Other artists, including Jules-Joseph Lefebvre, responded more lightheartedly to the popular French vogue for Japanese curios, fans and costumes. They produced a number of fancy-dress *portraits à la japonaise* – romantic genre images of women in stylish, Oriental garb. The Chrysler Museum painting is an enchanting example, painted by Lefebvre in 1882. It depicts a coquettish young woman posing in a brilliant red kimono with matching red fan – a seductive statement of contemporary chic. As Eric Zafran has noted, there is "a marvelous interplay between the real flowers [at the lower left of the painting] and the embroidered ones [on the woman's clothes]." The painting was originally titled *Une Japonaise.* How-

ever, when it was sold in New York in 1909 from the estate of James Inglis, it was given the more anecdotal title of *The Language of the Fan,* which harmonizes well with the painting's suggestive tone.

Lefebvre's academic credentials were impeccable. He first studied in Paris with the painter Léon Cogniet and in 1852 enrolled in the Ecole des Beaux-Arts. He won the Ecole's coveted fellowship, the *Prix de Rome,* in 1861, which allowed him to continue his academic studies in Italy. He remained there until 1867. After returning to Paris, Lefebvre abandoned the high seriousness of academic style and devoted himself to society portraiture, fashion-

able genre images and paintings of female nudes. He became widely known in later years as a painter of beautiful women. "An unusually skilled draughtsman, Jules Lefebvre better than anyone else caresses, with a brush both delicate and sure, the undulating contour of the feminine form," wrote a sympathetic critic of the day.

Lefebvre's ultimate choice of subject matter did nothing to detract from his reputation as an academician. An esteemed member of the Legion of Honor and Institut de France, he exhibited his work regularly at the Salon from 1863. He was also one of the most popular artist-teachers at the Académie Julian in Paris.

117 Frederick Childe Hassam

American, 1859-1935

At the Florist, 1889

Oil on canvas, 36¾″ x 54¼″ (93.3 x 137.8 cm)

Signed lower right: *CHILDE HASSAM. Paris*

Gift of Walter P. Chrysler, Jr., 71.500

References: Zafran, *CM,* 1978, no. 33; Lois Marie Fink, *American Art at the Nineteenth-Century Paris Salons,* Cambridge, 1990, p. 221.

Painters in the United States turned to Impressionism somewhat belatedly, more than a decade after it had come to the fore in France. Indeed, Impressionism achieved its first unqualified success in the United States only in 1893, when a display of American Impressionist paintings at the World's Columbian Exposition in Chicago was enthusiastically received by the critics and public alike. The movement finally crystallized in 1897, when a small group of painters resigned from the Society of American Artists in New York to form an independent exhibition alliance committed to the new style. The group, which came to be known as "The Ten American Painters" (see also nos. 121, 125), showed their works annually for the next twenty years. The most prominent and productive member of the original Ten – and also its most fully Impressionist artist – was Frederick Childe Hassam.

The son of a hardware merchant, Hassam initially studied wood engraving in Boston, where he won early acclaim as a book illustrator and watercolorist. After his first visit to Europe in 1883 – he would make four such trips during his career – he turned to oil painting, producing Boston street scenes in a tonal realist style. He began to adopt Impressionism while in Paris in 1886-89 – his second visit abroad. There he viewed the last of the Impressionists' group exhibitions (1886) and responded warmly to the brilliant palette and free, form-dissolving brush techniques of Claude Monet and his colleagues. He returned to America and established himself in New York, where, in the 1890s, he reached his creative zenith in a series of vigorously painted landscapes, sun-filled garden and interior scenes, and New York street views. His famous Flag paintings, created during World War I, sustained his reputation well into the twentieth century.

Painted in Paris in 1889, Hassam's *At the Florist* is a key document in his transition to an Impressionist aesthetic. Though the figures and the pavement in this delightful early-morning market scene retain the precision of Hassam's earlier realist style, the flowers are

evoked in a colorful blur of summary strokes that is typical of the artist's nascent Impressionist manner. The water on the pavement is masterfully portrayed; Hassam loved to depict the reflective properties of water and rain-washed streets.

In the painting Hassam comments subtly on the beauty of women and flowers, comparing the freshness and brilliance of the spring bouquets to the natural beauty of the girls who sell them. For example, the girl who stands in profile at right, patiently waiting on a customer, wears a long white work apron whose shape and hue are echoed in the brilliant white paper cones encircling the bouquets and flowering plants. The significance of the analogy could not be more obvious: the girl herself is a living, breathing bouquet, her flawless face merely the crowning blossom in the armful of flowers she holds.

Before Hassam left Paris in mid-1889, he arranged for the painting to be shown at the 1890 Salon, where he had already displayed works in 1887 and 1888. The picture was exhibited in 1891 in Philadelphia, at the Pennsylvania Academy of the Fine Arts, where it was purchased from Hassam by Dr. George Sands of Philadelphia.

118 Mary Cassatt

American, 1844-1926

The Family, c. 1892

Oil on canvas, 32¼" x 26⅛" (82 x 66.4 cm)

Signed lower right: *Mary Cassatt*

Gift of Walter P. Chrysler, Jr., 71.498

References: Adelyn Dohme Breeskin, *Mary Cassatt: A Catalogue Raisonné of the Oils, Pastels, Watercolors, and Drawings*, Washington, D.C., 1970, p. 83, no. 145; Zafran, *CM*, 1978, no. 32; Szabo, *CM*, 1986, no. 1.

Independent and strong-willed, Mary Cassatt ignored Victorian expectations for women – marriage and motherhood – and instead pursued an exceptional career as a professional painter. Born the daughter of a well-to-do investment banker in Allegheny City, Pennsylvania (today part of Pittsburgh), she first became interested in art at the age of seven when her family embarked on a lengthy European sojourn (1851-55). Returning to America, the Cassatts settled in Philadelphia, where her father, after much resistance, acceded to her wish to become an artist and allowed her to enroll at the Pennsylvania Academy of the Fine Arts.

Between 1866 and 1872 Cassatt returned twice to Europe where she studied and copied the Old Master paintings in the museums of France, Italy, Spain and Belgium. By 1875 she had resolved to live abroad and pursue her artistic career as an expatriate, a decision made by many American painters of her generation (see also no. 104).

Basing her career in Paris, Cassatt initially tried to follow a traditional path and regularly submitted her paintings to the Salon from 1868 to 1876. A change began to occur, however, as she became increasingly interested in the works of Edgar Degas and his fellow Impressionists (nos. 120, 111, 113). When Degas came to her studio in 1877 to invite her to join the avant-garde artist group, Cassatt eagerly accepted:

> At last I could work with absolute independence, without considering the eventual opinion of a [Salon] jury. I had already recognized who were my true masters. I admired Manet, Courbet and Degas. I hated conventional art. I began to live.

Cassatt was the only American to exhibit with the Impressionists – between 1879 and 1886 she took part in all but one of their shows – and she sustained a lifelong friendship with Degas.

Though Cassatt painted several pictures of women sewing, taking tea or attending the opera, after 1887 her dominant theme became mothers and their children. Among the most famous of these warm and intimate images is *The Family*. In this work a mother poses with her baby and young daughter in a verdant, parklike setting. The subtle interplay of glances and gestures unites the figures compositionally and underscores their harmony as a family.

Cassatt's classic, pyramidal composition was probably derived from Renaissance prototypes, such as Raphael's paintings of the Madonna and Child with the young Saint John or an angel. Yet, as Joyce Szabo has noted:

> The asymmetrical arrangement with the viewer's angle of vision slightly above the group, the cropping of figures and trees at the edge of the canvas, and the overall linear emphasis are attributes both Cassatt and Degas adapted from Japanese prints.

Though the undated painting has sometimes been placed c. 1886, it is more likely from 1892, when Cassatt was at work on *Modern Woman*, her mural for the Woman's Building of the 1893 World's Columbian Exposition in Chicago. The style of *The Family* – its bright, strong colors flatly applied and contained by delicate contours – is typical of her mature work of the 1890s, and all three of the figures in the painting reappeared, with variations, in her 1893 mural. Cassatt's preparatory pencil drawing for the baby in *The Family* is in the collection of Gordon K. Allison, New York.

In a letter written from France on February 15, 1894, Cassatt remarked that *The Family* was then being offered for sale at the New York gallery of Durand-Ruel (see no. 113). Later that year it was purchased by Louisine and Henry O. Havemeyer, who had long been friends of Cassatt and who, with her encouragement and guidance, amassed one of the earliest and finest collections of Impressionist art in the United States.

119 Paul Gauguin

French, 1848-1903

The Loss of Virginity, 1890-91

Oil on canvas, 35½" x 51¼" (90.2 x 130.2 cm)

Gift of Walter P. Chrysler, Jr., 71.510

References: Harrison, *CM*, 1986, no. 40; *The Art of Paul Gauguin*, exhib. cat., National Gallery of Art, Washington, D.C., and Art Institute of Chicago, 1988, no. 113.

In 1883 Paul Gauguin abandoned his career as a Paris stockbroker to devote himself solely to art. Seeking artistic inspiration from the religious myths and superstitions of "natural men" uncorrupted by modern culture, he embarked upon a restless search for "the savage and the primitive." This quest led him first to Brittany, where from 1886 to 1890 he often worked at the artist colony of Pont-Aven and at the nearby, but more secluded and "primitive" coastal spot of Le Pouldu. Gauguin's early visits to Brittany were preliminary steps in his long retreat from European civilization, which culminated in his first trip to Tahiti in 1891-93.

Working together with Emile Bernard and other painters at Pont-Aven and Le Pouldu, Gauguin put aside his earlier Impressionist aesthetic and, for a time, experimented with the Post-Impressionist style of Cloisonism, or Synthetism. As can be seen in his Cloisonist masterpiece of 1890-91, *The Loss of Virginity*, Gauguin at this time began to compose in broad fields of bright, unmodulated color compartmentalized by dark outlines. Following the dictates of Synthetism, Gauguin also rejected naturalistic representation in favor of a more purely Symbolist aesthetic, employing the colors, shapes and objects of the visible world as subjective evocations of ideas and moods.

"Art is an abstraction," he proclaimed; "derive this abstraction from nature while dreaming before it."

In November 1890 Gauguin returned to Paris from Le Pouldu with plans to depart for Tahiti, which he did the following April. Though some scholars contend that the undated *Loss of Virginity* was painted at Le Pouldu in the early autumn of 1890, most have argued that Gauguin produced it in Paris in the winter of 1890-91, when he was in close contact with the Symbolist poets and critics. In all likelihood, the painting is his "final major canvas in an overtly Cloisonist and Symbolist vein and as such [it] constitutes both the culmination and termination of his pre-Tahitian development" (Bogomila Welsh-Ovcharov).

The picture's densely Symbolist theme was correctly explicated in 1906 by Gauguin's early biographer, Jean de Rotonchamp. Rotonchamp described the subject as that of "a virgin seized in her heart by the demon of lubricity" – i.e., a young woman's loss of sexual innocence. Lying deathlike on the ground, the naked maiden holds a plucked flower (an iris?), a traditional symbol of lost innocence. With her left arm she embraces an evil-eyed fox, who precipitates her downfall with a paw upon her heart. In two of Gauguin's wood sculptures of the period – the 1889 *Be in Love and You Will be Happy* (Museum of Fine Arts, Boston) and *Luxure* of 1890-91 (J. F. Willumsens Museum, Frederikssund) – a fox also appears as an emblem of lasciviousness. In fact, in an 1889 letter to Emile Bernard, Gauguin identified the fox in *Be in Love* as "an Indian symbol of perversity." In the painting's background Breton peasants proceed

along a narrow path. A wedding party, perhaps, or a group of pious churchgoers, they may symbolize the maiden's dream of respectability.

The landscape in *The Loss of Virginity* is that of Le Pouldu, its fields of grain leading down to the grass-covered dunes at the mouth of the Laita River, which flows into the Atlantic Ocean. The season is autumn: the grain has been harvested and a sheaf lies at the maiden's feet. In planning the setting of the painting, Gauguin probably consulted one of his earlier landscapes painted on site at Le Pouldu, the 1890 *Harvest: Le Pouldu* in the Tate Gallery, London. Gauguin's preparatory charcoal study for the fox and young woman's head is in the collection of Marcia Riklis Hirschfeld, New York.

Wayne Andersen has suggested that Gauguin derived the maiden's supine pose from that of the dead Christ found in late-medieval Breton "Calvary" sculptures. From this he concludes that the artist intended to parallel Christ's death on the cross with the sacrifice of the maiden's virginity. Consulting Breton harvest legends, Andersen also interprets the harvested grain in sacrificial terms, as an emblem of the "reaping" of the maiden's innocence.

Gauguin's symbolic treatment of the painful passage from maidenhood to womanhood may have had a highly personal meaning for him. It has often been noted that the woman who modeled for *The Loss of Virginity* – a young seamstress named Juliette Huet – was Gauguin's mistress at the time. The artist met Huet in Paris toward the end of 1890, and though she was pregnant with his daughter, he abandoned her when he departed for Tahiti.

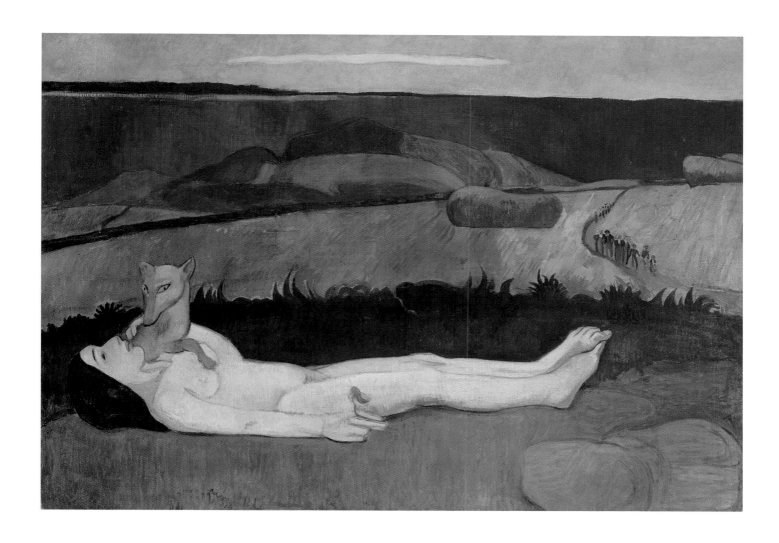

120 Edgar Degas

French, 1834-1917

Dancer with Bouquets, c. 1895-1900

Oil on canvas, 71″ x 60″ (180.3 x 152.4 cm)

Signed lower right: *Degas*

Gift of Walter P. Chrysler, Jr., in Memory of Della Viola Forker Chrysler, 71.507

References: Harrison, *CM,* 1986, no. 39; *Degas,* exhib. cat., Grand Palais, Paris *et al.,* 1988-89, p. 423.

Edgar Degas was most widely known in his lifetime, and is beloved today particularly, as a painter of the dance. Already in 1867, in his *Mlle Fiocre in the Ballet from 'La Source'* (Brooklyn Museum), he had begun to interpret subjects drawn from the ballet of the Paris Opéra. He continued to do so – in hundreds of paintings, sculptures, pastels and prints – for the next forty years.

In the nineteenth century the ballet was one of the prime cultural diversions of the Parisian upper class. Degas' fascination may have been fostered at an early age by his father, a wealthy Paris banker who was deeply interested in music and surely held a subscription, or *abonnement,* to the Opéra. Degas chose for his subjects not merely the seasoned stars of the Opéra stage, like the dancer portrayed in The Chrysler Museum picture, but the lesser ranks of the *corps de ballet* and even the adolescent apprentices, the *petits rats.* He showed dancers in performance, at rest or in transit backstage, and at work in the rehearsal hall, moving their often reluctant bodies through endless hours of exercise at the barre. In the discipline of the dance Degas may have sensed a metaphor for his own lifelong quest for aesthetic control. More important to the Impressionist Degas, however, was the opportunity the ballet offered to research the transitory effects of gesture and motion, the dynamics of human movement.

Dancer with Bouquets was produced late in Degas' career – around 1895-1900, when his eyesight was failing and he had begun to work in broader, more vigorous strokes. In the painting a prima ballerina takes a bow at the end of a performance: at her feet are bouquets of flowers tossed by an adoring audience. Standing before a painted landscape backdrop, she raises her hand as if to kiss the crowd before her. The footlights, which fill the scene with a magical, if rather harsh, incandescence, transform the gauzy layers of her gown into a smoldering violet-grey cloud. Though painted on a large, "official" scale – unusual for the late

Degas – *Dancer with Bouquets* was not exhibited during the artist's lifetime, but remained in his studio, where it served as a model for other works. The dancer's pose was also used in one of Degas' later sculptures, *The Bow* of c. 1896. The *pentimenti* visible along the contours of the dancer's face and arms indicate that Degas reworked her pose considerably. There are at least four preparatory studies for the figure. One, a half-length *étude* in pastel, was included in the second Degas atelier sale in Paris in December of 1918. The remaining three – full-length figure studies in charcoal and pastel and yet another half-length sketch in charcoal – were dispersed in 1919 at the third of the posthumous Degas sales.

In *Dancer with Bouquets* the scene is viewed obliquely, as if from the wings or a private side box. The odd angle of the viewer's vantage point and the tricks it plays with perspective and the dancer's pose are typical of Degas' later, more abstracted compositions. The sharply lighted, unlovely features of the aging dancer's face and the sense of motion arrested create an image of nearly photographic frankness and immediacy – an unstudied "snapshot" of reality stolen from the flow of time.

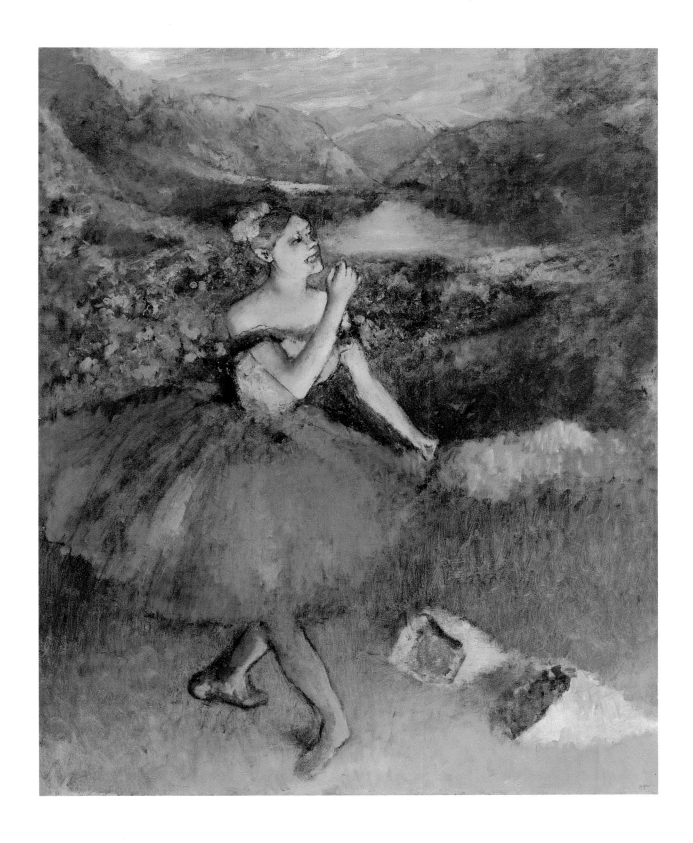

121 John Henry Twachtman

American, 1853-1902

October, c. 1901

Oil on canvas, 30″ x 30″ (76.2 x 76.2 cm)

Gift of Walter P. Chrysler, Jr., 71.713

References: Zafran, *CM*, 1978, no. 34; *John Twachtman, Connecticut Landscapes,* exhib. cat., National Gallery of Art, Washington, D. C. *et al.,* 1990, p. 37.

A founding member of The Ten (see also nos. 117, 125), John Twachtman has been described as the most poetic of the American Impressionists, a "painter's painter" whose ethereal, contemplative landscapes were more readily understood by other artists than by the public of his day. He was born in Cincinnati, where he began formal art studies in 1871 at the McMicken School of Design, working under the Munich-trained painter Frank Duveneck. Inspired by Duveneck, Twachtman continued his training in 1875-77 at the Royal Academy in Munich. For the next several years he produced landscapes that displayed the dark tonalities and bravura brushwork of the nineteenth-century Munich style.

He eventually wearied of that somber aesthetic and in 1883 sought an antidote in contemporary French art. He studied in Paris at the Académie Julian (1883-85) and painted in the French countryside with fellow Americans Childe Hassam (no. 117) and Theodore Robinson, returning to New York by 1886. Influenced particularly by Oriental art and by the paintings of Jules Bastien-Lepage and James McNeill Whistler, he evolved during this period a thinner, more vaporous brush technique, a cooler palette and a flatter, more abstract approach to illusionistic space. Twachtman reached his creative zenith – and his closest accommodation of the French Impressionist style – in the years after 1890, when he lived mainly in Greenwich, Connecticut. There, and in the adjacent fishing community of Cos Cob, he produced a succession of mature landscapes that includes *October* in The Chrysler Museum.

Twachtman had worked on and off in the Greenwich area since 1886. But it was not until 1889, when he was hired to teach at the Art Students League in New York, that he felt financially secure enough to settle there. Soon after, he purchased a seventeen-acre farm for himself on Round Hill Road in Greenwich and began to conduct summer art classes at Cos Cob for his New York students. Cos Cob quickly became a thriving art colony that attracted several of Twachtman's painter friends, including Robinson and J. Alden Weir. It was probably due to Robinson, who returned from France in 1892 and shortly thereafter joined Twachtman in Connecticut, that the artist finally adopted the lighter colors and broken brush technique of the French Impressionist style. Twachtman was less interested, however, in the Impressionists' commitment to "optical truth." As the gentle autumn landscape in *October* reveals, his vision of nature remained essentially lyrical and subjective.

Produced by Twachtman around 1901, the Chrysler painting depicts an early twentieth-century Cos Cob landmark, the Brush house and store. It was one of the oldest structures in the village, and since it stood next to the Holley House, where many artists boarded, it was often depicted by painters there. In *October,* "Twachtman used very sketchy and free brushwork, relating the feathery branches of trees and grasses to the delicate lines of the double-tiered porch of the Brush house…and the columned veranda of the small grocery beside it" (Lisa N. Peters). Though the house is viewed from a distance, the illusion of deep space is mitigated by the planar emphasis of Twachtman's design and brushwork, and by the abstracting effect of the painting's square shape, a format the artist often used. What results is a strongly abstracted composition in which the house seems to dematerialize amid veils of light and color, to float poetically "between reality and a dream."

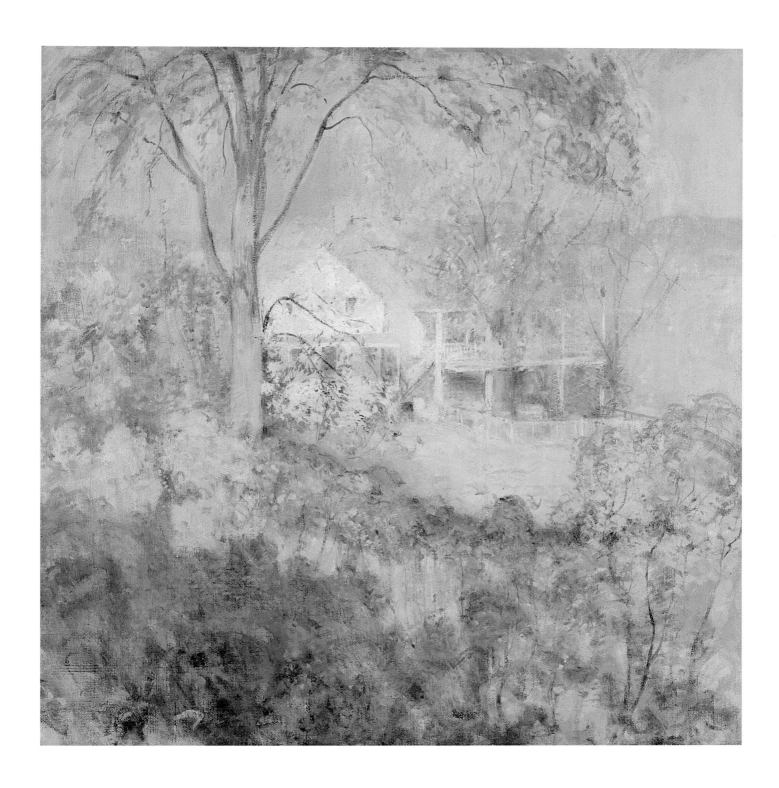

122 Paul Signac

French, 1863-1935

The Lagoon of Saint Mark, Venice, 1905

Oil on canvas, 51″ x 64″ (129.5 x 162.6 cm)

Signed and dated lower left: *P. Signac 1905*

Gift of Walter P. Chrysler, Jr., 77.344

Reference: Harrison, *CM*, 1986, no. 42.

Georges Seurat spearheaded the Neo-Impressionist movement, but it was his close friend Paul Signac who served as its principal promoter and public spokesman. After Seurat's death in 1891, Signac emerged as the leading practitioner of the Neo-Impressionist style, and with the 1899 publication of his treatise *D'Eugène Delacroix au néo-impressionnisme,* he became the movement's chief theorist as well. Though around 1890 Signac produced a number of figurative works in the manner of Seurat, he devoted himself mainly — and, after 1896, almost exclusively – to marine and landscape paintings. In later years he executed an ambitious series of port and harbor scenes, including The Chrysler Museum's splendid *Lagoon of Saint Mark, Venice,* of 1905.

Though fascinated by the optical breakthroughs the Impressionists had made, Seurat and Signac objected to their undisciplined and impetuous mode of painting. After meeting Seurat in Paris in 1884 at the founding of the Société des Artistes Indépendants, Signac joined him in a study of modern optical and color theory,

hoping to find a rational basis for the reform of the Impressionist technique and a scientific method of achieving greater structure, luminosity and chromatic brilliance in their own works. The two artists developed divisionism, a highly controlled method of painting in tiny, tight touches of prismatic color that were painstakingly laid on the canvas in accordance with specific chromatic laws. Through the process of "optical mixture," these separate, systematically applied color touches would, they maintained, blend in the viewer's eye to achieve the vibrancy of natural light and the broader tonal harmonies of nature.

The divisionists made their public debut in 1886 at the eighth and final exhibition of Impressionist art in Paris. Captivated by their works, the Symbolist writer Félix Fénéon coined the term "Neo-Impressionism" to describe the movement and its intention to create, quite literally, a "new" Impressionism disciplined by optical science and aesthetic tradition.

Within a year of Seurat's death, Signac left Paris and settled in Saint-Tropez in the south of France. There, joined by fellow-divisionist Henri Edmond Cross (no. 124), he gradually abandoned the tightly dotted, granulated textures of earlier Neo-

Impressionist painting and by 1905 had perfected a more audacious method of composing in large, rectangular bricks or mosaic-like squares of raw, bold color. His efforts marked the advent of Neo-Impressionism's second style, a visually richer manner that swept aside the theoretical subtleties of "optical mixture" for bolder decorative patterns and sensuous chromatic harmonies. *The Lagoon of Saint Mark, Venice* is a highpoint of this later style.

Inspired particularly by the Venetian paintings of J. M. W. Turner and by John Ruskin's *The Stones of Venice,* Signac visited Venice repeatedly after 1904. Cross, too, was enchanted by the City of the Lagoon – he called it a "sensual joy" brimming with "blond light and decorated with the most precious jewels" – and both artists paid tribute to it in a brilliant series of Venetian views. The Chrysler painting, which was first exhibited in Paris in 1911 at the Galerie E. Druet, captures beautifully the poetry and magic of Venice's color and light. The painting's sparkling palette of primary hues and parade of patterned sails convey a festive mood of carnival gaiety. Signac's compositional study for the painting – a full-size transfer sketch measuring 51″ x 62″ – is also in the Museum's collection (no. 123).

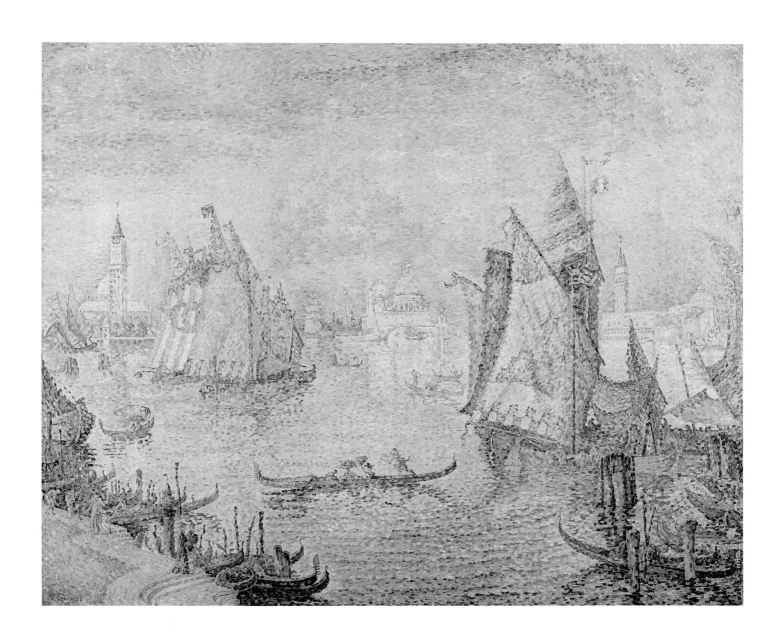

123 Paul Signac

French, 1863-1935

Study for *The Lagoon of Saint Mark, Venice,* c. 1905

Pastel, tempera and pencil on brown paper, laid on canvas, 51″ x 62″ (129.5 x 157.5 cm)

Inscribed throughout with color references and descriptive notations

Museum Purchase with funds from the Accessions Fund and Arthur and Renée Diamonstein, 91.13

Reference: *French Masters of the Nineteenth and Twentieth Century,* exhib. cat., Finch College Museum of Art, New York, 1962, no. 39.

Executed in pastel, tempera and pencil, this extraordinary drawing is Signac's full-scale preliminary design, or cartoon, for his 1905 painting, *The Lagoon of Saint Mark, Venice* (no. 122). Signac inscribed the drawing extensively in pencil with color references, a series of numbers ranging from "2" to "435" with which he established the palette of the painting. These references are accompanied by numerous descriptive notations – e.g., *eau* (water), *voile* (sail), *drapeau* (flag), *ciel* (sky). The artist also drew a ruled grid over the sketch to facilitate the transfer of his design to the canvas. Together these marks provide a rare and fascinating glimpse into Signac's working method, recording his "shorthand" notes to himself and even his changes of mind. Signac eventually gave the drawing to his painter-friend Henry van de Velde, a Belgian Neo-Impressionist (cf. no. 122) who ultimately achieved fame as an architect and Art Nouveau designer. Van de Velde kept the drawing until his death in 1957.

In her 1922 biography of Signac, Lucie Cousturier noted that full-scale cartoons were a customary part of the artist's preliminary working method:

> After executing a tiny color sketch, [Signac] summarizes his intentions in a sketch showing the general effect on a sheet of paper the size of the proposed canvas. He first of all delineates with soft charcoal or India ink the principal arabesque which is to be the starting point of his inspiration and distinct style. Then he seeks to draw the large sweeping lines which will encompass the subject and which, by their rhythmic qualities, converging from all corners of the canvas, will draw the viewer's gaze to the work.

Though a number of Signac's cartoons have survived, most (as Cousturier suggested) are muted monochromes executed in black ink, charcoal or chalk. Both the pastel-and-tempera medium of the present work and its vivid palette of blue, green, yellow and orange are remarkable for a Signac cartoon. So, too, is the artist's handling, which is unusually free and expressive even for a sketch of this kind. "The first concern of the painter," Signac wrote, "should be to decide what curves and arabesques will cover the canvas." This is precisely what he determined in the drawing, through its broad arcs and other lines of influence.

The freedom of Signac's sketch is all the more apparent when compared with the painstaking divisionist technique he employed in the finished canvas (no. 122). Placed side by side, the drawing and painting demonstrate beautifully the classic Renaissance distinction between artistic invention and execution, between the inspired improvisation appropriate to a sketch and the more deliberate rendering expected in a finished work.

124 Henri Edmond Cross

French, 1856-1910

Excursion, 1895

Oil on canvas, 45¾" x 64¾" (116.2 x 164.5 cm)

Signed and dated lower left:
HENRI EDMOND CROSS 95

Gift of Walter P. Chrysler, Jr., 77.416

Reference: Isabelle Compin, *H. E. Cross*, Paris, 1964, pp. 135-136, no. 45.

Like his colleague Paul Signac (no. 122), Henri Edmond Cross played a key role in the development of Neo-Impressionism following the death of the movement's founder, Georges Seurat, in 1891. Born the son of a Douai ironmonger, Cross arrived in Paris by 1881 to conclude his art studies with the painters Emile Dupont-Zipcy and François Bonvin. As an inaugural member of the progressive Société des Artistes Indépendants, Cross met Seurat and Signac at the founding of that institution in 1884, though he did not fully adopt their dotted painting method – divisionism – for another seven years (see no. 122).

By 1892 both Cross and Signac had left Paris and settled in Provence, Cross at Saint-Clair and Signac at nearby Saint-Tropez. Stimulated by the warm-ing radiance and boisterous colors of the Mediterranean coast, they gradually renounced the constraints of Seurat's optical theories and densely granulated brush technique. In a series of light-soaked, arcadian landscapes, they evolved a more vibrant divisionist method, painting in progressively broader blocks of brilliant color. Their research was already well advanced by 1895, as seen in Cross' imposing *Excursion* of that year. In time their style would have a profound influence on the art of the young Henri Matisse and his fellow Fauves (nos. 132, 128), who frequently visited Saint-Tropez around 1904 to study with Signac and Cross.

One of Cross' most complex figurative landscapes, *Excursion* depicts a carefree group of summer holiday-makers as they relax on a windswept bluff overlooking the Mediterranean Sea. The painting's arcadian mood evokes the eighteenth-century *fêtes galantes* of Antoine Watteau. Its decorative surface patterns – its sweeping curves and arabesques – bring to mind the contemporary work of the Nabis. The subdued color scheme of pink, mauve, green and light blue captures perfectly the sun-bleached palette of Provence. Indeed, Cross noted as he worked on the picture that it would require "tints compatible with a sunny plain – not too rich, but more neutral and grey in tone."

The *Excursion* was largely finished by December of 1894, when fellow-divisionist Maximilien Luce mentioned it in a letter to Cross: "Signac has told me about a painting of yours that he likes very much (the excursionists); from his description it sounds very interesting." While on display in Paris at the 1895 Salon des Indépendants, the work was viewed by Camille Pissarro (no. 96), who referred to it in an April 8 letter to his son Lucien, and by Signac, who recorded his impressions of it in the April 26 entry of his journal.

The painting remained with Cross until his death and was sold at the 1921 Paris auction of his atelier. Three preliminary works survive: a pencil sketch for the standing female figure (Cabinet des dessins, Louvre, Paris), a large compositional study in oil (Petit Palais, Musée d'Art Moderne, Geneva) and a smaller oil sketch of the landscape (private collection, Paris).

125 William Merritt Chase
American, 1849-1916
An Italian Garden, c. 1909
Oil on canvas, 16″ x 21⅝″ (40.6 x 55 cm)
Signed lower left: *Wm. M. Chase.*
Gift of Edward J. Brickhouse, 59.79.1

William Merritt Chase was among the most cultivated and sought-after painters in late-nineteenth-century New York. He treated a broad range of subjects during his long and prolific career: portraits, genre pieces, landscapes and still lifes. He is prized today particularly for his later landscapes like *An Italian Garden.* Their *plein-air* vibrancy and lush, atmospheric brush technique confirm his role as a leader of the American Impressionist movement. From 1905 Chase was a central member of The Ten, the artist group that did much to foster the Impressionist style in the United States (see nos. 117, 121).

A tireless promoter of American art and artists, Chase was also a con-summate teacher, who left his mark on a generation of younger American painters. After studying at the Royal Academy in Munich, he settled in New York in 1878 and joined the faculty of the newly founded Art Students League. In 1896 he opened his own teaching institution in New York, the Chase School of Art, and also served for years on the faculty of the Pennsylvania Academy of the Fine Arts in Philadelphia. Between 1891 and 1902 Chase conducted summer art classes at Shinnecock Hills on Long Island. Thereafter, from 1903 to 1913, he led his summer pupils to Europe to study the Old Masters.

Initially Chase chose different sites for these yearly European trips: Haarlem, London, Madrid. From 1907 to 1911, however, he centered his summer sessions in Florence, where he had acquired a house, the Villa Silli, in 1907. Situated in the hills south of the Arno, about a half-hour's ride from the city, the villa was described by a con-temporary visitor as "most picturesque, dating back to 1400 and...furnished in part with antique objects corresponding to its age." The entry hall opened onto a garden which contained an orangery, clusters of olive and cypress trees and a gigantic oleander bush whose blooms, the visitor wrote, made "a gorgeous bouquet of pink near the house."

As Ronald Pisano has suggested, the sun-soaked setting of The Chrysler Museum picture may well be the garden of the Villa Silli. The painting, which was probably made during the artist's visit to Florence in the summer of 1909, was shown in 1910 at the National Academy of Design in New York. Pisano has observed that Chase's color schemes brightened dramatically in later years as he responded to Impressionism and the brilliant light of Tuscany. The palette of *An Italian Garden* – a dazzling medley of pure, primary hues – proves his point to spectacular effect.

Twentieth Century

126 Georges Rouault

French, 1871-1958

Head of Christ, 1905

Oil on paper, mounted on canvas, 39″ x 25¼″ (99.1 x 64.1 cm)

Signed upper left: *G. Rouault*

Gift of Walter P. Chrysler, Jr., 71.519

References: James Thrall Soby, *Georges Rouault: Paintings and Prints*, exhib. cat., Museum of Modern Art, New York, 1945, p. 15; Harrison, *CM*, 1986, no. 45.

In the paintings of his early maturity – among them the 1905 *Head of Christ* – Rouault stood apart from his fellow artists in the early twentieth-century School of Paris. While his contemporaries were devoting themselves overwhelmingly to secular subject matter, Rouault, an ardent Catholic, produced intensely emotional religious images and genre pictures that elucidated the timeless Christian themes of sin and salvation. He has been called the premier devotional artist of the twentieth century, "the monk of modern art." His blunt and brutal Expressionist style also found few parallels in the French art of his day. Genuine stylistic correspondences do, however, exist between his work and that of the German Expressionists of Die Brücke.

The son of a Parisian cabinetmaker, Rouault was apprenticed in Paris at the age of fourteen to the stained glass maker Hirsch. In the paintings he later created he was clearly influenced by the structure and hues of medieval glass windows, by their broad, flat fields of translucent color and thick, leaded contours. In his subsequent study (1892-98) with the great Symbolist painter Gustave Moreau, he perfected his powers as a colorist and crystallized his interest in religious subject matter.

Around 1900 Rouault discovered the writings of Ernest Hello and Léon Bloy, two prominent Catholic theorists in late-nineteenth-century France. The painter met Bloy in 1904 and for a time became his intimate friend. Under Bloy's influence Rouault produced over the next decade his first great series of paintings. These dark and despairing images of prostitutes, clowns, judges and the head of Christ directly reflected Bloy's tragic vision of mankind's spiritual corruption. The ferocious power of these violently painted pictures reached an expressive climax in 1905-06 in such masterpieces as the *Head of Christ*. The paintings of this period, which Rouault exhibited alongside the Fauves (nos. 128, 132) at the 1905 Salon d'Automne and showed regularly between 1905 and 1912 at the Salon des Indépendants, scandalized the Paris public and dismayed even Bloy, who in time denounced them as "the most atrocious and avenging caricatures."

In The Chrysler Museum painting, the Man of Sorrows – his face streaked with blood and his great, pain-filled eyes seemingly melting into tears – bears anguished witness to the sins and cruelty of humankind. The heavy black contours that lash his face "are used as a virtual flagellation of the surface," wrote James Thrall Soby, "a direct translation of the artist's emotion before the subject." "You paint," Rouault's friend André Suarès once said to him, "as one exorcises."

127 William J. Glackens

American, 1870-1938

The Shoppers, 1907

Oil on canvas, 60″ x 60″ (152.4 x 152.4 cm)

Signed and dated lower right: *W. Glackens 07*

Gift of Walter P. Chrysler, Jr., 71.651

References: *The Eight,* exhib. cat., Whitney Museum of American Art, New York, 1983; Judith Zilczer, "The Eight on Tour, 1908-1909," *American Art Journal,* 16 (summer, 1984), pp. 33-34; Szabo, *CM,* 1986, no. 9.

At the beginning of the twentieth century, a small group of progressive American painters began to challenge the narrow academic tastes and restrictive juried exhibition system of New York's powerful National Academy of Design. Their challenge grew into an open revolt in February 1908, when the group, known as The Eight, mounted their first independent exhibition at the Macbeth Galleries in New York. Led by Robert Henri, The Eight also included John Sloan, George Luks, Everett Shinn, Arthur B. Davies, Ernest Lawson, Maurice B. Prendergast and William J. Glackens, the painter of *The Shoppers.*

Though The Eight produced works that varied widely in style, they were generally united in their commitment to ordinary subjects drawn from everyday life. Their passion for common-place and sometimes gritty urban themes and their penchant for dark tonalities led unsympathetic critics to dub them "the apostles of ugliness" and "The Ashcan School." The historic Macbeth Galleries show marked the advent of twentieth-century American art in all its variety and individuality. It also laid the groundwork for another, more influential New York exhibition of modern art, the 1913 Armory Show, which several of The Eight, including Glackens, were instrumental in organizing.

Among the six paintings that Glackens showed at the Macbeth Galleries was *The Shoppers.* It is the largest of the artist's works and one of the most important examples of his early realist style. Like Sloan, Luks and Shinn, Glackens had worked initially in Philadelphia as a newspaper reporter and illustrator. These jobs surely determined his choice of contemporary subjects for later paintings like *The Shoppers* and influenced their mood of detached reportage.

The ambitious figurative composition of *The Shoppers* gave Glackens a good deal of trouble as he hastened to finish the painting for the Macbeth Galleries show. He documented his frustration in letters to his wife, Edith, who had left New York briefly to visit her family in Connecticut. On January 31, 1908, less than a week before the opening of the exhibition, Glackens wrote Edith that the picture had at last been "rescued" and would be ready for the show. His effort was rewarded, for *The Shoppers* was one of the few works in the exhibition that the critics consistently applauded.

The subject of the painting is a slice of middle-class New York life: well-dressed women shopping for clothes. The three principal figures are all portraits. The woman standing at center is Edith Glackens. Her companion at right is Florence (Mrs. Everett) Shinn. The woman seated at left, her back turned to the viewer, represents another family friend, Lillian E. Travis, who was noted for her beautiful auburn hair. Mrs. Travis was an old schoolmate of Edith's from the Art Students League and a frequent visitor to the Glackens' Washington Square apartment. The painting's somber palette and broadly handled forms recall the pictures of Velázquez and Manet (nos. 31, 85), which Glackens had studied during his trips to Europe in 1895-96 and 1906.

128 Othon Friesz

French, 1879-1949

Autumn Landscape, 1907

Oil on canvas, 41½″ x 45½″ (105.4 x 115.6 cm)

Signed and dated lower right: *Othon Friesz 07*

Gift of Walter P. Chrysler, Jr., 71.647

References: *Les Fauves und die Zeitgenossen,* exhib. cat., Kunsthalle, Bern, 1950, no. 56; Marcel Giry, *Fauvism: Origins and Development,* New York, 1982, p. 237.

The town of Le Havre on the Normandy coast produced two artists who became leading practitioners of the Fauve style (see no. 132): Raoul Dufy and the landscape and figure painter Othon Friesz. After preliminary artistic study in Le Havre, Friesz moved to Paris in 1897 and completed his training there at the Ecole des Beaux-Arts (1899-1904). Though he exhibited alongside Henri Matisse at the ground-breaking "Fauve" Salon d'Automne in 1905, his art remained essentially Impressionist in style until 1906. That summer he traveled to Antwerp with Georges Braque (no. 139), who was already experimenting with bright Fauve hues, and there began to embrace the hot palette and formal distortions of Fauvism. It was not until the following summer, when he worked again with Braque at La Ciotat on the Mediterranean coast, that Friesz's Fauve

style reached its climax. This somewhat tardy conversion was short-lived. Within a few months Friesz had discovered the paintings of Cézanne (no. 91), and under their influence he tempered the vibrant palette and expressive freedom of Fauvism with a more classically structured style.

Before leaving Paris for La Ciotat in the summer of 1907, Friesz finished several landscapes that he had started the previous autumn at Honfleur in Normandy, on the Côte de Grâce. Included in this group of roughly ten paintings – sometimes called the "Côte de Grâce" series – is *Autumn Landscape,* dated 1907. Here, in a rush of passionate Fauve color and frantic, feathered brushwork, Friesz gave lyric expression to what Marcel Giry calls

> the "shock" [he] felt through contemplating nature; the attempt at [natural] description [in the painting] has completely disappeared; the drawing, although it has not yet achieved the bold simplification soon to be seen in the landscapes of La Ciotat, nevertheless already shows a far more abbreviating character than before; light as a naturalist feature is absent, to make

way for an arrangement of colored areas that become its equivalent.

The landscape setting in the canvas – a bowl-shaped meadow traversed by a path and enclosed by a ring of trees – appears in several of the other paintings in the Côte de Grâce series, as do the small figures involved in the autumn activity of gathering wood. (Friesz initially intended to include at least seven figures in the picture. As the *pentimenti* at the lower left reveal, he later painted out two of them.) There are closely related, though somewhat smaller and more sketchy landscape oils by Friesz in the Musée de Peinture et de Sculpture, Grenoble, and the University of Iowa Museum of Art, Iowa City. Both, dated 1907, may have been studies for the present work. *Autumn Landscape* served as a point of departure for Friesz's *The Labors of Autumn* of 1908, a large-figure composition in the Nasjonalgalleriet, Oslo.

Friesz exhibited five paintings from the Côte de Grâce series at the 1907 Salon des Indépendants in Paris. Though it is no longer possible to determine which of the artist's works were shown at that time, *Autumn Landscape* may have been among them.

129 Alexej von Jawlensky

Russian, 1864-1941

Sicilian Girl in Blue Shawl, 1913

Oil on board, 26¾″ x 18¾″ (68 x 47.6 cm)

Gift of Walter P. Chrysler, Jr., 71.663

Reference: Clemens Weiler, *Alexej Jawlensky,* Cologne, 1959, p. 239, no. 161.

The son of a Russian army officer, Jawlensky was encouraged by his family to pursue a military career, and in 1884 he graduated from Moscow's Imperial College of Pages with the rank of lieutenant. But his passionate interest in painting gradually triumphed over his family's wishes, and in 1890 he convinced his superiors in the army to transfer him from Moscow to St. Petersburg so he could attend the Imperial Art Academy. Six years later he resigned his captain's commission and departed for Munich, where he continued his artistic studies full-time in the company of another young Rus-

sian émigré, Wassily Kandinsky.

Through his subsequent association with the Fauves in Paris (nos. 132, 128) and the Blaue Reiter group in Munich, Jawlensky had evolved by 1909 a distinctive painting style that combined the emotional force and bold, simplified forms of German Expressionism with the hot colors of Henri Matisse and his fellow Fauves. He quickly became a prominent member of Europe's pre-World War I avant-garde.

Jawlensky was fascinated by the sensual and spiritual power of the human face. Between 1911 and 1914 he painted a series of faces – including his *Sicilian Girl in Blue Shawl* – that number among his finest works. The abbreviated, bust-length formats of these pictures bring

to mind Russian icons. So, too, does the hieratic force of the faces portrayed, their wide, hypnotic eyes filled with a burning light. Jawlensky had his first important artistic and religious experience when he viewed an icon at the age of nine, and in his later work he sought to recapture the mystical intensity of that early encounter. "Great art," he once proclaimed, "is only to be painted with religious feeling."

Above all Jawlensky used color – brilliant, flashing color – to express emotional and spiritual sensations. "My language, after all, is color....apples, trees, human faces are only hints to me to behold something more in them: the life of color grasped by a passionate man, a man in love."

130 Jacques Lipchitz

French, 1891-1973

Seated Figure, 1916

Bronze, 45″ (114.3 cm)

Signed and numbered on the base:
 6/7 JLipchitz

Gift of Walter P. Chrysler, Jr., 71.2013
(reproduction © Estate of Jacques
Lipchitz/VAGA, New York 1991)

Jacques Lipchitz arrived in Paris in 1909 from his native Lithuania to pursue the art of sculpture. He studied at the Ecole des Beaux-Arts and Académie Julian and during the first years of his Paris career produced rather traditional, naturalistic figure sculptures that bear the imprint of both classical prototypes and Art Nouveau.

By 1914 Lipchitz had joined the Cubist avant-garde centered around Picasso. He rapidly abandoned all vestiges of his former realism and by 1916 evolved a severely geometric, semiabstract style, a cool, reflective formal approach based on the tenets of Synthetic Cubism. Like the 1916 bronze *Seated Figure,* many of Lipchitz's Cubist works from this period interpret the human form in decidedly vertical terms, as towering arrangements of sleek, rectangular planes.

Bolstered by his friendship with Juan Gris, Lipchitz sustained his Cubist researches well into the 1920s, creating an oeuvre that constitutes one of the fullest and purest expressions of sculpture in the Cubist mode. After 1925, however, he abandoned Cubism for a far more passionate and curvilinear art, a dramatic "baroque" style that took its inspiration from Auguste Rodin (no. 105).

Seated Figure, which exists in both stone and bronze replicas, reveals the Cubist Lipchitz at his most intellectual and austere. A seated human form – its head, eye, torso and legs are clearly articulated – has been reduced to a semiabstraction of simple, geometric shapes, an elegant bundle of vertical shafts fused together with tight, geometric logic. The coexistence of multiple viewpoints exemplifies the Cubists' effort to present a figure or object as though it were being seen simultaneously from 360 degrees. Lipchitz's Cubism was influenced by the tribal art of Africa and the Pacific islands, and

Seated Figure possesses something of the mystery and power of a primitive Oceanic totem.

131 Henri Matisse

French, 1869-1954

Jeannette III, 1911

Bronze, 24″ (61 cm)

Initialed and numbered on the base: *HM 8/10*

Gift of Walter P. Chrysler, Jr., 71.516

Reference: *Henri Matisse 1869-1954: Sculpture,* exhib. cat., Victor Waddington Gallery, London, 1969, no. 11.

Though he is remembered most as a painter (see no. 132), Matisse also produced a considerable body of sculptures – some seventy pieces – between 1899 and 1932. Like The Chrysler Museum's *Jeannette III,* nearly all of these works are small-scale bronzes cast from terra-cotta originals.

The Chrysler sculpture is part of Matisse's *Jeannette* series, a set of five bronze heads that he produced in 1910-13 at Issy-les-Moulineaux and that is recognized today as one of his premier achievements as a sculptor. The first two pieces in the series – *Jeannette I* and *Jeannette II* – are fairly naturalistic portraits that Matisse made in early 1910 of a model named Jeanne Vaderin, a young woman who was then convalescing from an illness in the neighboring village of Clamart. (The same model posed for the artist's 1910 painting *Girl with Tulips* in the Hermitage, St. Petersburg.) Beginning with *Jeannette III* in 1911, however, Matisse relinquished the use of a model. Inspired by African tribal art and his own imagination, he experimented in *Jeannette III* through *V* with increasingly schematic and abstract forms.

In *Jeannette III* this process of abstraction is already well-advanced. Poised atop a rough-hewn base, the bust-length figure has been redefined as an aggregate of exaggerated, bulbous shapes. What results is a haunting, sphinx-like image with great, hypnotic eyes. "To one's work," Matisse counseled his students, "one must bring knowledge, much contemplation of the model or other subject, and the imagination to enrich what one sees. Close your eyes and hold the vision, and then do the work with your own sensibility."

132 Henri Matisse

French, 1869-1954

Bowl of Apples on a Table, 1916

Oil on canvas, 45¼" x 35¼" (115 x 89.5 cm)

Signed lower left: *Henri Matisse*

Gift of Walter P. Chrysler, Jr., 71.515

References: *Henri Matisse: Sculptor/Painter,* exhib. cat., Kimbell Art Museum, Fort Worth, 1984, no. 31; Harrison, *CM,* 1986, no. 43.

By 1905 Henri Matisse had emerged as a leader of a small group of French avant-garde painters who focused totally on the expressive and decorative potential of pure, rapturous color – color freed from the mundane task of realistic description and granted an independent, evocative power. When these painters exhibited that year at the Salon d'Automne in Paris, outraged critics dismissed them as "the wild beasts," *les fauves.* Despite the uproar their brilliant-hued canvases provoked, the Fauves rapidly became one of the most influential artist groups in early twentieth-century Europe (see also no. 128).

The Fauve movement crested by 1907, and over the course of the next decade Matisse's passion for chromatic expression was rivaled increasingly by his commitment to greater formal discipline. Inspired particularly by the Cubists (see no. 139), he produced, between 1913 and 1917, a series of

remarkably abstract and austere paintings, including The Chrysler Museum's *Bowl of Apples on a Table.* Despite his growing formal concerns during these years, Matisse never renounced the opulence and sensuousness of decorative color. Indeed, he strove throughout his career for an art that would delight and calm both the eye and the mind:

> What I dream of [he once said] is an art of balance, of purity and serenity devoid of troubling or depressing subject matter, an art which might be for every mental worker, be he businessman or writer, like an appeasing influence, like a mental soother, something like a good armchair in which to rest from physical fatigue.

In 1909 Matisse moved from Paris to nearby Issy-les-Moulineaux. He worked on and off there until 1917, when Nice became his principal residence. It was at Issy in the late spring of 1916 that he produced *Bowl of Apples on a Table.* Two related paintings of that spring are the comparably designed still life, *Apples* (Art Institute of Chicago), and *The Window* (Detroit Institute of Arts), an interior scene that features the same pedestal table as the Chrysler picture. In a letter written

from Issy on June 1, 1916, to his friend Hans Purrmann, Matisse noted that he had finished *The Window.* Scholars posit that the undated *Bowl of Apples on a Table* was painted immediately after. The sketchy and improvisational *Apples* in Chicago probably served as a prelude to the more formal and finished Chrysler composition.

The humble imagery of the Chrysler still life – a bowl of fruit on a table with a curtain or louvered door at left – achieves an impression of "monumental dignity and colossal size" (Alfred Barr) as a result of Matisse's closely cropped and frontally ordered design. Cubist influence pervades the composition. As Michael Mezzatesta has noted, it can be traced in "the linearity and simplified geometry focusing on the round tabletop; the strong vertical axis established by the table pedestal; the flattening of space caused by tipping the tabletop forward, the elimination of the third leg, and the folding out of the right side of the pedestal." Yet, over these formal considerations, the poetry of Matisse's color prevails. The apples, brilliant in hue, glow magically in their yellow bowl as if lit from within. "To copy the objects in a still life is nothing," Matisse told his students. "One must render the emotion they awaken."

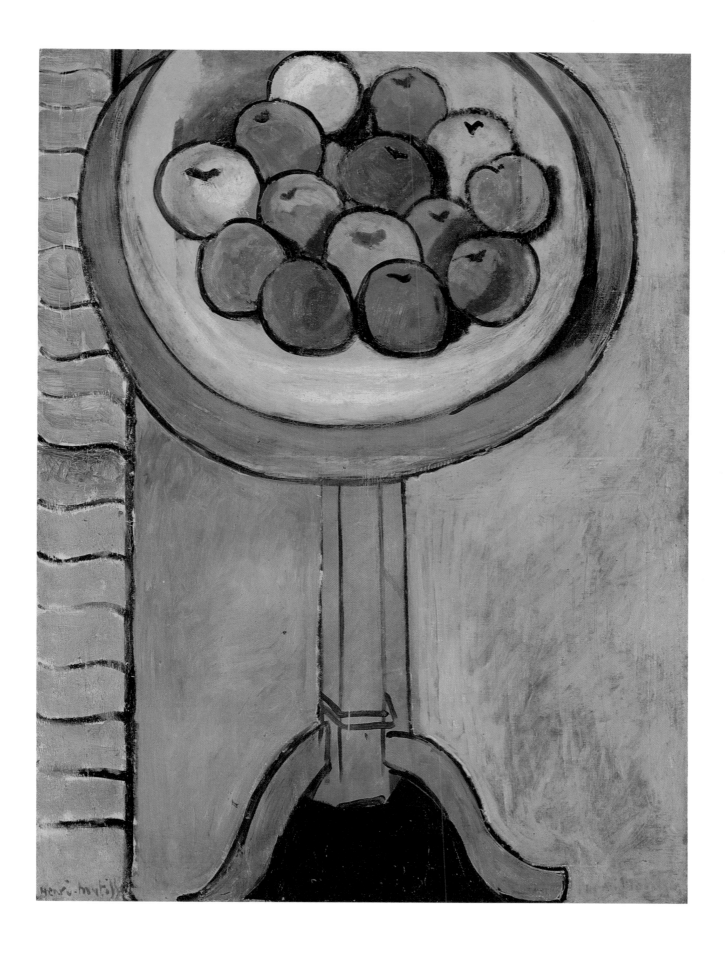

133 Oskar Kokoschka

Austrian, 1886-1980

Prince Dietrichstein and His Sisters in the Park of Schloss Weidlingau, near Vienna, 1916

Oil on canvas, 71¼" x 79¾" (181 x 202.6 cm)

Gift of Walter P. Chrysler, Jr., 71.667

Reference: Hans Maria Wingler, *Oskar Kokoschka: das Werk des Malers,* Salzburg, 1956, p. 306, no. 109.

Widely traveled and long-lived, the Austrian Oskar Kokoschka was, quite probably, the only central European Expressionist to achieve an international reputation in his lifetime (cf. no. 129). After studying the graphic arts at the School of Applied Arts in Vienna (1904-09), he worked to establish himself as a portraitist in that city. But his avant-garde portraits scandalized the conservative Viennese, as did his equally radical plays and poems, and in 1910 he visited more cosmopolitan Berlin. In Germany (and, more gradually, in Austria) Kokoschka became known as a leading Expressionist,

painting a succession of psychologically penetrating portraits and symbolic figure pieces, including his famous *The Tempest* of 1913-14 (Kunstmuseum, Basel).

In early 1915, soon after the outbreak of World War I, Kokoschka enlisted in a cavalry regiment of the Austro-Hungarian army. In the fall of that year he suffered a head and lung injury while fighting against the Russians on the eastern front and was sent back to Vienna to convalesce. Called upon again in July 1916, he went to the Italian front to serve as a liaison officer for war correspondents and artists. Kokoschka began the large and impressive group portrait in The Chrysler Museum in the early summer of 1916, while in Vienna recovering from his war wounds. The work was left unfinished when he was posted to the Italian front in July.

The painting depicts four members of an aristocratic Austrian family, the Dietrichsteins, who are shown in the

park of Schloss Weidlingau, their estate near Vienna. The young man in uniform is the seventeen-year-old Alexander, Prince Dietrichstein-Nikolsberg (b. 1899), who is accompanied (from left to right) by his sisters Alexandrine (b. 1894), Olga (b. 1895) and Marie (b. 1901).

Shaken by his experiences in battle, Kokoschka gave up the relatively controlled naturalism of his pre-war portraits and in 1916-17 embraced a far more agitated style. While the figures in the unfinished Chrysler portrait are necessarily undetailed and schematic in conception, they illustrate nonetheless the broad, slashing brush technique and thickly applied impasto of Kokoschka's wartime aesthetic. Though unfinished, the figures convey, too, a remarkable degree of individuality and psychological insight. This is especially true of the refined and melancholy Prince Alexander, who, though seated in profile, turns his head to gaze gravely at the viewer.

134 Kees van Dongen

Dutch, 1877-1968

Mlle Monna Lils, c. 1929

Oil on canvas, 76½" x 77" (194.3 x 195.6 cm)

Signed lower center: *van Dongen.*

Gift of Walter P. Chrysler, Jr., 71.714

References: Louis Chaumeil, *Van Dongen: L'homme et l'artiste – La vie et l'oeuvre,* Geneva, 1967, p. 312; Peter C. Sutton, *A Guide to Dutch Art in America,* Grand Rapids, Michigan, 1986, p. 207.

The Dutchman Kees van Dongen was, perhaps, the most spirited of the Fauve painters (see nos. 132, 128). His heady, fast-paced life surpassed even the Fauves' exuberant vision of *joie de vivre.* "I have always played," he once jested. "Painting is nothing but a game." His early art was indeed playful and very chic, a sophisticated blend of boisterous Fauve hues and sensual outline.

After some rudimentary artistic training in Rotterdam, Van Dongen settled in Paris in 1897. His paintings sold poorly at first, and he took a number of colorful odd jobs – wrestler, newspaper vendor, longshoreman – to support himself. His artistic career began in earnest in 1904-05, when he exhibited with the art dealer Ambroise Vollard and at the "Fauve" Salon d'Automne. He soon became the toast of Montmartre, hosting a series of raucous parties for the artistic and social elite of Paris.

After World War I, Van Dongen renounced the hot colors of his earlier works for a chillier palette of steely blues and greens. He maintained his social prominence, and with his many portraits of the rich and famous of Paris – actors, politicians, international society beauties and celebrated women of the evening – he captured all the glitter and glamour of the *Folle Epoque,* the French Roaring '20s.

Among the most arresting of these portraits is the seductive *Mlle Monna Lils,* which Van Dongen exhibited in Paris at the 1929 salon of the Société Nationale des Beaux-Arts. In the painting a worldly demimondaine – a heavily rouged "china doll" dressed for dancing – reclines on a couch with predatory abandon, her body set against her fur-lined cape like a costly jewel encased in velvet. "I love everything that shines," Van Dongen once declared, "precious stones that sparkle, fabrics that bristle, beautiful women who inspire carnal desire. And painting gives me the most complete possession of that."

135 Edward Hopper

American, 1882-1967

New York Pavements, 1924

Oil on canvas, 24″ x 29″ (61 x 73.7 cm)

Signed lower right: *Edward Hopper*

Gift of Walter P. Chrysler, Jr., 83.591

References: Sokolowski, *CM,* 1983, pp. 27-28; Robert Hobbs, *Edward Hopper,* New York, 1987, pp. 130-131, 134.

Isolation, separateness, silence – such words are often used to describe the elusive mood evoked by Edward Hopper's works. Widely recognized today as "the major realist painter of mid-twentieth-century America" (Gail Levin), Hopper has long been famous for his hauntingly empty New York cityscapes and rural New England views, and his bleak interior scenes inhabited by solitary, introspective figures.

Hopper was born and raised in Nyack, New York, where his father ran a dry goods establishment. He exhibited an early proclivity for drawing and in 1900-06 studied illustration and painting at the New York School of Art, where one of his teachers, the Ashcan painter Robert Henri (see no. 127), made a particularly strong impression on him. There followed three brief visits to Paris – in 1906-07, 1909 and 1910 – where he abandoned Henri's dark tonalities for the lighter palette and *plein-air* technique of Impressionism and endorsed the Impressionists' interest in urban, architectural themes. When Hopper returned to New York City, his frankly realist paintings were at first unpopular, and, to make a living, he reluctantly turned to commercial illustration. "I was a rotten illustrator – or mediocre, anyway," he later contended. "What I wanted to do was to paint sunlight on the side of a house." Finally, in 1924, a successful exhibition of his watercolors at the Frank K. M. Rehn Gallery in New York freed him financially from his graphic work and allowed him to concentrate exclusively on painting.

New York Pavements of 1924 is an important work from this early period of renewed oil painting. In it a child's nurse, wearing the uniform of an English-trained nanny, briskly wheels a pram past a New York apartment house. The painting is among the first in which Hopper used boldly cropped forms and strong diagonal accents – the oblique placement of the building and an elevated "bird's-eye" prospect – to capture the viewer's attention and force him to confront the eery reality of an otherwise unremarkable stretch of urban landscape. The stark simplicity of the composition and virtual absence of narrative content are typical of Hopper's art, as are the hard light and shadow that play across the building's facade. "Hopper saw the city as a metaphor for the human condition," Thomas Sokolowski has written. "His view is that of a detached voyeur – like the dead observers in Thornton Wilder's *Our Town* – who sees only potential and absence in a world frozen at the edge of tragedy."

136 Arshile Gorky

American, 1904-1948

Still Life, 1929

Oil on canvas, 38½" x 50⅜" (97.8 x 128 cm)

Signed and dated on the reverse: *1929 Gorky*

Bequest of Walter P. Chrysler, Jr., 89.51

References: Jim M. Jordan and Robert Goldwater, *The Paintings of Arshile Gorky: A Critical Catalogue,* New York and London, 1982, pp. 38-40, 214, no. 86; *Abstract Painting and Sculpture in America, 1927-1944,* exhib. cat., Museum of Art, Carnegie Institute, Pittsburgh *et al.,* 1983-84, no. 55.

Born Vosdanig Adoian in the Armenian village of Khorkom, the young Gorky lost his mother in 1919 during the Turkish occupation of his homeland. In 1920 he followed his father to America and settled near him in New England. Though Gorky took art classes at Boston's New School of Design, he was largely self-taught. In 1925 he left Boston for New York City and, having changed his name to Arshile Gorky (an invention typical of this supremely self-invented artist), he there began his career as an instructor at the Grand Central School of Art.

Extraordinarily eclectic, Gorky worked his way through a variety of modernist styles during the 1920s and 1930s, assimilating European avant-garde impulses with an intelligence and speed that few of his native American colleagues could match. His Impressionist landscapes of the mid-1920s gave way c. 1927 to more constructed landscapes and still lifes in the manner of Cézanne. Around 1929 he embarked upon a long period of Cubist influence. In a series of semi-abstract still lifes which includes The Chrysler Museum painting, he mastered the Synthetic Cubist styles of Picasso and Braque (see no. 139) and then reworked those styles to fit the free-flowing, organic shapes of his emerging biomorphic imagery. In his powerful portraits of the period Picasso's influence is equally evident.

In the later 1930s, inspired increasingly by the art of Joan Miró and Wassily Kandinsky, Gorky at last began to forge a genuinely original and personal style. Between 1942 and his suicide in 1948, he produced his most brilliant works, a series of postsurrealist biomorphic abstractions. These paintings exerted a formative influence on the Abstract Expressionists (see nos. 144, 142) and insured Gorky's place as a principal founder of the post-World War II New York School.

The Chrysler painting is one of several still lifes from c. 1930 in which Gorky utilized the semiabstract, planar imagery of Picasso's artist-and-model interiors of the 1920s. Yet Gorky, in his work, distorted this imagery biomorphically, creating exaggeratedly curvilinear, sensual shapes that are often difficult to decipher. In the painting the brown, kidney-shaped object at right is probably an artist's palette, with the legs of a chair visible beneath it. As Jim Jordan notes:

> The palette…is studded with mouths, eyes, or navels (one cannot tell which), and it is connected – via a light, bulbous form – to what may have once been a Cubist compote at the center top. Questions of positive-negative [space] and image-ground dominance have not been resolved. Small white biomorphs on a large dark shape appear to sprout insect wings, mouths.

The horizontal stripes – a motif owed ultimately to Picasso – occur as well in the contemporary paintings of John Graham, who met Gorky in the later 1920s and prompted his move toward biomorphic imagery. The picture's dense, saturated color scheme of dark blue, red, yellow and black is typical of Gorky's work of the period. So, too, is the thickly painted surface; Gorky overpainted his compositions repeatedly as he corrected and refined them.

137 Philip Evergood

American, 1901-1973

Music, 1933-59

Oil on canvas, 67" x 119½" (170.2 x 303.5 cm)

Signed and dated lower right: *Philip Evergood XXXIII-LIX*

Gift of Walter P. Chrysler, Jr., in Memory of Jack Forker Chrysler, 80.73

Reference: Kendall Taylor, *Philip Evergood: Never Separate from the Heart,* Cranbury, New Jersey, 1987, p. 87.

Like fellow social realist Thomas Hart Benton (no. 138), the New York painter Philip Evergood devoted much of his art of the 1930s to gritty, populist images of contemporary life. In his paintings he celebrated the vitality of the American worker and urban common man and often protested the political and social injustices they suffered during the Great Depression. Using an incised linear style, he relied heavily on caricature and intentionally "naive" figure distortions to drive home his often disturbing political points.

Surprisingly, in light of his themes, Evergood had been educated in England – at Eton, Cambridge and London's Slade School of Art, where he studied drawing. After further travel and study abroad, he returned to his native New York in 1926 and by the mid-1930s had established a reputation there as an idealist, committed to politically liberal issues. An early supporter of the civil rights movement and an activist in the radical Artists' Committee of Action, he often used his art to propagandize egalitarian causes. He worked on a number of artistic projects for the Works Progress Administration – the WPA – and lobbied to keep talented artists on its rolls.

Evergood painted the mural-size *Music* in December 1933 for a wall in the meeting room of the Pierre Degeyter Club, which he had joined earlier that year. The club, located in Manhattan at 5 East Nineteenth Street, was at that time a haven for political free-thinkers and socially radical artists, particularly musicians. Though tradition has it that *Music* represents New York's first WPA band, Kendall Taylor argues convincingly that the painting instead portrays a group of musicians who belonged to the Degeyter Club. He suggests that the canvas was inspired by a specific performance at the club, during which Evergood's wife Julia, "wearing a red, flowing scarf, did a dance set to revolutionary music."

After hanging for some time in the Degeyter Club, *Music* was returned to Evergood, who later lent it to the Amalgamated Bank in Manhattan. When the bank gave the work back to him in 1956, he retouched it, "updating" the facial features of the two principal foreground figures. One of these figures, standing at right and holding a violin, is almost certainly a self-portrait.

In *Music's* cacophony of riotous color and jostling forms, Evergood captured all the diversity and joyful energy of an amateur orchestra. He was also able to create a powerfully democratic image of harmony among "the people." As David Peeler observes:

> ...there are no pitched battles [in the painting] between police and workers, nor do people dance to someone else's tune. Instead, the people peacefully make their own music. Players of all races and ages harmonize and do so with looks of obvious satisfaction upon their faces. These are plainly people from different social classes, for orchestra members wear the costumes of both the rich and the poor; but they all cooperate with each other.

138 Thomas Hart Benton

American, 1889-1975

Unemployment, Radical Protest, Speed, 1932

Tempera on board, 32″ x 176½″ (81.3 x 448.3 cm)

Gift of Walter P. Chrysler, Jr., 71.2011 (reproduction © Estate of Thomas Hart Benton/VAGA, New York 1991)

References: Matthew Baigell, *Thomas Hart Benton,* New York, 1973, pp. 114-128; Zafran, *CM,* 1978, no. 40; *Thomas Hart Benton: An American Original,* exhib. cat., Nelson-Atkins Museum of Art, Kansas City *et al.,* 1989-90, pp. 184-191.

The life and art of Thomas Hart Benton were marked by numerous contradictions. He studied in 1908-09 at the Académie Julian in Paris and experimented in his early pictures with Impressionism and the color abstractions of Synchromism. Eventually, however, he denounced the "foreign tyranny" of European and expatriate American avant-garde painting and instead developed a conservative, figurative art that celebrated indigenous American themes.

Locale was a second point of contradiction. Much of Benton's mature work – from 1912 to 1935 – was produced in New York City. Yet the Missouri-born artist railed against the aesthetes and intellectuals of the New York art establishment and devoted much of his painting to a "regionalist" vision of the ordinary working poor in the rural South and Midwest. By the mid-1930s he had joined fellow-regionalist painters John Steuart Curry and Grant

Wood at the forefront of the nationalistic "American Scene" movement, emerging as a vociferous defender of purely American subjects and straightforward realist styles. All this notwithstanding, his compositions derived much from Michelangelo, Pieter Brueghel and other European Old Masters, and his agitated, hard-edged figure style owed a good deal to El Greco and Tintoretto.

During the 1930s Benton was a key figure in the revival of public mural painting in the United States. Indeed, he established his reputation in New York with a multi-panel mural cycle entitled *The American Historical Epic* (1919-26) and a 1930 mural series, *America Today,* for the New School of Social Research.

In 1932 Juliana Force, the director of the recently founded Whitney Museum of American Art in New York, commissioned Benton to do a set of murals for the reading room of the museum's library. The series, called *The Arts of Life in America,* included four large wall panels, a lunette and three long ceiling panels, one of which is The Chrysler Museum's *Unemployment, Radical Protest, Speed.* The series celebrated the popular arts of the city, of the American West and South, and of Native Americans. As the Chrysler picture shows, the suite also underscored the social and political issues of the day. The racing locomotive in the painting (signifying "Speed") was a recurring

Benton image. Together with the airplane and jeep, it suggests the vitality and breakneck pace of industrialization in 1930s America. The confrontation of strikers and gunmen ("Unemployment, Radical Protest") alludes to the violence that surrounded the labor movement during the Depression.

Many critics of the day found Benton's Whitney murals irreverent and distasteful, while others applauded their raucous energy. In his review of the series in the December 24, 1932, issue of *Art News,* Ralph Flint called the murals a "brilliant bit of Bedlam" and praised Benton's "fervor and conviction":

> He has expounded his gospel of the "art of life in America"…with all the conviction of a Billy Sunday or an Aimee Semple McPherson…. You may not like Mr. Benton's new murals but you can't get away from them any more than you can close your eyes to the headlines in the morning's papers. They have an inescapable ring to them, a terrible "tabloid" insistence that keeps them strumming like a taut wire.

The series remained in place until 1954, when the Whitney Museum moved in Manhattan from Eighth Street to West 54th Street. Thereafter the murals were removed from the walls and sold. Today the four wall panels and lunette are in the New Britain Museum of American Art, New Britain, Connecticut.

139 Georges Braque

French, 1882-1963

The Pink Tablecloth, 1933

Oil and sand on canvas, 38¼" x 51¼" (97.2 x 130.2 cm)

Signed lower right: *G. Braque*

Gift of Walter P. Chrysler, Jr., 71.624

References: Robert Rosenblum, *Cubism and Twentieth-Century Art*, New York, 1959, pp. 318, 340; Harrison, *CM*, 1986, no. 44.

Following in the footsteps of his father and grandfather, Georges Braque worked initially as a house-painter. But he soon broke with family tradition and in 1902 began to study painting as a fine art at the Académie Humbert in Paris. After a brief Fauve period (1905-07; see nos. 132, 128), Braque discovered Cézanne (no. 91), whose tightly reasoned, architectonic compositions prompted him to begin a sequence of increasingly abstract, proto-Cubist landscapes and still lifes. Equally influential was Pablo Picasso's revolutionary *Demoiselles d'Avignon,* which Braque saw in 1907. In this painting Picasso had achieved a radical synthesis of African primitivism and Cézannesque form that had taken him also to the threshold of Cubism.

Sensing their parallel interests, Braque and Picasso in 1909 began an intensive, five-year collaboration that brought the new Cubist style to frui-tion. They worked, Braque later said, "like mountaineers roped together." In their early Cubist works the two artists

swept aside traditional assumptions about three-dimensional perspective and illusionistic space. They redefined form in terms of its own internal struc-tural logic, as a geometric semiab-straction of interlocking facets and planes. Their novel approach was endorsed by scores of vanguard paint-ers and sculptors (cf. no. 130), and Cubism emerged as the most influen-tial European art movement of the early twentieth century.

During the first half of the 1930s, Braque painted a series of "decorative" still lifes – *The Pink Tablecloth* among them – in which he abandoned the taut geometry and complex spatial struc-tures of his earlier work for flatter, sparer and more abstract compositions. The curvilinear impulse that had become increasingly evident in Braque's art of the 1920s now triumphed, inspir-ing sensual surface patterns of sweeping arcs and lazily looping lines. As a result the objects in Braque's still lifes of the early 1930s are often reduced to shad-owy, two-dimensional diagrams, their forms distorted or overwhelmed by the artist's free-flowing linear patterns.

This process of abstraction is readily apparent in *The Pink Tablecloth* of 1933, where several objects placed upon a table are nonetheless still recognizable: a bowl of fruit, a glass goblet, a sheet of music and a pipe. Less easily identified are the lobed form to the left of the

goblet and the flaccid, pendulous shape – a mandolin, perhaps, or a carafe – in front of it.

More important to Braque than the objects he painted were the affiliations – both formal and poetic – that bound them together. "Let us forget things," he counseled the viewer, "and consider only the relationships between them." As he worked to reveal these relation-ships, Braque sought "that particular temperature at which objects become malleable" and begin to mimic and merge with one another, that moment when they disclose the deeper, poetic truths that lie unseen within and be-tween them.

Among the hidden resonances that Braque sensed between objects and that he accentuated in paint were con-gruences he called "rhymes." The playful poetry of *The Pink Tablecloth* is conveyed not only through its gay pal-ette of pink, purple and red – lively hues typical of Braque's work at the time – but through a sequence of witty rhymes. The large meandering line in the right foreground, for example, is echoed in miniature in the snaky deco-ration on the goblet; the toothy pattern of the tablecloth's zigzagging edge is repeated on the wall behind. The sandy surface that lends a stucco-like quality to the painting was a textural trick the artist learned during his early years as a housepainter.

140 Charles Sheeler

American, 1883-1965

Shaker Buildings, 1934

Tempera on gesso panel, 9⅞″ x 13⅞″ (25.1 x 35.2 cm)

Signed and dated lower left: *Sheeler – 1934.*

Gift of an Anonymous Donor, 80.224

References: *Charles Sheeler,* exhib. cat., Museum of Modern Art, New York, 1939, no. 32; *Charles Sheeler,* exhib. cat., National Collection of Fine Arts, Smithsonian Institution, Washington, D.C., 1968, no. 74.

Charles Sheeler achieved fame during the 1920s and 1930s as a photographer and as a painter of industrial and architectural subjects. Characterized by a remarkable formal simplicity, his meticulously realistic paintings of factories, turbines, barns and silos helped place him at the forefront of the Precisionist movement in Depression-era American painting.

Sheeler studied commercial design in 1900-03 at the School of Industrial Art in his native Philadelphia and afterwards attended the Pennsylvania Academy of the Fine Arts. Though he was exhibiting his paintings as early as 1908, he initially enjoyed more success as a photographer. From 1926 to 1929 he worked as a commercial fashion photographer for Condé Nast Publications in New York. Visiting France in 1929, he produced his celebrated photographs of Chartres Cathedral.

Sheeler's paintings finally began to attract widespread attention by 1939, when New York's Museum of Modern Art gave him a large retrospective exhibition. Included in that historic show was the small tempera-on-gesso panel now in The Chrysler Museum, *Shaker Buildings* of 1934. The painstaking realism of Sheeler's paintings was undoubtedly influenced by his photography, and scholars have long acknowledged the creative relationship of the two media in his work.

Sheeler was fascinated by the piety and cloistered self-sufficiency of the Shakers, and by the simplicity of their way of life. Founded by Quakers in Britain in 1747, the Shaker sect had established communities in New England in the decades after the Revolutionary War, though by Sheeler's day these settlements were in decline. Like other keen-eyed connoisseurs who were then rediscovering American folk art, Sheeler deeply admired the spare, pure designs of Shaker furniture and architecture. He decorated his own homes with Shaker pieces and in the years around 1930 frequently painted and photographed the Shaker villages at New Lebanon, New York, and Hancock, Massachusetts. As Sheeler once said:

> The Shaker communities...have given us abundant evidence of their profound understanding of utilitarian design in their architecture and crafts. They understood and convincingly demonstrated that rightness of proportion in a house or a table, with regard for efficiency in use, made embellishment superfluous. Ornament is often applied to forms to conceal uncertainty – and this applies to painting too.

The simple white clapboard structure that dominates the Museum's picture was the Shaker wash house in Hancock. (A photograph of the building appears in the November 1963 issue of *Art in America.*) The cool austerity of the composition – its emphasis on pure planes and volumes – evokes the abstract aesthetic of Cubism (nos. 130, 139), which exerted a formative influence on Sheeler's art.

141 Franz Kline

American, 1910-1962

Hot Jazz, 1940

Oil on board, 45½″ x 46½″ (115.6 x 118.1 cm)

Signed lower right: *KLINE 40*

Inscribed and monogrammed on the reverse:
 BAR ROOM PAINTING
 1940
 FK (in ligature)

Gift of Walter P. Chrysler, Jr., 71.1077

Reference: Harry F. Gaugh, *The Vital Gesture: Franz Kline,* New York, 1985, pp. 34-39.

The vigorously painted black and white abstractions that Franz Kline began producing in New York around 1950 brought him worldwide acclaim and secured his position as a leader of the Abstract Expressionist movement (see no. 144). Yet he began his New York career not with abstractions, but with more traditional figurative works like *Hot Jazz* of 1940. In these early pieces Kline was influenced by the German Expressionists (cf. no. 133) and the social realist styles of Americans John Sloan and Reginald Marsh.

After working unsuccessfully as a designer of window displays for a Buf-falo, New York, department store, Kline came to New York City in 1938 and settled in Greenwich Village. As an unknown and struggling young artist, he initially took on whatever artistic work was offered him. He frequently made portrait sketches of the more colorful residents of Greenwich Village, and he painted murals for neighborhood bars and taverns.

In 1940 the owner of the Bleecker Street Tavern in Greenwich Village hired Kline to paint a series of murals — some eight or nine oils on composition board — for which he was paid five dollars apiece plus the cost of materials. As Harry Gaugh has noted, this set of wall panels was Kline's earliest sizable public commission and his most ambitious project to that date. Among the most appealing of these lively Bleecker Street pictures of dancers, singers and circus performers is *Hot Jazz,* which was removed from the tavern before 1966, by which time the building had been demolished. The other surviving works from the series are today mostly in pri-vate hands.

In the painting a voluptuous torch singer is accompanied by a jazz combo as she belts out a song. The pungent colors and a forceful composition of diverging diagonals effectively evoke the music's raucous energy. So, too, does Kline's vigorous, sketchy brush technique. As Gaugh observes:

> Unlike [Kline's] previous work, which had been heavily dependent on line, the [Bleecker Street Tavern] murals are dominated by brush drawing; compositions are integrated in painterly ways that Kline had never before attempted on an easel-painting scale. He brushed in colors and values after the skeletal composition was drawn, reinforcing and pulling the figures forward through insistent contour.

Kline's brushwork would become increasingly spirited and open as he freed himself from representational form and devised the vital calligraphic imagery of his mature abstractions (nos. 144, 145).

142 Jackson Pollock

American, 1912-1956

Number 23, 1951 (Frogman), 1951

Enamel on canvas, 58⅞" x 47¼" (149.5 x 120 cm)

Signed and dated lower right: *Jackson Pollock 51*

Gift of Walter P. Chrysler, Jr., 83.592

References: *Jackson Pollock: The Black Pourings, 1951-1953,* exhib. cat., Institute of Contemporary Art, Boston, 1980, pp. 10-11, 13; Sokolowski, *CM,* 1983, pp. 29-31; Ellen G. Laudau, *Jackson Pollock,* New York, 1989, p. 215.

Between 1947 and 1950 Jackson Pollock produced in New York the revolutionary, multicolored "pourings" that would prove to be the most famous works of his troubled and tragically brief career. (He died in an automobile accident on Long Island at the age of forty-four.) In these monumental paintings he perfected his controversial "drip" technique; positioning his canvas on the floor, he would trickle enamel paint onto it to create airy, calligraphic webs of color. This spontaneous painting method, which borrowed much

from the Surrealist technique of "automatism," won Pollock a leading role in New York's emerging Abstract Expressionist movement (see no. 144). By 1951, the young artist had become the subject of numerous interviews, exhibitions and film documentaries.

Despite his success, Pollock keenly felt the need for new aesthetic challenges. In 1951-52, after one of many dark periods when he struggled with alcoholism and depression, he temporarily turned away from color and pure abstraction to produce a group of exclusively black, figurative paintings and drawings. As Pollock himself noted at the time, these works revived some of his earliest figure motifs:

> I've had a period of drawing on canvas in black – with some of my early images coming thru – think the non-objectivists will find them disturbing – and the kids who think it simple to splash a Pollock out.

Among the most potent of these black pourings is *Number 23, 1951.* In it a large, hulking figure – positioned frontally and defined by the triangular arrangement of its head and hands (or breasts?) – looms within a thicket of black paint. As Francis V. O'Connor has noted, the work echoes the figurative imagery found in a number of Pollock's paintings of the 1930s, for example, *Woman* of c. 1930-33 and *Head* of c. 1938-41 (both formerly Lee Krasner Pollock collection, New York). Several of these symbolic works were inspired by the Jungian psychotherapy Pollock was then undergoing in New York, and like them, *Number 23, 1951* may well contain "an intolerable, if unconscious memory" of the artist's formidable and controlling mother (O'Connor). The painting also brings to mind the disturbing, even repellent images of women being painted at this time by Willem de Kooning.

143 Richard Diebenkorn

American, 1922-

Coffee, 1956

Oil on canvas, 67" x 58¾" (170.2 x 149.2 cm)

Initialed and dated lower right: *RD 56*

Gift of Walter P. Chrysler, Jr., 71.2003

References: *American Figure Painting: 1950-1980,* exhib. cat., Chrysler Museum, Norfolk, 1980, p. 111; *Bay Area Figurative Art: 1950-1965,* exhib. cat., San Francisco Museum of Modern Art; Hirshhorn Museum, Washington, D.C.; and Pennsylvania Academy of the Fine Arts, Philadelphia, 1989-90, pp. 33-35.

During the latter 1950s, Richard Diebenkorn, who was then living in the San Francisco Bay area, gained recognition as one of the most promising contemporary California painters. He has since transcended this regional label and today is rightly ranked among America's finest living artists.

Born in Portland, Oregon, and raised in San Francisco, Diebenkorn began his career as a figurative painter. Around 1945, however, he turned to abstraction and remained an abstract painter for the next decade. During these years he drew artistic inspiration from a variety of sources: from the spare, realist paintings of Edward Hop-per (no. 135) and the chromatically vivid works of Pierre Bonnard and Henri Matisse (no. 132); from the classically structured paintings of Cézanne, Picasso and Mondrian; and, above all, from the Abstract Expressionist paintings of Robert Motherwell and other members of the New York avant-garde (cf. no. 144).

Late in 1955 Diebenkorn returned to representational imagery. He began to produce landscapes, still lifes and figure paintings like *Coffee* of 1956, one of the earliest and most evocative of these newly representational works. To explain his about-face Diebenkorn later said that he had begun to "sense an emptiness" in his abstractions. "It was almost as though I could do too much too easily [in them]. There was nothing hard to come up against." Together with fellow-artists and close friends David Park and Elmer Bischoff, Diebenkorn was soon dubbed a leader of a new school of Bay Area figurative painters.

After moving to Santa Monica in 1966, the artist once again changed his style and returned to abstraction. His most impressive works since then have been his *Ocean Park* canvases, an ambitious series of monumental abstractions that takes its name from the section of Santa Monica where he had his studio.

Like many of Diebenkorn's figurative works, *Coffee* features a single figure who seems lost in contemplation. By eschewing detail for a broader, more reductive approach to form, the artist lends the figure a powerful, though unspecified psychological presence. The painting is one of several from Diebenkorn's middle period in which a man or woman, standing or seated at a table, prepares a cup of coffee. The setting is a public one – a café or bar at night; the scene is bathed in the chilly glow of electric lights. Though *Coffee's* vibrant palette owes a clear debt to Matisse, its mood of isolation and "enigmatic stillness" brings to mind Edward Hopper's paintings of lonely, solitary city dwellers.

144 Franz Kline

American, 1910-1962

Zinc Yellow, 1959

Oil on canvas, 93″ x 79½″ (236.3 x 201.9 cm)

Signed on the reverse: *FRANZ KLINE '59*

Gift of Walter P. Chrysler, Jr., 71.666

References: *Franz Kline: the color abstractions,* exhib. cat., Phillips Collection, Washington, D. C. *et al.,* 1979, no. 7; *Abstract Expressionism: The Critical Developments,* exhib. cat., Albright-Knox Art Gallery, Buffalo, 1987, no. 26.

With the rise of Abstract Expressionism in the late 1940s, New York at last supplanted Paris as the leading art center of the Western world. The new movement was spearheaded by an array of extraordinarily talented painters – Jackson Pollock (no. 142), Willem de Kooning, Robert Motherwell, Hans Hofmann, Franz Kline (this entry and nos. 145, 141) – and it remained America's predominant avant-garde aesthetic until the end of the 1950s.

Though the members of the group, which was also called the New York School, practiced a variety of personal styles and techniques, they were generally united in their adherence to abstraction and to working on a monumental scale. Many, like Franz Kline, were also committed to the exuberant, gestural act of painting, freeing their work of all rational constraints and making it, instead, the vehicle for their own spontaneous, subconscious im-

pulses (cf. no. 142). "The need," said Motherwell, "[was] for felt experience – intense, direct, subtle, unified, warm, vivid, rhythmic." Profoundly disillusioned by the political failures of the Depression and World War II, the Abstract Expressionists rejected the intellectual and technological mainsprings of earlier twentieth-century culture, which they viewed as bankrupt. In so doing, they overturned long-held notions about the basic moral and aesthetic functions of art and with their abstractions created an entirely new visual language.

Kline began his career in a traditional, figurative vein (see no. 141). But by the time of his first one-man exhibit in 1950 at the Egan Gallery in New York City, he had fully embraced abstraction and begun to perfect the primal black and white linear structures that rapidly became his signature imagery. He emerged as the consummate Action Painter; "the negligent edges of shape [in his work], the

changes, revisions, and overpainting give the impression that [he was] directly engaged by the creative process" (Sam Hunter).

After half a decade of notoriety as "the black and white artist," Kline reintroduced color into his art in 1955-56. Painted in Provincetown, Massachusetts, in the summer of 1959, The Chrysler Museum's *Zinc Yellow* is an important late work in which Kline's traditional black-white imagery is enriched by color. In the painting a roughly slashed rectangle and triangular wedge of yellow (Kline sometimes worked with wide housepainter brushes) collide with an advancing wedge of black. This painterly action is set against an atmospheric veil of white through which play subtle blue and grey tones. As in much of Kline's finest work, the effect is intensely exciting, yet somehow lyrical and contemplative.

Kline's small oil study for *Zinc Yellow* is also in the Museum's collection (no. 145).

145 Franz Kline

American, 1910-1962

Untitled (Study for *Zinc Yellow*), c. 1959

Oil on paper, 12″ x 9¼″ (30.5 x 23.5 cm)

Museum Purchase, 85.43

Reference: Joyce M. Szabo, "New Accession: *Study for Zinc Yellow*," *The Chrysler Museum Bulletin*, 15 (July-August, 1985), n. pag.

Acquired by The Chrysler Museum in 1985, this small oil-on-paper study by Franz Kline is a preliminary compositional sketch for his monumental canvas of 1959, *Zinc Yellow*, which has been part of the Museum's collection since 1971 (no. 144). Kline often used such preparatory sketches to establish the designs of his paintings. In many cases he perfected the various parts of a projected composition in a series of detail drawings that he then blended to create a single full-size design.

In the present study Kline determined the basic composition of *Zinc Yellow* in its entirety. He also developed the general chromatic scheme for the canvas, setting dramatic black and yellow hues against a more neutral field of white, grey and blue. As Joyce Szabo has noted, Kline adjusted the composition of his study in several key areas as he worked on the final canvas:

> ...the black triangular form in the lower left [of the sketch] has become a more complex, multi-faceted image [in the painting]. The texture of the black paint and the drag of the brush across the surface of the canvas have become integral parts of the composition that create, simultaneously, a flat image and the illusion of depth. The far more powerful oblique lines of *Zinc Yellow* have become dynamic forces that move our eyes immediately to the center of the painting.

As in many of the Abstract Expressionists' most successful works, the extraordinary energy and sweep of *Zinc Yellow* give the illusion of having resulted from a spontaneous and unstudied burst of creativity. Yet the deliberateness of Kline's method is proven by the sketch, in which the artist carefully laid out the composition for his eight-by-seven-foot canvas in a format less than a foot square.

146 Morris Louis
American, 1912-1962

Gamma Lambda, 1960

Acrylic on canvas, 103″ x 154″ (261.6 x 391.2 cm)

Gift of Walter P. Chrysler, Jr., 77.1240

Reference: Diane Upright, *Morris Louis: The Complete Paintings,* New York, 1985, pp. 220, 261.

During the late 1950s, Morris Louis emerged along with Kenneth Noland as a leader of the Washington, D. C., school of Color Field painters. Working with specially thinned acrylic paints on unprimed canvas of raw cotton duck, Louis created his three landmark series of "color stain" paintings – his Veils, Unfurleds and Stripes, in which ribbons, channels and broad sheets of pure color flow across, and merge with, the unsized canvas.

Born in Baltimore, the son of a Russian-émigré father, Louis studied in 1927-32 at the Maryland Institute of Fine and Applied Arts. During the late 1930s and 1940s, he worked in New York City and Baltimore, settling in Washington in 1952. Louis experimented with a wide variety of representational and abstract styles until 1953. That spring he and Noland vis-

ited the New York studio of Helen Frankenthaler, where they discovered in her painting *Mountains and Sea* a revolutionary method of applying pigment to canvas. Though Frankenthaler had employed the novel drip technique of Jackson Pollock (no. 142) – placing her canvas on the floor and pouring paint onto it – she used paint so fluid that it washed across, and soaked into, the unsized fabric support. Frankenthaler's method of stain painting transformed Louis' art (E. A. Carmean). "It was as if Morris had been waiting all his life for [this] information," Noland recalled. "Once given the information, he had the ability to make pictures with it." Shortly after, Louis began his mature color stain works. At the time of his death from lung cancer in 1962, his importance as an East Coast Color Field painter had just begun to be widely recognized.

Gamma Lambda belongs to Louis' Unfurled series, a group of some 120 monumental paintings produced between mid-1960 and early 1961 that he considered his most significant artistic achievement. Typically leaning his unstretched canvas against an angled scaffolding, Louis created the water-

color-like channels of his Unfurleds by pouring paint from the edges of the canvas and directing its flow diagonally downward by masking, folding and pleating the fabric. The large central portion of the canvas he left open and empty, challenging one of the fundamental conventions of Western painting: "centrality of focus" (Kenworth Moffett).

Bleeding into the weave of the fabric (and sometimes leaving behind ghostly auras of excess thinner), Louis' peripherally placed rivulets of color lose all sense of weight and texture as they merge with the yawning expanse of cotton duck that they bracket. "The effect conveys a sense not only of color as somehow disembodied, and therefore more purely optical, but also of color that…opens and expands the picture plane," observed critic Clement Greenberg, who promoted Louis' work in the artist's final years.

In *Gamma Lambda,* rivulets of black, green, blue and purple skirt a vast stretch of virginal canvas. Though visually empty, the dazzling white canvas assumes a powerful pictorial presence within the context of the composition's lyric sweep.

147 David Smith

American, 1906-1965

Gondola, 1961

Painted steel, 69″ (175.3 cm)

Signed and dated on the base: *David Smith 4-12 1961*

Gift of Walter P. Chrysler, Jr., 77.419
(reproduction © Estate of David Smith/VAGA, New York 1991)

References: E. A. Carmean, *David Smith,* exhib. cat., National Gallery of Art, Washington, D.C., 1982-83, pp. 46-47, 172-173, 177-179, 183; Karen Wilkin, *David Smith,* New York, 1984, pp. 102-104.

Though celebrated today as one of the most creative of mid-twentieth-century American sculptors, David Smith began his career as a painter. In later years he readily admitted that his sculpture quite literally evolved out of his painted work and that the sculptural problems he found interesting were often determined by the art of painting:

> My painting had turned to constructions which had risen from the canvas so high that a base was required where the canvas should be; I was now a sculptor.

The influence of painting on Smith's mature sculpture is particularly evident in The Chrysler Museum's welded steel construction *Gondola,* 1961. The idea for the piece began when Smith suggested that his painter-friend Robert Motherwell make a sculpture in imitation of his series of monumental black and white canvases titled *Elegies to the Spanish Republic.* Among the most powerful creations of Abstract Expressionist painting, Motherwell's *Elegies* feature large black oval and rectangular shapes that abut or blend into one another as they run horizontally across a white ground. Motherwell, who had difficulty envisioning how the two-dimensional imagery of his *Elegies* could be successfully translated into the three-dimensional medium of sculpture, chose not to act on Smith's suggestion:

> Several times David said to me that I "should make an Elegy sculpture." He said he would show me how, help me make it, everything. But I didn't do it because I could never imagine what an Elegy would look like from the side.

Smith, however, pursued the project himself and in *Gondola* produced his own sculptural tribute to Motherwell's *Elegies* (E. A. Carmean).

Smith began work on a rectangular steel plate painted white in imitation of a canvas, mounted vertically on wheels and dissected by another, "open rectangle" of steel bars. On the plate he painted a series of rectangular and oval shapes in black. He then "cut away the leftover areas of white field in such a way that the resulting black shapes were given a more geometric vocabulary. In the final sculpture, the Elegy forms stand free in space, lifted from the white ground of their pictorial origins" (Carmean).

Like a painting, *Gondola* was conceived laterally, as an essentially planar object, and, thus, it challenges the traditional idea of a free-standing sculpture as a fully three-dimensional form. "I don't see [sculpture] from five different angles at once," Smith proclaimed. "I see one view. The round is only a series of fronts."

With the notable exception of Alberto Giacometti, few twentieth-century sculptors before Smith had used wheels to support their sculptures. Smith, however, made liberal use of them in *Gondola* and in his other "Wagons" from the early 1960s. The sculptor was fascinated by industrial machines with wheels – tractors, road graders, trains. It seems likely that the title of the Museum's sculpture refers to a specific kind of railroad freight car, the gondola.

148 Tom Wesselmann

American, 1931-

Bedroom Painting No. 15, 1968-70

Oil on canvas, 84¼″ x 119¼″ (214 x 302.9 cm)

Gift of Walter P. Chrysler, Jr., 77.420
(reproduction © Tom Wesselmann/VAGA,
New York 1991)

References: Slim Stealingworth, *Tom
Wesselmann,* New York, 1980, pp. 58, 65; Gail
Levin, *The Thyssen-Bornemisza Collection: Twen-
tieth-century American painting,* London, 1987,
pp. 344-347.

Among the most irreverent and
playful of post-World War II aesthetics,
Pop Art came to the fore in England
and America in the late 1950s and over
the next decade gained acceptance as a
major style. Reacting to the abstract
and subjective pictorial language of the
Abstract Expressionists (nos. 142, 144),
America's Pop artists embraced figura-
tion and devised a readily accessible
vocabulary of forms drawn from popu-
lar culture. Like his colleagues Andy
Warhol, James Rosenquist (no. 149) and
Roy Lichtenstein, Pop artist Tom
Wesselmann has made liberal use of the
"throw-away" imagery of urban mass
culture – of newspapers, comics and
magazines, movies and television – and
he has often done so to comment iron-
ically on the nature of the erotic impulse

in contemporary American life.

Wesselmann showed no inclination
toward art until he joined the army
and began to try his hand at cartoon-
ing. Thereafter he studied at the Art
Academy of Cincinnati (Cincinnati was
his hometown) and at the Cooper
Union in New York City, where he
encountered, and ultimately rejected,
Abstract Expressionism.

His first significant works were small
collages in a Cubist vein that jux-
taposed his own drawings of female
nudes with magazine clippings of soda
bottles, food and other commercial
products. With time he abandoned
these tiny assemblages for large paint-
ings, though he maintained the collage
approach to imagery and the bright,
slick colors and hard-edge realism
of the magazine ads. In 1962 he em-
barked on his series of *Great American
Nudes.* These brashly colored, mon-
umental canvases feature highly
suggestive female nudes in bath- or
bedroom settings and often incorpo-
rate actual objects – telephones, radios,
tables and chairs – to create a more
palpable domestic environment.

In 1967 Wesselmann began another
series of large-scale canvases, the *Bed-
room Paintings,* in which he pursued

his fascination with erotic themes. In
these highly compressed images the
artist combines still-life objects appro-
priate to the bedroom and redolent
of "pop" romance – pillows, lighted
cigarettes, roses, oranges, a lover's pho-
tograph – with erotically charged parts
of the male or female anatomy.

As in *Bedroom Painting No. 15* of
1968-70, the contours of these canvases
are often shaped to fit the objects
depicted and, thus, echo the imagery's
sensuously undulating forms. Wessel-
mann himself noted that in *Bedroom
Painting No. 15* he "gave the main role
to a huge yellow pillow, and set up a
dramatic scale change in the painting,
between the pillow and the other ele-
ments." The gigantic foot with its
glossily painted nails serves as a tan-
talizing reference to an unseen female
nude reclining on a bed, and as such it
frustrates the viewer's desire to play the
voyeur. In fact, Wesselmann reserves
this role for himself: it is he who gazes
from the photograph at bedside and
who alone can "see" all from this priv-
ileged vantage point.

The Chrysler Museum also pos-
sesses two of Wesselmann's preliminary
drawings for *Bedroom Painting No. 15,*
both executed in pencil on paper.

149 James Rosenquist

American, 1933-

Silver Skies, 1962

Oil on canvas (three panels), 78″ x 198½″ overall (198.1 x 504.2 cm)

Gift of Walter P. Chrysler, Jr., 71.699
(reproduction © James Rosenquist/VAGA,
New York 1991)

Reference: *James Rosenquist,* exhib. cat., Denver Art Museum *et al.,* 1985-87, pp. 36-37.

The mural scale of James Rosenquist's canvases and his preference for lowbrow, consumerist images of automobiles, food and women were influenced by his early work as a professional billboard painter. Born in Grand Forks, North Dakota, Rosenquist began painting billboards in 1953 while a student at the University of Minnesota, where he studied art with Cameron Booth. In 1955 he moved to New York City to continue his instruction at the Art Students League. During the next half-decade he established himself as a fine artist, although to earn a living he continued to work on billboards and also painted window displays, joining the New York Sign, Pictorial & Display Union in 1957.

Rosenquist's earliest canvases were small, abstract works, but by 1960 he had begun to incorporate the realistic imagery of billboards into his paintings. By the late 1950s he had met Jasper Johns, Robert Indiana and other pioneers of the emerging Pop

Art movement (see also no. 148). In 1962 he, too, came to the fore of the movement when he had his first one-man exhibit at the Green Gallery in New York and was included in the "New Realists" show, the groundbreaking Pop Art exhibition at the Sidney Janis Gallery. One of the two paintings Rosenquist displayed in the "New Realists" show was *Silver Skies* of 1962, a pivotal work of his early Pop period.

Like many of Rosenquist's most ambitious compositions, *Silver Skies* borrows from the technique of collage, offering the viewer an assemblage of fragmented, quintessentially American images "pulled" from other contexts and combined in a seemly random manner that divests them of their original meanings. The painting features a car windshield and tires, a soda bottle and a woman's smiling face. "In 1960 and 1961," Rosenquist noted, "I painted the front of a 1950 Ford....I used images from old magazines – when I say old, I mean 1945 to 1955 – a time we haven't started to ferret out as history yet." *Silver Skies'* muted palette of silver grey punctuated by areas of bright red does indeed recall the glossy grisaille technique of 1950s magazine advertisements. Rosenquist saw the wallpaper pattern at the upper right in an elevator lobby.

Though the viewer may attempt

to interpret Rosenquist's paintings in narrative terms, his works resist traditional analysis. "The strange couplings, abrupt color changes, disproportions of scale [in Rosenquist's works]...disrupt the process of recognition.... Manipulating perceptions, Rosenquist keeps viewers off balance, making us stop and start, see and not see, so that a picture's meaning...remains veiled and under wraps, revealed only incrementally and over time" (Judith Goldman).

The overall effect of *Silver Skies* is dreamlike and somewhat disconcerting, not unlike the Surrealist paintings that influenced Rosenquist's Pop style. "At the painting's right edge," Eugene Narrett notes,

a man's legs disappear into a soda bottle, its mouth tipped next to a cropped, beak-like car hood which hovers over a woman's face, its windshield echoing her eyes, its hood her nose. Above her forehead, like a thought, is an image of thighs on a tricycle, the soft friction of their implied motion contained in an unfolding red rose. Christian emblem of the loving plentitude of the cosmos. But here eros is both mechanical and narcissistic and its stroking is given a mean edge by Rosenquist's juxtaposition of two tires...that seem to decapitate a screaming bird.

Alphabetical Index

Artist's name, title of work, entry number

A

Anonymous (Franco-Flemish)
Saint Michael the Archangel, 3

B

Badger, Joseph
Jemima Flucker, 55

Barbieri, Giovanni Francesco, *called*
Guercino
Samson Bringing Honey to His Parents, 22
Cephalus Discovers the Mortally Wounded Procris, 23

Beechey, Sir William
Portrait of Sir Thomas Livingstone Mitchell, 74

Benton, Thomas Hart
Unemployment, Radical Protest, Speed, 138

Bernini, Gianlorenzo
Bust of the Savior, 37

Bertos, Francesco
Sculpture and *The Drama,* 49

Bierstadt, Albert
The Emerald Pool, 101

Bijlert, Jan van
Mars Bound by Amoretti, 27

Bingham, George Caleb
Washington Crossing the Delaware, 83

Boucher, François
Pastorale: The Vegetable Vendor, 51

Boudin, Eugène
Beached Boats at Berck, 109

Bouguereau, Adolphe William
Orestes Pursued by the Furies, 87

Braque, Georges
The Pink Tablecloth, 139

C

Caliari, Paolo, *called* Veronese
The Virgin and Child with Angels Appearing to Saints Anthony Abbot and Paul, the Hermit, 13

Carpeaux, Jean-Baptiste
Ugolino and His Sons, 92

Cassatt, Mary
The Family, 118

Castiglione, Giovanni Benedetto, *called*
Grechetto
Moses Striking the Rock, 25

Cavallino, Bernardo
Procession to Calvary, 26

Ceccarelli, Naddo *(attributed to)*
Madonna and Child Flanked by Four Saints, 1

Cézanne, Paul
Bather and Rocks, 91

Chardin, Jean-Baptiste-Siméon
Basket of Plums, 56

Chase, William Merritt
An Italian Garden, 125

Clerck, Hendrick de
Venus and Adonis, 15

Coello, Claudio
The Vision of Saint Anthony of Padua, 35

Cole, Thomas
The Angel Appearing to the Shepherds, 69
Study for *The Angel Appearing to the Shepherds,* 70
Study for *The Angel Appearing to the Shepherds,* 71

Copley, John Singleton
Portrait of Miles Sherbrook, 59

Corot, Jean-Baptiste-Camille
Landscape in a Thunderstorm, 72

Couture, Thomas
Pierrot the Politician, 82

Coysevox, Antoine *(or follower)*
Fame and *Mercury,* 42

Crawford, Thomas
Paris Presenting the Golden Apple to Venus, 73
Boy with Broken Tambourine and *Dancing Girl (Dancing Jenny),* 79

Crespi, Giuseppe Maria
The Continence of Scipio, 47

Creti, Donato *(attributed to)*
Musical Group, 46

Criscuolo, Giovan Filippo
Adoration of the Magi, 10

Crivelli, Carlo
Saint Anthony of Padua, 4

Cropsey, Jasper Francis
The Old Mill, 107

Cross, Henri Edmond
Excursion, 124

D

Daubigny, Charles-François
The Beach at Villerville at Sunset, 103

David, Gerard *(attributed to)*
Christ on the Cross between Saints John the Baptist and Francis of Assisi, 6

De Clerck, Hendrick
see Clerck, Hendrick de

Degas, Edgar
Dancer with Bouquets, 120

Delacroix, Eugène
Arab Horseman Giving a Signal, 76

De Troy, Jean-François
see Troy, Jean-François de

Diaz de la Peña, Narcisse Virgile
Young Girl with Her Dog, 77

Diebenkorn, Richard
Coffee, 143

Dongen, Kees van
Mlle Monna Lils, 134

Doré, Gustave
The Neophyte (First Experience of the Monastery), 97
The Neophyte, 98

Dossi, Dosso
see Lutero, Giovanni de

Durand, Asher B.
God's Judgment Upon Gog, 78

Dyck, Anthony van
Saint Sebastian, 20

E

Evergood, Philip
Music, 137

F

Fantin-Latour, Henri
Portrait of Léon Maître, 114

Field, Erastus Salisbury
Harriet Sophia Jones, 67
The Last Supper, 102

Artist's name, title of work, entry number